VISUAL CONCEPTS
FOR PHOTOGRAPHERS

FOCAL PRESS LTD.,
31 Fitzroy Square, London W1P 6BH

FOCAL PRESS INC.,
10 East 40th Street, New York, NY 10016

Associated companies:
Pitman Publishing Pty Ltd., Melbourne.
Pitman Publishing New Zealand Ltd., Wellington.

Visual Concepts
for Photographers

Leslie Stroebel,
Hollis Todd and Richard Zakia

Focal Press Limited, London

Focal Press Inc, New York

Published in Great Britain by FOCAL PRESS LIMITED

🕮 British Library Cataloguing in Publication Data
Stroebel, Leslie
 Visual concepts for photographers
 1. Visual perception 2. Photography
 I. Title II. Todd, Hollis Nelson
 III. Zakia, Richard Donald
 152.1'4'02477 TR183

Library of Congress Cataloging in Publication Data
Stroebel, Leslie D
 Visual Concepts for photographers.

 Bibliography: p.
 Includes Index
 1. Vision. 2. Perception. 3. Photography.
I. Todd, Hollis N., joint author. II. Zakia, Richard D.,
joint author. III. Title.
QP475.S74 152.1'4'02477 79–16371

ISBN 0 240 51025 9

First Edition 1980

Printed and bound in Great Britain by A. Wheaton & Co. Ltd., Exeter

Contents

Photograph and Illustration Credits:

For each page the credits are listed left to right, top to bottom. Unless otherwise stated the copyright for each picture is held by the photographer credited.

Front Cover—Vici Zaremba, North-South Photography. Page 19—Andrew Davidhazy. 25—Courtesy of NASA; Neil Montanus. 31—Peter Gales; Neil Montanus; Douglas Lyttle. 41—Dick Swift. 43—George DeWolfe. 45—Bottom drawings by John Wolven. 47—Norm Kerr (2 photographs); John H. Johnson. 51—David M. Spindel. 53—Tom Rogowski; From 'Photographic Filters' by L. Stroebel. 55—Susan Mustico; Nile Root (4 photographs). 57—Dick Swift; John Jean; Günther Cartwright; Courtesy of Martin Rennalls. 59—James Laragy; Courtesy of National Technical Institute for the Deaf, Rochester Institute of Technology. 61—Jeffrey H. Holtzman. 63—Courtesy of NASA. 65—Parfumes Givenchy; Perfumes Dana. 69—Elliott Rubenstein. 71—Leslie Stroebel. 73—John Jean; Douglas Hunsberger (3 photographs). 83—Robert Stolk; Courtesy of Graphic Arts Research Center, Rochester Institute of Technology. 85—Bottom photograph by Lori Stroebel. 87—Steve Diehl, North-South Photography (3 photographs). 91—From 'Munsell. A Grammar of Color', edited by Faber Birren © 1969 by Litton Educational Publishing, Inc. Reprinted by permission of Van Nostrand Reinhold Co. 93—Bottom graph: Holway and Boring. American Journal of Psychology, 1941, *54*, 21–37. © 1941 by Karl M. Dallenbach, The University of Illinois Press, Publisher. 95—Logo (top right) by courtesy of Photographic Sciences Corp., Webster, New York. Target (top left) by courtesy of Graphic Arts Research Center, Rochester Institute of Technology. 101—Bill Lampeter (bottom photograph). 103—Bottom 2 photographs by Richard Gicewicz. 105—Bill Lampeter. 107—Advertisement for Renfield Importers Ltd., N.Y., 'New Yorker' magazine Oct 14, 1975. 121—Bottom 2 graphs from 'Neblette's Handbook of Photography and Reprography' edited by John Sturge © 1977 by Litton Educational Publishing, Inc. Reprinted by permission of Van Nostrand Reinhold Company. 123—Two photographs by Cap Palazzolo. 125—Middle photograph by Don Maggio. 127—Bottom cartoon by permission of Johnny Hart and Field Enterprises, Inc. 131—Top photograph by Ralph Amdursky. 135—Illustration (top left) by courtesy of Metropolitan Museum of Art, Bequest of Mary Martin, 1938. 137—Bottom 2 photographs by Charles A. Arnold Jr. 139—Bottom photograph by Douglas Lyttle. 141—Top left illustration from 'Eye and Camera', George Wald, © Scientific American Inc. All rights reserved. 143—Neal Slavin. 145—John Jean (3 photographs). 147—Photograph courtesy of Ogilvy and Mather Inc. on behalf of its clients, General Foods. 149—Sketch by Nile Root; Bottom illustration courtesy of Society of Photographic Scientists and Engineers. 151—Middle graphic illustration by John Wolven; Photograph by Tom Rogowski. 153—Bottom photograph by C. F. Cochran. 155—Ralph Amdursky; David Spindel. 161—Courtesy of Plenum Press, 1967; Noton and Stark, © 1971 Scientific American, Inc. All rights reserved. 163—© Aviation Hall of Fame, Inc. (3 photographs). 165—Courtesy of Harry Miller. 167—Photograph by Lee Howick. 169—Photograph (top left) by David Korbonits; Photograph (bottom left) by Alonzo Foster; 'Ma Jolie' by Picasso, from the collection of the Museum of Modern Art, New York (Lillie P. Bliss Bequest). 171—Photograph by Liza Jones. 173—Jeffrey H. Holtzman (2 photographs). 175—Photograph by David Spindel. 177—Photograph by Robert Walch. 179—Top illustration, detail from Belvedere by Escher; Sketch (bottom right) of a 'Bull's Head' by Picasso, the original bronze cast is in the Galerie Louise Leiris, Paris. 183—Photographs (2) by courtesy of RIT Instructional Media Services. 189—David Spindel. 193—Bottom photograph by Neil Montanus. 195—Photograph by Günther Cartwright; Graph (bottom right) by Jenkins and Dallenbach, American Journal of Psychology, 1924, *35*, 605–612. © 1924 by The American Journal of Psychology. The University of Illinois Press, Publisher. 197—Andrew Davidhazy; Courtesy of KLM Royal Dutch Airlines. 199—Data for graph from Newhall, Burnham and Clark, J. Op. Soc. Am, vol 47, no. 1, January 1957. 203—Arthur Underwood; Ansel Adams; Douglas Lyttle. 205—David Korbonits; John Jean; Abigail Perlmutter. 207—John H. Johnson. 209—Peter Henry Emerson; John H. Johnson (2 photographs); Andrew Davidhazy. 211—M. A. Geissinger (2 photographs). 215—André LaRoche (5 photographs). 217—Lori Stroebel (6 photographs). 219—John Jean (2 photographs); M. Abouelata (3 graphs). 223—Photograph (bottom left) by A. Franklin. 225—Photograph by Penny Rakoff. 229—Bottom 2 photographs by Langone. 231—Top photograph by Steve Diehl, North-South Photography. 233—Leslie Stroebel; Peter Gales; Andrew Davidhazy. 237—Photograph by George Waters Jr. 239—Photograph by David Spindel. 241—Photograph by John Jean. 243—Photograph (bottom left) by

William W. DuBois. 249—Photograph (bottom) by Abigail Perlmutter. 255—Photograph by Ryszard Horowitz, Courtesy Fieldcrest Mills, Inc. 257—Photographs (2) by courtesy of Eastman Kodak Company. 263—Photographs (8) by Michael M. Dobranski. 265—Courtesy of Graphic Arts Research Center, Rochester Institute of Technology. 269—Graph (bottom left) adapted from Judd, D.B. 'Color in Business, Science and Industry', New York: John Wiley, 1952. 271—Paintings by Henry B. Crawford (top), and Henry and Elizabeth Crawford (bottom). 279—Photographs (2) by John Jean. 281—Photograph (top right) by Neil Montanus; Graph by Hecht and Smith, 1936. 283—Photograph (top left) courtesy of Martin Rennalls; Photograph (top right) by Fred Schmidt. 285—Lee Howick; Dick Swift; Norm Kerr; Leslie Stroebel. 287—Photographs (2) by Andrew Davidhazy. 289—Photograph by Elliott Rubenstein. 291—Top illustration by courtesy of International Museum of Photography, George Eastman House, Rochester, N.Y. 295—Photographs (3) by Langone. 297—Middle graph from 'Neblette's Handbook of Photography and Reprography' edited by John Sturge © 1977 by Litton Educational Publishing, Inc. Reprinted by permission of Van Nostrand Reinhold Company. 299—John Jean; Günther Cartwright; Dick Swift;

John H. Johnson by courtesy of Rochester Institute of Technology permanent collection. 301—Photographs (2) by Tom Mason. 303—R. Walters; J. Brian King. 305—Top illustration courtesy of Munsell Color Co., Inc.; illustration (bottom left) courtesy of Dutch Boy Paints. 307—Photograph (top right) by Charlotte Marine; Photograph (bottom) by Norm Kerr. 309—Illustration (top left) by Joyce Culver. 311—André LaRoche. 313—Eva Rubinstein. 315—Bottom photograph by Anne Bergmanis, RIT Communications. 317—Photograph by J. Hood. 319—Photograph by UPI Cablephoto. 321—Lori Stroebel; John Jean; Dennis C. Kitchen; Douglas Lyttle. 323—Top 3 paintings by Piet Mondrian, courtesy of the Haags Gemeentemuseum collection, The Hague; bottom photograph by Robert D. Routh. 325—'Ritual Branch, 1958' by Minor White, courtesy of The Art Museum, Princeton University. 327—Norm Kerr; Elliott Rubenstein; Courtesy of Wide World Photos. 329—Top photograph by John Jean; Bottom photograph by Sylvia Rygiel. 331—Painting by René Magritte, courtesy of the Minneapolis Institute of Arts; Photograph by Duane Michals. 333—Beach scene by David Hamilton, ice cream scoops by Frank Foster, art direction by Jim Fitts. 335—Photograph by C. B. Neblette.

Acknowledgments

We are indebted to the following for their generous assistance:

Mohamed Abouelata
Sven Ahrenkilde
Terry Bollmann
Peter Bunnell
John Carson
Michael Dobranski
Mary Donadio
Tom Forrester
Kathleen Hafey
Thomas Hill
Lee Howick
Sue Hubregsen
John Jean
Mary Kerr
Larry McKnight
Peter Nicastro
Milton Pearson
John Pfahl
Herbert Phillips
Roger Remington
David Robertson
Grant Romer
Ginger Simonetti
Donald Smith
Arnold Sorvari
Maureen Spindler
Mary Lou Vanden Brul
John Wolven
Lois Zakia

We are grateful for the photographs and other illustrations provided by the following:

Ansel Adams
Ralph Amdursky
American Journal of Psychology
Charles A. Arnold, Jr.
Günther Cartwright
C. F. Cochran
Henry and Elizabeth Crawford
Joyce Culver
Andrew Davidhazy
George DeWolfe
Steve Diehl (North-South Photography)
Michael M. Dobranski
William W. DuBois
Ducos du Hauron (Courtesy IMP-GEH)
Dutch Boy Paints
J. Elliott (Courtesy IMP-GEH)
Peter Emerson (Courtesy IMP-GEH)
Alonzo Foster
Frank Foster
A. Franklin
Peter Gales
M. A. Geissinger
Richard Gicewicz
Graphic Arts Research Center, RIT
David Hamilton
Johnny Hart (Courtesy of Field Enterprises)
Winifred Hilliard
Jeffrey H. Holtzman
John Hood
Ryszard Horowitz
Lee Howick
A. Holway and E. Boring (AJP)
Douglas Hunsberger
International Museum of Photography at the George Eastman House
John Jean
John H. Johnson
Lisa Jones
Norm Kerr

Acknowledgments continued

J. Brian King
Dennis C. Kitchen
David Korbonits
Konrad Kramer
 (Courtesy IMP-
 GEH)
Bill Lampeter
James Langone
Jim Laragy
André LaRoche
Jodi Luby
Douglas Lyttle
Don Maggio
Charlotte Marine
Tom Mason
Duane Michals
Harry Miller
Neil Montanus
Munsell Color
 Company, Inc.
Susan Mustico
National Aeronautics
 and Space
 Administration
National Technical
 Institute for the
 Deaf, RIT
C. B. Neblette
C. N. Nelson
Cap Palazzolo
Abigail Perlmutter

Photographic
 Sciences
 Corporation
Princeton
 University
Penny Rakoff
Martin Rennalls
Rochester Institute
 of Technology
Tom Rogowski
Nile Root
Robert D. Routh
Elliott Rubenstein
Eva Rubinstein
Sylvia Rygiel
Fred Schmidt
Neal Slavin
David M. Spindel
Robert Stolk
Lori Stroebel
Dick Swift
Arthur Underwood
United Press
 International
Robert S. Walch
George Walters, Jr.
R. Walters
Minor White
Wide World Photos
John Wolven
Vici Zaremba

Preface

To become an able photographer requires the acquisition of many skills. It is generally agreed that photographers just beginning must master certain craft skills involving the use of photographic equipment and materials —there is an abundance of literature on these topics. However, it is strange that so little has been written especially for the photographer about the equally important area of how the process of visual perception operates. The primary objective of this book is to inform photographers about concepts that are basic to the process of vision and are relevant to the production of effective photographic images.

Visual perception has traditionally been considered a subdivision of the disciplines of physics, physiology and especially psychology. So considered, much research has been carried out on various aspects of vision and reported in numerous articles in the relevant journals. Some psychology textbooks have summarized the results of this research, which for the most part stress theory rather than application and details rather than coherence. Much of this material has little relevance to the art and craft of photography. In this book we have chosen the concepts of visual perception that relate directly to the work of the photographer as a visual communicator. Only to the extent that the photographer understands how he perceives the visual world and how his audience sees the images he produces can he expect to produce images that will not only depict but also stimulate, inform and communicate to the viewer.

Visual perception is dependent upon light received by the eye from the real world environment or from representations of that environment such as photographs. Therefore, the physical aspects of light are of great importance to the study of visual perception. Robert Boynton (1968) lists four physical variables of light—*intensive, geometric, spectral* and *temporal.*

Thus, much of the book is concerned with the response of the individual to visual stimuli involving variations of these four basic attributes of light. This is applied especially to subject material of a pictorial nature and with due consideration of psychological and physiological factors that may determine or influence the response.

Each topic involves a single concept of visual perception which is first defined, then explained in a concise discussion that concerns photographic applications. To further clarify the application and nature of the concepts, demonstrations and experiments are often included. Since it is impossible to communicate visual concepts solely with words, the page facing the discussion of each topic is devoted to illustrative pictures and diagrams with captions. A list of related terms is included so that the reader can place the concepts into larger contexts, and references are suggested for those who wish to look further into specific areas. The number preceding each reference identifies that item in the bibliography at the back of the book where the publication data are recorded. Topics have been grouped into chapters to facilitate the study of general areas of visual perception and to methodically unfold the subject material in a logical sequence. Since the chapter categories are not all mutually exclusive, certain topics were placed in the chapter that seemed most appropriate for learning. The index will enable the reader to locate topics that could belong to more than one category.

The book is primarily intended for students studying photography at the college level. However, it should be understandable to anyone who is familiar with basic photographic terminology. No previous study of perception or of psychology is assumed. For this reason, the book will also be useful to those not enrolled in formal study but who have an interest in photography as a visual medium.

Introduction

Process of Visual Perception
On page 15 is a diagram of the general sequence of events that affects what is finally perceived when a person views a scene, a photograph or other image. The diagram is intended to display in part the complexity of a remarkable system that incorporates physical, physiological and psychological factors, most of which we usually take for granted.

In this book we discuss in detail the most important characteristics of this perceptual system with respect to the art and the science of photography. We begin here with a framework into which the later material can be fitted, which provides a conceptual overview of the system. Also, we mention some of the important concepts basic to the visual process. Referring to the diagram:

1 Obviously, a *light source* is necessary for seeing. The color, strength and geometry (and duration) of the light influence what we see. For example, some vision is possible in the weak illumination outdoors on a starry night, but then we can perceive no hues—everything looks gray. A person's complexion looks strange under the light from mercury arc lamps because of the unusual color of the light. Directional lighting, as from a clear tungsten lamp, produces the visual impression of harshness because of the distinct shadows. Diffused lighting, like that from the overcast sky, generates an impression of delicacy.

2 The *medium* (usually air) through which the light travels to and from the scene modifies both the color and the distribution of the light. The scattering effects of the atmosphere are responsible for the bluish color of the sky and of distant objects, and for the dramatic reddish colors of sunrises and sunsets. The presence of fog, rain or a layer of hot air near the ground and other atmospheric conditions each has a dramatic effect on the light reaching the observer.

3 Objects that receive light modify it in various ways. We ordinarily distinguish an *object from its surround* because of differences in light level or color resulting from differential absorption of light. On the other

hand, nearly transparent materials like glass are visible because they refract light or reflect it as does a mirror. Surface sheen determines the nature of reflections seen on objects, such as the small bright catchlight on the glossy surface of a person's eye, and the broad diffused reflection of light from the matt surface of dry sand. The colors of most birds and butterflies are caused by light interference. Polarization effects, which are important in some photographic applications, can also be observed directly through polarizing eyeglasses. The factors mentioned so far involve only physics. The interaction of the surround with the object, however, is largely psychological, as when a blue object looks bluer against a yellow background than against a gray background.

4–6 In Chapter 1, *Vision*, we begin with a discussion of the most important physiological aspects of the visual apparatus—the *optics of the eye,* and the structure and functions of the *retina* and the associated *nervous system.* There we deal with the unique operating characteristics of this equipment that are important to an understanding of later chapters.

In Chapter 2, *Perception*, we approach the process of visual perception in general terms and discuss the processes fundamental to vision. Thus we distinguish between sensation and perception before discussing a variety of concepts including visual thinking, perceptual development and information processing.

Chapter 3, *Measurement of Perception*, describes some of the ways by which experimenters obtain data about visual perception, thereby helping us to understand how it works. Also included are methods, such as matching and paired comparison, that can be used to measure various attributes of photographs. In addition, the concept of variability is introduced—this concept concerns the changes in the appearance of a picture or other stimulus at different times.

In Chapter 4, *Contrast*, we deal with the important concept that our perceptions depend greatly upon comparisons of stimuli. Thus consideration is given to the notion that

we perceive contrast more nearly on the basis of ratios of luminance or other attributes, than on the basis of differences. The various factors (eg. flare, luminance level, positioning of stimuli) that influence our perception of contrast are also discussed.

Consideration is given in Chapter 5, *Adaptation/Constancy*, to complementary physiological and psychological aspects of vision that enable us to maintain nearly stable perceptions despite dramatic changes in illumination or other viewing conditions. We are also concerned with the concomitant problem of detecting or accurately estimating the magnitude of such changes in the viewing conditions.

In Chapter 6, *Analysis of Information*, we look at how the visual system obtains information from a scene, including figure-ground, visual search, coding and attention. Also we examine factors affecting the accuracy of the information obtained such as visual noise, visual masking and ambiguous figures.

In Chapter 7, *Synthesis of Information*, we consider how the visual system makes use of the information obtained from the analysis stage including picture scanning, Gestalt and a number of Gestalt laws, and how synthesis is affected by planned or accidental camouflage.

Chapter 8, *Poststimulus Perception*, is concerned with visual perceptions that occur after the stimulus has been removed from the field of view, and includes such concepts as the persistent image, afterimage, and various types of memory images. We also discuss \imagination imagery, which is related to the entire memory bank rather than to specific visual experiences, its involvement in creative picture making and how it can be enhanced.

In Chapter 9, *Perception of Depth*, three different aspects of the perception of depth and the representation of the third dimension in photographs are considered—namely distance, form and texture. Monocular and binocular depth cues are identified and explained, with special attention given to the concepts of linear perspective and the center of perspective.

Chapter 10, *Perception of Detail*, describes the stages leading to the identification of an object—detection, localization and recognition. Also discussed are the concept of visual acuity including factors affecting acuity and its measurement, and the related concepts of sharpness and resolution.

In Chapter 11, *Perception of Shape and Size,* we discuss factors affecting the accuracy of the perception of shape, which is generally the most important object attribute for recognition and identification. The relationship between size and distance, psychological factors affecting the perception of size, and concepts related to the accurate representation and intentional misrepresentation of size in photographs are also included.

We consider in Chapter 12, *Perception of Brightness/Lightness*, the distinction between the perception of objects as emitting light and as reflecting light; the perception of white, black and a midtone; the relative brightness of different wavelengths of light; the relationship between the illumination level and the perceived lightness of a photograph; and the Mach Band illusion produced by lateral inhibition and excitation.

In Chapter 13, *Perception of Chromaticity*, hue and saturation (the two components of chromaticity) are discussed in addition to basic theories of color perception, additive and subtractive methods of forming color images, defective color vision, specification of the color quality of a surface or light source, and metamerism.

Chapter 14, *Perception of Time and Motion,* includes various visual concepts related to motion-picture photography, such as flicker and the phi phenomenon, implied motion in still photographs, and the perceptual effects involved in moving laterally or toward a three-dimensional scene.

Finally, in Chapter 15, *Esthetics*, we discuss a number of perceptual concepts related to the esthetic quality of the visual image, including both subjective approaches and objective procedures validated by correlation with subjective criteria.

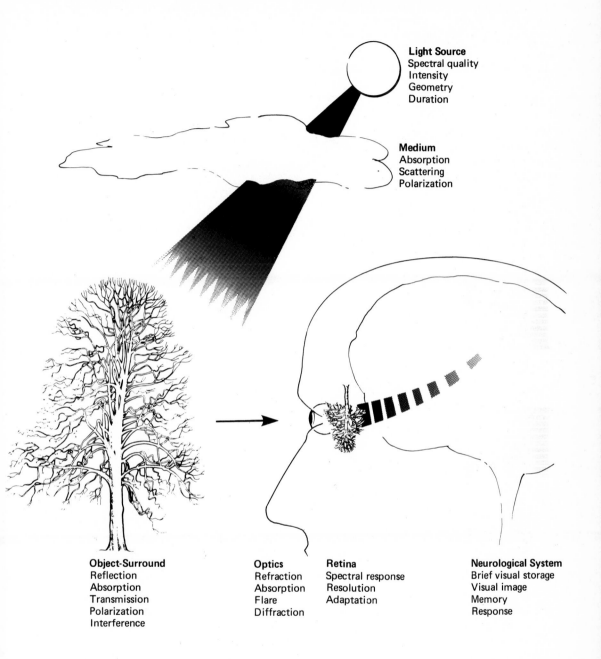

Light Source
Spectral quality
Intensity
Geometry
Duration

Medium
Absorption
Scattering
Polarization

Object-Surround
Reflection
Absorption
Transmission
Polarization
Interference

Optics
Refraction
Absorption
Flare
Diffraction

Retina
Spectral response
Resolution
Adaptation

Neurological System
Brief visual storage
Visual image
Memory
Response

The visual-perception process
A simplified representation of the path of energy from a light source to the perceived image in the brain. The light is modified by the atmosphere, surroundings, object, and eye before reaching the retina. The retina converts the optical image to nerve pulses. Information processing of the nerve pulses by the brain to form visual images involves both physiological and psychological factors.

Vision

1.1 Optical system

Definition: The image-forming mechanism of the eye, including the cornea, lens and iris.

The optical system of the eye forms inverted images on the retina in much the same way a camera lens forms inverted images on film. Although the eye has a single element lens, six surfaces are involved in image formation—the front and back surfaces, in sequence, of the cornea, the lens cortex and the lens nucleus. The major change in direction of light rays occurs at the front surface of the cornea, but the lens serves the important function of adjusting the focus for objects at different distances.

Since the image formed by the optical system cannot be examined directly as with a camera lens, information about the quality of the image is obtained either by examining the image through the pupil (allowing for the double passage of light through the optical system) or by tracing rays from surface to surface in a detailed schematic eye (allowing for the changes in the index of refraction of the various layers). When less precision is required a simplified schematic eye, such as the Helmholtz (*see* opposite), may be adequate. For conceptual ray tracing purposes it is only necessary to retain the optical axis and the cardinal points as in the third illustration.

A valid comparison can be made between the eye and a 35 mm camera since the diameter of the retina is approximately the same as the 24 mm width of the image area on 35 mm film. Whereas a normal lens for a 35 mm camera has a focal length of about 50 mm, the focal length of the typical eye is approximately 17 mm. This short focal length combined with the curved retina produces an angle of view of approximately 180°, in comparison with a normal angle of view of about 50° for the camera. The short focal length of the eye also produces a large depth of field. Since the depth of field varies inversely with the focal length squared, the eye has about nine times the depth of field of the normal camera lens at the same relative aperture.

Variations in tension of the ciliary muscles, attached to the zonal fibers at the edge of the lens, change the thickness of the lens and therefore slightly alter the focal length; this permits focusing on objects at different distances. An earlier notion that the entire eye becomes elongated to assist in focusing on near objects, as with a camera, has been disproved. As a person ages, the lens becomes less flexible so that focusing on near objects becomes more difficult and eventually can be accomplished only by using supplementary lenses such as reading glasses.

Muscles in the iris enable the size of the pupil (the iris opening) to be altered from approximately 2 mm to 8 mm. These openings correspond to relative apertures of $f/8$ and $f/2$ respectively. In addition to controlling the amount of light that enters the eye over a modest range of 1 to 16, pupil size also alters image definition and depth of field. Since depth of field is directly proportional to relative aperture, it is increased by a factor of four from the largest opening to the smallest.

The size of the pupil changes primarily in response to variations of scene luminance, but it also changes somewhat with variations of interest and emotional states, and the pupil becomes smaller as the eye is focused on closer subjects. The optical system of the eye is subject to a number of shortcomings that are also found in simple camera lenses such as spherical aberration, chromatic aberration, coma and astigmatism. Loss of definition due to aberrations tends to be reduced as the pupil decreases in size, but loss of definition due to diffraction tends to increase. The best compromise is obtained with a pupil size of about 4 mm ($f/4$) with in-focus images.

Related terms: cornea, iris, lens, pupil.
References: **31** (39–59), **67** (647–670).

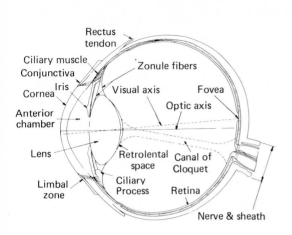

A cross-section view of the human eye. Each transparent medium in the eye has a different index of refraction. The largest change in direction of light occurs at the front surface of the cornea.

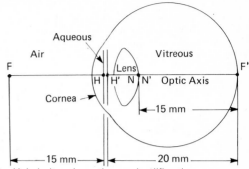

The Helmholtz schematic eye simplifies the computations involved in image formation when great precision is not required.

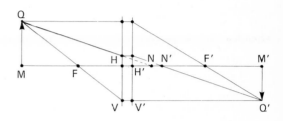

Image formation can be illustrated without showing the actual structure of the eye by using cardinal points to represent a typical eye.

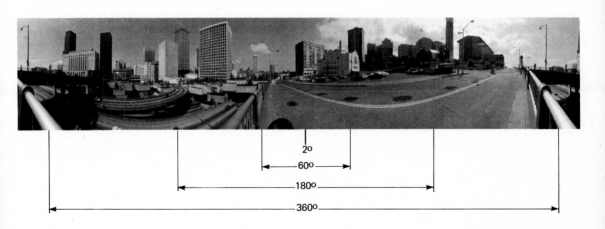

A 360°+ photograph made with a revolving slit camera. A conventional camera with a normal focal-length lens records about 60°. Although the eye lens forms images over an angle of approximately 180°, critical vision is only achieved for the part of the image that falls on the fovea of the retina, which represents an angle of approximately 2°. *Photograph by Andrew Davidhazy.*

1.2 Retina

Definition: The lining on the back of the eye containing light-sensitive rods and cones, and a network of nerve cells.

Just as there is a close relationship between the type of film used in a camera and the characteristics of the image produced, so there is a relationship between the structure of the retina and the perceived image. There are approximately 130 million light-sensitive receptors (rods and cones) in the retina. Unlike silver halide grains in photographic film, these elements are not distributed randomly. A large proportion of the approximately seven million cones are located near the visual axis in a small area called the *fovea*, the part of the retina used when we look directly at an object point. Although both rods and cones respond to a range of wavelengths of light, the perception of hue depends entirely upon the cones. Thus, the cones correspond to color film and the rods correspond to black-and-white panchromatic film; rods distinguish between colors only on the basis of their lightness attribute. The concentration of cones decreases rapidly away from the axis, but some are found even in the outer areas of the retina (*see* opposite). There are no rods in the fovea, but their concentration increases rapidly to a maximum about 20° off the visual axis and then decreases gradually toward the outer edges of the retina.

The fundamental reaction that occurs when light falls on a receptor is to convert molecules of pigment to a different form in a bleaching action which in turn initiates a signal in a nerve cell. Bleached molecules are simultaneously regenerated to maintain an equilibrium of bleached and unbleached molecules. All rods contain the pigment rhodopsin, but there are three types of cones (identified as blue-, green-, and red-sensitive) each of which contains a different pigment. While rods cannot produce hue perceptions they do function at lower light levels than cones, but with a sacrifice of image definition (as with high-speed coarse-grain films). Low light level rod vision is known as *scotopic* vision, higher light level cone vision is *photopic*, and the overlap region where both rods and cones function is *mesopic*. The rods in the periphery also serve the useful function of detecting motion and lightness differences, thereby signaling the viewer to quickly shift his gaze in the appropriate direction for a more critical examination with the cones.

There is a small area on the retina less than 20° off the visual axis that contains neither rods nor cones known as the *blind spot*, where the bundle of optic nerve fibers leaves the eye. Although no detail can be seen in this area, the mind fills in the discontinuity to the extent that we do not see a black spot in our field of vision.

Strangely, the image formed by the eye's optical system does not fall directly upon the rod and cone receptors, but must first pass through a complex network of neural cells which performs important information processing functions and is considered to be an extension of the brain. For example, hundreds of rods may be linked together with a single cell resulting in an increase in sensitivity through spatial summation and a corresponding decrease in resolution. These cells also perform important inhibitory and excitatory functions on adjacent cells to produce, for example, edge enhancement in a perceived image.

With the exception of the fovea, light must also pass through a network of small blood vessels before reaching the receptors. These blood vessels are quite obvious on photographs of the eye lining taken through the lens of the eye. They are not apparent to the viewer because of automatic adjustment in sensitivity of the underlying receptors, a process known as local adaptation.

Related terms: blind spot, cone, fovea, mesopic, nerve cell, photopic, receptor, rod, scotopic.
References: **44** (91−152), **80** (44−50).

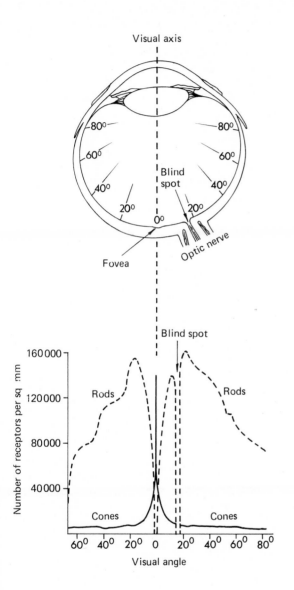

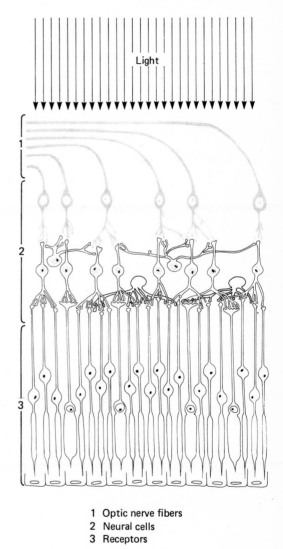

1 Optic nerve fibers
2 Neural cells
3 Receptors

There are no rods in the fovea, but their concentration increases rapidly to a maximum about 20° off the visual axis. The high concentration of cones in the fovea rapidly decreases toward the periphery of the retina.

Light must pass through a complex network of neural cells before it reaches the light-sensitive receptors near the bottom of the drawing.

1.3　Neurological System

Definition: The network of nerve cells in the visual system that transmits and processes information received at the retina.

Light falling on the receptors in the retina produces a reversible chemical reaction, in the form of bleaching pigments, which in turn initiates electrochemical impulses. A complex network of nerve cells (*neurons*) permits the rapidly moving impulses to be used in any of a variety of ways. These include sending a message more or less directly to different parts of the brain, enhancing or inhibiting other signals, or if the impulses are sufficiently weak they may even be ignored. Considerable progress has been made in recent years in perfecting the technique of inserting fine probes at selected positions in the visual system of monkeys and other animals. These probes measure variations of the electrical impulses in neurons, that are in response to controlled variations of the stimulus.

The major pathways from the receptors in the retina to the visual cortex at the rear of the brain are shown in the top illustration opposite. The entire network is considered to be part of the brain, and vision is the only sense where the stimulus has direct access to the brain. Important processing of the information from the receptors begins in the retina itself, and a close-up view of the neurons in the retina (second illustration) reveals different types of circuits. For example, a horizontal cell combines the signals from a number of receptors, thus resulting in high sensitivity but low resolution.

Some of the nerve cells in the visual system respond only to a specific type of stimulus such as a certain shape, orientation or direction of movement. This is especially true with lower forms of life that depend upon such specialized perception for food or protection. But even human vision is highly sensitive to movement in the periphery of the field where the perception of detail and color is poor— this is possibly for protective purposes. Such nerve cell responses that are common to members of a species are apparently hereditary.

Neurons also have a memory capacity, as yet not fully understood, that produces a different response when a stimulus has been experienced previously. This enables us to recognize and respond appropriately to shapes such as letters, words and even complex stimuli such as a friend's face in a crowd. It is now generally believed that the pattern of stimulation in the visual cortex does not physically resemble the original stimulus and the retinal image, but that it serves as a coded record which the mind is able to reconstruct. Selective response to simple shapes may be attributed to neurons in or near the retina. On the other hand, selective response to complex stimuli is accomplished by neurons farther back in the visual system, where they can receive input from a network of other neurons. It has been estimated that at least 10% of the cerebral cortex is used for interpreting visual data. Neuron memory is not automatic with repeated experiences but depends also on factors such as attention and motivation at the time of the experiences— processes which are not well understood.

In addition to transmitting information from the retina to the visual cortex, it is necessary to transmit signals to the eye to control eye movements, pupil size, accommodation and convergence. These tasks are accomplished by motor neurons that are oriented in the opposite direction to that of the sensory neurons.

Related terms: nerve cells, neurons, optic nerve, receptive fields, visual cortex.
References: **31** (51–55), **74** (56–64), **112** (1–7, 22–29), **123** (42–55), **179** (282–283).

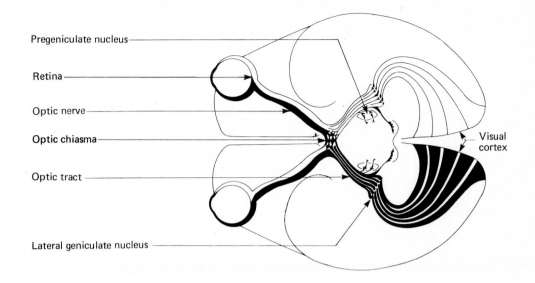

Pregeniculate nucleus

Retina

Optic nerve

Optic chiasma

Optic tract

Lateral geniculate nucleus

Visual cortex

A simplified representation of the major neurological pathways from the retina to the visual cortex at the rear of the brain. The optic nerves divide at the optic chiasma, with the inner halves crossing over to the opposite sides of the brain.

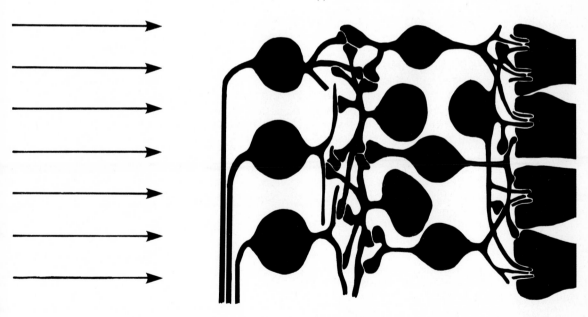

Light entering the eye from the left must pass through a network of nerve cells before reaching the light-sensitive receptors on the right. These nerve cells perform important information-processing functions on the signals received from the receptors before forwarding them through the optic nerve.

1.4 Cerebral Hemispheres

Definition: The right and left halves of the human brain, which serve distinctly different perceptual functions.

The *cerebral cortex* of the brain consists of extensive outer layers of gray tissue on the cerebral hemispheres which are largely responsible for higher mental functions, including seeing, hearing, smelling, tasting and touching. The two hemispheres are of special interest since each seems to serve a quite different function in our everyday activities. Although both work together in processing information, the left hemisphere tends to be highly analytical, logical, sequential, verbal and mathematical; while the right hemisphere tends toward the opposite, being qualitative and intuitive. In other words, simultaneous processing of information occurs primarily in the right hemisphere and sequential processing in the left hemisphere. The 'artist' tends to be a right-hemisphere person, the 'engineer' a left-hemisphere person. The artist depends heavily on pictorial language, the engineer on verbal and mathematical language. One tends to operate on feeling, the other on thinking.

This concept of a divided brain is not a new one. Carl Jung pointed out, in conceptualizing four functions of man, that people vary with respect to how they process information. Some tend to be more thinking and some more feeling, some rely more on sensation and others on intuition. The Bible states that '. . . the heart of a wise man is in his right hand, and the heart of a fool is in his left hand' (*Ecclesiastes*, chapter 10, verse 2). (The left hand is controlled by the right hemisphere and the right hand by the left hemisphere.) The ancient yin-yang symbol of China can be interpreted as describing the two hemispheres in man, the technical and the artistic, and the masculine and the feminine qualities in all of us.

Perhaps one of the reasons why 'artists' and 'engineers' sometimes have difficulty in communicating with each other is that they operate and function in different hemispheres —they have different languages. The artists' world is one of feeling and emotion involving the right hemisphere, and he or she may choose to use means of communicating these other than words and numbers. This can take forms such as music, painting, photography and dance. When words are used, as in poetry and lyrics, they are carefully selected to project imagery and feelings. In contrast, an engineer or scientist chooses words and numbers to construct sentences with precision and logic. For the engineer, words such as tension and balance represent measurable quantities, while to the artist they refer to visual and kinesthetic perceptions and feelings.

A photographer who has an underdeveloped right hemisphere may be unsuccessful in making highly esthetic photographs, but may excel instead in the technical aspects of photography. Some photographers have been able to combine both. In 1933, when Edward Weston looked over 30 years of his photographs, he noted in his *Daybook*: 'There seemed to be two forces warring for supremacy, for even as I made the soft, *artistic*, work with poetic titles, I would secretly admire sharp, clean *technically* perfect photographs . . .' Highly creative effort requires the use of both hemispheres of the brain. If the interest and desire are present, the artist and engineer can learn to strengthen the weaker brain hemisphere. For many engineers, this often happens naturally with age.

Related terms: cerebral cortex, right and left brain, split-brain.
References: **162** (49–73), **168**, **189** (42–52).

Left hemisphere: Engineering,
Science, Mathematics, Computers, Logic.

VERBAL
ANALYTICAL
INTELLECTUAL
NUMERICAL
SEQUENTIAL

Zone system calibration
Light Meters f -numbers,
Development, Zone Ruler

Right hemisphere: Art, Music,
Dance, Photography, Athletics

VISUAL
GESTALT
ARTISTIC
SYMBOLIC
SIMULTANEOUS

Zone system visualization
Values, Color, Texture, Shape,
Contrast

The arts, such as dance, are considered to be primarily right brain functions while the sciences, such as space science, are considered left brain functions. *Dance photograph by Neil Montanus, Moon Walk courtesy of NASA.*

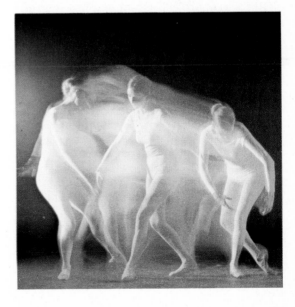

25

1.5 Cell Assembly

Definition: A hypothetical reverberating neural circuitry system in the cerebral cortex used to describe perception in terms of cortical actions.

To appreciate the role of cell assemblies in perception, consider this situation: you are shown a photograph (*stimulus*) for several seconds and then a few minutes later you are asked to describe it (*response*). What happens during the delay between stimulus and response that allows you to recall the photographic information? One answer is that the information is stored in memory and then, through the thought process, retrieved. Learning psychologists refer to this as a *mediating process* by which the brain can hold the excitations caused by the stimulus after the stimulus has been withdrawn. But how is this accomplished, since a single neuron circuit (consisting of only two or three neurons) can hold the excitation for only about 1/50 second? An answer lies in the grouping of such circuits into a *cell assembly*. This can be looked upon as a three-dimensional lattice in which nerve impulses will continue to reverberate for some time even after the initial stimulus has ended, and in which nerve impulses can easily be reactivated at a later time.

The concept of cell assemblies provides us with a better understanding of how perceptual learning takes place. Every *new* experience, whether that of a child or an adult, involves perception. A baby encountering a small ball for the first time will repeatedly see and feel the shape of a ball; this will excite certain groups of neurons in the cortex. Although the same neurons are not involved each time, a common core of neurons is excited—the neurons then tend to interface with one another to form a single assembly of cells. The excited neurons within the closed circuit assembly continue to fire even after stimulation has ended ie. they are self re-exciting circuits. In addition, excitation can occur from systems within the cortex, instead of from the original sensory stimulation.

Hebb points out (**93**) that 'the increase of organization of the cell assembly, with experience, is perceptual learning, which theoretically means increased clarity and distinctiveness of perception . . .' For the photographer, this means that the development of visual skills that are so essential to making good photographs requires a great deal of practice and a variety of experiences. It means a determined effort is required to build new cell assemblies from new sensory experiences and existing cell-assemblies.

As an example, when a photographer sees Niagara Falls, an assembly of brain cells is excited. At the same time, he hears the roar and may even feel the mist which excites other assemblies. The various assemblies interact in some way to provide the perceptual experience of the Falls. A photograph made and viewed at a later time will be successful to the extent that the visual record can excite not only the 'visual cell assemblies' but also the 'sound cell assemblies.'

The photographer when looking at the photograph of Niagara Falls later benefits in that his experience in taking the picture has provided him with cell assemblies upon which he can draw. For a person who has not seen the Falls, or something similar, the photograph can present a perceptual handicap. This is perhaps one reason why audio visual and motion pictures are so effective in representing experiences—they include sound and motion which provide a variety of associated stimuli.

Related terms: central nervous system, cortex, neural connections, short-term memory, synapse.
References: **69** (32–36, 292–297), **93** (69–71, 84–86), **105** (90–95).

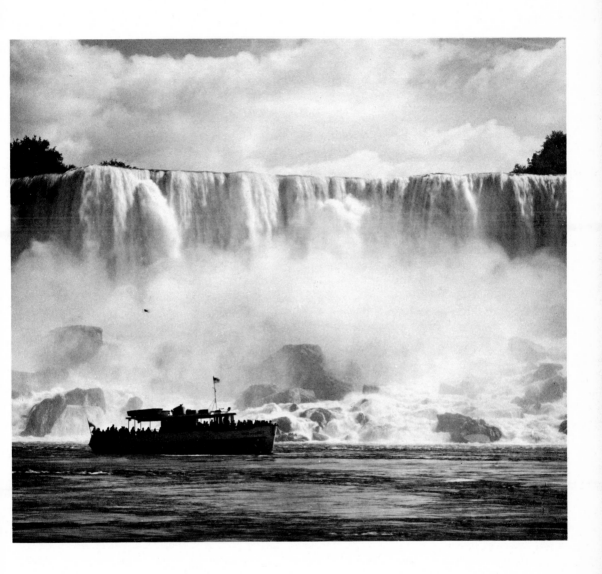

This photograph of Niagara Falls means most to the person who made the picture, much to a person who has had a similar experience and least to one who has not had a similar experience. Experience increases the organization of cell-assemblies which are essential to the perception of our environment, and therefore essential to the making of the photograph and to its subsequent viewing. *Photograph by Neil Montanus.*

1.6 Feature Detectors

Definition: Specific clusters of receptor cells in the retina that are excited by stimulus configurations such as lines, angles, curves, color and movement.

The process of visual perception is initiated when specific retinal receptors are activated by specific stimulus features such as lines and angles. When a certain stimulus feature is seen, a predictable grouping of retinal receptors will fire beginning a chain of events which leads to perception. The first stage has been called an *iconic stage* or *iconic storage* to suggest that the coding of visual features is automatic and independent of expectations, memory or thinking.

In 1962 Hubel and Wiesel found that there was a predictable relationship between the response of certain cells in the visual cortex and the stimulus pattern on the retina. Thus a small vertical line may cause a specific cortical cell to fire. The corresponding region in the retina which initiates this firing is called a *receptive field*. Different cells will respond to different categories of stimuli and each has its own receptive field at the retinal surface.

The receptive fields of three types of cortical cells have been described as *simple*, *complex* and *hypercomplex*. (Responses of simple and complex cells are shown opposite.) A simple cortical cell responds to a moving stimulus and to a spot of light anywhere within a single region. But it is most responsive to an elongated stimulus such as an edge or a bar oriented parallel to the axis of the cell's receptive field. Simple cortical cells, therefore, are edge detectors or line detectors.

Complex cortical receptive fields are larger than the simple fields and each responds to a certain kind of feature regardless of its position within the receptive field. Thus the field acts as a feature detector which can directly code an edge or slant regardless of where it falls within the field.

Hypercomplex cortical cells act as a feature detector for shapes such as the angle between two lines, rather than to the line alone. These cells have also been found to detect retinal disparity and could, therefore, provide coding for binocular stereoscopic depth. The locations of specific visual features as indicated by the receptive fields which signal them, serve as *edge detectors, line detectors, movement detectors* and *depth detectors.*

The concept of feature detectors provides a model for helping us to understand why some traditional design practices and the Gestalt laws of organization work so well. For example, a simple cell which responds best to a straight vertical line is also excited by a single spot of light. It can be excited even more strongly by a column of spots in close *proximity* to each other. Visual elements such as dots which are close to each other are readily grouped and seen as an organized whole such as a line; this is because they excite the same specialized detector cells that a line does. Throughout the history of art and photography the use of triangular shape has been a basic design configuration. It is reasonable to assume that the effectiveness of such a shape is due to the response of complex cortical fields to slant features regardless of their position within the field. This also provides insight as to why slanted lines in a composition are dynamic and perhaps why an S-shaped composition suggests depth.

Rudolph Arnheim may have been speaking about feature detectors when he stated that there are certain things in a picture that are *invariant* and that artists, with only a few strokes can represent faces and objects.

Related terms: Cell assemblies, feature abstractors, feature extractors, gestalt, invariants, receptive fields, visual features.
References: **86** (52–58), **113** (54–62), **119** (286, 288, 487–492).

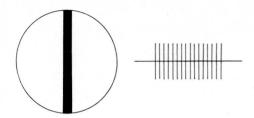
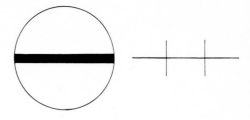

Simple cortical cells and orientation
Imagine the circular area as the receptive field and the bar as a line stimulus. The detection of the line feature is dependent upon the position of the line. In the vertical position there is a rapid firing of receptor cells as indicated by the frequency of the 'spikes' to the right of the circle. In the horizontal position there are few 'spikes.'

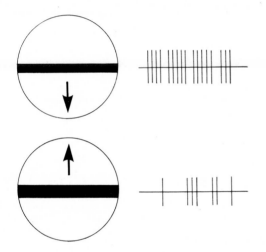
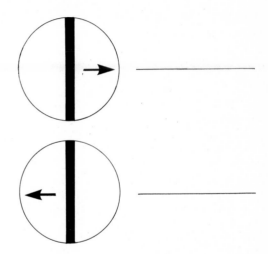

Complex cortical cells and movement
The receptive field for these particular cells is a strong visual detector for slow downward movements but weaker detector for upward movements and 'blind' to horizontal movements.

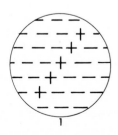
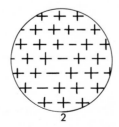

Simple cortical cells and slant
The plus signs in the three types of receptive fields shown indicate locations where stimulation increases the activity of the cortical cells (excitation). Minus signs indicate the opposite or inhibition. (1) represents maximum response to a narrow white line on a black background, (2) represents the negative of this and (3) represents an edge.

1.7 Eye Movements

Definition: Changes in the position of the eyes in relation to the head for purposes such as locating an object, converging the two eyes on the object, and tracking the object during movement.

The basic function of eye movements is to enable the eye to lock onto an object for as long as necessary to examine it, so that the image remains nearly stationary on the *fovea* (the small area of sharpest vision on the retina). But, perfection in this task would result in a poor image or no image. Laboratory experiments in which images are completely stabilized on the retina reveal that the image fades rapidly. Fading is prevented from happening in everyday life by small involuntary movements of the eyes known as *nystagmus*. These movements are so small that they are not noticed either in our own vision or when looking at another person's eyes.

Voluntary eye movements are controlled by three pairs of opposing muscles which move the eyes vertically, horizontally and slightly rotationally about the optical axis. When searching for an object, the eyes move in quick jumps called *saccades*, which is an old French word meaning 'the flick of a sail.' Although the eyes can consciously move in any chosen direction, they often move automatically toward motion or other changes detected on the periphery of the retina. The eyes continue to move until the image of the object of interest is located on the fovea. (Movement of the eyes in looking at pictorial images is covered in the topic 7.1 *Picture Scanning*.)

If the search movement involves a change in object distance, the relative position of the eyes must be altered, a movement known as *convergence*—this places the images on the foveas of both eyes to produce the perception of a single fused image. When looking at a distant object the axes of the eyes are essentially parallel, and as the object distance decreases the angle of convergence increases. It is the absence of fusion of the two images that serves as a signal to the visual system to change the convergence Changing the convergence from a distant to a near object may require almost $\frac{1}{5}$ second, a relatively long time in comparison to a saccadic movement which can attain a velocity as high as 80° per $\frac{1}{10}$ second. Convergence is the only visual activity that requires the eyes to move in opposite directions.

The tracking movement of the eyes is necessary in order to fixate an object that is moving, or to fixate a stationary object when the viewer is moving. Anyone who has tried to obtain a sharp photograph by panning with a moving object and using a slow shutter speed appreciates the difficulty of this task. However, the eye is quite accurate in tracking, so long as the movement is regular or predictable. This is the only visual task where it is natural for the eyes to move smoothly rather than in quick jumps. This can be verified by attempting to move the direction of your eyes smoothly across your desk top in comparison with tracking your finger as you move your hand from side to side. (You may be able to scan the desk top more smoothly if you move your hand under the desk top and pretend that you have X-ray vision.)

A complicating factor involved in eye movements is that the head, which is the frame of reference for the eyes, is often moved during the viewing process. Thus, if you shake your head from side to side while looking steadily at a stationary object, your eyes are moving in your head but there is no perception that the object is moving. It has been established that the brain makes use of head-movement information from the inner ear and incorporates the appropriate compensations in the visual perception. This can be demonstrated by spinning rapidly until you become dizzy and noting that the sense of vision is affected in addition to the sense of balance. Conversely, people have commonly reported feeling dizziness or other sensations of motion while watching a motion picture of a roller-coaster ride or other activity involving rapid movement.

Related terms: convergence, fusion, nystagmus, pursuit, saccade, scanning, search, stabilized image, stereopsis.
References: **4** (369–391), **117** (76–78), **180** (1219–1224).

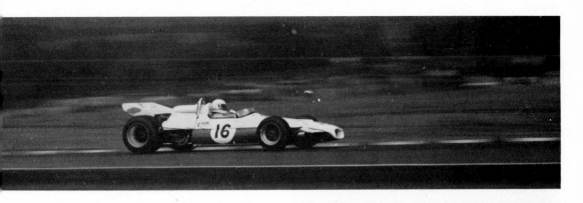

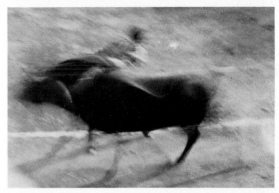

With practice a photographer can obtain a sharp image of a rapidly moving object such as a race car by panning the camera. It is more difficult to track unpredictable movement and impossible to track the movement in different directions of the parts of a scene. The photographers purposely used slow shutter speeds to obtain impressionistic effects in the photographs of the bullfight and the dance. Photographs by (top to bottom) Peter Gales, Neil Montanus, Douglas Lyttle.

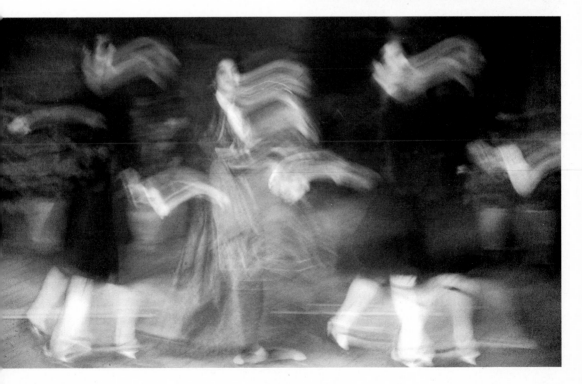

1.8 Accommodation

Definition: The automatic process by which the shape of the eye lens changes to focus on objects at different distances.

Images formed by the eye, like those formed by a camera lens, can be in critical focus for only one object distance at a given moment—although depth of field enables images of objects at somewhat larger and smaller distances to appear acceptably sharp. This change in focus is seldom noticed when objects at different distances are viewed since the process is automatic. The retinal images of a 40×50 cm (16×20 inches) print placed twice as far from a viewer as a 20×25 cm (8×10 inches) print from the same negative will be identical if the eyes focus on each in turn. There is a minimum distance, known as the *near point*, that the eyes can focus on without strain. The near point is typically less than 8 cm (3 inches) for children under 10, and gradually increases to more than 2 m (7 ft) for elderly people.

Since image size on the retina is inversely proportional to the viewing distance, the perception of fine detail in a picture, for example, requires a short viewing distance. (To obtain a 1 to 1 scale of reproduction on the retina would require a viewing distance of about 3 cm—just over 1 inch). Due to limitations of the near point, however, it may be difficult for photographers to perform certain visual functions with the unaided eye. These difficult tasks include critically focusing the image on a camera ground glass, retouching negatives or prints, and inspecting contact prints of 35 mm negatives from the center of perspective. Fortunately, it is possible to add a glass lens (magnifier) to the visual system to increase the effective accommodation of the eye. By placing the object that is to be examined at the principal focal point of the magnifier (i.e. one focal length behind the magnifier), the rays of light from a point on the object will enter the eye traveling parallel to each other as though they came from a distance, so that no accommodation of the eye is required. If the magnifier is moved away from the object, accommodation will be required and when the distance becomes so large that the eye cannot accommodate, the image will appear unsharp. It will be noticed in looking through a magnifier, that increasing the distance between the eye and the magnifier has no effect on the image size or focus (because the rays of light from an object point are parallel to each other), but that the angle of view decreases (because the rays of light from two different object points are not parallel to each other). (Top two illustrations.)

The power of magnifiers is usually specified in terms of *angular magnification*, which is found by dividing 25 by the focal length of the magnifier in centimeters ($M=25/f$). A 50 mm (5 cm) focal length lens, for example, would be identified as a 5x magnifier. Since the image seen through the magnifier remains constant in size and the image seen with the unaided eye decreases in size as the viewing distance increases, the experienced magnification depends upon the viewing distance—which for calculation purposes has been standardized for a near point of 25 cm (10 inches). (Bottom two illustrations.) Thus, a young person who can focus comfortably at 12·5 cm (5 inches) experiences $2\frac{1}{2}$ times magnification with a 5x magnifier, only one-half the specified value. An older person with a near point of 50 cm (20 inches), on the other hand, experiences 10 times magnification with the same 5x magnifier.

Related terms: near point, presbyopia, visual focus.
References: **22** (78–85), **44** (53–55), **80** (36–38).

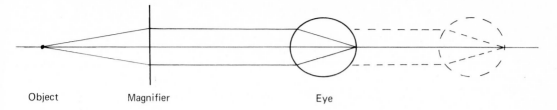

Object Magnifier Eye

A magnifier collimates the rays of light from an object point. Since the rays of light enter the eye travelling parallel, a sharp image is formed in the unaccommodated eye regardless of the magnifier-to-eye distance.

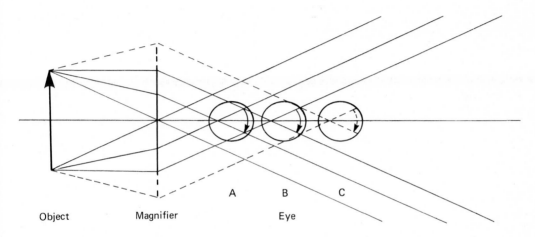

Object Magnifier Eye

The entire arrow is seen through the magnifier with the eye in positions A and B, and the images are the same size because the image-forming rays are entering the eye at the same angles. The ends of the arrow are not visible with the eye in position C, indicating a narrower angle of view. It is necessary to increase the diameter of the magnifier to see the entire object from this position, as indicated by the dashed lines.

A 5X magnifier on a grid with the eye at 25 cm produces an image that is 5 times as large as that seen with the unaided eye.

Increasing the eye to grid distance to 50 cm has no effect on the size of the magnified image but reduces the unmagnified image to half the original size, producing an *effective magnification* of 10 times. The magnifier iteslf appears smaller with the larger viewing distance, as indicated by the dashed circle, producing a smaller angle of view.

1.9 Diplopia

Definition: Double vision of an object due to failure of the visual system to fuse the images formed by the two eyes.

Diplopia is commonly thought of as a defect of vision that results from failure of the eye muscles to properly align the two eyes so that they converge on the object of interest. A person suffering from this defect sees two images of everything in the overlap area, but the visual system attempts to compensate for this confusing situation by giving more attention to one image than the other. Fortunately, this condition generally can be corrected with surgery. A person with normal vision can create a momentary approximation of this defect by purposely crossing his eyes. Actually, anyone with normal vision commonly experiences a less obvious form of diplopia. The images formed by the two eyes are effectively fused into a single image only for the plane of the scene that is being fixated, whereas double images are formed of closer and more distant objects.

If a person holds the forefinger of his left hand 30 cm (1 ft) in front of his nose and the forefinger of his right hand 60 cm (2 ft) in front, he will see two images of the far finger when he fixates the near finger and vice versa (*see* illustrations opposite). Each of the double images is a ghost image in that the background can be seen in the same area by the other eye. Even though the relative positions of the fixated (sharp) and non-fixated (unsharp) images reverse for each eye when the attention moves from one object to the other, the combined perception is of a single sharp image with an unsharp image on each side. The double images may be considered a distraction, in contrast to the two images that are fused into one in the area of fixation, but the double images serve to contribute to the perception of depth in the scene. The absence of such double images when viewing a conventional photograph is one factor that makes it obvious to the viewer he is looking at a two-dimensional representation of a scene rather than at a three-dimensional scene. On the other hand, the absence of double images may be a factor that contributes to the esthetic appeal of some photographs and paintings—viewing the reproduction may be more satisfying than viewing the original scene. The photographs opposite illustrate the visual effect produced by fixating first a near object and then a far object.

Why are we not more conscious of double images in our daily lives? The fact that the double images typically occur in the peripheral area of the retina, rather than in the fovea, means they will be relegated to a lower level of consciousness. Since the mind does not like conflicting perceptions, it will tend to give unequal attention to the two images, sometimes on an alternating basis. Furthermore, it is possible to speculate that an adaptation process takes place—this has been demonstrated by showing that the visual system can adapt to images produced by distorting glasses and even inverted images produced by prisms. Similarly, the blind spot in each eye is seldom noticed, even when the other eye is closed so that it cannot supply the detail in that area.

Related terms: convergence, disparity, retinal rivalry, stereoscopic vision, stereopsis. *References:* **80** (52–53), **86** (313–315).

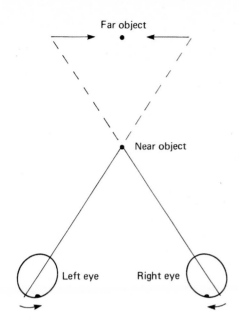

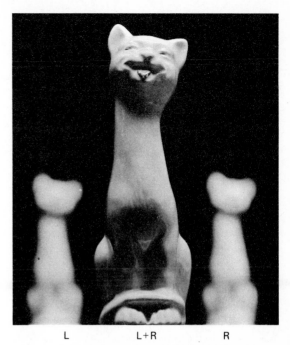

L L+R R

Fixating a near object (*above*) produces double images of a more distant object since the images are displaced in opposite directions in the two eyes. Fixating the far object (*below*) produces double images of the near object.

A photographic representation of the visual effect produced by two objects at different distances when the near object is fixated (*above*) and when the far object is fixated (*below*). The letters 'L' and 'R' identify the eye that each image is formed in.

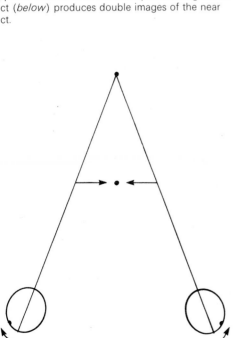

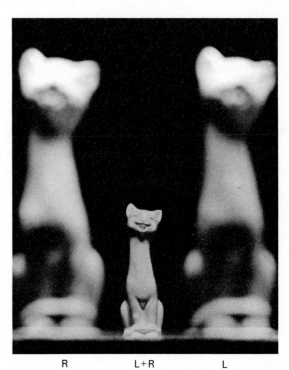

R L+R L

1.10 Stereopsis

Definition: The perception of depth attributable to binocular vision.

Binocular or stereoscopic vision refers to seeing with two eyes, as distinct from monocular vision, seeing with one eye. The perception of depth is so often associated with binocular vision that it is easy to overlook monocular depth cues such as linear perspective, aerial perspective and interposition. Closing one eye does not suddenly flatten the real world. The major difference noticed with monocular vision is with precision closeup manipulations—for example, try touching the points of two pencils held in separate hands, first with one eye closed and then with both open.

What binocular vision contributes to depth perception is the ability to present two different views of three-dimensional scenes to the brain simultaneously. The average separation of the pupils of the eyes in humans is about 64 mm (2·5 inches). With closeup objects the difference between the two images can be dramatic. For example, it is possible to see the front and back of a playing card simultaneously by holding it edgeways a few inches in front of one's nose. As the viewing distance increases the two images become more similar, and at distances larger than 135 m (150 yd) binocular vision makes no contribution to depth perception.

When looking with both eyes at a flat surface, such as this printed page or a picture, the two images are essentially identical and are fused into a single perceptual image. This can be experienced by alternately covering one eye, then the other. Substituting a three-dimensional object for the flat surface or adding other objects in front of and behind the distance focused on results in obvious differences between the two images. With most three-dimensional scenes, parts of the images formed by the two eyes are so similar that fusion can occur as with a two-dimensional subject. The remaining differences constitute *disparity* between the images which provides the mind with information for depth perception. Disparity serves this function, however, only when the viewer can interpret the different images as representing the same scene. If totally different pictures are presented to the two eyes with an optical device, the disparity is no longer interpreted as depth. The mind still tries to make sense out of the unrelated images, which it may do by combining them, somewhat like a motion picture dissolve; or it may simply reject one image or the other, sometimes on an alternating basis.

Attempts have been made since the early days of photography to make photographs more realistic through the use of stereoscopic vision. All such attempts involve two photographic images made from slightly different positions, each of which is then presented to the appropriate eye of the viewer. The *stereoscope*, which became popular in the 1860s, is an individual viewing device that holds the pictures side by side with a separate viewing lens for each eye. With practice it is possible to view side by side stereograms without a stereoscope. The *anaglyph* consists of superimposed red and green images. By looking through a red filter with one eye and a green filter with the other, the viewer sees the appropriate image with each eye—this system only gives black and white stereo images. Superimposed images that are polarized at right angles produce depth perception with stereoscopic vision when viewed through polarizing filters that are also rotated at right angles to each other—both black and white, and color polarized stereo images are possible. Viewing devices can be eliminated by using a system that combines the two photographs as very narrow alternating vertical strips over which is placed a plastic layer containing ridges that refract the light from each set of strips to the appropriate eye.

Related terms: binocular vision, depth, disparity, fusion, stereoscopic vision, three dimensional.
References: **106** (480–494), **119** (269–321).

A stereo pair made around 1860 (*Joan of Arc taken prisoner* by *J. Elliott*). The two photographs produce the perception of a three-dimensional scene when viewed in a stereoscope such as that shown on the left.

The differences between the images formed in the left and right eyes can be dramatic with closeup objects, as illustrated in the two photographs (*below*). The two eyes see opposite sides of a plastic ruler when the end of the ruler is placed at the bridge of the nose, and background objects appear in different positions.

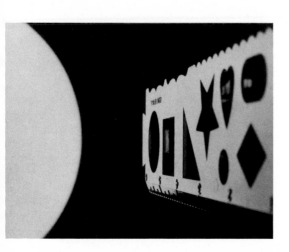
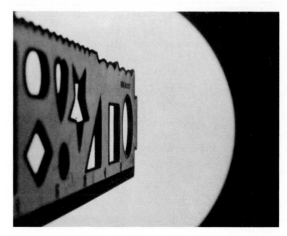

Perception

2.1 Sensation

Definition: Direct response of a person to a stimulus, e.g. visual sensation is a response to light.

Some philosophers and psychologists hold the view that all information from the environment reaching the brain must first pass through sensory receptors and their neural pathways. Contact with our environment is made through our five or more senses. Loss of contact with our world can lead to sensory deprivation and adverse psychological effects, including hallucinations and insanity. Persons deprived of one or more of their senses, such as the deaf and blind, live in a world quite different from the world of those with all their senses functioning.

The view that all information must pass through our senses provides a structure in which the physical world provides the *stimulus*, its effect on a person is *sensation*, and the interpretation of the effect is *perception*. In a synergetic concept of the world, the three are not separable, particularly the last two. Sensation and perception constitute a continuum of experiences from the simple to the complex.

The translation of physical stimuli into sensory information for the nervous system to process can be called sensory transduction. Pavlov referred to the sensory organs as the 'transformers of external energy.' The transformation or transduction produces physicochemical changes in nerve cell membranes which cause a change in the membrane potential and hence the receptor potential. These potentials obviously depend upon the stimulus intensity. Relationships between stimulus and sensory response have been studied extensively by Weber, Fechner and Stevens. Fechner, who extended Weber's original work on just-noticeable differences' (jnds) in 1834, is considered by many as the father of the science of psychophysics—the measurement of sensory responses to physical energy.

The sensory receptors are highly active systems that continuously attend to *change* in the environment. The eyes, ears, nose, mouth and skin can orient, explore and investigate. Sensory information is picked up by actively looking, listening, touching, smelling and tasting. The senses work together as needed and through the process of perception sensory information is integrated with memory information and thinking. Seeing a fire, for example, involves much more than the eyes and the limited information they provide. Experiencing fire is a multisensory perceptual experience. Looking at a photograph of a fire is a single sensory experience, solely dependent upon visual information. This is the main reason that still photographs of fires or of any multisensory event are so limited. Motion pictures extend the visual information by including movement and sound. Missing, of course, are the senses of smell and warmth.

It is convenient to categorize the senses into two broad categories (*see* opposite). Distance senses are called *exteroceptors* and near senses are *proprioceptors*. There are also deep senses called *interoceptors* which include our sense of balance—the kinesthetic sense resulting from changes in muscles, tendons and joints.

Related terms: perception, psychophysics, stimulus-response.
References: **65** (7), **71** (1–5).

Physical energy (stimulus)	Sensory receptors	Sensation
1. DISTANCE SENSES Electromagnetic radiation between 400–700 nm (light)	Eye	Seeing
Mechanical vibrations between 20–20,000 cps (sound)	Ear	Hearing
2. NEAR SENSES Pressure and temperature	Skin	Touching
Liquid chemicals	Tongue	Tasting
Gaseous chemicals	Nose	Smelling

Physical energy is transduced by sensory receptors into sensations. Sensory measurements, which are basic to the science of psychophysics, usually involve the response of persons to a basic dimension or attribute, such as lightness or brightness. Look at the photographs below and answer these questions:

1. Which photograph appears lighter? (ordinal measure)
2. How much lighter is one photograph than the other? (magnitude measure)
3. Which photograph more closely represents the original scene? (This requires a memory match which is more difficult and is subject to greater variance.) *Photographs by Dick Swift.*

2.2 Perception

Definition: A response of a person to a stimulus—a process which includes sensation, memory and thought; and which results in meaning such as recognition, identification and understanding.

Experts who are concerned with perception have been unable to agree on its precise definition. Numerous definitions have been offered over the years, but some writers simply avoid the issue—some books on perception do not even define the word or list it in the index.

Broadly defined, perception is the meaningful internal response of man to his environment. It is a process we perform constantly as we gather information from our changing surround whilst we engage in a variety of activities. At one time perception was thought to be instantaneous. This is no longer thought to be true, but perception is rather the result of a sequence of stages which include sensing, information processing, memory and thought. In general, the more complex the sensory stimulus, the longer the processing time. Also, the more information desired from a given stimulus pattern, such as a picture, the longer the processing time. Some psychologists list stages of perception such as detection, localization, recognition and identification, which require increasing amounts of time in the order listed. If the perception involves making judgments for an appropriate response, additional time is required.

The different levels of perception, from simple to complex, involve various amounts of mental activity and are influenced by short and long term memory, set, expectancy and perceptual defense. There is more to seeing than meets the eye. The biblical saying 'We have eyes to see and see not . . .' means that we have eyes and brains to perceive and perceive not—perhaps because of ignorance, detachment, chance or other factors. One of the functions of art and photography is to assist us in our perceptions of things. Paul Klee has written, 'the purpose of art is not to reproduce the visible but to make visible'.

The star (*see* opposite) serves as an example of perception as a sequential process, requiring time. Recognizing and identifying the stimulus as a star or religious symbol is an almost immediate perception based on experience and memory. Perceiving six small triangles surrounding a hexagon requires more time for visual search and visual thinking.

Although perception cannot be isolated from sensation, it can be distinguished from sensation in that the same sensory information can result in different perceptions and that different sensory information can give rise to the same perception. A classical example of variability in perception for the same stimulus array is the ambiguous figure-ground goblet of Rubin (see 6.1 Figure-Ground). Different perceptions arise from identical stimulus arrays because of several possible factors including adaptation, memory, set and physiological differences. On the other hand, different stimulus arrays can be perceived as being the same due to a factor such as perceptual constancy, low ability to discriminate or inattention. Thus, the long-time goal of perceptual psychologists of being able to predict perception on the basis of the physical attributes of the stimulus seems to be impossible to attain, although much progress has been made in this direction in the specialized area of psychophysics.

Related terms: information processing, sensation, sensory scaling, stimulus-response.
References: **93** (217–242), **119** (3–23), **151** (2–9).

Perception takes time. What else do you see besides the obvious star?

The same sensory stimulus can lead to different perceptions.

The gray scale to the left of the photograph represents the range of values in the photograph. The perception of those values within the photograph, however is quite different due to the manner in which the tones are distributed (size, shape, position, local contrast) and the meaning associated with the picture. *Photograph by George DeWolfe.*

2.3 Visual Thinking

Definition: Visual thinking is problem solving with visual imagery, and involves the receiving, storing, retrieval and processing of pictorial information. These operations can be carried out consciously or subconsciously, voluntarily or involuntarily.

Visual thinking involves reasoning with two-dimensional images such as photographs, sketches, paintings and graphs; or three-dimensional objects in our environment. It is also possible to reason with visual mental images from information stored in memory. This process occurs daily and is hardly ever a conscious action. The ability to recognize people, places, things, and their relationships exemplifies this type of reasoning. An example of more deliberate visual thinking consists of closing your eyes and counting the number of windows in your home. Try it and reflect on the process by which you arrived at an answer.

Visual thinking can vary from a relatively simple task of looking at an unfamiliar camera and figuring out how it operates, to looking at the unfamiliar terrain contained in the photographs of planets from outer space or photographs of the cellular structure of inner space made with scanning electron microscopes. Compare the quite different levels of visual thinking required to prove the Pythagorean theorem $C^2 = A^2 + B^2$ from the sequence of pictures shown opposite.

Three conditions are involved in such productive or creative thinking: a challenge in the form of a problem to be solved, stimuli in terms of visual information to be manipulated and processed, and flexibility since the problem posed is a new situation. Chinese tangrams constitute an excellent example of a game based on creative visual thinking. Visual analyses of photographs in medicine, astronomy, space explorations, etc., provide other examples.

Visual thinking is simply one style of thinking which is highly relevant to the visual arts. It is also possible to talk about auditory thinking in the musical arts, and taste thinking in culinary arts (wine tasting being one example). All thinking which involves the senses might be called perceptual thinking.

Photographers have always been concerned with visual thinking. Their concern has been, and is, to increase their visual and technical skills so they can transfer a momentary visual experience onto a permanent 'silver canvas' that will provide a similar experience. As early as 1930, Edward Weston told how he would visualize the end result before exposing the film in his camera: '. . . the finished print previsioned complete in every detail of texture, movement, proportion, *before exposure . . .*' (Newhall, N. 1973, p154.). The same concept has been formalized by Ansel Adams and Minor White in their practice and writings about the *zone system* approach to photography. The distinction is made between visualization that occurs before the film is exposed and that which can occur while the negative is being printed. During previsualization, the photographer uses his visual perception process in relating the final print he envisioned to the scene before him—in postvisualization, the final print is related to the visual memory of the scene.

Related terms: perception, perceptual thinking, postvisualization, previsualization, seeing photographically, visualization, visual memory.
References: **9** (13–23), **60, 144** (1–17), **172**.

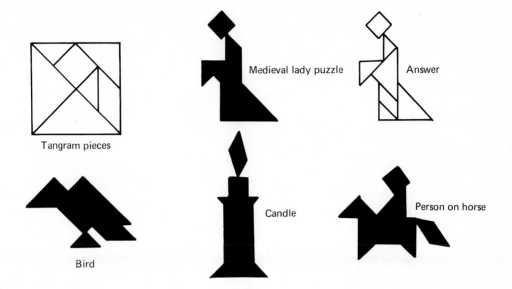

Tangram pieces

Medieval lady puzzle

Answer

Bird

Candle

Person on horse

TANGRAMS This ancient Chinese puzzle consists of seven geometric pieces taken from a square of about 15 cm (6 in). The rule of the game is simply to use *all* of the seven pieces to form a given silhouette. As you work on the puzzle, remember that each piece has two sides and several possible orientations.

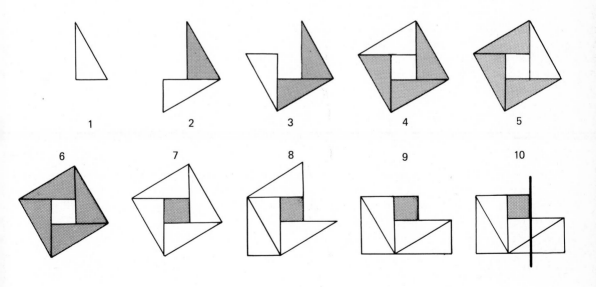

1　2　3　4　5

6　7　8　9　10

A visual sequence showing that the square of the hypotenuse is equal to the sum of the squares of the other two sides provides an exercise in visual thinking. *Drawings by John Wolven.*

45

2.4 Attributes

Definition: Particular properties of an object, such as shape or size, or the representation of those properties in a photograph or other image.

Cave drawings and other primitive art (and many line drawings in contemporary publications) represent only one attribute of the subject—shape. *Shape* refers to the outline of an object, as in a silhouette. Even though it is possible to identify many objects on the basis of shape alone, additional attributes are necessary when greater realism is desired. The following are object attributes over which photographers have considerable control when they make a photograph—either with modifications of the subject (e.g. lighting) or of the photographic process (e.g. print contrast).

Shape can be controlled by the relative positions of the camera and the object, as with front and profile views, and to some extent by tilting the back on a view camera or the negative or easel in printing. *Size* of small objects such as coins and stamps can be represented accurately on photographs, but usually the viewer is more concerned with relative size. With unfamiliar objects, relative size can be established by including an object of known size for comparison. *Color* may be considered a single attribute, but it is usually subdivided into *lightness, hue* and *saturation.* In color printing, lightness is controlled by the exposure; hue typically by the use of yellow, magenta and cyan color compensating filters; and saturation by the density of the filters. *Arrangement* can be controlled in studio photography by changing the relative positions of objects. With stationary objects, the apparent arrangement is controlled by the camera viewpoint. The *time* that an object is available for viewing is often limited due to factors such as a rapid change in the appearance of the object (e.g. a flash of lightning), or a change in position of the object or the viewer. Time can be extended indefinitely with still photographs and shortened to subliminal levels with flash cuts in motion pictures.

Motion, which may be thought of as a separate attribute, is here treated as a change in object position (or arrangement) with time. The representation of motion can be controlled with slow-motion, fast-motion, and time-lapse techniques in motion pictures and by variations of blur in still photographs.

Apparent *depth* can be controlled in photographs by a variety of techniques, but the choice of lens focal length is especially important in controlling the appearance of distance, and the lighting is an important control over the appearance of form and texture. *Sheen* of the object surface, from glossy to matt, can be controlled most effectively by studio lighting techniques. A polarizing filter may be useful in reducing glare reflections and the appearance of gloss in some situations. Glossy objects are sometimes treated with dulling spray, and dull objects may be oiled, waxed or lacquered to increase the gloss. *Transparency* is an attribute of a limited number of objects; it can be represented in photographs by providing something that can be seen through the transparent object and by placing visual cues such as reflections on the transparent surface itself.

With respect to realism of photographs, the first five object attributes—shape, size, color, arrangement and time—can be represented with the *same* attributes in photographs. Obviously, depth is not represented in pictures with a corresponding three-dimensional attribute. The sheen of printing papers is an artificial representation of object sheen at best and cannot accommodate variations within a given photograph. The transparency of color slides and other rear-illuminated images has little to do with the perception of transparency in the objects represented.

Related terms: characteristic, quality, property.

References: **55** (168), **191** (9–16).

Primitive art (*above, left*) and silhouettes (*above, right*) use the attribute of shape to convey information to the viewer. *Photographs by Norm Kerr.*

A more complex image (*below*) that makes effective use of the object attributes shape, form, texture, lightness, and arrangement. *Photograph entitled 'Elephant Rocks' by John H. Johnson.*

2.5 Perceptual Development

Definition: An improvement in ability to respond to a stimulus, such as an increase in sensitivity, speed or accuracy.

Theories of perception have long been divided with respect to the relative influence of heredity and learning on perceptual development. Experiments with newborn and young babies support the position that at least some perceptual ability is inherent. Changes in the brainwaves of newborn infants in response to visual stimuli indicate that a functioning visual system exists at birth. Fantz has demonstrated that a young baby looks longer at a pattern that resembles a human face than at a random pattern made from the same elements. It is estimated, however, that the resolution of the newborn infant is only about one tenth that of an adult with normal vision.

Since it is difficult to completely separate maturational influences based on heredity and learning influences based on experience, most studies on normal perceptual development involve both. Frostig found that perceptual development increases at a fairly rapid and uniform rate from infancy through the age of seven where it begins to level off gradually over the next few years. Perceptual ability tends to remain relatively constant over the adult years and then tends to decrease with old age. Not all abilities develop at the same rate, however. It appears that with respect to estimating lengths and sizes, children may reach the adult level of accuracy at the early age of four or five. With ambiguous or illusory stimuli, the maximum accuracy may be reached at a considerably older age.

Since educators have no control over the hereditary factor, except by acceptance or rejection of applicants or by grouping students with similar abilities, they are primarily interested in determining the extent to which perceptual ability can be improved by educational experiences. In a study designed to measure the effect of practice on visual perception, Neisser used series of unrelated letters which the subject searched for a critical property, such as the presence or absence of a 'Z'. He found the average processing time was reduced to less than half over a period of five days with practice. Although there are obvious physiological limitations in man's visual system, Hilgard and Bower (1966) cautioned against setting absolute limits to man's perceptual capabilities, especially if the reinforcements for exceptional performance are stepped up sufficiently. This statement is supported by an experiment in which 'tone-deaf' persons were trained to identify acoustic tones correctly with reinforcement of correct responses.

Even though perceptual performance can be improved under experimental conditions, the question remains whether it is improved under normal educational conditions for students majoring in visual subject areas. A study using art, photography and science (as a control group) students revealed no significant difference between first-year and fourth-year college students in ability to detect small differences between paired photographs, which were presented sequentially with a 4-second delay between images (*see* opposite). Subjects were not informed as to which of a number of attributes such as size, shape, lightness or hue might change. A significant difference was found, however, on the basis of academic achievement, in which perceptual ability improved with academic achievement (Stroebel, 1973).

Related terms: experience, heredity, learning, maturation, nature-nurture.
References: **27**, **58** (296–297), **66, 101** (572–584), **152** (376–385), **191** (v–vii, 5–9, 34–40, 48–59), **218** (353–387).

Sixty pairs of photographs were shown to 300 college photography and art students. There was no significant difference in ability of first-year and fourth-year students to detect the difference in arrangement of these pictures or differences in color balance, lightness, sharpness, and other attributes of other pairs of pictures. The photographs were presented sequentially with a 4-second delay between images.

A schematic graph showing the relationship between perceptual ability and age. The most rapid development occurs between birth and eight years. Although the graph shows little change for college and subsequent ages, experiments have indicated that specific perceptual abilities can be improved even in adults with intensive training.

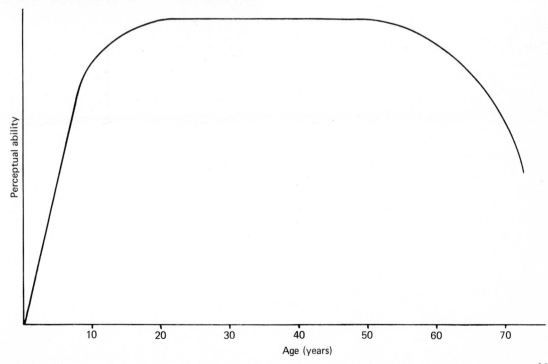

2.6 Color

Definition: The aspect of visual perception that is associated with objects, including surfaces and light sources, and that has the attributes of hue, lightness (or brightness) and saturation.

When someone is asked to say what color he perceives, the response is usually the color 'name.' For example, grass is 'green.' Green is in fact only one of very many *hues*; yellow, red, magenta, blue and bluish-green are others. For any hue, there exist many different color perceptions. The green of grass varies, and is different from the light green of some lettuces or the dark green of pine needles. Thus, to describe a color verbally a statement needs to be made about its *lightness* in addition to its hue. There is yet a third aspect of color, called *saturation,* that identifies the vividness or strength of the color perception, as in comparing the colors of California and Florida oranges. Their hues may be similar and the lightnesses nearly the same, but the first gives rise to a more striking, and thus more saturated, color perception.

As perceived, color is therefore at least three-dimensional. A map that depicts color space requires three coordinate axes in order to display the three color qualities of hue, lightness and saturation. Color space contains a million or more discriminable points, since this is roughly the number of different colors that can be distinguished by a skilled observer in favorable viewing conditions.

The chain of events that gives rise to a specific color perception—'the daffodil appears a light vivid yellow'—involves a complex set of interacting factors. These are the light source, the surround, the physical characteristics of the object, and the physiological and psychological processes within the observer. All these affect the perception of the yellow daffodil.

Although the color perception lies at the end of a long sequence of events and is internal, it is normal to project that perception into the external world, and we often think that the object itself 'contains' the color. Thus, there exists white snow or black charcoal or a red apple. In *usual* circumstances it is true that the object, because of its reflection or transmission of various wavelengths of light, strongly influences the perceived color. Grass, for example, looks green despite the great changes in the color of outdoor light during the day. On the other hand, a navy blue garment may look black in the light from a tungsten lamp. Thus, the color of the light source may be a significant factor in the perception.

When distant forested mountains are viewed, they look bluish. Here the cause of the bluishness is light scattered by the intervening atmosphere. It is known that the wooded hillsides are really dark green, but the environment in this case dictates our perception.

Furthermore, the state of the observer strongly influences the color that is seen. A tungsten lamp appears yellow when the viewer's eyes are adapted to daylight, but nearly white when it is the only light source.

Each of the preceding examples demonstrates that a successful prediction of what color an observer will perceive demands knowledge of many subtle related factors. In most cases this knowledge is impossible to acquire, and for this reason studies of color perception require introspection by skilled observers. There is certainly no simple unique relation between perceived color and the physics of the situation, that is, the wavelengths and intensities of the light reaching the observer.

Related terms: brightness, CIE, hue, lightness, Munsell system, saturation.
References: **36** (11), **55** (1–6), **216** (I, items 1–16).

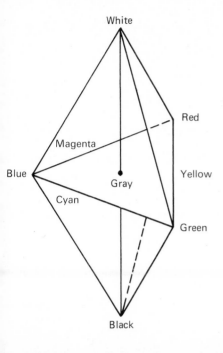

White

Red

Magenta

Blue

Gray

Yellow

Cyan

Green

Black

One of the many attempts to map different colors. Various hues are placed on the periphery of the horizontal triangle and different lightnesses are found on the vertical axis. The saturation lessens on a line from each hue toward the center of the triangle. Whatever the exact form of the figure, three dimensions are required.

A high fidelity color system should reproduce a large gamut of colors varying in hue, saturation and lightness. *Photograph by David M. Spindel.*

2.7　Operant Conditioning

Definition: The process by which a change in the response to a stimulus is produced through the influence of reinforcement.

When a visual stimulus is presented to a person repeatedly, any of three basic patterns of response may occur—the probability (strength, duration, etc.) of the response may increase, decrease or remain constant. If a response is accompanied by a reward, the response is reinforced which increases the probability of occurrence with future presentations of the stimulus. Punishment produces negative reinforcement which decreases the probability. The absence of either reward or punishment leaves the probability of occurrence unchanged, unless the response has been rewarded or punished previously. (Withholding reward may be interpreted as punishment and vice versa.)

To apply operant conditioning to the training of a photographer with respect to visual perception, it is necessary for him to know what he is expected to learn and then to reward correct responses. With on-the-job training the objectives are often quite specific. An inspector in a photographic laboratory may have the limited responsibility of determining if the density and color balance of the finished prints are satisfactory, and a picture editor may be mostly concerned with determining whether or not pictures submitted to him have sufficient human interest. Correct responses tend to be rewarded with words, pay and promotions, and incorrect responses usually receive negative reinforcement. Thus, the worker's perceptual behavior is shaped to the requirements of the job.

Photographic students are usually expected to gain experience in a wide range of skills rather than to become expert in a few, although more emphasis is commonly placed on one area than on others, such as an emphasis on expressive, craft or technical qualities. It is commonly believed that certain things such as creativity cannot be taught. Proponents of operant conditioning maintain that a person's behavior can be shaped toward seeing his environment more creatively simply by rewarding (e.g. monetary rewards in business) examples of such behavior. Grades serve as a type of token reward, since they have no intrinsic value, but there are many less tangible rewards such as praise, a smile, or even the attention of another person. B. F. Skinner's practical application of operant conditioning to learning with instructional programs is based largely on the internalized self-satisfaction of learning as a reward, through the use of immediate feedback.

Reward and punishment as positive and negative reinforcers are not always supplied as separate and deliberate acts. The stimulus itself can acquire reinforcing characteristics. Certain foods are rewarding and are eaten more often. Certain types of pictures, for example sport pictures, have a rewarding effect and more time is spent looking at them. When professional photographers deal with their customers on a person-to-person basis they can use the salesman's technique of verbal reward to reinforce favorable responses to their photographs, but when dealing with mass audiences they must depend upon the reinforcing qualities of the photographs themselves. Knowledge of the viewers' likes and dislikes is useful to the photographer in his effort to produce images that viewers will find rewarding.

The ability of a photographer and model to work well together depends to a large extent on positive reinforcement, both visual and verbal, as they work to create and capture a specific expression or mood. Visual reinforcement for the model would include reassuring facial expressions and gestures by the photographer.

Related terms: learning, punishment, reinforcement, reward.
References: **35** (83–94), **87** (476–513).

A photography student's attempt to imitate Edward Weston's *Nude 1936*. The instructor's remarks provide positive reinforcement of the desired perceptual behavior and negative reinforcement of that which needs to be changed. *Photograph by Tom Rogowski.*

22. In a similar manner, when magenta light enters a red filter, the red component is transmitted and the blue is absorbed. If yellow light enters a red filter, the _____ component will be transmitted and the _____ component will be absorbed.

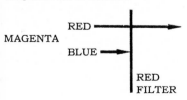

A sample frame from an instructional program. The reader is able to compare his response immediately with the correct response and thus is motivated to learn through the process of operant conditioning. *From Photographic Filters by L. Stroebel.*

22.
Red
Green

2.8 Cognitive Responses

Definition: The aspects of visual perception that involve intellectual matters as distinct from affective and psychomotor responses.

The communicative function of pictures can be divided into the same three broad categories used for educational objectives—cognitive, affective and psychomotor. The traditional concept of academic learning is most closely associated with the cognitive domain. To many students it seems that the emphasis in learning is almost entirely on gaining knowledge by *memorizing*, even though the teacher points out that it is necessary to remember certain basic information in order to achieve the higher order cognitive objectives of *comprehending, applying, analyzing, synthesizing* and *evaluating*. These objectives apply to the general process of communicating, whether the communication is accomplished with pictures, words or a combination of the two.

Record-type photographs serve essentially as substitutes for the objects or scenes represented. They are realistic to the extent that associations are established with *remembered* images from previous perceptual experiences. The purpose of using such photographs is largely cognitive in nature, to communicate to the viewer what the objects or scenes look like. In the specific case of catalog photographs, the purpose includes the creation of a memory image that will influence the viewer's behavior with respect to buying the item.

Comprehending means that the viewer of the picture knows what is being communicated and can use the material or ideas even though he may not see all of the ramifications. Many photographs of a scientific, technical, photojournalistic and illustrative nature satisfy this communicative objective. Comprehending suggests that a concept is involved. Thus, the picture is more than a representation of an object.

Applying refers to the transfer of a concept from one context to another—the ability to create a visual analogy. This objective is most useful when it involves the presentation of a principle or abstraction that can be applied to a great variety of specific situations. For example, a viewer who learns the principle of balancing weights on a beam and fulcrum from a picture, may be able to apply the concept to composing a photograph to obtain a balance of psychological weights of significant image areas. Photographers who maintain 'swipe' files—collections of photographs they admire made by other photographers—are knowledgeable of this function of pictures. The extent to which they can apply a concept to dissimilar situations is a measure of their creativity.

Although *analyzing* may involve nothing more than thinking critically about a straightforward photograph, it often requires the use of special procedures such as photomicrography, X-ray, time-lapse, and exploded-view photography. Analyzing refers to separating an object or scene or its pictorial representation into component parts, so that the organization of one or more parts can be identified and studied.

Synthesizing consists of combining elements to form a whole, thereby revealing a concept that was not evident before. This process typically requires a high degree of creativity on the part of the photographer since it is necessary to anticipate the end product. It can appear in a variety of forms including combining elements within a single photograph (such as figure and ground), or combining pictures to form a picture story, or combining shots and scenes to form a motion picture.

Evaluating refers to the judgmental aspects of the viewer's response to a picture. If he places little value on the content, the percept may be dismissed immediately, whereas if he judges the content to be of vital importance it may be remembered long and have a significant effect. A viewer begins evaluating a picture with the first glance; the feedback determines how much time and attention will be devoted to the viewing process. The final decision depends upon whether the picture is believable, effective, economical and satisfying.

Related terms: intellectual, knowledge.
References: **23.**

Photographs of the retina, when analyzed by persons trained in medicine, can provide information about a variety of health problems. *Photograph by Susan Mustico.*

The use of four photographs to form the unified concept of a lunar eclipse is an example of synthesis. *Photographs by Nile Root.*

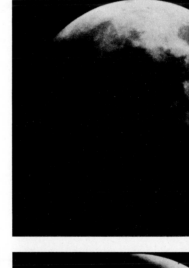

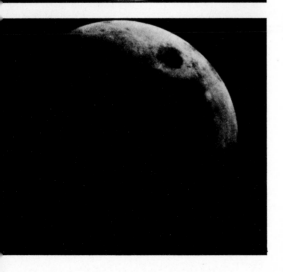

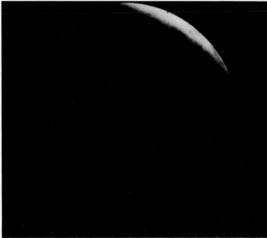

2.9 Affective Responses

Definition: The subjective aspects of visual perception involving feelings as distinct from cognitive and psychomotor responses.

Although numerous specific terms are used to identify different types of affective involvement in the perception of pictures, three are of special importance—*interests*, *attitudes* and *emotions*.

When a picture is presented to a person for viewing he will not become involved with it in a meaningful way unless the first exploratory glance stimulates his *interest*. This encourages photographers to introduce innovations to make their pictures distinctive. To hold the viewer's attention, the main subject of the picture must be made interesting to him; a challenge when the subject is not inherently stimulating. A common technique in advertising is to include a pretty model with the less attractive product. Unfortunately, the greater the interest in a particular object, the less likely is the perception of other objects in the field of view. Research has revealed that viewers tend to remember the sexy advertisement but not the name of the product associated with it.

An experiment by Hernandez-Peon *et al* demonstrated that when a mouse was placed in a cat's field of view, an electrical signal in the cat's auditory nerve produced by a repetitive clicking sound suddenly stopped. Thus, there appears to be a physiological basis for the effects of the interests of the viewer on the resulting perception.

Attitudes are especially important in the study of visual perception due to the strong influence they have on motivation and because people tend to resist changes in their existing attitudes. Pictures can be used effectively in Thematic Apperception Tests (whereby the subject makes up a story based on his perceptions) to detect prejudices and other attitudes. There is no simple formula for changing attitudes, but it appears that the use of the affective function of pictures is more promising than the use of cold facts. Finesse is required in the creation of pictures for motivational purposes. If the message is too subtle, it is not perceived by the viewer whereas if it is too heavy-handed, it may produce a reaction against the desired attitudinal change. A major characteristic of illustrative photography is a concern for attitudes and the other affective functions of photographs. The principle of association is commonly used to link a product toward which the viewer may have a neutral attitude (a certain brand of soft drink) with a situation toward which he is likely to have a positive attitude (a party). The psychological process whereby a person with whom the viewer can identify is shown using the product, for example, is another effective technique.

In certain circumstances, pictures can evoke powerful *emotional* responses. Motion pictures constitute the most effective pictorial medium for communicating material of an emotional nature for several reasons, including the relatively long viewing time that permits the development of an emotional theme, the combination of visual and audio stimuli, and the effect of being a member of a large group of viewers. Some evidences of emotional responses by viewers are obvious, such as laughter and tears, and in extreme cases even screams and fainting. Less obvious affective responses can be detected with equipment designed to measure the rate of breathing, the pulse, galvanic skin response, etc. Dramatic physiological changes should not be expected from a picture that has no more significance than being esthetically attractive. But researchers are using sensitive equipment and sophisticated procedures, including pupillometrics (measurement of pupil size) and electroencephalography (measurement of the brain's electrical impulses) in an effort to measure subtle—even subconscious—affective responses to pictures.

Related terms: attitude, emotion, feeling, interest, mood, motivation.
References: **99** (331–332), **102** (46–54), **131, 175** (55–59).

Examples of pictures which tend to produce affective responses, as distinct from cognitive and psychomotor responses. *Photographs by Dick Swift (above left), John Jean (above right), Günther Cartwright (left).*

A physiograph trace of a person watching and listening to the motion picture *Bolero* in which the visual and auditory attributes build up to a climatic ending. *Courtesy of Martin Rennalls.*

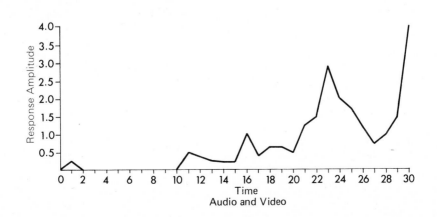

2.10 Psychomotor Responses

Definition: The aspects of visual perception that involve mind-muscle cooperation which typically involve manipulative abilities and skills.

There has long been a controversy over the relative effectiveness of demonstration and instruction of psychomotor skills, versus actual practice. Since the viewer of pictures presented for psychomotor instructional purposes generally projects himself into the depicted activity, it is more realistic to refer to the two processes as mental (*covert*) practice versus actual (*overt*) practice rather than as no practice versus practice.

It is not surprising that an early study on mental practice versus actual practice in relation to accuracy of throwing a basketball showed superiority of actual practice. However, it now appears that most psychomotor skills can be learned best by a combination of the two approaches, rather than by specializing in one to the exclusion of the other. The optimum ratio of covert to overt practice and the most effective sequence vary with the nature of the psychomotor task, especially with the relative amounts of skill and understanding involved in the task. Demonstration and instruction, accompanied by covert practice, increase in importance as the amount of understanding involved in the psychomotor task increases.

Learning to shoot free-throws with a basketball is a high-skill, low-understanding task. Even in this high-skill activity, the beginner could improve his performance by watching a motion picture of a professional basketball player shooting free-throws. He would note that the professional bounces the ball and takes a deep breath to prepare himself, and he would note whether the ball is thrown underhand or overhand. In addition to such obvious factors, the beginner may make valuable observations of a more subtle nature. If he identifies with the professional he may try to imitate his style including posture, rhythm and follow-through. B. R. Bugelski points out that although imitation is not a popular concept with learning theorists (because rats, cats, and dogs are not active imitators) man does imitate, and he is motivated to imitate by the positive reinforcement he receives when his efforts are successful.

Although the psychomotor function of pictures is most appropriate for the early stages of the learning process, even professionals sometimes find they can improve their skill by studying pictures of their own performance. It was recently reported in the press that a major league baseball pitcher who had won 21 games the previous year but was depressed over his poor performance in the new season, suddenly regained his form after studying a series of still pictures of his throwing motion.

At the other extremity are psychomotor activities that involve much understanding and little skill. Research indicates that beginners are able to develop skill in these types of tasks with mental practice while viewing pictures and having little or no actual practice. A group that practiced threading a motion picture projector mentally while watching an instructional film did the task as well as a group that received individualized instruction combined with actual practice. In a more complex motor assembly experiment, learners who had the opportunity to engage in additional recognition practice with pictures were less affected by an increase in the size of the demonstration unit.

Most psychomotor tasks require a balance of understanding and skill—a corresponding balance of mental practice with pictures and actual practice is appropriate. Even in formal educational situations it is often necessary to delegate a significant part of the psychomotor domain to mental practice due to limitations of equipment, time, and qualified experts for the number of learners involved.

Related terms: bodily, manipulation, manual, movement, physical.
References: **35** (125–126), **89, 91, 206** (4A).

Left: This sand trap shot by professional golfer Terry Diehl exemplifies a high skill psychomotor task. Beginning golfers can improve their skill by practicing imitation of the performance by an expert. *Photograph by James Laragy.*

Above: A type of psychomotor task that requires considerable knowledge but little manipulative skill.

Below: The sign language and finger spelling used to communicate with deaf persons, are psychomotor tasks that require both knowledge and manipulative skill. A deaf actor is shown using sign language in a stage performance. *Courtesy of National Technical Institute for the Deaf, Rochester Institute of Technology.*

2.11 Sensory Deprivation

Definition: A severe reduction in the variety and intensity of environmental information received through the sense receptors.

The environment is so much a part of everyday life that it is often taken for granted, but sensory contact with the environment is essential to normal existence. This has been dramatically demonstrated in experiments in which young healthy college students at McGill University, Canada, were paid an attractive sum of money each day, as long as they would remain in a specially designed room equipped to isolate them totally from their environment. Their eyes were covered with a translucent plastic that prevented pattern vision, hands were gloved and enclosed in extended tubes so that touch was not possible, and ears were covered with earphones from which a constant buzzing sound emanated to prevent pattern hearing. Except for a short period to eat, the subjects would lie on a comfortable bed, deprived of sight, sound, touch, taste, smell, and extended movement.

The results were frightening, but revealing. Most subjects could not stand the monotony of this nearly total sensory isolation for more than two or three days—six days was the longest any subject could tolerate it. During the isolation period, simple tests were given to measure changes in mental ability. Performance was impaired on nearly every test. The subjects became irritable; seemed to lose their sense of perspective; began experiencing strange images, sounds and sensations of movement or touch. In short, they began to hallucinate.

After coming out of isolation and while adjusting to a normal room environment, the subjects experienced gross visual disturbances:

1 Their entire field of vision appeared to drift and move.
2 Objects in their view seemed to move as their eyes, head or body moved.
3 There were distortions in shape—flat surfaces appeared convex or concave and straight edges appeared curved.

These disturbances were temporary, lasting about 30 minutes.

Dynamic contact with the environment provides changing sensory stimuli, which serve to keep the brain alert. Mental functions are impaired when restricted to the monotony of few or no stimuli, or continuous stimuli from an unchanging environment.

Photographers seldom if ever encounter conditions of extreme sensory deprivation such as those found in experimental situations or in 'brain-washing' episodes. However, the concept is a useful one, since the photographer can from time to time become involved with conditions of at least partial deprivation. He can unknowingly deprive himself of sensory stimulation by failing to remain perceptually alert to his surroundings. Change, internal or external, is the remedy for potential deprivation. There are a variety of ways to cause change. It is possible to establish closer contact with the environment through such methods as sensitivity training. This takes the form of either confronting the environment or, paradoxically, in becoming involved in various forms of meditation and prayer in which the person temporarily withdraws from the external environment. Edward Weston found fasting from time to time helpful.

Related terms: perceptual deprivation, perceptual isolation.
References: **69** (281–282), **93** (210–213), **94** (52–56), **209** (104–117).

After prolonged periods of sensory deprivation or monotonous stimulation, visual hallucinations are experienced by many subjects. These hallucinations usually begin with simple visions such as seeing dots of light or simple geometric forms and then become more complex.

Simple hallucinatory forms

Complex hallucinatory forms

Visual deprivation
Seeing depends upon changes in the visual field. If the entire field is completely homogenous (*ganzfeld*), seeing is impaired. Forms become difficult to recognize, contours blur, shapes change and movement is difficult to perceive. After about 20 minutes seeing ceases. A ganzfeld can be stimulated in such ways as staring at a blank wall, covering the eyes with two halves of a ping-pong ball, or by using an optical device which presents a stabilized image to the retina. The consequence of this unchanging visual imput is a reduction in a person's ability to see. *Photograph by Jeffrey H. Holtzman.*

2.12 Perceptual Readiness

Definition: A condition in which a person is more receptive to seeing what he expects or wants to see than alternative responses.

Perception is a decision-making process involving the act of classifying. In order to perceive something in a meaningful way, a person must be able to relate it to an existing category within his memory bank. For example, if there were no category for camera and a person were shown one, he would not be able to perceive it as most do. A World War II reconnaissance story relates that in 1939 British photoreconnaissance missions revealed that the Germans were building large circular configurations that seemed to have no apparent function; four years later they were recognized as launching pads for deadly rockets. In recent years it has been revealed that this story was untrue and was used as a coverup to protect sensitive secret British information. The large circular patterns in the aerial photographs made over Peenemude were recognized by British intelligence as being ramps for launching V1 rockets, with some ramps having rockets on them. Prior to such recognition, there were no categories for the photo interpreters to identify such objects as 'pilotless aircraft,' 'flying bombs' or 'buzz-bombs.' Once a category was established, the perception of the circular configurations and pilotless aircraft changed radically. Unless we have categories for new visual experiences, we find perception to be difficult or confusing.

The lack of perceptual readiness is an important reason why avant-garde photographs, both artistic and scientific, often seem confusing when first viewed. It required new perceptual learning before photographs made with X-rays, infrared radiation and electron-scanning microscopes could be accurately perceived. The first aerial photographs required new perceptual categories as did the first photograms, Kirlian photographs, tone-separation and other derivative photographs. Perceptual adjustments were also required for the various painting styles including impressionism, pointillism, cubism, and abstraction.

Being open to new experiences and learning new concepts require flexibility to extend existing perceptual categories. One of the reasons we react differently to the same physical stimulus or picture at different times is that the categories to which we relate the visual input are personal, poorly defined, or nonexistent. For this reason, providing a commentary is useful when a person does not readily perceive what was intended from a picture alone. Comments can help a person relate a picture to existing categories in the memory or establish new categories by suggesting associational verbal cues. Captions commonly serve this function.

The greater the accessibility of categories, the less the sensory input that is necessary for accurate perception. This assumes that the stimulus is not ambiguous and that the viewing conditions are favorable. Classification facilitates perception, but can also hinder it as is the case when we become so familiar with an event that we immediately label it after a glance and then dismiss it. To see something new in something familiar requires some type of change. A variety of techniques can be used depending upon your interests and skills. For example, some photographers will repeatedly return to the same outdoor scene and observe it under various lighting conditions and seasons. Indoors, photographers can try different lightings, arrangements, backgrounds, viewpoints, props, films and any of a multitude of special effects.

The principles of set and expectancy play an important role in perceptual readiness. When we prepare ourselves to expect something, we are in effect preactivating a related set of memories. Perception is achieved when we consider the number of alternatives in a particular context or set, and then choose the most probable.

Related terms: attention, cell-assemblies, expectancy, set.
References: **33** (634–662), **209** (78–86).

Before reading the upside down caption, study the photograph more carefully and remember your perception of it as you compare it to your perception after reading the caption. What do you see? *Photograph courtesy of NASA.*

The photograph was taken by an orbiting satellite over New York State in 1972. The black areas are lakes and the white areas are clouds. This information immediately provides you with a set or context, and limits the number of alternatives from which to choose in making decisions about the information shown. If you are familiar with upper New York State, you have an appropriate category and expect to see the Finger Lakes (elongated black areas in the bottom half of the photograph). Lake Ontario (large black area in upper left) and Rochester (at a 9 o'clock position and covered by a white cloud, usually expected over Rochester). The Canadian shoreline is across Lake Ontario at 11 o'clock.

2.13 Perceptual Defense

Definition: A psychological process by which a person uses his perceptual system to avoid threatening stimuli.

Certain types of situations can cause tension and anxiety—for example, taking a final examination, or seeing a horror movie. The function of anxiety is to warn a person of an impending threat so that he can defend himself against it. Sigmund Freud called attention to a variety of behavior patterns (defense mechanisms) people use to protect themselves against such threats, including repression, projection, reaction formation, fixation and regression. They all have two common characteristics—they deny or distort reality and they operate unconsciously.

Perceptual defense is a form of repression by which we attempt to prevent unpleasant situations from reaching conscious awareness. Most of the experiments dealing with perceptual defense have been done with words. A list of words, some of which are unpleasant, is shown to a person and he is asked to respond to each word as quickly as possible. The length of time taken to respond to a word is called reaction time. For unpleasant words such as putrid, sickness, death, vulgar and whore, reaction time is longer than for pleasant words such as brave, honest, joyful and courteous. Furthermore, reaction time tends to increase with the degree of unpleasantness. The reason for the longer time to perceive and respond to unpleasant stimuli is attributed to a temporary repression or perceptual defense. A related but somewhat different form of perceptual defense is distortion, whereby an objectionable stimulus is mistakenly perceived as something less objectionable. A person who is offended by the word 'bitch,' for example, may perceive it as 'ditch.'

For the photographer who deals with pictures rather than words, the concept of perceptual defense is perhaps even more important. It is very difficult to look at unpleasant photographs that are the equivalent of words such as putrid, sickness and death. The reality of the situation is avoided by repressing it, a protective device for maintaining self-esteem and defending against anxiety.

It has been found that certain mass media campaigns aimed at inducing people to give up smoking, drive slower, etc., through the use of frightening statistics or photographs had less effect than anticipated—due at least in part to perceptual defense by members of the target audience. People who want to protect themselves against such unpleasant messages can do so in any of several ways, including not looking at the message, looking at the message but repressing the perception, or looking at the message but rejecting it as being an exaggeration. On the basis that a person who refuses to listen to a dirty joke may very well enjoy a double entendre, it is the task of the communicator of unpleasant messages to present them in a palatable form. This requires considerable ingenuity and finesse, but it generally involves tempering the unpleasantness with appeals to other emotions, even humor.

A somewhat more controversial procedure for penetrating the perceptual and other defenses of viewers of pictures has been used by the advertisers of certain products in recent years. This consists of embedding the unacceptable message, frequently related to sex or death, in what appears on the surface to be a straightforward advertising picture. A sexually oriented embedded image perceived at a low conscious level may well be a pictorial equivalent of the double entendre. Claims have been made for the high motivating power of embedded messages involving subliminal perception, which have been refuted by others. At one time there was sufficient confidence in the power of the subliminal message for restrictions to be placed on the use of embedded images in motion pictures.

Related terms: defense mechanism, inhibition, repression, sensory gating, subliminal perception.
References: **84** (778–788), **135** (164–165), **209** (218–227).

Think of it as investment spending.

Eau de Toilette
After Shave Lotion
Bath Soap
Shaving Foam
Protein Shampoo
Spray Talc

One way to circumvent a person's perceptual defense is to present information indirectly. There is speculation that some advertising agencies do this by embedding images such as grotesque faces and sex symbols in their advertisements. The one shown on the left looks conventional enough and a person may look at it and pass on to something else without much thought. The bottle is readily seen as figure against a ground which contains a distorted reflection. A careful look at the ground area reflections of the bottle, however, reveals a grotesque face or death mask. Some speculate that this image is registered subliminally and has an effect in remembering the product.

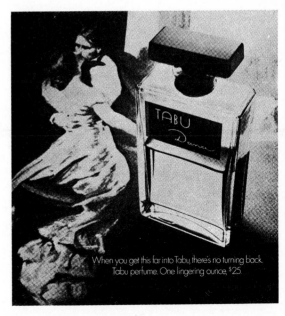

When you get this far into Tabu, there's no turning back.
Tabu perfume. One lingering ounce, $25.

How many times have you seen the advertisement above without being aware of the distorted image embedded in the lower left corner?

2.14 Visualization

Definition: The process of visual thinking in which the image to be photographed or printed is determined through the analysis and synthesis of perceptual and mental images.

To show in a photograph what was seen and felt by the photographer requires that he, in Edward Weston's terms, 'sees photographically.' The visual process records information quite differently from the photographic process. Seeing involves memory and imagination since the eyes are an extension of the brain. Within limits we see what we want to see, and it is easier to see things that can be related to images already in memory. Furthermore the visual process is binocular, has different color sensitivity, is continually scanning, is highly selective in what it chooses to see, can adjust to a brightness range larger than can be recorded photographically, is influenced by adaptation and constancy, and is restricted to a single 17 mm focal length lens.

The *zone system* approach to photography provides a means by which the photographer can relate what he sees when he takes a photograph to what he hopes to experience when he looks at the photograph later. The first step in the process is calibration. In this stage the photographer tests and calibrates his entire photographic system to assure accuracy and repeatability. Through a series of tests he determines the exposure, development and printing conditions necessary to produce different print tones. Opposite are some of the print tones and contrasts made possible by simply using different grades of paper.

To help visualize a scene in terms of the final print tones, a Zone Ruler consisting of ten zones of increasing value from 0 to IX (from black to white) is used. The photographer studies the various objects in a scene (trees, sky, rock, grass, water, faces, etc.) and learns to see the colors as mental tones of various lightnesses. This requires the photographer to 'see photographically'—to see subject colors having hue, saturation and lightness as having only lightness. For example, light foliage or north sky should be seen as a gray print tone of about Zone V (an 18% gray). Relating subject tones to print tones requires a good visual memory, so it is useful to make comparisons with steps on a gray scale until you develop such a memory. It is also helpful to use a dark amber Wratten 90 monochromatic viewing filter, which reduces hue and saturation of color objects so you can concentrate on lightness differences. If such a filter is not readily available a dark neutral density filter (density of about 2·0) may be used. You can see approximately how a color filter will shift the tonal contrast in the negative simply by looking at the subject through the filter. A deep yellow or red filter, for example, increases contrast between white clouds and blue sky by darkening the blue.

The color sensitivity curves for the eye and for film (*see* opposite) illustrate how the eye-brain system sees the lightness of blue, green and red colors in comparison with how a panchromatic black-and-white photographic system renders the same colors. The color temperature of the light used to expose the film is an important factor because the eye adapts to changes in color temperature but the film does not. When using black-and-white panchromatic films you can notice subtle differences in tones when the same objects are photographed using tungsten light as compared to daylight. To record tones in a photograph faithfully on panchromatic film requires a pale green filter when using tungsten and a pale yellow filter when using daylight. There are more dramatic differences between the visual and photographic images when blue-sensitive, orthchromatic, or infrared-sensitive films are used.

Related terms: postvisualization, previsualization, visual thinking, Zone System. *References:* **2** (21–25), **9** (13–53), **60**, **212** (10–21).

Blue	Green	Red

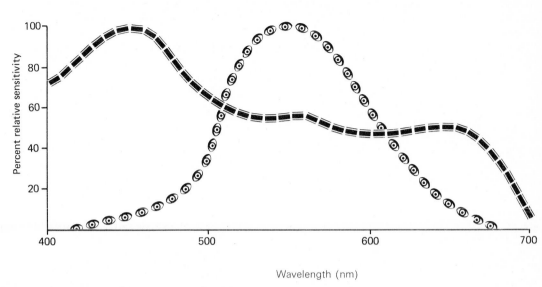

Wavelength (nm)

Above: The relative color sensitivity of panchromatic film and eye have been adjusted to 100% at their peaks. Note that the eye is more sensitive to green than film and much less sensitive to blue than film. In order to 'see photographically', you must learn to adjust for this difference.

Left: Different grades of photographic papers provide different palettes of print values.

Below: The zone ruler consists of a scale of ten units which represent and relate subject values, negative exposures and print values.

ZONE RULER

O	I	II	III	IV	V	VI	VII	VIII	IX

2.15 Field Dependent/Independent

Definition: The relative influence of visual and nonvisual stimuli on a person's spatial orientation.

If you were for a few minutes to pay attention carefully to your visual field you would notice that much of it is either vertical or horizontal—tables, chairs, desks, windows, walls, pictures, tree trunks, the horizon and the like. If you sense how you are oriented within that visual environment you tend to relate your body positions to the vertical and horizontal lines. Without hesitation you know whether your body is upright or tilted. Such an ability to relate the position of your body to the vertical–horizontal axes of space has two bases. The first has to do with the gravitational field and the second with the visual field. The force of gravity acts on the kinesthetic sense in the muscles, tendons and joints and the static sense in the inner ear so that you experience yourself as being upright or not. This is independent of the visual field and is easily experienced by tilting your body with the eyes closed. Immediately you know you are not upright and can usually sense the direction and degree of tilt. Spatial orientation is also influenced by tilting the visual field with the body in an upright position.

Everyday experiences are such that you find yourself upright relative to both the gravitational field and the visual field much of the time. It is difficult, therefore, to determine whether a person perceives his body position on the basis of gravitational forces, visual forces or both. One of the first perceptual researchers to investigate the extent to which the gravitational field and the visual field influence perception of the upright was Herman Witkin. To separate and control both fields he built a 'tilting-room/tilting-chair' apparatus. Both chair and room can be moved independently and the extent of rotation or tilt is measurable in terms of angle. A person sitting in the chair is tested under various tilted-room/tilted-chair combinations. For each situation the person is put into a non-upright position and is instructed to tell the experimenter to adjust either the room or the chair, and by how much, until he perceives

his body in an upright position. The results of Witkin's experiment, and many others which followed, showed that people differed considerably in how they attempted to change to an upright position—some changed the visual field (tilted room) and others the gravitational field (tilted chair). The term *field-dependent* was coined to describe those that adjusted the tilted room and *field-independent* for those that adjusted the chair. Similar results were found when other devices such as a rod and frame apparatus, and an embedded figure test were used. Persons who easily separate figure from ground tend to be field independent.

Often a photographer finds himself in a situation in which his body posture is not upright relative to the gravitational field or visual field and must somehow make adjustments. Examples include photographing while leaning out a car window, airplane or other vehicle; intentionally tilting the visual field in a motion picture camera for effect; operating swings and tilts on a view camera to adjust the vertical and horizontal perspective; and mounting prints in which the subject matter is not vertical relative to the mount board.

Photographers must understand how typical viewers will perceive the position of an object represented by an image that is tilted in the picture frame. This also applies to the movement of an object, such as an airplane in flight, when the image remains fixed within a motion picture frame due to panning. The viewer will have different field cues than were available when the photograph was taken.

Related terms: embedded-figure, figure-ground, motion perspective, psychomotor responses, Rorschach.
References: **10** (101–103), **42, 47** (73–77), **173**, (26, 64, 116–117), **213** (50–56).

| Rod and frame test position | Field-independent adjustment | Field-dependent adjustment |

A rod and frame test can be used to determine field dependency. A rod is located within a luminous square frame. Both frame and rod can be rotated independently. The subject is presented a situation such as shown at the left, in which both the frame and rod are not vertical. He is then told to set the rod so that it appears upright or vertical. A field-independent person ignores the visual field and sets the rod vertical according to his gravitational field. The field-dependent person does the opposite.

A field-dependent person would probably experience more tension when looking at this photograph than one who is field-independent.
Photograph by Elliott Rubenstein.

2.16 Information Processing Model

Definition: A schematic representation of a perceptual system, including basic components such as perceptual experience, perceptual memory and perceptual response.

An objective of information-processing models for visual perception is to correlate, conceptually, visual stimuli and visual responses in a manner that is consistent with the observed facts. Such models make it apparent that perceptions do not occur simultaneously with the presentation of stimuli, and they serve to show the flow of information in the perceptual system. Over the years many information-processing models have been proposed. Some models, for example, place the major emphasis on the neurological pathways, whereas others are more concerned with perceptual tasks. The latter type is illustrated (*see* opposite) with a simplified version of a model proposed by Ralph Haber and Maurice Hershenson.

Formation of an optical image on the retina can be followed by any of various outcomes as a result of information-processing variations. For example, the visual information can be lost to the system, as by interference due to a loud noise, or it can produce a visual experience, or a verbal or other response, or the information can be stored in memory. A combination of two, or all three of the last three alternatives commonly occurs. The *visual image* box represents the major component of the information-processing model as this is where information is assembled to produce the perceived image—the construction of the reality of the environment as interpreted through the sense of sight. There are still unanswered questions concerning the incorporation of separate optical images (resulting from eye movements) into a composite visual image. Also the input arrows from the *short-term* and *long-term* boxes indicate that the Visual Image is not a straight photographic-type record of the stimulus input, but is subject to being modified by other components in the system.

There are differences of opinion concerning the form in which visual information is encoded or represented in the *brief visual storage*, but it is generally agreed that the maximum duration of storage is about 1/4 second. An important function of this short storage is to permit processing of visual information when the stimulus is available for shorter times, such as an individual frame in a projected motion picture. The brief visual storage also appears to be an important factor in the processing of visual information obtained during short fixations between saccadic eye movements.

Short-term memory covers a longer time span than brief visual storage, typically several seconds, and longer with rehearsal and concentration. Thus, if a person closes his eyes while looking at an object, he can continue to see a mental image of the object, perhaps for some time if he concentrates on keeping it in his consciousness. If he can recall the mental image after an interruption by other visual experiences, it means that the information has been placed in *long-term memory*.

Although we do not confuse a memory image with the original visual image, memory influences our perception of original visual images—as in the recognition of a friend's face in a crowd of strangers, or which of alternative shapes we see in an ambiguous figure because of greater familiarity of one.

Output response represents different possible types of responses to a visual stimulus including spoken, written, and pointing or other movement responses. A picture editor, for example, may draw cropping lines on a proof print, and give verbal or written instructions for changes to be made in printing based on his visual perceptions. Output Responses involve complex transformations of visual information, by encoding into other communication languages, since there is no way a person can show another person his visual images directly. Artists and photographers, however, use the Output Response component to produce representations of their visual images in the form of drawings, paintings and photographs.

Related terms: brief visual storage, iconic storage, long-term memory, output response, parallel processing, persistent image, response organizer, serial processing, short-term memory.

References: **85** (1–15), **86** (161–167), **119** (526–539).

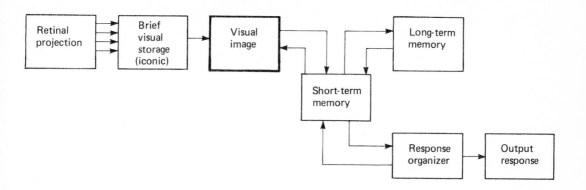

Visual perceptions are represented in the information-processing model shown at the top of the page by the box labeled *Visual image*. Since you cannot show others your visual images directly, the only way you can communicate about your perceptions is from the *Output response* component, usually in the form of spoken or written words. Artists and photographers have the advantage of being able to express their output responses as pictorial representations. *Photograph by Leslie Stroebel.*

2.17 Sequential/Simultaneous Processing

Definition: Alternative methods of treating discrete units of information—one unit at a time (sequential), and two or more units at a time (simultaneous).

Conflicting views are held by experts concerning the extent to which the visual system processes information sequentially and simultaneously. Much of the research in this area pertains to reading, where a page of print is scanned in a sequential manner but chunks of information are received during brief fixations. Receiving a certain amount of information at one time does not necessarily mean that it is all processed simultaneously. For example, when a bright light and a dim light are flashed simultaneously in a darkened room, viewers commonly report that the bright light was flashed earlier.

The visual system has the capacity to retain visual information for a period of time up to 1/4 second, during which it must either be processed or be lost. Since it has been estimated that individual letters can be processed at a rate of about 1/100 second per letter, it is possible for the visual system to receive a certain amount of information simultaneously and then process it sequentially.

Even if it is assumed that the visual system has but a single channel for conveying information at a maximum rate of 1/100 second per unit, there are conceivably various ways in which the system's capacity can be increased. An obvious method is to increase the size of the information unit. For example, rather than process letters one at a time, it is possible to process words, or phrases, or even concepts involving larger numbers of words. Speed reading methods are based on including more words in each fixation, and adjusting the word span and the rate to the nature of the material being read. Because of the redundancy of the English language it is not necessary to read every word to understand the content.

Experiments by Ulrich Neisser have commonly been cited as providing evidence of simultaneous processing. When a person is presented with a list of meaningless letter groups and is asked to identify which of say twenty groups contain the letter 'V', a certain amount of time is required as the person scans the list. It was found that no additional time is required to identify a second letter 'Z' during the same search. In fact, some subjects are able to search for up to ten letters in the same time required to search for one.

There is less experimental evidence concerning sequential and simultaneous processing of information from pictures than from letters and words. But some people are able to make a reasonably accurate sketch of a picture flashed on a screen in a darkened room for times as short as 1/200 second (or even 1/500 second). This ability can be explained as sequential processing of information received simultaneously and held in brief visual storage. However, simultaneous processing is strongly suggested when a viewer is able to identify each picture of a series of different pictures presented in rapid sequence.

Motion picture films such as *American Time Capsule* and *Frank's Film*—consisting of sequential series of familiar still pictures, each flashed on the screen for about 1/50 second —allow little time for sequential processing of information from one picture before the next picture is presented. The fact that more meaningful perceptions are obtained with familiar pictures than with new pictures, indicates that the organization of information into larger units or *gestalts* is an important aspect of rapid perception. It is a common experience, even when viewing a still photograph for the first time, to have the feeling of seeing it all within a fraction of a second —this implies simultaneous processing.

Related terms: eidetic imagery, eye movements; information processing, information theory, serial/parallel processing, scanning pictures, short-term memory, visual search, visual thinking.

References: **85** (6–10), **86** (222–226), **154** (65–72, 99–101), **160** (35–43).

Simultaneous processing is used to recognize the subject of this picture as a pile of old tires and to perceive the design made by the tires. *Photograph by John Jean.*

Pictures are sometimes displayed as a related sequence. In order to comprehend the statement being made, both the items within each picture and the pictures must be processed in some *sequence* and then synthesized. *Photographs by Douglas Hunsberger.*

Measurement of Perception

3.1 Psychophysics

Definition: The scientific study of the relationship between the physical attributes of a stimulus and the psychological response of the viewer.

A goal of psychophysics is to be able to predict the appearance of a stimulus on the basis of physical measurements of the stimulus. In a loose way, this has been achieved for a long time. For example, sodium vapor emits a narrow wavelength band of radiation at approximately 590 nm, and it can be predicted that viewers generally will identify the color of the light as being yellow. If, on the other hand, a number of viewers are asked to specify exactly the appearance of, for example, the light reflected from a person's forehead in terms of the three basic attributes—hue, saturation and lightness—a wide variety of answers will be given.

There are a number of reasons why psychophysics does not enable us to predict the appearance of light or objects with great precision. One reason is that different people may respond differently to the same stimulus. This may be due to physiological differences such as defective color vision, myopia and astigmatism; or temporary factors such as the effects of fatigue or drugs; or different learning experiences e.g. a given color may be identified as blue by one person and cyan by another. A second reason is that there are no precise scales for measuring sensations or perceptions. Photographers typically use only six names to identify hues—red, green, blue, cyan, magenta and yellow. Most people cannot judge the magnitude of a stimulus attribute, such as luminance or length, more precisely than to place it in one of ten steps on a scale (Miller, 1958).

Another reason why psychophysics does not predict stimulus appearance is that appearance changes with the conditions of presentation. For example, the color of an object may appear to change with changes in the surround (simultaneous contrast or assimilation), the illumination level (Bezold-Brucke effect), or the preceding visual experience of the viewer (successive contrast or adaptation).

In spite of these and other limitations, much research is being conducted in the field of psychophysics and considerable progress is being made toward the goal of predicting perceptions. For example, the effect of individual differences is minimized by using the average of the responses of a number of persons with normal vision. A person with a limited vocabulary of color names may be able to correctly identify a hundred hues by using a method of comparing the samples with a set of calibrated colors. Also, experimenters are becoming more sophisticated in recognizing and controlling the major factors that can influence perception in addition to the independent variable.

The relationship of psychophysics to physics and psychology can be illustrated with a comparison of the corresponding terms used for a light source. *Radiance* is a physical term for the intensity of a source which can be measured precisely in watts per unit angle, a unit of energy which does not involve vision. *Brightness* is a psychological term for the appearance of the intensity attribute of the source—there are no standardized units for the measurement of brightness. The corresponding psychophysical term is *luminance*, and the basic unit of measurement is candela per square meter. This provides a quantitative relationship between the source and the response of the average visual system under standardized conditions, but does not specify the appearance of the source to an actual observer. Psychophysical measurements include the following three major categories—threshold, matching, and stimulus–response—each of which will be considered in following sections.

Related terms: limen, matching, physical, psychological, stimulus-response, threshold. *References:* **55** (1—6, 38—41), **76** (60—67), **141, 148** (187—202).

You can correctly predict from the objective data presented in the above filter spectrophotometric absorption curve that since the filter freely transmits the red and green portions of the visible spectrum, viewers will identify the color of the filter as yellow.

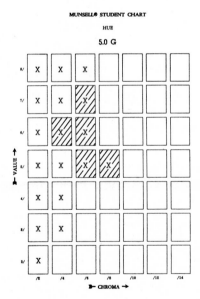

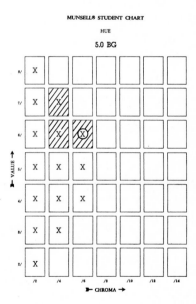

Viewers have little difficulty in correctly identifying a stimulus on the basis of its physical attributes when only a few broad categories having well-known names are involved, such as the four psychological primary hues red, green, blue and yellow, or the three distinctive lightnesses white, gray and black. Increasing difficulty is encountered as the differences between the choices become smaller. Thirteen people were shown a blue-green patch and 2 minutes after it was removed were asked to select the colour from the Munsell Student Set of colors. Eight different colors, shaded in the diagrams, were selected including two hues (blue-green and green), three lightnesses (values) and three saturations (chromas). Five viewers selected the correct color identified with the circled X in the diagram.

3.2　Sensory Scaling

Definition: The use of psychological scales to measure the quality, intensity or magnitude of sensations.

Instruments, such as exposure meters, have taken over a number of measurement tasks involved in making photographs that were formerly estimated by the photographer. It is still necessary, however, for the photographer to make many important decisions concerning the quantity and quality of light in relation to both the subject and the photographic image. *Psychological measurements* of sensations differ from the corresponding *physical measurements* of the stimuli in two important ways. Firstly, a given change in a stimulus in physical units (eg. 0·02 change in print density) may or may not produce a detectable or significant perceptual change. Secondly, a series of equal physical increments or decrements usually do not produce equal perceptual changes. Therefore, if physical measurements are to be significant, they must be shown to have a high correlation with psychological measures.

There are four basic types of sensory scales, which are identified as *nominal, ordinal, interval* and *ratio*; and they are related to four different types of visual tasks. The *nominal* scale is not a measure in the conventional sense, since it consists of categories and its use involves applying appropriate class names to the stimulus objects. In making prints, for example, the categories could be 'acceptable' and 'unacceptable,' and each print made would be placed in one category or the other. However, there is a quantitative aspect to nominal scaling with respect to the position of the cut-off point used for making a decision.

Use of the *ordinal* scale consists of arranging the objects so that the variable under consideration changes progressively from one extremity to the other, as from lightest to darkest. If five color slides are made with varying exposures to test the published film speed, they might be arranged in order of increasing density for the purpose of matching the adopted film speeds with the corresponding slides.

With the *interval* scale, the variable not only changes progressively as with the ordinal scale, but the intervals on the scale are uniform, as on a thermometer. The Munsell color chart (*see* 3.8 Munsell system) was designed to provide equal lightness increments between adjacent patches of gray from black to white, for example. Photographers who take midtone reflected-light exposure meter readings are using a three-tone (two-step) interval scale when they select a subject area that appears to be midway between the lightest and darkest areas in the scene.

The *ratio* scale is used to measure a sensation as a multiple of another sensation, whereas the interval scale measures the difference. A common application of the ratio scale is the visual judgment of lighting ratios on objects being photographed. Luminances of 20 and 10 for the highlight and shadow sides of a subject's face would appear to be equal in contrast to luminances of 200 and 100 since both have ratios of 2 to 1, even though the luminance differences are dramatically different—10 and 100 respectively. Although an exposure meter can be used to determine the lighting ratio, experienced photographers have sufficient confidence in their judgment to set up a 3:1 lighting ratio for a studio portrait, for example, without a meter.

The above direct subjective types of measurements are generally reasonably reliable because the eye is making comparisons between two or more stimuli, whereas the eye functions poorly in attempting to determine the magnitude of a single stimulus on the basis of the strength of the sensation. This latter type of task is best accomplished by establishing a visual match between the unknown stimulus and a calibrated standard. For example, the density of a gray card can be determined by noting the step on a calibrated gray scale that matches the card.

Related terms: interval, nominal, ordinal, ratio, subjective measurement.
References: **54** (47–86), **86** (86–95).

Accept Reject

Above: Nominal scale. Pictures are placed in categories on the basis of specified criteria. Differences within categories are ignored.

Above: Interval scale. Tones of gray are selected that provide equal lightness increments from white to black.

Above: Ordinal scale. Pictures are arranged in order of increasing size without consideration of the magnitude of the differences. A ratio scale can be applied to the same four pictures by estimating that each is, for example, $1\frac{1}{2}$ times as wide as the preceding picture.

Below: Ratio scale. The photographer judged the lighting ratios on the subject to be 1:2 (left), 1:4 (center), and 1:8 (right).

3.3 Variability

Definition: In a repetitive measurement process, the inability to obtain the same value consistently.

In even the simplest kind of experiment, differences in measurements will always be found when the estimation for the same object or event is carefully repeated. For example, with a sufficiently precise instrument the differences in the measured length of one page of this book at different positions along its width can be found, as well as differences in the lengths of different pages.

There are two kinds of measurement variability. One is that attributed to *chance*— meaning those random influences that can neither be isolated nor explained. The second kind of variability is *systematic*, associated with what are called assignable causes—an example being the change in length of a metal ruler with temperature.

In measurements of visual perception, the task is almost incomparably difficult as contrasted with the relatively simple estimation of length. Here there are no measuring instruments analogous to a ruler, and instead reports by observers or secondary data must be relied upon. Even measurements of neurological activity give no direct estimation of the perception.

Consider the sources of variability in a straightforward experiment. An observer is shown a neutral patch at a given level of brightness and is asked to adjust the level of another patch until it appears twice as bright as the first. Once he has performed this task, physical measurements are made of the two patches.

1. All the apparatus—the illuminated patches and the measuring instrument—is subject to random changes in characteristics. Also, such equipment changes over long time periods.

2. Because of chance, varying amounts of the light reaching the observer's eyes will be reflected from them, and varying amounts will be absorbed and scattered within the eyes, causing changes in the amounts of light reaching the retina. Whether or not the light is effectively absorbed by the rods and cones within the retina is a matter of chance.

3. Assignable causes for changes in the response of the observer are the processes of fatigue and adaptation, as well as contrast effects. Every observation is affected by the past history of the observer's visual system and by the nature of the surround.

4. Observers differ among themselves in sensitivity and training.

Even this incomplete analysis of the sources of variability in a simple visual experiment suggests why an observer will make different judgments from time to time, and why different observers will give different results. A similar analysis would apply to observers' judgments of the quality (contrast or color balance) of photographic images.

The task of the experimenter is to find the truth in the presence of such variability. One of his major problems is to recognize the existence of variability in his data and to design experiments that permit measurement of that variability. For example, if a photographer wants to determine his own variability in attempting to match the two fields in a visual densitometer, he would make numerous readings of an area on a negative with a densitometer and record the results. If his readings varied over a range of 0·04 in density, he would in the future assume that differences smaller than this would not represent real differences in the negatives but rather would be attributable to his own perceptual variability.

For a more formal quality control system, a control chart would be prepared with limit lines placed above and below the mean, to represent the variability that can be expected with a process that is operating normally. Only when values fall beyond the limits (or show a systematic change) would the operator assume that other than chance variability is involved and take appropriate action.

Related terms: control chart, matching, paired comparison, psychophysics, quality control, scales, threshold.
References: **26** (8–25), **177** (37–41), **201** (1–31), **202** (135–152).

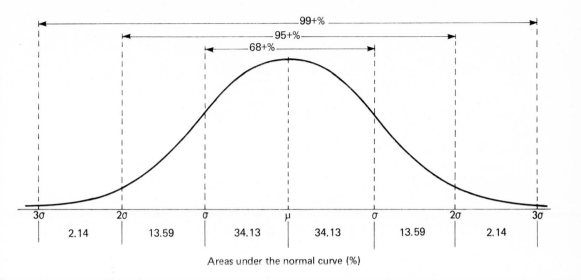

99+%

95+%

68+%

| 3σ | | 2σ | | σ | | μ | | σ | | 2σ | | 3σ |
| | 2.14 | | 13.59 | | 34.13 | | 34.13 | | 13.59 | | 2.14 | |

Areas under the normal curve (%)

Above: The normal or Gaussian curve. Repeated measurements that vary only by chance usually give data that resemble this curve. Most of the results cluster near the center of the symmetrical pattern, near μ which symbolizes the average of the values. Some of the values, however, are considerably different from the average. The standard deviation σ is a measure of the variability of the data. About 68% of the values lie between +1 and −1 standard deviation unit from the peak of the curve.

Below: Results of an experiment in which 52 observers estimated the relative effectiveness with which different wavelengths in the spectrum stimulate the perception of brightness. The solid line is the average value; the broken lines indicate the limits within which the observers reported data. All the observers supposedly had normal vision.

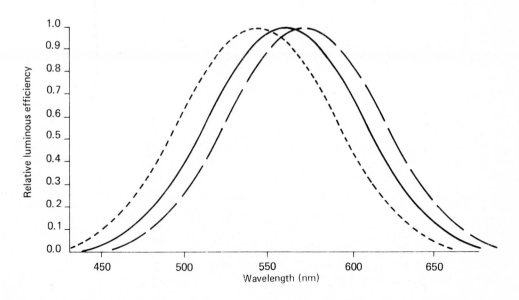

3.4 Threshold

Definition: The minimum value of a stimulus attribute, such as luminance, required for perception.

If the intensity of a small source of light in a dark room is gradually increased from zero, a minimum value will be found where an observer indicates he can see the light. Repetition of the experiment may produce a different value even though every effort is made to keep all conditions the same, due to variability of the observer. If the experiment is repeated many times, a range of values will be found from a low value where the observer never sees the light (0% detection) to a higher value where he always sees it (100% detection). The threshold is a value that has an arbitrarily selected probability of detection, commonly 50%.

In a famous series of experiments by Hecht, Schlaer and Pirenne the intensity, size, hue and position of a spot of light were varied to determine the absolute threshold of detection and limit of sensitivity of the human visual system. The total energy in such a flash of light was found to be approximately 10 quanta. One quantum is an elemental quantity of energy which corresponds to an atom of matter.

Photographers are seldom required to make critical decisions based on perceptions near the absolute threshold. But this position is being approached when a photographer can just barely see the luminous numbers on a timer after being in a darkroom for 30 minutes or longer.

The threshold concept can be applied to various stimulus attributes in addition to the total amount of light as used in the experiment described above. For example, the size can be altered with constant luminance to determine the minimum size that can be detected. The *Snellen* eye test chart is based on the minimum image size of alphabetical letters that can be identified. Movement threshold is the slowest movement that can be detected, which was found in one experiment to be 1–2 minutes of arc per second with a reference grid background and 10–20 minutes of arc per second without the reference grid.

A useful threshold concept for photographers is the *differential threshold* which refers to the smallest difference that can be detected in a stimulus attribute. The differential threshold is also referred to as the *just-noticeable difference (jnd)*. In a visual densitometer, for example, most viewers can detect a density difference of 0·02 in the adjacent fields. Thus, in a print having a maximum density of 2·0 and a minimum density of 0·0, a person ostensibly could detect 100 different tones. Since tones in pictures are not arranged systematically with sharp dividing lines as they are in a gray scale, a larger density difference is required to produce a jnd. The appearance of a continuous-tone image may be approximated with as few as 10 different tones (*see opposite*). Color vision tests are commonly based on the jnd concept. The Farnsworth-Munsell test divides the color circle equally into 85 hues which provide just-noticeable differences between adjacent samples for a person with normal color vision. A person with defective color vision will not be able to discriminate between some of the samples. In color printing, the smallest change available in color compensating filters is 0·025 in density, because the corresponding change in hue or saturation on the print is near the jnd for skilled printers.

Attempts have been made to use jnds for perceptual measuring scales. Although jnds are approximately uniform in terms of density (or log luminance) over a considerable range as indicated by Fechner's law, they require larger stimulus increments near the ends of the scales. This is shown by the fact that a change in density of 0·3 at the dark end of a gray scale, viewed in subdued illumination, appears smaller than the same change in density near the middle of the gray scale.

Related terms: detection, difference limen, difference threshold, Fechner's law, just-noticeable difference (jnd), limen, signal detection.

References: **17** (154–184), **44** (6–26), **86** (88–99).

A tone separation photograph made up entirely of the same 10 densities that appear in the gray scale. Although the differential threshold of the visual system permits you to detect up to 100 different print tones between black and white in a side by side comparison, the original 10-tone photograph is almost acceptable as a continuous-tone image. *Photograph by Robert Stolk.*

-12 E 2 E ◘

-11 Ǝ 2 8

-10 E Ǝ 2

-9 2 3 5

-8 5 3 8

-7 E 8 5

-6 Ǝ E 8

13825
1235E
11523
10832
983E
8BE5
7235
6E38
5BE5
4EB2
3253
2532
1823
0E52
-1285
-2538
-3385
-4235
-5523

The smallest set of characters that can be correctly identified when viewing this alphanumeric test target directly represents a threshold criterion for the viewer's vision. A threshold concept is also used when the target is photographed to establish the resolution of a photographic system. But the image is now examined through a magnifier and the threshold is determined by the merging of the bar elements of the characters due to limitations of the photographic process. *Courtesy of Graphic Arts Research Center, Rochester Institute of Technology.*

3.5 Matching

Definition: A method of specifying stimulus attributes by comparing visually the unknown stimulus with a standard stimulus.

The ability of the visual system to adapt to varying viewing conditions, such as the differences of illuminance between sunlight and moonlight in viewing outdoor scenes, greatly expands the limits of vision, but this same ability also decreases the usefulness of the eye as a measuring instrument. Because the visual system is so inaccurate in measuring the quantity and quality of light it receives, photographers must rely upon a variety of instruments (eg. exposure meters, color temperature meters, printing photometers, densitometers) when accurate measurements are necessary. In situations where a calibrated standard or an unknown stimulus can be varied until the standard and the unknown are perceived as matching, the eye can perform with considerable precision. It is important for the two fields to be located adjacent to each other with a sharp dividing line, and for them to be viewed simultaneously or in rapid sequence.

Densities of areas on a photographic print can be approximated by sliding a calibrated gray scale along each area and selecting the step that provides the closest match. This system is limited more by the large increments between steps on most gray scales than by the ability of the eye to select matching steps. Visual densitometers typically present the two fields simultaneously in the form of a circle surrounded by a ring with a sharp dividing line between them. The accuracy of density measurements made with visual densitometers is comparable to those made with the more expensive electronic instruments.

The task of matching the brightness of the two fields in a visual densitometer is complicated when they are not identical in hue or other visual attributes. Two fields that differ in hue can be matched accurately in brightness if they are presented alternately in the same area at an appropriate rapid rate. A difference in brightness is revealed as a flicker which disappears when the bright-nesses are made to match even though chromatic (hue and saturation) differences remain. The *flicker photometer* was designed for the purpose of matching the brightness of samples that may not match in hue or saturation.

Visual matching is also used for completely specifying the color of a sample rather than just the brightness or lightness attribute. In one system, the unknown is compared with a set of standard colors that vary systematically in hue, saturation and lightness to find the closest match, as in the Munsell system of color notation (*see* 3.8 Munsell System). It is sometimes difficult to select a matching patch when the unknown color is different in texture, sheen or other non-color attribute.

Colorimeters, on the other hand, typically use a variable mixture of red, green and blue light to obtain an exact match of hue, saturation and brightness with an unknown color when the two fields are viewed adjacent to each other through the eyepiece. An exact *visual match* with either of these two systems does not imply an exact *physical match*. Two fields which appear identical to one viewer may appear different to another, and if photographed on color film the two fields may be recorded differently.

Color matching systems greatly reduce the variability of specifying and reproducing colors, and are invaluable in conducting research on color perception. However, they do not relieve the photographer of the responsibility of making subjective decisions about color reproduction. Studies have revealed that even when a colorimetric match is made between the colors in a photograph and the colors in the original scene, viewers may perceive the photograph as an unfaithful reproduction. This is due to the influence of a variety of factors including adaptation, simultaneous contrast and color memory. Neutral subject colors, however, should be matched with neutral tones in color photographs.

Related terms: colorimetric matching, photometric matching.
References: **21, 55** (196–204), **57** (145–154).

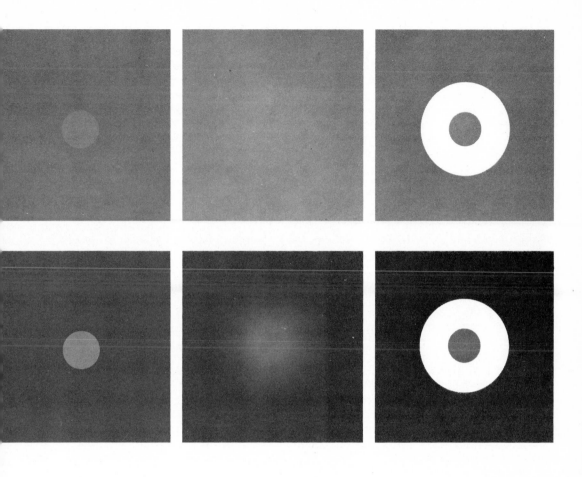

The difference in density between the central and outer areas is the same in all three figures in each row, but larger in the bottom row. It is easiest to detect this difference when the areas are adjacent to each other and are separated by a sharp line.

The density of an area in a picture can be determined with reasonable accuracy by matching it with a step on a calibrated gray scale. The arrow identifies the step that matches the road most closely. *Photograph by Lori Stroebel.*

3.6 Paired Comparison

Definition: A method for determining the consistency of viewers in their perception of differences between pictures in a set of three or more pictures shown two at a time.

Students sometimes refer to multiple-choice test questions as multiple-guess questions. When they are not positive about the correct answer they select the answer that seems most plausible or they may simply guess. A similar thing happens when viewers are required to arrange pictures in order on the basis of differences in an attribute such as lightness or beauty, or when they are required to determine if all of the pictures in a set are identical or not. The smallest difference that a viewer can detect between two stimuli is known as a *jnd* (just-noticeable difference). Because a viewer's responses at this level are not consistent, the jnd is determined by systematically varying the difference, presenting the stimuli many times, and selecting the value that the viewer detects 50% of the time. This procedure is often impracticable with pictures because of the large number of presentations required, the difficulty of measuring and systematically varying the differences, learning effects from repeated presentations, and other reasons.

The simplest situation that is appropriate for the paired-comparison method involves three pictures. Assume that you want to determine if small differences between three supposedly identical prints are detectable to a viewer. The prints are shown to the viewer two at a time in all three possible combinations, A–B, B–C and A–C; and he is asked to indicate his preference for each pair. If he selects A over B, B over C, and A over C; his choices are consistent as would be expected if detectable differences existed. However, if he reverses the last pair, and selects C over A, his choices are inconsistent, a combination referred to as a *triad*. Another viewer shown the same three prints could be consistent with a different order of preference. If the two viewers were asked to select the lighter of each pair of prints and both viewers were consistent in their three choices, you would expect the orders to be the same.

But if they were asked to select the more attractive print of each pair, both viewers could be consistent with different orders of preference because one person simply likes lighter or darker prints than the other. Thus the paired-comparison method is especially suitable for situations involving subjective evaluations.

Although subjective evaluations are not right or wrong, in the sense that the responses can be compared with physical measurements, it may be important to know whether or not the evaluator is using a set of criteria for his choices. To illustrate, assume that each of three print judges is asked to rank in order five prints selected in a preliminary judging, for the purpose of awarding prizes. It may turn out that all three lists are different, and a paired-comparison analysis may reveal that judges one and two had no triads (inconsistencies) whereas judge three had several. This would indicate that the first two judges were using stable criteria, though not the same criteria, but the third judge was making at least some choices because he was required to, rather than from real preference. If an inexperienced person is being considered for a subjective decision-making position, that of a picture editor, for example, the paired-comparison choices from an appropriate sample of pictures should not only be free of triads, but the choices should correlate well with those of a qualified expert.

Related terms: nonparametric statistics, subjective judgement.
Reference: **54** (51–54).

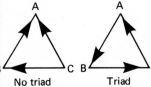

The three prints (*top* A, *bottom left* B, *bottom right* C) were shown to viewers two at a time in all three combinations and they indicated their preferences for each pair. The choices of the first viewer are consistent, whereas those of the other two viewers are not. The arrows in the diagrams point to the preferred print for each pair. *Photographs by Steve Diehl, North-South Photography.*

87

3.7 Viewing Conditions

Definition: Factors associated with the process of looking at a pictorial or other stimulus which if altered may affect the perception of that stimulus.

Some portrait photographers have found that they receive fewer complaints from their customers when they make prints a little lighter than they judge to be correct. The explanation offered is that the customers often display the prints in areas where the light level is low. In recent years considerable effort has been made by several professional organizations to establish standard viewing conditions for a variety of situations. Such standards generally include specifications for the quality of the illumination, the illumination level, the direction of the light, and the nature of the area surrounding the picture or other stimulus.

Although adaptation by the visual system reduces the change in appearance of a picture, eg. as the light level changes, it is not completely successful in compensating. Ralph Evans observed that the total luminance scale of perception decreases from approximately 100:1 to 20:1 when the illuminance is decreased from 100 footcandles to 2 footcandles. Thus, there is a real advantage in using high light levels for photographic print displays—providing the same high level is used for judging print quality during the production stage. This effect was demonstrated dramatically with 9×11 m (29×36 ft) color prints on the Kodak Photo-Tower at the 1964 New York World's Fair. Each print was illuminated with $12 \times 20\,000$ watt lamps which gave the prints the appearance of transparencies.

Adaptation should allow a good print made for normal room illumination to appear satisfactory at somewhat higher and lower levels, but at very high levels the 'blacks' in the print will appear gray and at very low levels detail will be lost in the shadow areas. At least one standard recognizes that different levels of illumination are appropriate for different visual tasks, such as judging uniformity among production prints as distinct from judging print quality for display purposes.

In general, the photographic images that come closest to matching the visual effects produced by original scenes are color transparencies strongly illuminated from behind with the area around the transparency masked off and viewed in a darkened room. As the room illumination is increased, the transparency appears to lose contrast and saturation. It is impossible to make a reflection photographic print or photomechanical reproduction from a transparency that matches the transparency viewed under optimum conditions. Therefore a standard for this situation specifies that the transparency shall be surrounded by a controlled illuminated area to purposely degrade the visual image.

To minimize variations in the appearance of photographs due to the color quality of the illumination, viewing lights having a correlated color temperature of 5000 K are generally recommended. However, it is best to use the same quality of illumination to judge photographs as will be used later for display, which may include incandescent lamps with correlated color temperatures as low as 3000 K. On the other hand, a correlated color temperature of 7500 K is specified in graphic arts where the higher discriminability of the yellow printer produced with the bluer light is required for judging color uniformity. Light sources must also have an appropriate balance of output in the red, green and blue regions; a characteristic indicated by a high *color-rendering index* (85–100).

The quality of projected images of slides and motion pictures generally increases with the illumination level as with reflection prints and transparencies. Ambient room light has a degrading effect on projected images, corresponding to surface reflections on prints and transparencies, although the newer high-reflectance projection screens produce good images within a limited viewing angle with the room lights on.

Related terms: adaptation color-rendering index, correlated color temperature, flare, spectral energy distribution, toner reproduction.

References: **5, 6, 7, 56** (158–161, 330–331), **174** (55–57, 109).

Above: Each of the five large reflection color prints on the Kodak picture tower at the New York World's Fair received supplementary illumination from banks of lamps totalling 15 million candlepower. This raised the illuminance well above that provided by daylight alone and gave the prints the vivid appearance of transparencies.

Below: Three reproductions of the same photograph and gray scale illustrate the importance of positioning the illumination to avoid surface reflections when copying and viewing. The glare reflection (center) is a direct reflection of the light source. The veiling reflection (right) is a reflection of a white wall. 'Nonglare' glass used for some framed photographs has a roughened surface which prevents glare reflections but produces a veiling reflection that reduces image contrast.

3.8 Munsell System

Definition: A method of color specification and measurement—the system is based on an array of samples arranged in logical perceptual order, each of which is designated by three numerical values.

Many different sets of pigment samples have been constructed, such as those seen in stores to assist a customer to select a desired paint. What makes the Munsell system unique is its basis of *equal perceptual* differences between adjacent samples.

The system recognizes that perceived color has three fundamental aspects, called *hue*, *value* and *chroma*. 'Value' is the term used in the Munsell system for the visual characteristic of lightness, and 'chroma' for saturation.

Different hues are arranged in a closed curve that approximates a circle, the *major hues* being placed in the following sequence: red, yellow-red (orange), yellow, yellow-green, green, blue-green (cyan), blue, purple-blue, purple (magenta), red-purple. The major hues are equally spaced around the hue circle. This is because the samples are chosen so as to appear equally different from the adjacent hues when they are observed by persons with normal color vision under a standard light source. The hue circle is thus divided into ten sections, one for each of the major hues, and each of these is divided into ten sub-divisions identified numerically. Each major hue is placed at the center of a primary division of the hue circle and designated, for example, as 5G (for green).

The neutral colors (those having lightness but no hue) are ordered from white through a series of grays to black, each gray being perceptually equally different from its neighbors. The set of neutrals is numbered from 0 (a completely nonreflecting ideal black) to 10 (an ideal white having 100% reflectance) in equal increments. Such a scale is similar to the Kodak reflection gray scale or to the zone system print value scale, but differs in the spacing of the sample patches. Every non-neutral sample can be visually matched for *value* (lightness) with one of the samples in the set of grays, and thus assigned the same numerical designation for this aspect of perceived color.

For every color of fixed hue and value, there exists a set of colors differing in the third aspect of color, i.e. *chroma* (saturation). In the Munsell system, samples that differ in chroma are placed on a scale from 0 for a neutral having no hue or saturation, to 16 which represents the most-saturated color obtainable with the pigments used to prepare the samples.

Color space in the Munsell system is therefore three-dimensional and based on a sphere as the model. Different hues are arranged as around the equator of the earth, the neutral colors as at different positions on the axis, and chroma as changing along a line from the axis toward the boundary of the color solid.

In use, the Munsell system relies on a book of colored samples. Each page displays samples of constant hue that differ in value and chroma. A given sample may be identified, for example, as 6R 8/4 (H V/C). 6R specifies a slightly-yellowish-red; 8 a very light value; 4 a comparatively low chroma. Such a sample is therefore a pink. Skilled users of the system can interpolate between samples to three-digit values, such as 8.42G 5.17/3.93. Samples are available in either a glossy or matt (dull) surface.

The Munsell system thus offers a means of measuring color in its perceptual aspect. It is the only internationally accepted method of color measurement in this sense.

Related terms: brightness, chroma, CIE, hue, Hunter, lightness, Ostwald, saturation, value.
References: **21**, **36** (167–169), **55** (215–216, 233), **169** (126–129).

The Color Tree

Above: The Munsell color tree has a vertical trunk which represents a scale of *values*, branches which represent different *hues*, and leaves extending along the branches which represent *chromas*. The hues change as you walk around the tree, the values increase as you climb up the tree and chromas increase as you move out along the branches. (From *Munsell, A Grammar of Color* edited by Faber Birren © 1969 by Litton Educational Publishing. Inc. Reprinted by Permission of Van Nostrand Reinhold Co.)

TEN HUES AT STRONG CHROMA

SIX REDS FROM GRAYISH TO STRONG

NINE GRAYS BETWEEN BLACK AND WHITE

Munsell student chart showing 10 different hues, 9 values and 6 chromas.

3.9 Brunswik Ratio

Definition: A mathematical designation of constancy of a perception of a stimulus attribute with specified changes in the viewing conditions.

Constancy implies that the perception of the attributes of an object does not change even though the viewing conditions change— for example, the perceived size of an object remains constant as the distance between the object and the viewer changes, the perceived lightness of an object remains constant as the illumination level changes, and the perceived hue or chromaticity of an object remains constant as the color quality of the illumination changes. Although constancy can hold with a considerable variation of physical viewing conditions, constancy is often found to be only partial or approximate. Even psychological factors, such as asking the viewer to assume a certain attitude, e.g. an analytical attitude, toward some aspect of the experimental situation, may significantly alter the completeness of constancy.

Although a person may indicate less than complete constancy by noting that the object appears to change in size or lightness, for example, measurement of the change requires some ingenuity on the part of the experimenter. With constancy, a medium gray card will be perceived as an unchanging medium gray regardless of the illumination level. Constancy tends to decrease when the card is viewed in front of a black background and the card is illuminated by a concealed variable spotlight.

One method of measuring the perception is for the viewer to select the step on a gray scale under standardized illumination that is thought to best match the reflectance of the gray card under variable illumination. As illustrated in the top figure opposite, if the illuminance on the 18% reflectance gray card on the left is one-half the illuminance on the gray scale on the right and the viewer is able through constancy to compensate for this difference, he will select the 18% reflectance step on the gray scale as a match even though its luminance is twice as large. The Brunswik Ratio in this situation is 1.0.

The formula for the Brunswik ratio is

$BR = \dfrac{S-S'}{L-S'}$ where S is the luminance of the selected gray scale step (100)
S' is the luminance of the gray card (50)
L is the luminance the gray card would have if it were placed on the right side (100).

Therefore $BR = \dfrac{100-50}{100-50} = 1 \cdot 0$, which repre-

sents perfect constancy. If, on the other hand, the viewer is unaware that the illumination is not the same on the two sides he might select the 9% reflectance step of the gray scale as a match because it has the same luminance (50) as the gray card. The Brunswik Ratio now

becomes $\dfrac{50-50}{100-50} = 0$, which represents a

complete absence of constancy. Any Brunswik ratio less than 1 represents underconstancy, or insufficient compensation for the difference in illumination.

If the viewer is misled into believing that the lighting ratio between the two sides is higher than the actual 1:2, he may overcompensate and select a step on the gray scale having a reflectance of more than 18%. The 36% reflectance step, with a luminance of 200, would produce a Brunswik ratio of 3·0. Any number larger than 1 represents overconstancy.

Corresponding values can be substituted in the basic formula to determine the Brunswik ratio for other object attributes such as hue, saturation and size. The bottom figure on the opposite page shows the results of a size judgement experiment by Holway and Boring, in which depth cues could be systematically eliminated. The solid line indicates that the size of the test target was correctly estimated at various distances, which corresponds to complete constancy, or a Brunswik ratio of 1.0. As the depth cues were eliminated, the slope of the line decreased, corresponding to underconstancy and a decrease in the Brunswick ratio.

Related terms: constancy, overconstancy, partial constancy, psychophysics, Thouless ratio, underconstancy.
References: **36** (82–85), **108** (21–37), **119** (322–331).

Above: Various styles of resolution targets used as a logo for *Photographic Sciences Corp. Webster, New York.*

Above, left: An alphanumeric target for estimating resolution. It also provides information about recognizability and legibility. *Graphic Arts Research Center, Rochester Institute of Technology.*

Left: Macbeth color-rendition chart (color-checker) for judging the color fidelity of color reproduction systems.

Below: The numerical values beside each of the ten gray patches are the reflection densities of the original target. By comparing similar measurements of the patches as reproduced, a tone reproduction curve may be plotted.

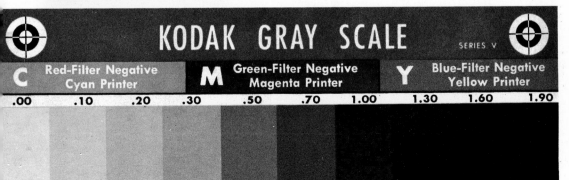

KODAK GRAY SCALE

SERIES V

C Red-Filter Negative Cyan Printer	M Green-Filter Negative Magenta Printer	Y Blue-Filter Negative Yellow Printer

.00	.10	.20	.30	.50	.70	1.00	1.30	1.60	1.90

3.11 Stimulus–Response

Definition: The input–output relationship of the visual system, such as increased detection of a dim light as the luminance is increased.

Stimulus refers to physical energy which is capable of producing a reaction in the viewer. Light is the general label for all stimuli for the visual system, but to be of value in visual perception studies it is necessary to specify the attributes such as luminance, size, hue, configuration and position of the stimulus. The fact that an object is too far away to be seen, for example, does not disqualify it as a stimulus since it is capable of being seen under the proper conditions—whereas radio waves, which are never seen, cannot be considered as visual stimuli.

Response refers to the effect produced in the viewer by the stimulus and it may vary from a specific effect that can be measured objectively, such as a change in the firing rate of a neuron in the optic nerve, to a broad subjective effect such as a change in mood of a person as a result of viewing a photograph. It is not necessary for a viewer to be aware of a stimulus for a response to occur. Stimulus–response relationships can take place at an unconscious or subconscious level where the perception can be brought into consciousness only with subsequent procedures such as hypnosis.

Not all activity in the visual system should be attributed to a stimulus–response relationship as there is considerable spontaneous activity which can serve to cover up a trivial signal which should be ignored. False responses (hallucinations) can be produced by a number of factors such as a physical jolt, drugs and dreaming. Of course, a given stimulus should not be expected to produce the same response every time it is presented due to a variety of reasons including adaptation and fluctuations of attention.

Much of the research in the field of visual perception is concerned with finding relationships between stimulus and response, usually by making controlled changes in the stimulus and noting the corresponding changes in the response. The relationship between stimulus and response can be presented in a variety of forms. An especially useful form is the input–output graph. As the intensity of a very dim light source (the input) is increased any of a number of visual output variables can be measured such as the probability of detection by the viewer, the probability of correct identification of the hue, variation in the time required for the viewer to respond and variation in the resolving power.

The first curve represents the relationship between the intensity of a light source and the probability of detection over a range of 0 to 100%. The curve bears a close resemblance to the adjacent characteristic curve for film which shows the change in density with increasing log exposure. Since the unexposed film contains millions of light-sensitive grains this also represents a probability situation with respect to the proportion of grains that will become developable at each level of exposure. Other visual functions, such as the variation in visual acuity with luminance of the test target, are represented by similar appearing curves. But this is not a universal shape as revealed by the distinctively different curve for the brightness response of the eye to equal amounts of radiant energy throughout the visible spectrum. The above examples of stimulus–response curves are all based on laboratory experiments. A practical application of this relationship would be to plot the number of viewer rejections of prints in response to systematic variations in density (or color balance) from a norm in establishing a quality control system for a print lab.

Related terms: input–output, cause–effect, psychophysics, sensory scaling, subliminal perception.
Reference: **76** (60–62).

The S-shape curve (*above, left*) produced by plotting the intensity of a light source against the probability of detection is typical of a number of visual functions. It also resembles the density-log exposure characteristic curve for film (*above, right*).

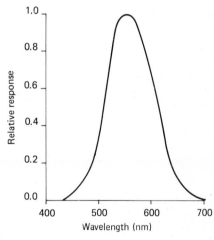

Above: Plotting the brightness response of the eye to equal amounts of radiant energy throughout the visible spectrum produces a distinctly different curve.

Left: When a person views a pictorial stimulus, such as a projected slide or motion picture, the response can be primarily of an affective, a cognitive, or a psychomotor nature, or a combination. The measurement of such responses is less straightforward than the measurement of responses to variations of luminance, hue and other basic attributes of light stimuli.

3.12 Modulation Transfer Function

Definition: A graphical display of the manner in which an optical or other imaging system records spatial waves of varying frequency.

A wave is a disturbance of some medium that varies with time. The concept of a wave has been extended to describe the variation of luminance within a scene or test object. For example, a resolution target consists of dark bars and light spaces that vary systematically in width. A plot of luminance versus position across the target is called a 'square wave.'

An alternative target changes gradually in luminance rather than abruptly. It is called a 'sine wave' target because at any point the luminance is proportional to the sine of the angle that measures position on the wave, a complete cycle being 360°. Two numbers suffice to describe completely the sine wave target or its image—the number of waves (cyclic elements) per unit distance, usually millimeters, and the height of the peaks in the trace of the target. The first of these numbers is called the *frequency* and the second the *amplitude.*

The ratio of the amplitude in the image to that in the target is called the *modulation*. It is an objective measure of system performance, unlike resolution which involves observer judgment and is therefore to some extent subjective. A perfect recording system would reproduce all spatial frequencies perfectly, giving a response of 100% no matter how small the wave element. The result would be a plot appearing as a horizontal line at 100% modulation and would be analogous to the flat response of a perfect sound reproduction system tested at all possible frequencies of sound.

In fact, no imaging system is perfect, and all such systems are described by modulation transfer functions that are other than flat. A typical photographic system gives a plot showing that it reproduces faithfully only low spatial frequencies. Thus it reproduces only coarse elements correctly and steadily decreases in fidelity as the spatial frequency increases.

The transfer function of the normal human eye shows a deterioration in response both for very coarse as well as very fine image elements. Such a plot indicates that the visual system has a bandpass function, like a sound system that has a rolloff in the bass as well as low fidelity for very high sound frequencies.

The reason for the failure of any system to respond adequately to very high frequencies is almost obvious. Every system has small-scale limitations associated with the minimum size of the recording sensors. In silver halide photography, the sensors are the grains, and their size limits the high-frequency response. Dye-forming photographic materials, such as diazo, have a high-frequency response limited only by the sizes of the molecular aggregations, and may extend to 2000 cycles per mm. In the eye, the high-frequency limit is in part determined by the sizes of the cones and the scanning behavior of the eye (nystagmus).

The lack of fidelity in the human visual system for low frequencies is more difficult to understand. It may result from neurological inhibition effects that decrease edge enhancement as the peak-to-valley distance increases in the target.

An advantage in the use of the sine-wave test target over others is that any luminance distribution, expressed as a complex wave form, can be conceptually built up from a set of sine waves of various frequencies and amplitudes. Therefore, a test of a system with such a target in principle yields all the information needed to understand the performance of the system with any other target or scene.

Related terms: acuity, resolution, sharpness.
References: **37** (106–114), **44** (342–360), **119** (500–521).

Above: A portion of a resolution test target which consists of sets of bars of systematically varied widths.

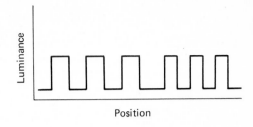

Position

Above: A small aperture trace across a resolution test target showing the abrupt changes in luminance with position.

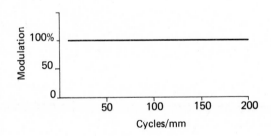

Above: A sine wave test target used in measuring modulation.

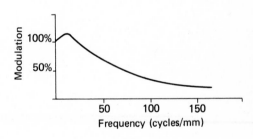

Position

Above: The luminance changes gradually with position.

Cycles/mm

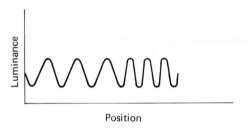

Frequency (cycles/mm)

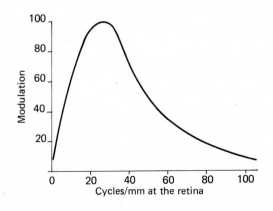

Cycles/mm at the retina

Above, left: The modulation transfer function of a perfect optical system. The amplitude of the target is correctly represented in the image, for spatial waves of every frequency.
Above: The modulation transfer function of a typical photographic system. Only waves of low frequency are correctly reproduced.

A modulation transfer function of a normal human eye, showing a loss of fidelity for both very coarse and very fine elements in the target. Like other measures of visual system performance, the results vary with viewing conditions and the state of adaptation of the observer, as well as from one observer to another.

3.13 Information Theory

Definition: The basis for estimating quantitatively the content of a communication.

Methods of communicating are almost innumerable. They include written and spoken languages, codes, tape and disk records, and the visual arts including photography. A *message* is a set of symbols—letters or sounds, or in photography a visual display of tones of silver or dye—intended to communicate meaningfully from one person to another. Informatiun theory provides a mathematical technique for expressing how much is communicated in a given message of whatever kind.

The unit of information is the *bit*, the amount of information contained in a message when there are only two possibilities, as in the fall of a coin. For a set of N independent equally probable messages, the amount of information contained in each message is $\log_2 N$. The value can be found by dividing the common logarithm of N by the log of 2, which is approximately 0·3.

For example, if every letter of the English alphabet were used with equal frequency, the amount of information contained in each letter would be $\log_2 26 = 4·7$, and in each five-letter word $5 \times 4·7$, or 23·5 bits. There would then exist $2^{23·5}$ different five-letter words, about seven billion. Such a count would include combinations such as AAAAA and ZXYYY! Obviously, the number of real five-letter words is far smaller than that calculated on the assumption of equal probability of occurrence.

By a similar method it is possible to estimate the amount of information in a photograph. If the eye can detect 64 different levels of gray in a small area of a print, each such area contains 6 ($\log_2 64$) bits. For a handheld photograph, visual resolution is about 10 lines per mm, and thus there are about 100 different spatial elements per mm². In a 20×25 cm (8×10 in) photograph there are about 5,000,000 such elements and in each such photograph 30,000,000 bits of almost unimaginable $10^{9,000,000}$

This approach, like that used in the alphabet example, is overly simplistic. It counts as 'pictures' those that are uniformly gray except for the presence of a single slightly different tiny spot somewhere in the field, and thus grossly overestimates the amount of information in any image. The flaw in the calculation is as before the assumption of equal probabilities of occurrence of each element, which is for photography certainly false. A communicative photograph is other than a random array of spots, as the rules of composition suggest.

Furthermore, the amount of information in a visual image is by no means a sufficient measure of the significance attached to the picture, which is strongly influenced by the subject matter of the photograph, and by the experience and 'set' of the viewer. On the other hand, a photograph has an information content that is the same for all viewers regardless of the image.

Despite its deficiencies, information theory provides a useful method of comparing different techniques of data recording, and serves as a basis for designing systems for information handling. Criteria of excellence are the amount of information that can be recorded per unit volume, and the rate at which information can be recorded and retrieved. By these criteria, the human nervous system is without a peer, and photographic film is superior to any other artificial device.

Related terms: coding, figure-ground, gestalt, information processing, redundancy, signal-noise.

References: **86** (159–161, 191–196, 222–224), **138** (148–156), **156** (8–25), **186** (257–262).

Left: A comparison of various information storage systems. The length of each bar is proportional to the product of: total bits × bits/cc × bits/sec.

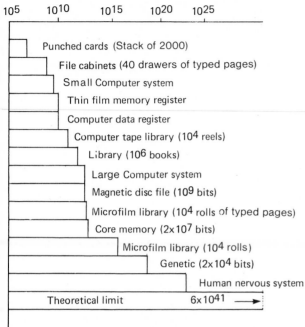

| 10^5 | 10^{10} | 10^{15} | 10^{20} | 10^{25} |

Punched cards (Stack of 2000)

File cabinets (40 drawers of typed pages)

Small Computer system

Thin film memory register

Computer data register

Computer tape library (10^4 reels)

Library (10^6 books)

Large Computer system

Magnetic disc file (10^9 bits)

Microfilm library (10^4 rolls of typed pages)

Core memory (2×10^7 bits)

Microfilm library (10^4 rolls)

Genetic (2×10^4 bits)

Human nervous system

Theoretical limit 6×10^{41} ⟶

A B C

Above: According to the principles of information theory, each of the three rectangles above contains the same amount of information. In terms of viewer interest, however, B is more attractive than A and C is more attractive than either of the others.

Below: The eye continually searches out areas of change within a photograph . . . changes in line, tone, color. Such areas are high information areas. *Photograph by Bill Lampeter.*

3.14 Pupillometrics

Definition: The measurement of pupil size as related to mental and emotional processes.

It is common knowledge that an increase or decrease of the pupil size automatically results when the light level decreases or increases. Physiologically, such a reflex is controlled by the autonomic nervous system in a way roughly analogous to the automatic diaphragm control of a camera. In a sense, eye and camera function automatically in adjusting pupil size or *f*-number to the luminance level of the scene. Of course, the actual mechanisms are much different.

A very interesting aspect of the eye, one of many that distinguishes it from a naive comparison to a camera system, is the automatic change in pupil size resulting from variations other than light intensity. Specifically, there is a high correlation between a person's pupil size and his emotional response to visual stimuli. When something is seen which arouses a person, pupil size tends to increase. It decreases when something unpleasant is shown. This can be easily demonstrated by carrying out a simple experiment, described by E. H. Hess. Select a variety of photographs and include a few which you feel are emotionally charged. Shuffle them so that you are unaware of the sequence. Hold them above your eyes facing the person who will be viewing the pictures. Do this in such a way that you can clearly see the person's pupils. When you note a change, take a look at the photograph that was shown. A sexy picture will cause pupils to dilate, while an unpleasant picture, such as bloodied bodies, sharks, and snakes will cause the pupil to constrict. This decrease in pupil size, due to aversive stimuli, is probably part of our perceptual defense mechanism.

Automatic changes in pupil size are not limited to the visual sense. Changes can also be observed when a person is smelling, tasting or hearing something pleasant or unpleasant. Such mental activities as intense concentration will also cause changes in pupil size.

Surprisingly enough, this pupil size phenomenon has been known for a long time and has, for example, been effectively used by magicians, card sharks and Chinese jade merchants. Dilation or constriction of pupils is a direct and reliable means of nonverbal communication. It tells your friend or adversary that something has triggered you and changed your mental or emotional state.

A photographer could make use of pupillometrics to obtain a nonverbal response to his photographs. Any change in pupil size will indicate that the picture has some impact. It will not however, as advertisers have found out after spending millions of dollars on research in this area, tell whether the person likes or dislikes the advertisement or photograph.

The use of electronic flash, in preference to bright studio lamps, provides a low-level modelling light necessary for large pupils. Portrait photographers are probably aware that large pupils in portraits are more interesting than small pupils and that they tend to provide a more romantic appearance. Women as far back as the Middle Ages were aware of this and some would use the drug belladonna (beautiful woman) as a cosmetic to dilate their pupils. Perhaps one of the reasons dinner by candlelight is considered romantic is that the low-light level produces larger pupils.

Related terms: perceptual defense, pupil size, subliminal perception.
References: **102** (46–54), **103** (110–119), **149** (169–172), **175** (55–59).

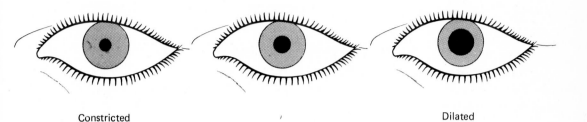

Constricted Dilated

Above: Pupil size automatically changes with interest in the visual stimulus, independent of light level. For a given light level, the pupil size is shown in the middle picture. If something pleasant is seen, the pupil increases in size, an unpleasant sight causes a decrease.

Below: Two photographs printed from the same negative are identical except for pupil size. The pupils in the picture on the left were retouched and made larger. A total of 80 male and female subjects were shown these pictures and 71% of them preferred the portrait with the larger pupil size. There was no difference between male and female preferences. Only two subjects were aware of the different pupil sizes when they made their choice. *Photograph by Richard Gicewicz.*

3.15 Semantic Differential

Definition: A special rating scale used to measure the associational or implicit meanings of words and pictures, apart from their primary explicit meanings.

One way to measure a person's subjective response to a word is to use a semantic differential scale which consists of a series of bipolar adjectives. Given a word such as *photography*, for example, the person is asked to rate the word on a scale between each pair of oppositional adjectives. The instructions specify that the closeness of the mark to each of the two adjectives indicates the closeness of the relationship, with the middle position being neutral. In the example given below, the rater felt neutral about whether the word *photography* was bad or good, but felt that it was slightly complex and pleasant, moderately intimate, strong and active, and very meaningful.

Photography

Bad	_:_:_: X :_:_:_	Good	
Simple	_:_:_:_: X :_:_	Complex	
Pleasant	_:_: X :_:_:_:_	Unpleasant	
Intimate	_: X :_:_:_:_:_	Remote	
Strong	_: X :_:_:_:_:_	Weak	
Active	_: X :_:_:_:_:_	Passive	
Meaningful	X :_:_:_:_:_:_	Meaningless	

Such ratings do not tell what the word photography means in a dictionary sense, but rather how the rater feels about the word. The ratings indicate the connotative meaning rather than the denotative meaning. Thus, the words photography and painting could receive similar ratings for all of the adjective pairs even though they have distinctly different definitions. If each bipolar adjective is assigned numbers from 1 to 7 then responses can be quantified and statistical analyses such as averages, variability, correlations and analysis of variance can be made.

For analysis purposes, bipolar adjectives can be classified according to three major dimensions:

Dimension		Scale example	
Evaluation	Good	__ __ __ __ __ __ __	Bad
Potency	Strong	__ __ __ __ __ __ __	Weak
Activity	Active	__ __ __ __ __ __ __	Passive

These three factors—*evaluation, potency* and *activity*—represent important aspects of connotation in a wide variety of languages.

Although the semantic differential has been used mostly to determine connotative meanings of words, it has also been used to determine the meanings associated with paintings and photographs. In a study to find out if there was a difference between the meanings a group of artists and a group of nonartists gave paintings, it was found that meanings for representational paintings were similar for both groups but quite dissimilar for abstract paintings. This suggests that artists have worked out and agreed upon a system of evaluation of abstract paintings.

A study of the effect of captions on photographs revealed that the captions could shift the meaning associated with a picture. For example, on a scale of happy to sad, a scene of a couple at an airline terminal captioned *Reunion* would be marked happy while the one captioned *Parting* would be marked sad. Captions which were quite the opposite of the pictorial content, however, did not alter the judgment of the photograph.

A comparison study of the reactions of viewers to outdoor scenes and photographs of those scenes revealed that color transparencies, color prints and on-site responses to the actual scene were similar. If, however, the photographs did not include the entire scene but only selected portions of the environment, the responses were significantly different. Some differences were also noted between transparencies and prints for some of the adjective pairs.

Related terms: affective, attribute, Rorschach stimulus—response, synesthesia, thematic apperception.
References: **38** (71–79), **163** (68–70, 83, 290–295, 313–314).

To obtain experience in the application of the semantic differential approach to the evaluation of a picture, look at the photograph above and use the scales below to indicate what it means to you. Place an X in the middle of the scale for a neutral response or toward one of the adjectives to indicate the closeness of the relationship. The strongest feelings are represented by the two outer positions. *Photograph by Bill Lampeter.*

hot	____	____	____	____	____	____	____	cold
pleasant	____	____	____	____	____	____	____	unpleasant
vibrant	____	____	____	____	____	____	____	still
repetitive	____	____	____	____	____	____	____	varied
happy	____	____	____	____	____	____	____	sad
chaotic	____	____	____	____	____	____	____	ordered
smooth	____	____	____	____	____	____	____	rough
superficial	____	____	____	____	____	____	____	profound
passive	____	____	____	____	____	____	____	active
simple	____	____	____	____	____	____	____	complex
relaxed	____	____	____	____	____	____	____	tense
obvious	____	____	____	____	____	____	____	subtle
serious	____	____	____	____	____	____	____	humorous
violent	____	____	____	____	____	____	____	gentle
static	____	____	____	____	____	____	____	dynamic
emotional	____	____	____	____	____	____	____	rational
bad	____	____	____	____	____	____	____	good

The above is an example of a semantic differential instrument which could be used to measure connotative meanings of photographs to determine, for example, if a picture satisfies the objectives for which it was made or if it is suitable for use in a certain context.

3.16 Subliminal Perception

Definition: A response to a stimulus that is below the level required for conscious perception. In vision, a stimulus may produce some impression on the viewer even though there is no recognition or even detection at the conscious level.

Much of the experimental work on subliminal perception makes use of a briefly presented word or picture at a luminance level just below the threshold of a 'conscious' stimulus. There is considerable evidence that people can be affected by stimuli they are unaware of. In some cases, the subliminal stimulus has a greater effect on a person than a supraliminal (above the threshold of consciousness) stimulus, as evidenced in dream analysis and REM (rapid eye movement) studies.

The subject of subliminal perception has a long history and is not without controversy. To begin with, the two words as they are ordinarily understood are contradictory when used together. Perhaps it would be better to use the term 'subliminal reception' or 'threshold regulation,' as Dixon has suggested, but subliminal perception has become part of our everyday vocabulary. Determining the threshold or the boundary between liminal and subliminal stimuli is also a problem. Recent work in signal detection theory reveals that the threshold is not a fixed position, but rather an arbitrary point within a range of variability. This threshold becomes statistically determined, based on variables such as the duration, luminance, size, sharpness and contrast of the stimulus, and the personality of the viewer. This was demonstrated in the film *The Exorcist*, when a frame or two of a death mask appeared briefly on the screen. Many were affected by it but few realized it had been presented.

Historically, Aristotle's theory of dreams implies the existence of stimuli that affect dreams, even though the stimuli are below the level normally required for conscious perception. Helmholtz observed that visual stimuli not consciously perceived could later emerge in subsequent afterimages. Purkinje observed a similar effect in con-nection with hypnotic imagery. That subliminal information received during waking hours could affect subsequent dream experiences was first shown in 1917 by Poetzl, a contemporary of Freud. He postulated the law of exclusion—information not reported after a stimulus is presented can occur in the subject's dream imagery.

In the late 1950s, there was fear that subliminal techniques were being used commercially. A firm claimed that the subliminal presentation of the words 'Eat Popcorn' and 'Drink Coca-Cola' on a movie screen increased sales. Wilson Bryan Key, in his books *Subliminal Seduction* and *Media Sexploitation*, takes the position that many advertisements contain embedded subliminal cues to influence the viewer.

There are mounting experimental data to support the concept of subliminal perception. Sperling, in 1960, demonstrated that the human visual system can .extract more information from a brief visual display than is evident from an immediate report. Haber, in 1970, showed that the limits on handling pictorial material are not determined by perceptual capacity but by how well the information is entered into short-term visual storage. Studies in backward masking and perceptual defense also support subliminal perception. Perceptual defense theory assumes that a person is able to ward off an anxiety-arousing stimulus without actually perceiving it at a conscious level.

Of significance to the photographer is the fact that the elements of a photograph not consciously perceived may have a profound influence on the viewer. Non-distinct imagery and symbolisms can be very effective. Peripheral placement of information can also be perceived subliminally. What is consciously seen as figure may be influenced by a subliminally perceived ground.

Related terms: law of exclusion, Poetzl effect, subception effect, subconscious, threshold, unconscious.
References: **49, 124, 149, 151** (319–327), **173**.

86 PROOF BLENDED SCOTCH WHISKY — RENFIELD IMPORTERS LTD. N.Y.

Look at this advertisement (*New Yorker Oct 14, 1975*) for a few seconds as you would normally. Then, look away from it and write down what you saw. When you have recorded your observations, turn this book upside-down and read the following statement:

Did you see the bottle and glass as figure and not consciously notice the peculiar face in the bottle?

Contrast

4.1 Lightness Contrast

Definition: The perceived variation between two or more parts of an object or image, relative to luminance.

The importance of appropriate contrast of photographic images is suggested by the number of contrast controls available to and used by photographers. These include control over lighting ratios on the subject, choice of film with respect to inherent contrast, degree of film development, choice of printing paper with respect to contrast grade and surface sheen as basic controls, plus special controls such as intensification-reduction, flashing, retouching, and the choice between diffusion and condenser enlargers. Early photographers were required to make judgments concerning contrast at each step of the picture-making process. Modern instrumentation and quality control procedures have relieved the photographer of much of this responsibility.

When a person is asked to evaluate the contrast of a photograph, the response is typically one word—flat, normal or contrasty. Actually, it is not uncommon for a photograph to have normal contrast in one area, and either high contrast or low contrast in other areas. For example, a print from a negative that has been underexposed and over-developed will probably have low contrast in the shadows and high contrast in the mid-tones. Even with normal exposure and development it is necessary to compress the 160:1 luminance ratio of an average scene, in order to produce an image on photographic paper that is capable of a maximum luminance ratio of about 100:1. Although it might seem that the most attractive photograph would be produced by reducing the contrast uniformly, it has been found that lowering the contrast in the highlight and shadow areas while maintaining about normal contrast in the midtone areas produces very acceptable images. Photographic films and papers produce such tone reproduction characteristics under normal conditions.

In fact, when it is necessary to reproduce the contrast accurately in all areas, as when making a facsimile photographic reproduction of a photograph, it is necessary to use a special copy film coated with two emulsions having different contrast characteristics.

The visual system perceives contrast more nearly on the basis of luminance ratios than luminance differences. This can be demonstrated by adjusting the level of the room illumination while observing a projected image of a slide on a screen. Adding uniform illumination to the projected image has no effect on the luminance *difference* between the highlights and shadows, but it lowers the luminance *ratio*—which we perceive as a loss of contrast. Conversely, increasing the illumination level on a photographic print increases the luminance *difference* between the highlights and shadows but has no effect on the luminance *ratio*—which, within a limited range, is perceived as no change in contrast. Since density is logarithmically related to luminance, density differences correspond to luminance ratios and serve as an objective measure of image contrast.

Two images having the same density differences, however, may be perceived as being different in contrast for any of several reasons. For a given adaptation level, the eye has a somewhat limited luminance response range, as does photographic film. Thus, 0·1 density differences in the highlight, midtone and shadow areas of a picture may appear different in contrast. In addition, the contrast of a picture may appear to change somewhat with significant changes in the level of the viewing illumination or in the lightness of the surround. The contrast between two areas appears higher when the areas are adjacent with an abrupt change in density than when the change is gradual or the areas are separated. Thus, an unsharp picture appears less contrasty than a sharp picture.

Related terms: assimilation, brightness contrast, chromatic contrast, density difference, flare, just-noticeable difference (jnd), log luminance range, luminance ratio, simultaneous contrast, size contrast, successive contrast, tone reproduction.

References: **31** (229–240), **56** (138–145, 161–167, 352–353), **57** (115–118), **202** (11–15, 90–94, 295–296).

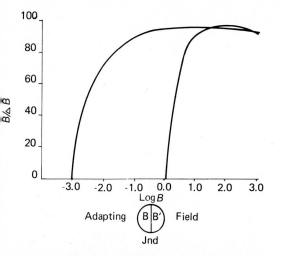

Left: Contrast sensitivity of the eye can be tested by increasing the luminance of the right half of a test field (B') to obtain a just-noticeable difference from the left half (B). Both curves show that the sensitivity to contrast increases rapidly with the luminance of the left half until the maximum is approached. Also, the contrast sensitivity is higher when the surround is dim (left curve) than when it is bright until the test field luminance reaches a high value.

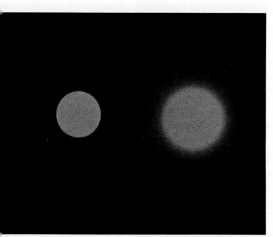

Left, middle: Although the densities of the two circles matched on the original print, the circle on the right was generally perceived as being darker. The abrupt edge gradient for the circle on the left enhances simultaneous contrast more than the gradual edge gradient for the circle on the right.

Below: Defocusing a camera lowers image contrast due to scattering of light into the darker areas. In addition, there is a difference in the perception of contrast due to the decrease in the simultaneous contrast effect with edges having a more gradual gradient. With subjects having fine detail, the decrease in image contrast can be apparent with only a slight decrease in image sharpness.

4.2 Flare

Definition: Nonimage-forming light pro-
duced by reflection and scattering in the eye,
camera or other optical instrument.

Some of the light that enters any optical
system is deviated from the desired image-
forming path due to several factors including
reflection, scattering and lens aberrations.
Of the light that is reflected and scattered
within the optical system, some will reach
the light-sensitive surface as a more or less
uniform veiling light, producing a nonlinear
reduction of image contrast. It is fairly easy to
measure flare in a camera because light
measurements can be made both at the
subject and at the image plane. More sophisti-
cated techniques are required to measure
flare in the eye, but studies indicate that flare
is quite similar in the two optical systems.
Flare is highly dependent upon the relative
lightness of the background and surround for
an object being photographed or viewed.
When we shield our eyes from the sun or
other bright light source in order to see more
clearly, especially in the darker areas of a
scene, we are reducing flare. The curves in
the top figure opposite illustrate camera
flare for an object of average reflectance with
black, gray and white backgrounds in
comparison with the straight line theoretical
no-flare situation. The curves reveal that
flare reduces contrast the most in the darkest
areas of the image, and that flare increases
with the lightness of the background. Flare
can also be expressed as a single number
obtained by dividing the scene luminance
range by the image illuminance range. The
flare factors for the four curves are 1·0 for
the no-flare straight line, 1·7 for the black
background, 2·8 for the gray background,
and 6·1 for the white background.
Visual flare can vary considerably among
persons, just as camera flare varies between
coated and uncoated lenses. With the
development of a cataract, some of the
transparent material in the eye becomes
cloudy and excessive scattering of the
image-forming light results.
Whereas flare in the camera and flare in
the eye have similar effects on the optical
images—namely a reduction of contrast—
the actions to be taken to compensate are,

surprisingly, opposite in direction. The image
contrast that is lowered by camera flare
can be increased by developing the film to a
higher gamma or by printing onto a higher
contrast photographic material. When flare
is introduced into the visual system the
contrast is similarly lowered, but an important
perceptual effect is that there is a loss of
shadow detail. To restore the shadow detail it
is necessary to lower rather than raise the
contrast of the viewed photographic image.
It has long been known, on the basis of
experimentation, that viewers prefer more
contrasty photographic images for viewing
in darkened rooms and theaters than for
viewing in normal room illumination. One
study found the optimum average gradient
for projected images in a dark room is 1·4,
whereas the optimum average gradient for
transparencies and prints viewed in a lighted
room is 1·0. This effect can be demonstrated
both subjectively and objectively by viewing
a transparent photographic step tablet on a
transparency illuminator with variations in
the surround. With the area around the step
tablet masked off and the room lights off, it
will be possible to distinguish easily the
differences between all of the steps over a
density range of 0 to 3·0 or higher. With the
mask removed to produce a bright surround,
the separation between several of the denser
steps will be lost or weakened so that the
effective density range may, for example, be
reduced to 0 to 2·4. Thus, a smaller range
of densities will be accepted as representing
all of the tones of the original scene from
white to black when the surround is light
than when it is dark. The loss of contrast at
the denser end of the step tablet with the
brighter surround is evidence of flare in the
eye. The acceptance of a lighter density as
representing black (coupled with the con-
comitant preference for a lower contrast
photographic image) with the brighter back-
ground is evidence of adaptation of the
visual system.

Related terms: adaptation, extinction,
glare, inducing field, tone reproduction,
veiling light, viewing conditions.
References: **44** (24, 56—66), **155** (464—498),
184 (240—246), **214** (219—221).

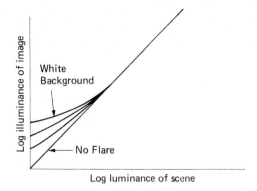

Log illuminance of image

White Background

No Flare

Log luminance of scene

Above: Four camera flare curves representing a theoretical no-flare situation (straight line) and increasing flare with changes in the background from black to gray to white. Flare curves for the eye would be similar.

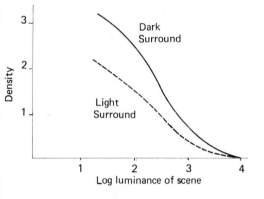

Density

3

Dark Surround

2

Light Surround

1

1 2 3 4
Log luminance of scene

Above: With an illuminator masked off around a 0.05 to 3.05 density step tablet all of the steps are clearly visible in a dark room. With the mask removed no distinction can be seen between several of the denser steps. Thus, higher contrast photographic images are required for viewing in darkened rooms (motion pictures and slides) than in normal room illumination (prints and transparencies).

Left: Preferred reproduction curves for photographic slides are shown for a dark surround (unbroken line) and for a light surround (broken line).

Below: The sun is hidden behind the post in the photograph on the left. When the sun is included in the photograph on the right, flare causes a loss of contrast in the darker areas which is especially noticeable near the image of the sun. Flare produces a similar loss of contrast in the eye.

4.3 Simultaneous Contrast

Definition: An apparent increase in differences between visual stimuli when they are juxtaposed, in comparison to being separated, especially with respect to attributes such as lightness, hue, saturation and size.

Simultaneous contrast is commonly illustrated in textbooks with two identical gray patches, one surrounded by a lighter area and the other by a darker area. The effect is evidenced by the lighter appearance of the gray patch that is surrounded by the darker area. Although the effect is detectable by most viewers, it is often not very dramatic for various reasons, including the set of the viewer—when he knows two things are physically identical, he may resist the influence of factors that tend to make them look different (*see* Constancy, 5.4, 5.5, 5.6).

Simultaneous contrast can be demonstrated more dramatically using a transparency illuminator and a reflection gray scale in the following way. Fasten a stack of six or more white file cards together with transparent tape to make them opaque and place them in the center of a 25×25 cm (10×10 inches) or larger transparency illuminator. With the room lights on and the illuminator light off, the white card will appear about the same in lightness as the white end of a gray scale placed a few inches to one side of the illuminator. When the illuminator light is turned on (with room lights still on), the white card suddenly appears darker due to simultaneous contrast, whereas the gray scale appears to change little if at all due to the spatial separation. The white card now appears to match one of the gray tones rather than the white step on the gray scale. As the room illumination is reduced, the match will be with progressively denser steps, even approaching the black end of the gray scale.

The extent to which viewer set counteracts simultaneous contrast can be demonstrated by overlapping the white end of the gray scale on the white card, with the illuminator light on and with subdued room illumination. Now gradually move the gray scale to one side until the lightness match moves up one step, noting the position of the gray scale. Next, place the gray scale several centimeters to one side of the illuminator, determine the closest match, and gradually move the gray scale back to the position noted above and again select the closest match. Any difference between the step selected moving out and moving in can be attributed to set.

The effect of simultaneous contrast on the perception of a picture can be demonstrated by replacing the white card on the illuminator with a small photograph, backed to make it opaque. Turning the illuminator light on and off, with the room lights on, will produce a dramatic difference in the perceived quality of the picture. Mounting identical pictures on white and black display boards will produce less drastic but observable simultaneous contrast effects.

A local change in sensitivity of the visual system is commonly credited for simultaneous contrast effects (*see* 5.1 Adaptation). Turning the illuminator light on produces a decrease in sensitivity not only in the areas of increased luminance but also in adjacent areas—especially those that are completely surrounded. The decrease in sensitivity in the area of the white card and the picture in the demonstrations above made them appear darker.

In addition to lightness effects, simultaneous contrast applies to stimulus attributes such as hue, saturation and size. A gray sample surrounded by yellow will tend to appear bluish, grayish red surrounded by a saturated red will appear more neutral than if viewed separately, and a difference in size of two objects is more obvious when they are juxtaposed than when viewed apart.

When photographing an object, the choice of background can have an important influence on the appearance of hue, saturation and lightness of the subject due to simultaneous contrast effects.

Related terms: adaptation, constancy, contrast enhancement, lateral inhibition, set, successive contrast.
References: **32** (229–233), **36** (63, figs 3–5 to 3–9, **55** (164–168).

Simultaneous contrast is revealed as a change in lightness of uniform gray squares viewed in front of different backgrounds. The gray tends to appear darkest in front of the white background.

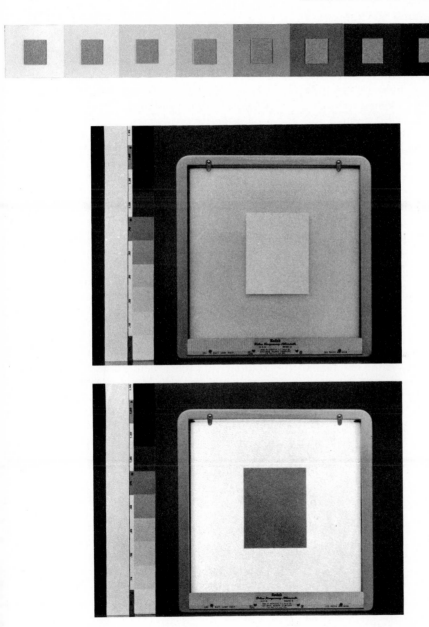

A simulation of the change in the perceived lightness of a white card on a transparency illuminator with the illuminator light off (top) and on (bottom), with no change in the light falling on the card and the gray scale.

4.4 Assimilation

Definition: A visual effect whereby an attribute of a stimulus, lightness for example, appears to change so as to more nearly resemble the corresponding attribute of a newly added visual element.

The perception of lightness of a gray sample is determined to some extent by the relative lightness of other areas in the field of view. Moving a black visual element adjacent to the gray sample may make the gray appear lighter (an effect known as simultaneous contrast), darker (assimilation), or it may have no effect on the gray—depending on the size, configuration, and placement of the black element, and on other factors.

Assimilation can be demonstrated by adding a pattern of black or white lines to part of a uniform gray sample as in the top illustration opposite. Although the effect is somewhat similar to what would be obtained by fusing the gray with the black or the white temporally or spatially, it should be noted that the lines are wide enough to be easily resolved. While it is difficult to predict assimilation with complex images, picture makers should be alert to the possible effects of such factors as narrow white or black borders on prints, lines drawn around mounted prints, texture screens that add a pattern of fine light or dark lines to a picture, and high-sheen textured photographic papers that can produce a pattern of small bright reflections from viewing lights.

Adding a pattern of black or white lines to a color rather than a gray sample can produce assimilation not only in the form of an apparent change in lightness but also in saturation. Thus, black lines would make a color appear darker and more saturated, white lines lighter and less saturated. Von Bezold, who first described these effects about a century ago, referred to them as spreading effects. Adding color lines to a gray sample can produce apparent changes in hue by means of assimilation. For example, yellow lines added to a gray background can make the gray appear yellowish, whereas blue lines would make the gray appear bluish.

The sharpness of the edge separating the different areas is another important factor that affects assimilation. Whereas a sharp edge between two adjacent tones tends to exaggerate the apparent contrast (*see* 12.8 Mach Band), an appropriate gradual transition from one tone to the other can reduce the apparent contrast. A photographic application of this principle is that a slight loss of sharpness can appear to lower the contrast of a picture, and with color photographs there also can be a loss of saturation of the colors. An unsharp optical image produces an overlapping or mixing of the light from adjacent areas, which produces an actual loss of contrast in the areas of fine detail, or larger areas with gross unsharpness. However, this physical effect is exaggerated by the visual effect which can be demonstrated with two identical sharp-edged gray (or color) circles on a white background. With an appropriate blending of the edge of one of the circles into the white background, the entire circle appears lighter than the circle with the sharp edge.

Although the term assimilation is commonly limited to the apparent decrease in contrast of hue, saturation or lightness, corresponding effects have been observed for other attributes of visual stimuli. Piaget, for example, demonstrated that when a larger circle is drawn around an original circle, the original circle is often judged to decrease in size due to simultaneous contrast, but if the added circle is only slightly larger than the original circle it appears to increase in size, an effect labeled centration.

Related terms: blending, centration, color mixture, Delboeuf illusion, equalization, simultaneous contrast, Von Bezold spreading. *References:* **18** (49–50), **36** (64, figs 3–10 to 3–12, figs 3–23), **44** (270–275), **55** (181–182).

Although the gray background is uniform in reflectance, it tends to appear darker with superimposed black lines and lighter with superimposed white lines. This is the opposite of what would be expected on the basis of simultaneous contrast.

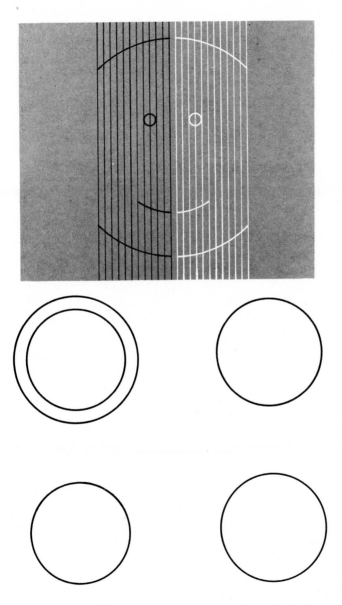

Cover the lower two circles and look at the top two. The inner circle at the top left is generally judged to be the same size or larger than the circle at the top right. It is actually smaller, but is perceived larger than its true size due to assimilation. Removal of the cover reveals the actual size relationship of the inner circles.

5

Adaptation/Constancy

5.1 Adaptation

Definition: A process of adjustment of the visual system to the environment, such as a decrease in sensitivity with an increase in the illumination level.

The dynamics of the visual system are such that it attempts to treat every stable stimulus of long duration as being normal, even though it appeared quite abnormal when first presented. This principle applies to a wide variety of stimulus attributes including lightness, color, size, motion, orientation, pattern and sharpness. The discussion here is limited to light and dark adaptation.

Adaptation enables the visual system to see the environment with large variations in the light level—as from sunlight to starlight, which represents an illuminance ratio of about a billion to one. As the light level decreases, the sensitivity of the visual system increases (and vice versa). This is a gradual process that requires about 40 minutes to reach full dark adaptation. Dilation of the iris can increase the amount of light admitted to the eye by only about 16 times. Almost all of the increase in sensitivity during dark adaptation is the result of changes in the pigments in the retinal receptors and changes in the neural processes.

In contrast to dark adaptation, a major part of light adaptation occurs within the first second and the process is completed within a few minutes. Photographers who need dark adaptation to be able to see clearly in low-light level situations, such as for certain darkroom operations, can avoid its quick destruction by using dark glasses when exposure to a higher light level is unavoidable. A rather intense red light can be turned on in a darkroom without destroying dark adaptation because of the insensitivity of the rod receptors in the retina to red light.

As a result of the change in sensitivity of the visual system during light and dark adaptation, the eye is a poor measuring instrument. When photographers correctly estimate the camera exposure settings without an exposure meter, it is on the basis of the memory of previous experience in similar situations, rather than by estimating the luminance visually. In visual environments containing a variety of tones, the adaptation level tends to be adjusted to an intermediate value that is dependent upon the size, luminance, and distribution of the tonal areas. There is sufficient local adaptation, however, to enable detection of more detail than was first visible in a dark shadow area of a scene. This is achieved by fixating the shadow area for a short period. Local adaptation makes it more difficult to estimate the luminance range of a scene, with the result that photographs of contrasty scenes typically have less shadow detail than was visible to the eye. Looking at the scene through a neutral density filter decreases the ability of the eye to adapt further for shadow areas, making previsualization of the finished photograph more accurate.

Large light or dark areas surrounding photographs can affect the level of adaptation and therefore the appearance of the photograph. A white mount board for a print or an unmasked area on an illuminator around a transparency can cause light adaptation which makes the photograph appear darker. Conversely, a dark area around the screen in a theater can cause dark adaptation which makes the image appear lighter.

The fact that adaptation does not completely compensate for changes in the illumination level is revealed by the difference in the appearance of the density of a photographic print viewed in direct sunlight and in normal room light. The intensity of the white inspection light in the printing darkroom is not unimportant.

Related terms: dark adaptation, light adaptation, photopic vision, scotopic vision, simultaneous contrast.
References: **25** (1283–1293), **56** (59, 113), **86** (27–31).

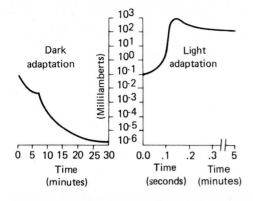

Left: Dark adaptation begins rapidly, but requires nearly 40 minutes to reach maximum sensitivity. A major part of light adaptation occurs within the first second and the process is completed within a few minutes.

Below: Local adaptation can be demonstrated by covering one eye and looking steadily with the other eye at the center of the black dot in the image on the left until the light circle disappears. Attempts to make the light circle on the right disappear are less successful. This is because of the sudden changes in illuminance for some retinal receptors produced by the sharp edge of the circle combined with the small involuntary movements of the eye (nystagmus).

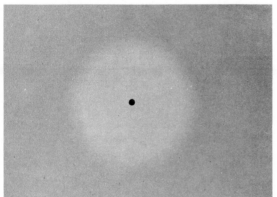

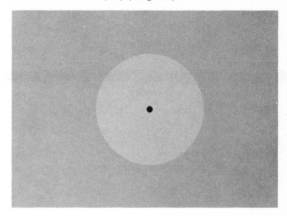

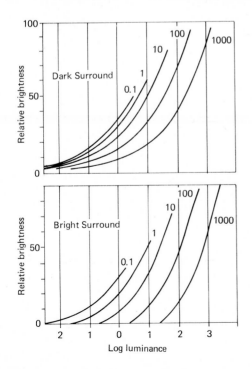

Left: Curves showing the relation between brightness and log luminance with a dark surround (*top*) and a bright surround (*below*). Different pre-adaptation luminance levels are identified by the numbers near the curves. If the visual system had no ability to adapt, there would be only a single curve on each graph. If adaptation were perfect, the curves would be parallel and separated by a distance equal to one log luminance unit on the horizontal axis. The differences between the top and bottom sets of curves, due to lateral adaptation (simultaneous contrast), illustrate why slides, motion pictures, and other images typically shown in a darkened room should have a higher density range than pictures viewed in normal room illumination. From *Neblette's Handbook of Photography and Reprography* edited by John Sturge © 1977 by Litton Educational Publishing, Inc. Reprinted by permission of Van Nostrand Reinhold Company.

5.2 Chromatic Adaptation

Definition: A process of adjustment of the visual system such that exposure to a given hue results in decreased sensitivity to that hue and an apparent increased sensitivity to the complementary hue.

An example of chromatic adaptation is the acceptance of both daylight and incandescent illumination as being white when viewed separately for long enough to allow the visual system to adjust—whereas, when viewed side by side, daylight tends to appear bluish and incandescent illumination yellowish. A change in sensitivity of the visual system to a color can be demonstrated by looking steadily at a saturated color patch or design for a minute or so, and then looking at a neutral surface. The appearance of an approximately complementary color will be noted.

Chromatic adaptation is thought to be primarily due to bleaching of the cone pigments in the retina. Upon exposure to blue light, for example, the blue-sensitive pigment becomes more transparent and then absorbs less blue light, resulting in a lowered sensitivity to that color. The fact that exposure to blue light does not reduce sensitivity to red light or green light provides further evidence of the existence of red-, green- and blue-sensitive photopigments in the retinal cones.

Although chromatic adaptation tends to compensate for changes in color temperature of ambient light, the compensation is incomplete. Thus, despite complete adaptation to light from incandescent sources, critical observers generally describe the illumination as being slightly yellowish rather than white. A number of experiments have been conducted in an effort to determine more specifically the changes that occur in sensitivity with chromatic adaptation. In such experiments the subject is typically adapted to a specific quality of illumination and then he is required to describe the color of a sample, to select a neutral sample from several, or to produce a neutral by mixing variable amounts of red, green and blue light. If chromatic adaptation compensated completely for variations in the stimulus, the selected neutral would always match the quality of the adapting illumination. In practice, the only time this occurs is when the adapting illumination has a color temperature of approximately 6000 K. When the subject is adapted to 3000 K illumination, for example, the selected neutral will be lower than 6000 K, but higher than 3000 K. Conversely, when the subject is adapted to 10 000 K illumination the selected neutral will be higher than 6000 K, but lower than 10 000 K. Thus, while the visual system adapts to higher and lower color temperatures, it most readily accepts illumination of approximately 6000 K as being neutral. The color temperature of the selected neutral, for a given quality of adapting light, will vary with factors such as the luminance of the stimulus and the length of the adaptation period.

Most slide and motion picture projectors use illumination of considerably less than 6000 K color temperature. Because the visual system, even when fully adapted, interprets this illumination as being slightly yellowish some photographers make their photographs a little bluish to produce the perception of more nearly neutral whites on the projected images. Complications are introduced when there is ambient light in a room that is different in quality from that used for a picture, such as a transparency on an illuminator or a television image. Although the television white has a color temperature of approximately 6500 K, only a little above the 6000 K that is most acceptable as white, black-and-white television pictures tend to appear quite bluish when the viewer is adapted to lower color temperature room lights. A factor other than chromatic adaptation, namely additive mixture, is involved when yellowish room lighting is allowed to fall directly on a projection screen and alter the color of projected images.

Related terms: color adaptation, spectral sensitivity.
References: **36** (80–82), **114** (112–115), **126** (334–344).

The arrows on the chromaticity diagram illustrate the relationship between the adapting fields, identified by color temperatures, and the corresponding samples that were judged to be neutral. The selected neutral was essentially the same as the adapting field for a color temperature of 5500 K, but for adapting fields having higher and lower color temperatures the selected neutrals were shifted toward the center.

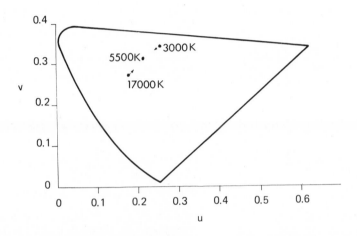

The difference in color temperature of daylight and incandescent lamps is illustrated in these photographs made on daylight and tungsten types of color films. When the eye is adapted to incandescent light, daylight will appear blue by comparison, as in the photograph on the right.
Photographs by Cap Palazzolo.

5.3 Illusion-Decrement Phenomenon

Definition: A gradual lessening of an illusory visual effect with repeated or prolonged viewing.

An illusion can be defined as a false perception. Although we experience many visual illusions in our daily lives, a few line drawings have become the classic examples of geometric illusions in the textbooks. The major research interest in visual illusions has been in obtaining evidence to support theories that explain the illusions. However, it has been observed that some of the illusions, rather than being stable, become less obvious when the stimulus is viewed repeatedly or for a long period.

The illusion-decrement phenomenon has been reported specifically on the Mueller-Lyer, Poggendorff and Zoellner illusions; the first of which pertains to the relative lengths of two straight lines, and the other two to the displacement of the two parts of partially concealed straight lines. Thus, the difference in apparent length of the two equal lines in the Mueller-Lyer illusion decreases with repeated or prolonged viewing. The decrement is not permanent, as the illusion will be restored to its original magnitude if the stimulus is presented again after having been removed for a day or so. Just as a variety of explanations have been offered for the geometric illusions, so have there been different explanations for the illusion-decrement phenomenon, one of which suggests it is due to a habituation effect.

The illusion-decrement phenomenon can be demonstrated also with illusory movement. When a spiral design is rotated, an illusion is created in that the spiral appears to be expanding or contracting, depending upon the direction of rotation. The effect decreases in magnitude with prolonged viewing, but when the spiral is stopped it appears to change size in the opposite direction. This is known as the *waterfall effect*, since stationary objects appear to move upward immediately after watching water flow downward for some time. Gregory explains it on the basis of adaptation of the visual system.

Another type of illusion is produced when a person is equipped with special eyeglasses that reverse, invert, enlarge, reduce or otherwise alter perceptions of the visual world. Even though such changes make it difficult for the person to interact with his environment at first, he gradually adapts so that the altered stimuli seem more and more normal as the illusion decreases. Because of the adaptation, the world again seems strange when the glasses are removed, requiring another period of adjustment. Thus, even aftereffects can be treated as illusions that decrease in magnitude as the person readapts to his environment.

The illusions that are encountered in everyday lives and in pictures are seldom as dramatic as those used for experimental purposes. One way of attracting attention with pictures is to make them in such a way that they appear illusory. For example, the use of a very long focal length lens results in photographs in which space seems to be compressed and distant objects, such as the sun, appear abnormally large. With repeated or prolonged viewing, illusion decrement occurs and the photographs appear less dramatic than they did at first. Even more important, when the public is bombarded with many pictures using the same technique, a corresponding psychological adaptation and illusion decrement occur—the pictures are perceived as being almost normal.

Related terms: adaptation, habituation.
References: **80** (99–109), **218** (160–163).

Left: If the spiral design is rotated clockwise an illusion is created that it is expanding, an illusion which decreases with prolonged viewing. When the rotation is subsequently stopped, the design appears to shrink.

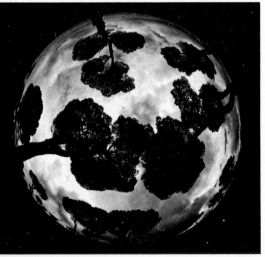

Left: Because fisheye pictures have been widely published in recent years, most viewers are now able to accept such images as representing the real world. It will be found that the illusory quality of this fisheye picture decreases with prolonged viewing. *Photograph by Don Maggio.*

Below: Even the illusion of an inverted world, produced by equipping a person with special eyeglasses, decreases with prolonged viewing.

125

5.4 Size Constancy

Definition: The tendency for a viewer to perceive an object as remaining fixed in size with variations in viewing distance.

When an object moves toward or away from the viewer, the retinal image changes in size inversely with the distance. Not surprisingly, this change in image size is interpreted as a change in viewing distance, rather than as a change in object size. This is because the experience of seeing objects change size dramatically in a short time is very rare. In fact, an experiment was designed whereby the size of an illuminated rubber ball was changed with air pressure in an otherwise darkened room—viewers perceived the ball as remaining constant in size and moving away from them as the ball became smaller.

Accurate perception of the size of an unfamiliar object depends upon knowledge about the distance. A white cube in front of a black background, viewed from a fixed position with one eye, can be perceived either as a small object nearby or a large object at a distance. Whereas under normal viewing conditions, both the distance and the size of a cube sitting on a table could be judged from the other side of the room with considerable accuracy. Conversely, with an object of known size, the distance can be judged accurately even in the absence of other depth cues.

A common example of size constancy is that when a person walks away from the viewer—the decreasing image size is interpreted as representing increasing object distance rather than a shrinking person. Although experience undoubtedly contributes to size constancy, it has been demonstrated that even young infants have similar perceptions. Size constancy is not infallible even when the distance can be judged accurately, as evidenced by the ant-like appearance of people at street level viewed from the top of a tall building, an effect known as *underconstancy*.

Of greater concern to photographers is size constancy as applied to viewing pictures rather than original scenes. If the photographer wants the viewer to perceive objects at different distances in a photograph in their true size relationship, then he should provide good depth cues, just as cues are required when viewing the original scene. Furthermore, a normal focal length lens should be used on the camera. This ensures that the decrease in image size with increasing object distance recorded on the photograph, corresponds to that experienced by a person viewing the original scene from the same viewpoint. This approach is appropriate for various fields of photography, including documentary and forensic.

For some other uses, more dynamic and effective pictures can be produced by varying conditions to produce either underconstancy or overconstancy. *Underconstancy* is when a distant object appears too small or a near object appears too large. This can be produced either by using a short focal length lens for a strong perspective, or with a single object, by eliminating distance cues and making the image of a distant object smaller than is customary or of a near object larger than is customary. A photomacrograph of an ant that nearly fills the picture frame, for example, may take on the appearance of a monster.

Overconstancy, on the other hand, can be achieved by using a long focal length lens at a greater distance from the subject, to produce a weak perspective—objects appear to change little in size with distance in the picture. Also, with a single object, making the image of a distant object (eg. the moon) larger than normally perceived, produces a dramatic effect through overconstancy. One explanation of the moon illusion, where the moon appears larger near the horizon than overhead, is that the moon is subconsciously thought of as being farther away when it is near the horizon as bird or plane would be. Thus, the same size retinal image of the moon is perceived as being larger through overconstancy.

Related terms: Brunswik ratio, overconstancy, perspective, underconstancy.
References: **80** (145–155), **119** (328–366).

The photograph on the left was made with a 'normal' 50 mm focal length lens on a 35 mm camera. The decrease in size of the images of the posts, which are located at intervals of 2 m (6 ft), appears natural. The posts in the second photograph, made with a 15 mm wide-angle lens, appear to decrease too rapidly in size (an effect known as underconstancy), whereas the posts in the third photograph, made with a 1400 mm telephoto lens, appear to decrease too slowly in size (overconstancy).

B.C. By Johnny Hart

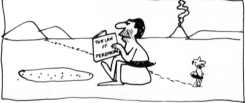

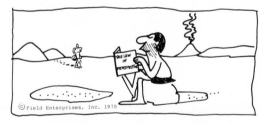

A world in which *The Law of Perspective* breaks down is depicted in the comic strip *B.C.* Failure of the approaching figure to increase in size as expected causes the viewer to perceive him as shrinking. The figure moving away is perceived as becoming larger with no change in the actual size. The effects represent the limit of overconstancy. This limit can be approached but not reached photographically with long focal length lenses at large distances from the subject. *B.C. by permission of Johnny Hart and Field Enterprises, Inc.*

5.5 Shape Constancy

Definition: The tendency for a viewer to compensate mentally for perspective effects when viewing an object or an image of an object and thereby to perceive the actual configuration of the object.

When a circular object such as a coin or a ring is viewed obliquely, the retinal image is an ellipse, not a circle. When a photograph is made of the circular object from the same viewpoint, the photographic image is an ellipse. In both of these situations, the viewer will tend to perceive the images as representing perspective views of a circular object rather than as an elliptical object. This perception should not be a surprise, since it is known from experience that if a coin is held between the fingers and slowly rotated, the coin is not changing shape. Thus, it appears that shape constancy is a psychological phenomenon, based on previous experience and memory. Even though the cover of the cosmetic case is circular and the bottom is elliptical in the picture opposite, the viewer feels confident that the two halves will fit quite precisely when the cover is closed.

It should be noted, however, that under certain circumstances it is not difficult to deceive the viewer about the shape of an object represented in a picture. The black line on a white background in the second illustration can be perceived either as an oval object or as a circular object seen in perspective. This is because no information has been provided about the situation. The ambiguity can be dispelled readily in two different ways—by providing cues that identify the object as one known from previous experience to be circular or oval, or by providing cues that clearly indicate the orientation of the object with respect to the viewer. Thus, if a photographer wants to avoid confusion concerning the shape of an object he is photographing, he should provide visual information about the nature of the subject and the orientation. If he wants to deceive the viewer, he should deprive him of these two types of information. Some writers refer to the preference of viewers in the absence of supporting visual cues to perceive ellipses as tilted circles, and both acute and obtuse angles as perspective views of right angles as shape constancy. More properly this phenomenon should be included in the concept of good figure (*see* 7.3 Gestalt). The two effects can occur simultaneously, as in a photograph of a tilted oval object that is perceived as a circle, both because it appears very similar to a perspective view of a circular object and the preference of the viewer for the simpler form of the circle.

Vertical subject lines are a special problem with respect to shape constancy due to the inconsistency with which photographers 'correct' the perspective. (This 'correction' is achieved by keeping the film plane perpendicular to the ground when aiming the camera upward or downward at the subject.) If the viewer has not seen the building shown on the left in the third illustration, it is difficult for him to know whether the converging vertical lines on the image are due to perspective or to tapered sides on the building or both.

Related terms: anamorphic effect, good figure, perspective.
References: **56** (47–50, 322–323), **80** (169–177).

128

Left: When viewers are asked to identify the shape of each of the two halves of this cosmetic case, they generally respond that the top is circular and the bottom is oval or elliptical—yet they are confident the two parts would fit if the case were closed. Due to shape constancy, the bottom is perceived as a tilted circle.

Above: In the absence of clues, the black line can be perceived either as an elliptical object or as a circular object seen in perspective.

Below: Because of the inconsistency with which photographers 'correct' the vertical lines on photographs, viewers cannot be certain whether the building, in the photograph on the left is tapered toward the top or the convergence is the result of tilting a camera upward. This suggests that shape constancy depends partly on custom. The parallel sides in the photograph on the right eliminate the ambiguity.

129

5.6 Color Constancy

Definition: The phenomenon whereby a viewer perceives the hue, saturation and lightness of a stimulus as remaining unchanged when the color quality and the level of the illumination are changed.

Although subject and image colors have three attributes—hue, saturation, and lightness—color constancy is commonly divided into two categories. *Chromaticity constancy* refers to the first two attributes, hue and saturation, and *lightness constancy* refers to the third, lightness.

Lightness constancy is demonstrated by the fact that the light end of a gray scale, which appears white when viewed in direct sunlight, also appears white when viewed under low-level illumination indoors. The luminance in this last situation may actually be lower than for the 'black' end of the gray scale in sunlight. For example, in sunlight the luminance of the white and black ends of the gray scale may be 30 000 and 300 candelas per square meter, whereas indoors the luminance of the white end may be only 30. Two important factors that contribute to this constancy effect are that the visual system adapts to variations in the illumination level, and the perception of lightness depends more on a comparison of the area being evaluated with the surroundings than the actual luminance. Also, viewers compensate psychologically for variations in illumination within the field of view, as between the stage and audience areas in a theater. This psychological effect can be demonstrated by varying the illumination in a local area in such a way that the viewer is unaware of the variation. If a gray card and a white card are viewed simultaneously, they will obviously be perceived as such when the illumination is the same on both. Even if the illumination is increased on the gray card until the luminance of the two cards is the same, they will still be perceived as gray and white provided the viewer is aware of the extra light on the gray card. If the source of light is concealed and the illumination is masked down so that it falls only on the gray card and not on the background or surround, the viewer will perceive both cards as being white when the luminances are equal. A practical application of this concept is the masking of the area around a transparency on an illuminator. This practice makes the image appear brighter than when the illumination source is apparent to the viewer.

An example of chromaticity constancy is that a 'red' apple appears red under illumination that varies considerably in color temperature; including white daylight, relatively blue skylight in the shade, and relatively yellow incandescent light indoors. There are contributing factors for chromaticity constancy that are analogous to those cited for lightness constancy. These are chromaticity adaptation, the effect of comparing colors with other colors in the environment, and the psychological factor of compensating for variations in the color quality of illumination within the field of view. Also, it is claimed that the viewer depends upon his memory—he knows an object is red so he may not evaluate the color very critically under different illuminants.

If there were no failure of color constancy, it would not be necessary for photographers and artists to be concerned about the color quality and the level of the illumination used for viewing pictorial images. Highly saturated colors tend to produce the most stable perceptions with changes in the illumination. Colors that are less saturated can change significantly, and metameric colors can change dramatically.

The American National Standards Institute (ANSI) has published standards for viewing transparencies and prints for the purpose of minimizing such changes in the appearance of pictures. When the illumination of a display area cannot be altered to conform to the standard, it is recommended that the photographer use the same type of illumination in evaluating a photograph as will be used for the display.

Related terms: brightness constancy, chromaticity constancy, color adaption, lightness constancy, metamerism.

References: **36** (84–85), **44** (279–284), **55** (133–137).

Above: Lightness constancy enables the viewer to perceive the ship and sails as being white even though they are printed as a medium tone due to the strong backlighting. *Photograph by Ralph Amdursky.*

Color photographs which illustrate the difference in color quality of tungsten illumination and daylight, achieved by using tungsten-type color film with tungsten illumination (*left*) and adding the filters recommended when using tungsten film in daylight (*center*) and daylight film with tungsten illumination (*right*). Viewers would generally perceive the original subject as a red apple on a white plate with each type of illumination due to color constancy.

Analysis of Information

6.1 Figure-Ground

Definition: In a given environment, that to which you attend is called figure while that to which you do not attend is called ground. Related to a photograph, the figure corresponds to the subject, while the ground corresponds to the surrounding, or the background and the foreground.

In 1914, the Danish psychologist, Rubin, studied visual perception in terms of two basic components, figure and ground. Long before that, artists were making playful applications of this perceptual experience. Discriminating figure from ground involves the process of selective attention. That which attracts your attention emerges as figure and that which does not remains as ground. At different times, what is seen as figure may change. This depends on what in the visual field has the greatest organizational strength due to associations from memory.

Artists and photographers sometimes refer to figure-ground as positive–negative space. In Henry Moore sculptures for example, the solid material and the open areas constitute positive–negative spaces which are perceived as figure and ground. This relationship can change depending upon the observer's perception. Photographic engineers might refer to figure-ground as signal and noise, with graininess being an example of noise in a photographic system. The more pronounced figure is from ground, the higher the signal to noise ratio. Techniques such as camouflage reduce the signal-to-noise ratio.

Figure and ground have several contrasting properties:
1. Figure has stronger shape or form qualities than ground.
2. Figure is seen as having boundary while ground is not.
3. Figure usually occupies an area smaller than ground.
4. Figure is usually experienced as nearer than the ground.
5. Figure and ground are rarely seen simultaneously.
6. Figure is more easily seen and identified, and more easily associated with meaning and feeling.

Reversible figures are examples where both figure and ground have similar properties and contours. The attention to and perception of figure can flip back-and-forth as seen in Rubin's symmetric vase profile and in the 1795 Saule Pleurer etching (*see* opposite).

A photographer continually uses the concept of figure–ground in making pictures although he may use terms such as focus, contrast and composition to describe it. By selectively focusing his camera, he chooses what is figure (in focus) and what is ground. Lighting can be used to emphasize and reveal the form of a particular figure. Catalog photographers often use a white or plain background to separate figure from ground.

The knowledge that persons vary in their ability to separate figure from ground has become the basis for a method of psychological testing called *embedded figure test (EFT)*. In this test a person is asked to find specific geometric form embedded in larger complex form (*see* opposite). Persons who do exceptionally well on the test are referred to as 'field independent' while those who encounter difficulty in separating specific figures from the larger, complex ground are called 'field dependent.' This nonverbal test provides a means of classifying how people perceive their environment. For a field dependent person, perception is strongly dominated by the overall organization of the surrounding field—the parts are not readily separable from the whole. Field independent persons are more analytical and easily perceive parts of the total field as separate or discrete. Photographers should not assume that everyone will see photographs in the same way since people differ in their ability to distinguish figure from ground.

Related terms: embedded figures, field dependent/independent, positive–negative space, Rorschach, signal and noise.
References: **97** (50, 116–117, 161–162), **105** (84, 85, 135, 136), **215** (9–31), **21** (113–124).

Left: Five hidden silhouettes are incorporated in this 1795 engraving by Saule Pleurer commemorating the death of Louis XVI. *Metropolitan Museum of Art, Bequest of Mary Martin, 1938.*

Above: Rubin's vase profile, 1915. Figure–ground alternates between vase and profile. Vase is more easily seen as figure. Compare with the illustration below.

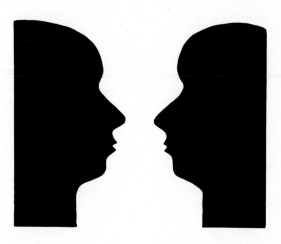

The concept of figure–ground is the basis for embedded figure tests. Pencil in the shape of the smaller figure on the larger figure. Field-dependent persons will have more difficulty than field-independent persons.

Profile is more easily seen as figure.

6.2 Signal-Noise

Definition: In communication theory, signal—noise is the relationship (usually expressed as a ratio) between the desired component of an image or other message and any random disturbance in the image.

In an area of poor television reception, the image is typically afflicted with 'snow.' The desired image is the signal and the random disturbing pattern of white flecks is noise.

The important feature of the signal—noise relationship is the *ratio* of the strengths associated with the two image components. If the signal is strong, even a fairly high level of noise will go unnoticed. It is when the signal is weak that the noise seriously interferes with the quality of the picture.

In addition to variations of signal and noise as related to changes in the stimulus, there are several sources of variability of the signal—noise ratio within the viewer.

Firstly, the visual system changes in sensitivity due to adaptation. Thus in a low light level situation, dark adaptation results in an increased ability to see detail and a higher signal—noise ratio. Also, near the threshold of vision, small variations in the effectiveness of light quanta reaching the individual receptors in the retina become a factor. This variability is one of the causes of the disappearance and reappearance of a very dim star, and is a problem in experiments seeking to measure visual thresholds.

The second source of variability of the signal—noise ratio is the spontaneous firing of neurons, even though the receptors in the retina receive no light. This noise is detectable as faint flashes in the visual field in the complete absence of light. One cause is thought to be the slight pressure changes on the neurons resulting from pulsed blood flow in the retinal blood vessels. A similar phenomenon can be demonstrated by lightly pressing or tapping the closed eye in a darkened room.

Thirdly, light scattered from the small particles referred to as 'floaters' in the otherwise transparent substances that fill the eyeball, and light reflected from the internal structures of the eye cause signal—noise variability. This type of noise makes it difficult to see the details in the form of a back-lit subject because the signal—noise ratio is low.

The fourth kind of variable is the psychological factor. People have been found to alter the frequency with which they report seeing a signal of constant strength near the threshold, presented at random intervals, depending upon the reward or punishment associated with their decisions. Thus, if a person is rewarded each time he correctly reports seeing the signal and is not punished for reporting a nonexistent signal, he will report seeing many more signals than if the situation is reversed. An example of a low decision criterion level was the detection of nonexistent 'canals' on Mars by astronomers.

In photographs, the strength of the signal may be measured as the difference in density across an image edge. Noise can be estimated from a trace made with an instrument (a microdensitometer) that can detect the grain in the image, and is expressed by a quantity called *granularity*. Granularity is proportional to the standard deviation (root-mean-square variation) of the density values read from a trace across an otherwise uniform image patch. Graininess in the image reduces the signal—noise ratio, but may be attractive if it produces a desirable feeling of texture.

A high signal—noise ratio is desirable for photographs made to communicate information concerning physical attributes of the stimulus, as in the fields of documentation, reprography, scientific research, and photo-intelligence. The success of pictorial photography, however, often depends upon de-emphasizing part of the vast amount of information that can be presented in a photograph. The intentional introduction of noise, as with the use of textured paper surfaces, texture screens, coarse grain films, and soft-focus lenses, selectively reduces the signal—noise ratio.

Related terms: figure—ground, information theory, redundancy, signal-detection theory, variability.

References: **44** (78–88), **86** (99–102, 131–134), **119** (60–67).

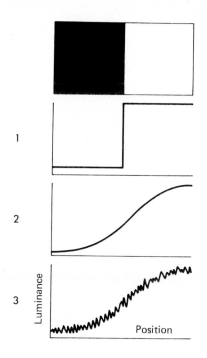

1

2

3

Luminance

Position

Left: A black-and-white target and graphical representations of three images—(1), a trace across an ideal image; (2), a trace across an image affected by optical defects; (3), a trace across an image affected by noise in addition to optical defects.

An example of the deliberate introduction of noise to achieve an artistic effect. The original photographic print on the left was copied on an electrostatic office copier. The copy was then recopied, and the process was continued for many generations. The final picture is a composite containing third, sixth, and twelfth generation copies from bottom to top, with a progressive decrease in the signal–noise ratio.
Photographs by Charles A. Arnold Jr.

6.3 Coding

Definition: The systematic transformation of visual information for the purpose of increasing the efficiency of perception.

The efficiency of visual perception is vastly increased by the process of coding which enables the viewer to be most aware of those aspects of his environment that are likely to be important to him. Without a coding system, it would be necessary to have approximately 260 million transmission lines between the receptors in the retinas and the visual cortex at the back of the brain. It is estimated that there are actually about one million such neurological lines in each optic nerve. Major coding of visual information occurs not only at the two terminals, the retina and the visual cortex, but also at a relay station known as the *lateral geniculate.*

Haber and Hershenson indicate that the bulk of the coding of visual information is accomplished with the following three strategies: (1) ignoring steady-state stimulation, (2) having specialized components for different functions, and (3) precoding critical visual features. A blank sheet of paper viewed under continuous, as distinct from intermittent illumination, represents an area of steady-state stimulation with respect to both spatial and temporal attributes. Although cells in the visual system can inhibit or excite their neighbors, in steady-state situations such effects cancel out in adjacent cells and the cells fire at a spontaneous rate. Adding a black dot to the blank paper causes a change in the rate of firing of the corresponding cells, and attention is attracted to the dot. Similarly, dust spots on photographs are distracting to a viewer because they disrupt more uniform tonal areas. The temporal steady-state condition is disrupted if the light source flashes at less than the critical fusion frequency, as with early motion pictures. Flicker becomes annoying because our visual system does not allow us to ignore the changing stimulation.

An obvious example of specialized components for different functions is *photopic-scotopic* vision where the rods provide scotopic vision under low light levels where cones cannot function, but without providing color information. The coding of color by the cones is especially fascinating to photographers because of the similarity to the recording of colors on photographic film. The several million subject colors that can be perceived are coded by the cones in the retina in terms of only three hues—red, green and blue—just as the same three colors are recorded in different layers of color film. There is evidence that additional coding takes place in the lateral geniculate. The sophistication of the decoding process, whereby the mind reconstructs the subject colors, is more fully appreciated when it is realized that the colors appear realistic under either daylight or tungsten illumination, while photographers must use a filter and carefully adjust the exposure to compensate for color temperature and illuminance differences when changing from one light source to the other.

Precoding critical visual features is based largely on the concept of receptive fields in which a cell in the visual system responds only to an appropriate configuration of stimuli on the retina. The shape and complexity of the receptive fields vary for cells in the retina, the lateral geniculate, and the visual cortex. Different cells respond selectively only to configurations such as a spot, an edge, a line, an angle and even movement in a certain direction at a certain rate. A so-called hypercomplex cell in the visual cortex may have a receptive field that involves millions of retinal receptors. Although some aspects of visual coding are innate, coding must involve memory where it enables us to recognize words or faces instantaneously. While the mechanism of visual memory is not well understood, it is apparent that a memory for visual features based on coding is important to a creative photographer just as a memory for words is important to a creative writer.

Related terms: cortical cell, feature detector, ganglion cell, geniculate cell, information processing, receptive field, visual memory.
References: **44** (434–438), **86** (35–59).

138

Left: A blank sheet of paper represents a steady-state stimulus. The corresponding neurological cells code this information by firing at a spontaneous rate until an irregularity is added. The altered rate of firing attracts our attention to the irregularity.

BLUE GRAY

Left: Coding with specialized components for different functions is illustrated by the greater sensitivity of the rods than the cones, but with a loss of color information. At a low light level the words BLUE (printed with blue ink) and GRAY (printed with gray ink) are legible but both appear neutral in hue.

Below: Some cells are precoded to respond only to an appropriate configuration such as a line at a certain angle. A more sophisticated coding enables you to recognize a friend in a crowd. *Photograph by Douglas Lyttle.*

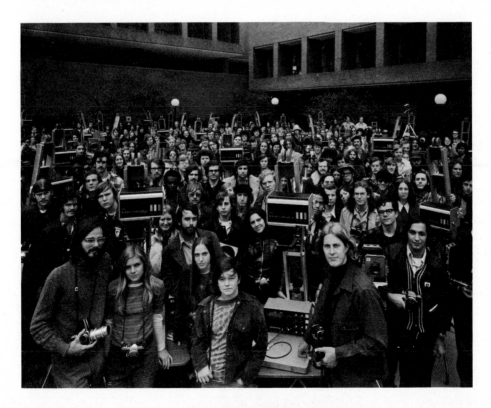

139

6.4 Image Dissection

Definition: The subdivision of a photographic or other image into small spatial elements for the purposes of image recording, transmission or enhancement.

The retina is a mosaic of photosensitive receptors—the rods and cones—each having a finite cross-section area. The continuous optical image that falls on the retina is therefore recorded, according to the pattern of the mosaic, as an array of small discrete areas, and is thus dissected. The discrete nature of the retinal array is not apparent because of the scanning behavior of the eye that smooths out the discontinuities.

Because of this scanning behavior and also because of the limitations of the visual optical system, photographic and other images appear continuous when appropriately viewed. This occurs even though the images may consist of small elements. In silver photographic images, the dissecting structures are the grains of silver that are randomly arranged within the emulsion layer. In a color photograph the original silver grains are replaced by tiny clouds of dye that are moderately distinct under high magnification.

Dissected images are also seen in television, where in black-and-white the raster—an array of horizontal lines—can easily be seen. In color television the image is further dissected into the red, green and blue dots that compose the image. The original image dissection is accomplished by a mosaic of photosensitive structures in the television camera. They are similar in function to those in the retina.

In each of these systems, image dissection in part results from the finite size of the basic recording structures, which must have areas large enough to absorb sufficient energy for the record to be made. In halftone pictures in newspapers and magazines, where it takes only low power magnification to see the dots of which the image is composed, dissection of the image is necessary because of the way in which the final image is formed. In a mechanical printing process, the press plate either deposits ink in a given area or leaves it blank. Such a go-no-go process demands subdivision of the image into small areas, accomplished by the use of a screen at some stage of the plate preparation.

Photographic images have for a long time been transmitted by an electrical signal over wire or by radio. The original is scanned by a small spot of light, and the light reflected from the surface of the photograph is received by a photosensitive receptor that generates an electrical current in accordance with the light level. At the receiving end of the system a sheet of photosensitive material is exposed using the light from a small lamp powered by the variable electrical current it receives.

It required only a technological extension of such a system to record signals from a camera placed on the moon or on Mars. In the high-resolution mode of the Mars camera, the receptor has a diameter of 0·035 mm, in each vertical scan of the camera there are 512 elements, and the camera system sequentially alters each scan line by an angle of 0·04°. For transmission purposes the continuously variable light on the sensor is stepped—the system can transmit any one of 64 levels representing white and black at the extremes.

One price that is paid for such a system is that the signal must be transmitted sequentially for a time sufficient to complete the scan of the scene. It takes about 10 minutes to receive on earth the data needed for one picture. It would take only a fraction of a second for a human observer to see the same scene if he were there.

An advantage of such a system is that the signal may be amplified, smoothed, or otherwise changed to produce a better image. Such changes, generally termed *enhancement*, take place in the visual system as well.

Related terms: analysis, information theory, redundancy, retina.
References: **90** (71–82), **119** (501–511), **208** (74, 77, 80).

Above: In a conventional photographic emulsion the dissecting structures are randomly arranged grains of silver.

Above, left: The human retina is a mosaic of rods and cones. The semicircle indicates the foveal area which contains primarily cones. From *Eye and Camera*, George Wald, Copyright © by Scientific American, Inc. All Rights Reserved.

Left: In television the image is dissected into a set of horizontal lines called the raster.

In graphic arts dots of varying sizes are used to dissect the image.

141

6.5 Visual Search

Definition: The perceptual strategy used to select specific information from pictures and other visual stimuli.

The term visual search implies that the viewer is purposefully looking for something specific. This is distinct from somewhat similar related activities such as selection and attention, where the effort is generally less conscious and the objective less definite. The most satisfactory procedure for studying a person's behavior during the searching process is to tell the person exactly what he is to look for. This is the procedure used by Ulric Neisser who did extensive research in this area, some of which was reported in *Scientific American* in 1964.

Neisser presented his subjects with columns of about 50 different letter groups (*see* opposite). The subjects were instructed to look at the columns and as quickly as possible locate the specified target, which had been placed in a randomly selected position. In one experiment the visual search tasks were varied in this way:

Column A: Find K in one of the letter groups.

Column B: Find a letter group that does not have a Q.

Columns C and D: Find Z in one of the letter groups.

Neisser found that the column A task required less time than the column B task—it is easier to locate and identify a specified item than to note its absence, which apparently requires a more careful examination of all of the letters. Somewhat different conditions were established for the visual search task of finding the Z in columns C and D. You may want to scan the two columns to note whether more time is required to locate the Z in one column than in the other. Neisser discovered that subjects required less time for column C where all of the background letters have roundish shapes than column D where both the background letters and the target letter have angular shapes.

A relevant observation for photographers is that a viewer separates figure from ground more easily when their features are distinc-

tively different. It was also found that a person can do multiple search tasks in about the same length of time required for a single task. In less than a month of practice, subjects were able to attend to five different target letters in the same time required for one. This suggests that there are perceptual strategies that can be used, analogous to combining separate small units of information into larger chunks, to make visual search more efficient.

Before tripping the shutter to make a picture, photographers are commonly expected to perform certain visual search tasks. Such tasks can be divided into two basic categories—to locate the presence of desirable features and to confirm the absence of undesirable features. Thus, in trying to capture a fleeting expression on a person's face during a portrait sitting, a photographer will first perform a visual search to be sure the lighting and the pose are correct and that there are no distracting features such as loose hairs, wrinkled clothing and light traps. Then, having set in his mind the expression he desires, he will continuously monitor the facial features waiting for the decisive moment which cues him to take the picture. Neisser's research suggests that these are perceptual skills which can be learned when the person knows what he is searching for.

Related terms: attention, information processing, instructional set, picture scanning, sequential/simultaneous processing, selection.

References: **86** (230–239), **153** (94–102).

A	B	C	D
ODC	QLHBMZ	URDGQO	XVWMEI
VBP	QMXBJD	GRUQDO	WXVEMI
EVZ	RVZHSQ	DUZGRO	XMEWIV
LRA	STFMQZ	UCGROD	MXIVEW
CEN	RVXSQM	QCURDO	VEWMIX
LRD	MQBJFT	DUCOQG	EMVXWI
BOD	MVZXLQ	CGRDQU	IVWMEX
HMU	RTBXQH	UDRCOQ	IEVMWX
HFK	BLQSZX	GQCORU	WVZMXE
NJW	QSVFDJ	GOQUCD	XEMIWV
QXT	FLDVZT	GDQUOC	WXIMEV
GHNR	BQHMDX	URDCGO	EMWIVX

A partial listing of the letter groups used by Ulric Neisser in his visual search studies.

Group photograph of some of the members from the Society for Photographic Education taken by *Neal Slavin* at the 1974 conference in Rochester, New York. (Search out the girl exhibiting her breast. She is standing near Mickey Mouse.)

6.6 Selection

Definition: The active seeking and extracting of information from the environment by means of vision and the other senses.

A useful way to think about perception is that it is a process of information selection. At any moment, whether you are looking at photographs, listening to music or eating at a restaurant, the senses are confronted with a potential galaxy of information. It is not possible or necessary to attend to all of the information available. It is only necessary to select that information considered important or interesting. The process by which this takes place is not well understood but is known to include the proper orientation and adjustment of our sense organs coordinated through our central nervous system and memory. During a soft falling snow or rain, a single snowflake or raindrop can be followed to the ground. Man's ability to be selective is amazing.

Certain everyday experiences often repeated become routine. For example, when driving a car attention is given only to a small fraction of the available information—other cars, street signs, signal lights, and whatever else is essential for safe driving. Occasionally, of course, the driver becomes distracted and attends to things of interest that are unrelated to the task of driving a car.

Repeated experiences which become routine simplify the perceptual task, but unfortunately at the expense of seeing new things in such experiences. Habit interferes with new selection. Once a figure is observed in a scene or picture, then the same figure is observed with continued or repeated viewing. Someone new to the situation will select differently and, therefore, see and photograph differently. This is one reason new locations and travel can be so expanding and exciting. A real perceptual challenge, however, is to see newness in a familiar environment and in routine situations. Helmholtz once suggested looking at a familiar landscape through one's legs to see it anew.

Photographers can use techniques such as framing part of a scene with the hands or scanning a scene through the camera view-finder as selection aids. Once the selection is made, further emphasis can be given by such photographic controls as choice of the camera viewpoint, a slow or fast shutter speed, a large or small aperture, an appropriate type of film, and later, by the use of various selective printing techniques. These controls guide the viewer's selection process when looking at the photograph.

Interest is an important factor which influences selection. One amateur photographer may take pictures mostly of people while another selects buildings or landscapes. Professional photographers must give preference to their clients' interests and they often have constraints placed on their freedom of selection. At one extreme they may be required to conform to an art director's sketch while at the other extreme they may be given complete freedom in illustrating a concept.

Memory also plays an important part in selection. Photographers commonly select a subject because of a similarity to a memory of an effective photograph, and some keep 'swipe files' of such photographs made by other photographers specifically for that purpose. On the other hand, a photographer may not select a subject because he remembers seeing so many similar photographs that it strikes him as being trite.

Related terms: attention, picture scanning, visual search.
References: **49** (287–307), **71** (250–253), **86** (228–230).

The photograph on the left was taken without a filter while the one on the right with a red filter. Note how the tonal values in the photograph are altered, particularly the red vest worn by the model. (Colors in a scene that are the same as the filter are lightened.)

The selection of camera position alters the relationships of objects and persons in a photograph. *Photographs by John Jean.*

6.7 Attention

Definition: A mental activity which predisposes a person to respond to certain aspects of his environment and not to others.

Although the term 'attention' is often used to refer to selectivity of information, it has a far broader meaning. In fact, even some psychologists find it difficult to separate attention from perception. They contend that to attend is to perceive. For our purposes, however, it is useful to extend the mechanisms of attention to include *arousal* and *intensity*. Using the visual system as an example, the rate at which the neurons in the optic nerve discharge is directly related to the intensity of light impinging on the retina. The intensity or strength of incoming stimuli affects the response of an area of the brain called the *reticular activating system*. This network of cells is known to be sensitive to stimulation received from all the senses. The senses, therefore, play an important role in maintaining a general level of arousal. Activating the senses leads to arousal and to attention. Deactivate the senses and the level of arousal drops, as does the attention level. An extreme case of deactivation is sensory deprivation.

In vision, the neural impulses traveling from the retina through the optic nerves go directly to the primary visual projection area in the occipital region of the brain and indirectly via the reticular system. As an indirect sensory pathway to the cerebral cortex for all the senses, the reticular activating system serves as a 'control center' for the regulation of activation and alertness. Since it serves all the senses, there must be some way of preventing an information overload. This is accomplished through a feedback system between the brain and the sense receptors, which act as a kind of attenuator or gating mechanism on sensory activity. When a visual stimulus needs to be attended to, for example, the brain sends information to the other senses to lower their sensitivity but to stand by in case something unusual occurs. This kind of sensitivity attenuation is called *sensory gating.*

Sometimes it is helpful to introduce controlled sound information (soft music or 'white noise') to mask out noises which compete for attention when a visual task requiring concentration is involved. The basic factor responsible for arousing attention is *change*—some type of change in the incoming sensory information. Consider the attention mechanisms as high-level feature detectors in which the feature is change. Only things that are changing are transmitted; steady-state conditions of the environment are not transmitted to the brain.

In terms of the visual process, the four major categories for change are intensive, geometric, temporal and spectral. Change any one of these attributes and attention is aroused. In addition, the idea of novelty calls attention to an event. A photograph of a girl in a classroom wearing a bikini will certainly draw more attention than the same girl at a beach. A few black-and-white pictures among many color pictures on display attract attention as would the opposite situation. In a recent motion picture designed to frighten the audience, occasional frames were blank so that the high intensity short duration light on the screen would heighten attention to what was to come next. In listening to and watching movies, a change in music is often used to alert the viewer that the scene is about to change. Experiments in how long a particular 'cut' should remain on the screen have shown that over the past 10 years the average duration has grown progressively shorter—a reflection of the fast visual pace of today.

Related terms: arousal, concentration, selection, sensory gating.
References: **86** (228–229), **119** (534–539), **209** (69–73, 100–101).

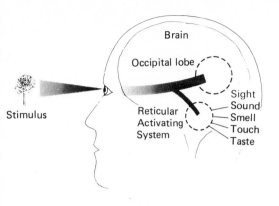

Brain

Occipital lobe

Stimulus

Reticular
Activating
System

Sight
Sound
Smell
Touch
Taste

Left: Visual information from the retina can go directly to the occipital lobe or indirectly via the reticular activating system. This system is sensitive to all sensory inputs and serves as a control center to prevent an information overload.

Below: Change is the key factor in arousing attention. Novelty is a consequence of change in expectation. *Photograph courtesy of Ogilvy and Mather Inc. on behalf of its clients, General Foods.*

6.8 Redundancy

Definition: The presence in a visual image of more information than is necessary to convey the message.

In the sentence 'Smith will arrive in New York at one o'clock in the morning' there are 58 symbols including word spaces. Of these, only a few are really needed to convey the meaning of the sentence, and a telegraph message such as 'Smith arrive NY 1 AM' with only 20 characters is intelligible. Thus, the original sentence can be diminished in length by about half, without loss of sense. As in most English, the redundancy in the sentence is roughly 50%.

Pictorial images contain far more redundancy than this. Compare a typical photographic portrait with a sketch by a skilled caricaturist. The latter makes the person recognizable with only a few significant lines, as contrasted with the richness of detail and the multitude of tones in the photograph.

In a 5 cm (2 inches) square identification picture, at a normal viewing distance, there are about 250,000 resolvable spots, each of which may have any one of about 64 distinguishable density levels. In such a picture, there is a total of $250{,}000 \times \log_2 64$ bits of information—approximately 1,500,000 bits. If there are 6 billion inhabitants of the earth, only about 32 bits of information in a picture would really be needed to distinguish any one person. Such an analysis indicates that there is far more information in the picture than is needed, and the redundancy is much more than 99%.

For many applications, the amount of information in a pictorial image can therefore be reduced in the interests of economy. In newspaper photographic reproductions, there are only two density levels—ink or no ink—and by the screening process the minimum dot size is increased, so that there are many fewer elements per unit area. Nevertheless, the images are comprehensible. The use of a finer screen, as in magazine reproductions, makes the pictures more attractive without increase in meaning. Only rarely, when significant fine detail must be reproduced, is the very fine screen necessary for other than esthetic reasons.

The transmission of images from space satellites required a reduction in redundancy to keep the amount of equipment, power and transmission time within reasonable limits. On the early models, only a few density levels and a fairly large element size were used. Similarly in television, redundancy is decreased by the limited number of scanning lines used in the screening process.

In motion pictures, redundancy is reduced both spatially and in time. A single frame from a 35 mm motion picture is poor in detail as compared with a 35 mm still photograph (due to smaller format and $\frac{1}{50}$ second exposure). Furthermore, instead of the continuous flow of motion in the original scene, only a sample is recorded at 24 frames per second, so that only a small fraction of the information contained in the scene is presented to the viewer.

Black-and-white photography is far less redundant than color photography, since all the hue and saturation characteristics of the scene are not recorded. Nevertheless, for reconnaissance and survey purposes, black-and-white images generally serve the purpose and color photography is used only when the additional information is required.

Redundancy is costly, but it helps to ensure the correct receipt of the message, even in the presence of unavoidable random error. If the telegraph message above were completely nonredundant, and contained only a single error, perhaps such as 'Smith arrive NY 1 PM,' the sense of the message would be lost. Similarly, any small defect in a completely nonredundant photograph would destroy its effectiveness.

Related terms: image dissection, information theory, signal–noise.
References: **147** (42–46), **154** (111, 123, 135, 235), **206** (60, 62, 226–229, 300).

If the message to be recognized is the face, the photograph is highly redundant compared to the photographic line derivation (middle) or the artist's sketch (right). *Sketch by Nile Root.*

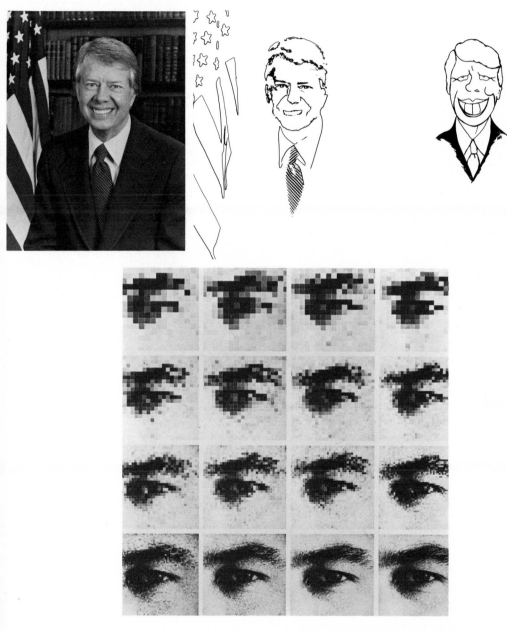

Examples of images varying in informational content. A photograph of the human eye was digitized and then reassembled in a sequence of mosaics having increasing information. *Courtesy Society of Photographic Scientists and Engineers.*

149

6.9 Ambiguous Figure

Definition: The arrangement of visual elements within a picture such that at least two different perceptions are possible.

Ambiguity of expression and communication has been a fascination to man throughout the ages. In some cases it has been intentional and in others accidental—sometimes it is inherent in the design and at other times incidental to it.

A simple and striking example of the problem that ambiguities of depth present to a scientist was described in 1832, by the Swiss geologist Louis Albert Necker. Necker called attention to the fact that the observation of a rhomboid crystal through a microscope could be seen in either of two different depth perspectives. Look for awhile at the illustration of the cubic crystal shown on the opposite page and experience this depth reversal. Such reversals could present a problem to the photographer if the subject matter contains, for example, geometric figures such as stairs or cornered walls. Care must be taken in the lighting arrangements, the camera position and the cropping. Ambiguous figures are much less common in photographs than in line drawings, however, because of the redundancy of information in most photographs.

An example of ambiguity in grouping of repetitive visual elements can be found in many of the different expressions of arts and crafts. Maurits Escher's work is a prime example, as are early American quilts which present not only a popular folk craft but also a fascinating design tradition. Ambiguous figures can also be embedded in cubistic paintings, such as Picasso's.

Ambiguous figures are a reminder that when alternative representations of visual information are contained within a picture, the human perceptual system will sometimes adopt one and sometimes another, provided the representation is about equally probable. The gestalt principles of visual organization can be used to intentionally reduce or enhance the probability of ambiguity.

Ambiguity also occurs with the spoken and written word. Homonyms are prime examples of ambiguity or confusability of words because they sound alike: made/maid, would/wood, sum/some, board/bored. A script to be narrated should be read aloud first to avoid confusability of words that have different meaning but sound alike. 'Knock-knock' jokes from years past were based on sound confusability:

Knock-knock!
Who is there?
Cantalope!
Cantalope who?
Cantalope tonight. Dad has the car.

The visual equivalents of homonyms are words that look alike, such as angel/angle, gentle/gentile, neutral/natural, conservation/conversation and public/pubic. During Edward Weston's career, a museum refused to display a couple of his nudes showing pubic hair. The letter from the museum stated that they would not display photographs showing public hair. From then on Weston referred to pubic hair as public hair.

Photographers can add humor and uncertainty to certain photographs by using words that are confusable. Graffiti functions on the basis of ambiguity. An example of ambiguity of meaning is 'My boss's wife wakes up with a jerk'. An example of ambiguity of sound is 'Some psychiatrists are symbol minded'. (The word 'photographers' could be substituted for 'psychiatrists' in the latter expression.) An example of ambiguity of sight is '*Conversation* helps preserve our natural resources'. Needless to say, some advertisers thrive on ambiguity of words and pictures.

Related terms: confusability, embedded figures, impossible figures, labile figures, reversible figures.
References: **13** (63–71), **127** (83, 183–186, 191–193), **173**, **197** (90–104), **204** (114, 136, 194).

Geometric figures such as the Necker cube (*left*) or cornered walls and stairs (*right*) can spontaneously shift in appearance and cause depth reversal.

Above: An early American quilt design. *Graphic Illustration by John Wolven.*

An ambiguous photograph. In which direction is the couple walking? *Photograph by Tom Rogowski.*

6.10 Illusion

Definition: A false perception of one or more stimulus attributes such as size, shape, form, distance, color and motion.

Like the tricks of a magician, illusions contradict daily experiences, and cause amusement and at times frustration by eluding rational explanation. Studies of illusions reveal more about the inner perceptual world than they do of the surrounding physical world. Naively, a direct correlation is assumed between certain characteristics of an object (such as size, spectral reflectance, luminance) and those of the percept (apparent size, color and lightness). When the correlation fails, an excuse is provided by labeling the situation an illusion. Such phenomena serve to demonstrate the complexity of the perceptual systems and the opportunities available to photographers who want to put illusions to use. Stage designers, and motion picture and television people spend a good part of their time creating sets, which provide within a limited space an illusion of great distance and solid form. The concept of illusion is also involved when scale models are used to represent full-size counterparts in motion picture and still photography. There are many different types of illusions but most can be fitted into three broad categories—*geometric, colorimetric* and *motion* illusions. The geometric illusions are a result of misperceptions of size, length and shape (*see* opposite). One of the sobering realities about illusions is that even when recognized, the perceptions they produce still remain uncorrected. The slanted lines in the Zollner illusion are parallel, yet they are not perceived as such. Only when the background is changed or a reference straight line inserted, is the illusion destroyed and the slanted lines are seen as they are actually drawn.

Colorimetric illusions involve misperceptions of hue, saturation and brightness. The *perception* of color is dependent upon its relationship to its surroundings. It is a figure–ground relationship. Change the ground and the perception changes—even if the physical amount of pigment and the lighting situation remain constant. A gray against a black ground looks lighter than a gray against a white ground (*see* opposite). Contrast has changed within the same physically gray area. The Hermann grid illusion, which depends on retinal inhibition, is one of the visual effects that make optical art paintings such as Vasarely's *Supernovae* so engaging and disturbing.

Many nature photographers have made use of the moon illusion to enhance their photographs. At the horizon, the moon looks much bigger than it does overhead. The best explanation of this phenomenon is an ancient one. The moon is known to be as far away at the horizon as it is overhead. Terrestrial perspective cues, however, cause the horizon moon to appear farther away than the overhead moon. Optically, if the image on the retina is to be the same size for objects at different distances, then the farthest object must be largest. To reconcile the error in distance judgment, the apparent size of the moon must be unconsciously increased. Size and distance are interrelated in what has been called a 'size-distance invariance.' Many illusions are a result of this invariance, such as the Emmert effect, which can be used to demonstrate the moon illusion. Stare at a bright horizon moon during daylight hours and then project the afterimage of the moon on the sky above. The moon appears smaller in size.

Related terms: ambiguous figure, constancy, Emmert effect, size-distance, invariance.
References: **82** (66–76), **83, 105** (78, 79), **120** (120–130), **135** (62, 63, 68–71), **139,** **173** (40–44), **218** (150–167).

1

2

3

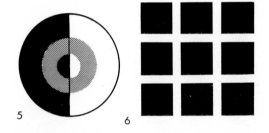

4

1, *Zollner illusion (shape and size):* The seven long lines are physically parallel to each other as are the many shorter lines.
2, *Mueller-Lyer illusion (depth):* The physical distance between the concave and convex arrows is the same.
3, *Helmholtz illusion:* The physical size of all three squares is the same. Divided areas *appear* larger.
4, *Jastrow illusion (shape and size):* Both crescents are physically the same shape and size.

5

6

5, *Lightness illusion:* The two halves of the gray ring have the same physical amounts of ink.
6, *Hermann grid illusion:* Small gray dots *appear* at the intersection of the white lines.

A special crate for shipping optical illusions. The photograph is a paste-up by *C. F. Cochran.*

6.11 Stroop Effect

Definition: Perceptual interference caused when a color hue name (eg. red) is printed in a different hue (eg. green).

Perception can provide clues to personality and psychologists have used a variety of perceptual tests as one way of studying personality types. Some of the more common tests are the Rorschach, thematic apperception test, closure tests—and also the embedded figure, and rod and frame tests for determining field dependency. The Stroop color-word test is a unique perceptual ability test which requires nothing more than the ability to read color hue names and to identify the hues used in printing the names. The difficulty of the task is a consequence of the contradictory situation the perceiver is put into and the pressure to resolve conflicts quickly. The ability to name the hue by overcoming the interference between the name of the word (red) and the hue of the printed word (green) is a measure of a personality characteristic some psychologists refer to as 'flexibility.'

In the Stroop test a page of 100 color words and patches is printed in various colors which contradict the color names. As the viewer looks at each word, conflicting verbal and color information are received causing interference. Part of the information presented, e.g. the hue name, is irrelevant and must be ignored when the hue of the printed word and not the meaning of the word is to be named. Overcoming the interference or noise depends on the perceiver's use of a perceptual strategy which allows him to block out irrelevant information —to separate the specified figure (hue) from the ground (word). Filtering out unwanted information requires a high degree of attention, selectivity and flexibility when confronted with conflicting information.

Stroop found that correctly reading the words printed in different hues required about the same time as reading them when they were in black. Naming the different red, green, blue, brown and purple hues used to print the words, however, required nearly 75% more time. Word meaning interfered with identifying the actual color hues.

The relationship of the word and color information presented in the Stroop Test is *contradictory*. Other possible relationships between stimuli are classified as *unrelated* (square shape in blue), *related* (heart shape in red), and *redundant* (the name of the word and the hue of the printed word are in agreement). When multisensory information is presented, it is usually related or redundant. If it is unrelated it is easily ignored, but if it is contradictory it causes dissonance.

The problem of contradictory information is relevant to photography in many ways. When infrared color film was introduced, it took a while for people to adjust to the 'false colors' that conflicted with the known colors of the objects. The viewer, for example, has to accept the photographic fact that green is red—healthy green foliage records as red. In obtaining information from a negative, it is necessary to learn that tones are reversed from black to white. The ability to visualize a positive image when looking at a black-and-white or color negative will vary among people, depending upon experience and the perceptual strategies each can bring to bear. Specialists in the field of photographic interpretation have developed such skills. Zone System photographers in previsualizing must selectively shift the various tones in the scene to the print tones they imagine and desire.

Related terms: cognitive dissonance, field dependency/independency, figure—ground, perceptual dissonance, perceptual readiness, projective techniques.
References: **43** (371–383), **46** (625–627), **86** (243–244), **194** (648–661).

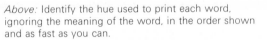

RED	GREEN
BROWN	PURPLE
BLUE	RED
GREEN	BROWN
PURPLE	BLUE

Above: Identify the hue used to print each word, ignoring the meaning of the word, in the order shown and as fast as you can.

Above: Photographs made with 'false color' systems such as Infrared Ektachrome are, when first experienced, disturbing. *Photograph by Ralph Amdursky.*

This unusual photograph of a single red apple with assorted white fruit attracts your attention, but you have become accustomed to seeing colored objects reproduced as tones of gray in black-and-white photographs without experiencing perceptual interference. *Photograph by David Spindel.*

6.12 Visual Masking

Definition: When pictures or other images are presented in quick succession, the alteration or even elimination of the perception of one image by an immediately preceding or following image.

The visual system is a poor timekeeper when it is presented with a quick succession of short, discrete visual stimuli. The length of time each image is available for viewing, the length of time between images and the nature of the configuration of each image all influence what is seen, particularly when the times are in the order of magnitude of 1/10 second. The ability to discriminate images presented for short times is referred to as *temporal resolution*, as distinct from the more familiar *spatial resolution*.

The term, *visual masking*, is used to describe three different but related phenomena that result from the interaction of visual events that are contiguous in time. The first is called *masking by light*. When a dark-adapted eye is suddenly flooded with light, it loses sensitivity, so that the luminance required to see detail in a dark area is increased, or tonal areas appear darker than before. Thus, if a resolution target on film is being read through a microscope in a darkened room and someone inadvertently turns the room lights on, the immediate effect is a reduction of contrast.

A second type of masking effect, called *masking by adjacent contours*, is dependent upon a precise spatial relationship of contours that are nearly touching. If, for example, a single letter is projected briefly onto a screen and then followed, about 1/20 second later, by an image that closely encompasses it, the letter which otherwise could have been seen clearly, may not be seen or may be seen as being dim with indistinct contours.

The second stimulus appears to act backward in time, degrading the first stimulus. Consider a single frame motion picture sequence in which a quite different image is projected every 1/24 second. Because the image on each frame is quite different, persistence of vision is not involved. If the contours of the second frame are close to some of those in the first frame, a backward masking effect can occur, which blocks out some of the image in the first frame.

Although both masking effects are similar in that they appear to act backward in time, they are different in that masking by light requires that the luminances of the two different light stimuli be different, and that they overlap spatially on the retina. The critical feature of spatially adjacent contours in masking by contours suggests a lateral inhibition effect.

The third type of masking is *masking by visual noise* and involves the temporal interaction between the first stimulus and the second one, which contains random lines, dots, grain, etc. The introduction of the visual noise stimulus masks the visual information in the first stimulus. It is likely that the contours in the visual noise mask are similar to many of those in the first stimulus, and when they occur in close spatial and temporal proximity, the viewer can no longer distinguish the features in the first stimulus from those in the second stimulus.

Related terms: masking, metacontrast, temporal integration, temporal resolution.
References: **86** (124–134), **119** (493–495).

Visual masking: The visual system is affected by discrete stimuli which occur in rapid succession. The second stimulus acts backwards to degrade and sometimes abolish the perception of the first stimulus. Three types of visual masking are demonstrated below.

Masking by light: First stimulus falls on dark-adapted eyes. Second stimulus overlaps spatially on the retina.

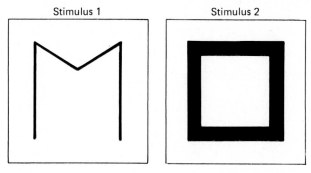

Masking by contour: Contours of second stimulus fall very close to contour of first stimulus.

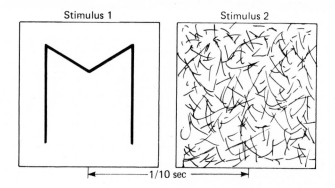

Masking by visual noise: Contours of second stimulus act as a visual noise since some of the contours are similar.

Synthesis of Information

7.1 Picture Scanning

Definition: The process by which a viewer integrates information from the parts of a picture, including shifts of attention and movement of the eyes.

There has been considerable interest in determining if people move their eyes as predictably when viewing pictures as when reading. Eye movement studies have revealed that when reading, the eyes typically move along the lines of words with alternating jumps (saccades) and pauses. The length of the jumps, the frequency, and the duration of the pauses vary among persons, as do the number of regressions. These factors also vary for a given person, especially if the reading material changes in difficulty or the desired degree of comprehension changes. Similarly, the eyes jump and pause while looking at pictures, but not as systematically with respect to direction as when reading. Viewers do not necessarily spend the most time looking at the part of a scene or picture that is assumed to be the most important.

Thus, eye movement studies can provide information concerning the parts of a picture or scene that provide the strongest attraction for the viewer. Direct observation can be used for crude eye movement studies. However, one sophisticated system uses infrared radiation which the subject cannot see, a concealed video camera and recorder, and a computer to process and analyze the recorded movement information.

It would seem that the viewer could simply be asked to identify the local areas he looked at during the picture scanning process. A comparison of such reports with the corresponding eye movement records commonly reveals discrepancies. An explanation of such discrepancies is that the viewer can see a considerable area around the point actually being fixated. Thus, while looking steadily at the center of a picture, he could conceivably mentally scan the entire picture without moving his eyes. In practice, the viewer cannot see fine detail very far from the point of fixation, but if he thinks he recognizes the shapes of the major objects in the picture he may not be highly motivated to move his eyes to examine the outlines more critically.

Further evidence of mental scanning is revealed by briefly flashing a picture on a screen in a darkened room. Viewers are often able to make surprisingly good sketches of the bold features in a picture presented for only 1/500 second, too short a time to permit movement of the eyes. Even though a persistent image is available for mental scanning for a somewhat longer time, movement of the persistent image with the eyes prevents eye scanning or optical examination of different parts.

Angles tend to attract the eye more than straight lines, and the viewer tends to fixate areas of high contrast more frequently than large uniform areas. Photography students are often cautioned to avoid making 'busy' pictures containing much irrelevant detail, which would attract the eye away from the main subject. When looking at a portrait, viewers spend more time fixating the eyes and lips than the neck, forehead, hair or clothing. Advertising photographers often include pretty models with the products they photograph, for the purpose of attracting the eye of a person leafing through a magazine. But unless the photograph is skillfully composed the person may devote the viewing time to looking at the model and ignore the product.

Even though different people may spend most of their viewing time looking at the same features in a picture, the order in which the different areas are fixated varies considerably, as distinct from reading where the direction of eye movement is generally from left to right. However, the human mind is able to accept such visual information sequentially over a considerable period of time, with the component features viewed in any haphazard order, and assemble it into a complete and accurate internal representation.

Related terms: eye movement, memory, sequential–simultaneous.
References: **160** (32–43), **187** (200–206).

Three variations of eye-fixation patterns as a result of different instructions. No instructions were given for the pattern on the top right. The subject was asked to estimate the material circumstances of the family in the picture for the pattern on the bottom left, and to give the ages of the people for the pattern on the bottom right. *Courtesy of Plenum Press, 1967.*

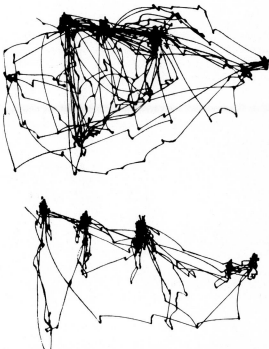

Left: The dots on the cube on the left indicate the actual fixation points of a viewer who was instructed to examine the drawing of a cube. The dots on the cube on the right are the points where the subject thought he had looked. The differences between the actual and the reported fixation points indicate that the subject's internal shifts of attention went beyond the changes provided by the eye movements. Such factors as redundancy, symmetry, and familiarity make it unnecessary for the viewer to fixate every detail in the image. *Noton and Stark,* ©1971 Scientific American, Inc.

7.2 Fusion

Definition: The perceptual integration of stimulus elements that are separated in time or space.

There are limits to the ability of the visual system to accurately perceive separate stimuli that follow each other very rapidly *(temporal resolution)* or are relatively small and close together *(spatial resolution)*. For many purposes, high temporal and spatial resolution are desirable. For example, high-speed and slow-motion photography are used to reveal details in rapidly occurring events, and eyeglasses, magnifiers and telescopes help to reveal details that appear too small to be seen clearly with the unaided eye. In other situations high resolution can interfere with the desired effect. For example, resolution of the individual pictures in a motion picture would destroy the 'realism,' so the rate of projection and other factors are controlled to produce a fusion of the consecutive images. Similarly, fusion smooths out the fluctuations of television images, and of fluorescent lamps which are used for transparency and print illuminators as well as for general room illumination.

The concept of temporal fusion has been useful in the study of additive synthesis of color. If sectors of white and black paper are attached to a motor and spun rapidly, the viewer sees a fusion of the separate elements, which appears gray. Changing the proportions of white and black changes the lightness of the gray. Albert Munsell made considerable use of the temporal fusion of colors in working out his color notation system. The three attributes of a color sample can be altered systematically by fusing it with varying amounts of other appropriate samples. Thus the *value* (lightness) of a red sample can be controlled by fusing it with white or black, the *chroma* (saturation) by fusing it with gray, and the *hue* by fusing it with green or blue. By making interlocking disks of the samples, the size of the sectors and therefore the relative amounts can be altered easily by rotating one of the disks in relation to the other. After obtaining a desired color by fusion, Munsell matched the color by mixing pigments. A shortcoming of this procedure is that even though only a single physical attribute of a color is altered, all three of the psychological attributes may be affected. For example, fusing black with a color may somewhat alter the hue and saturation in addition to the more obvious change in lightness.

Since silver and dye photographic images are not homogeneous, spatial fusion or blending is usually desirable to prevent detection of the particle clumps. This becomes a special problem when small negatives or transparencies are greatly enlarged. The maximum magnification at which spatial fusion occurs can be used as a measure of graininess, and is commonly referred to as the *blending magnification*. A number of factors can affect the blending magnification for a given negative, including print density and contrast, the viewing illumination level, the amount of detail in the scene, and the print surface. Textured printing papers are commonly used to camouflage graininess and therefore increase the blending magnification. Spatial fusion of the picture elements is also desirable for photomechanical reproductions of photographs. Unfortunately the finer halftone screens can be used only with the more expensive coated paper stocks, so that the picture elements of reproductions in newspapers usually do not fuse at the normal viewing distance.

Complete spatial fusion is not essential for the production of effective pictures. Mosaics constitute an example where the picture elements are too large to fuse at the usual viewing distance but are small enough to produce images with reasonably good detail.

Related terms: blending, critical flicker frequency, critical fusion frequency, flicker, integration, spatial resolution, temporal resolution.
References: **30** (288–291), **55** (210, 215–216).

Ceramic squares (2·5 cm, 1 in) containing 18 different pictures and designs (*lower left*), with systematic variations in the light-dark proportions, were used to make a 6×18 m (20×60 ft) mural in the Aviation Hall of Fame entrance lobby in Dayton, Ohio. Viewed from a distance, the elements fuse to form a realistic picture of the historic first flight by the Wright brothers on December 17, 1903. A closeup of an area between the wings is shown at the lower right. © *Aviation Hall of Fame, Inc.*

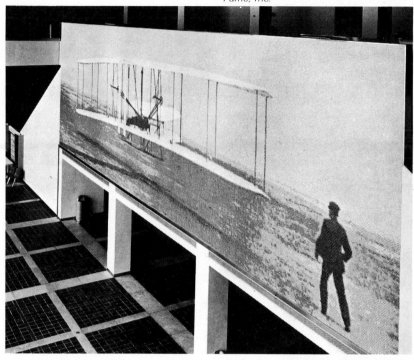

7.3 Gestalt

Definition: The perception of images as organized configurations rather than as collections of independent parts.

The word *gestalt* comes from the German language and means 'shape' or 'form.' Used in a perceptual context, it has come to mean 'the whole.' As applied to visual perception, gestalt refers to the observable fact that things are seen as relating to each other and not as discrete elements. Words or groups of words are seen as they are read, not letters— pictures are seen when mosaics are viewed, not individual pieces of tile. Motion is observed when films and TV are viewed, not a sequence of still pictures, or line elements. It is easier and more probable to see the totality of an event rather than the individual features or elements that make up the event. In short, the whole is greater than the sum of its parts—provided the parts are organized. Grouping or summation of spatial and temporal information is a natural perceptual process. It allows the viewer to cope with large amounts of information by grouping it. In terms of information theory, grouping reduces the amount of information.

Max Wertheimer founded the school of Gestalt psychology in 1912 and 7 years later Walter Gropius started the famous Bauhaus art school. Both schools approached the human problems resulting from the scientific advancements of that period in an integrated manner. The psychologists were influenced in their study of perception by the field theory of physics and believed that both physical and perceptual systems strive to reach as simple an organization as conditions allow. The Bauhaus artists developed a curriculum based on structure (Bau) that would bring together the basic design qualities inherent in all visual arts.

The tendency for two or more elements in a visual field to be seen as being part of an organized configuration depends upon how the elements perceptually relate to each other. In studying these relationships, the gestalt researchers established a number of principles that became known as the *gestalt laws*. Of special interest to photographers are figure— ground, proximity, similarity, symmetry, continuation, closure, common fate and isomorphism. Attention to these principles is basic to the understanding of photographic design. They can assist the photographer in decisions regarding the simplest arrangements between lines, shapes, forms, colors, textures and movements that facilitate relatedness and grouping. According to the *law of Prägnanz*, picture elements tend to assume the 'best possible' figure—which involves the concepts of meaningfulness, completeness and simplicity. All of the factors listed above as gestalt laws can contribute to the effectiveness of this figure.

Whereas viewers of pictures are primarily concerned with the gestalt, photographers must be able to switch their attention between the parts and the totality to determine if the whole picture can be improved by making changes in the parts. Attempts to compose photographs by devoting excessive attention to arranging parts according to rules, however, can produce an overall effect similar to that of a picture 'painted by numbers.'

Although the term gestalt is most commonly applied to uniting spatial elements, it also can be applied to other visual attributes and to other senses. In reviewing Stanley Kubrick's film *Barry Lyndon*, critic John Hofsess referred to portions of the film as '. . . cinematic gestalt—inspired combinations of words, images, music and editing rhythms, creating a kind of artistic experience that no other medium can convey' (*New York Times*, January 11, 1976).

Related terms: grouping, holistic, phenomenology, Prägnanz, synergy.
References: **10** (4, 63, 67), **86** (187–189, 193–195), **97** (108–110, 164, 241), **98** (134–138), **215** (15–17).

A 'human mosaic' consisting of 21 000 soldiers so positioned that a gestalt of an early American president is easily perceived. *Photograph courtesy of Harry Miller.*

7.4 Closure

Definition: The gestalt principle that nearly complete familiar lines and shapes tend to be perceived and remembered as being more nearly complete.

Visual shapes and forms may be open or closed, incomplete or complete. If the visual elements of an open or incomplete stimulus are properly positioned and oriented, there is a perceptual tendency to group these elements into a more stable form. The three disconnected lines shown on the opposite page are more stable when seen as a completed triangle, and the twelve dots when seen as a completed circle. Triangles and circles are very familiar shapes, and it would be a difficult task not to see the elements as such. The arrangements of the visual elements are such as to almost force a closure. With a small change, you could almost ensure they would not be seen as a triangle and circle. For example, if the distance between the dots were increased and if the shape, size and color of the dots were different, seeing a circle would not be as predictable.

The importance of the arrangement of visual elements is easily seen in the General of the Army flag, which consists of five similar stars. The distance between the stars and the orientation of each of the five pointed stars were carefully designed so that the viewer can easily form a closure on the area inside the stars to see a familiar geometric shape. The arrangement and design are perfectly balanced. If one of the stars were only slightly tilted from its position, closure would be impaired.

The concept of closure is important to every human experience. If the viewer is not allowed to complete things, he can become frustrated and lose interest. On the other hand, it has been shown that completed and incompleted tasks are retained differently in memory. The incompleted tasks tend to set up a tension that facilitates memory for them. Once the task is completed, the tension is released and the tendency to remember it is lessened. In psychology, this is called the *Zeigarnik Effect* (*see* topic 15.9).

In the design of photographs, the photographer should plan to allow the viewer to participate in the visual experience by contributing something to it. Whether the viewer is allowed closure will depend upon the intent of the photograph, whether to precipitate a mild tension with immediate release, or a strong tension with information stored in long-term memory for release at a later time.

Harold Edgerton's stroboscopic photograph of a golf swing can precipitate a mild tension when first seen, allowing easy participation in the spiral movement. The design of the photograph is such that the similarity and proximity of the multiplicity of golf club images provide continuity which facilitates grouping and therefore closure.

When making decisions on how to crop pictures, simulate different croppings before actually cutting the print. For example, how much of a hat or of a wedding gown can you crop out and still allow the viewer to form a closure and see the entire hat or gown?

In the making of photographs for highly expressive and artistic endeavors, opportunities for closure are equally important. Minor White, in his book *Mirrors, Messages, Manifestations*, provides us with this thought: 'So help me find opportunities which offer friends unclosed photographs which will present them a chance to close circles out of their roundness.'

Closedness is an extension of closure. Other things being equal, areas with closed contours will tend to be more readily seen as figure than those with open contours.

Related terms: closedness, Zeigarnik effect. *References:* **97** (149), **215** (66–75), **218** (131–132).

It is easier to see the lines and dots as forming a
triangle and a circle than not. This is called closure.

Below, left: When the area contained within the stars
is seen as closed, a geometric figure emerges.

1 ② 3 4 ⑤ 6

Above: Closed areas are more easily seen as figure than
open areas. This is called closedness.

Careful cropping of a photograph is important if
interrupted familiar shapes such as circles and elipses
are to be psychologically completed. Closure of a circle
is experienced when the upper part of the umbrella is
'filled in' and the lower part is seen as a continuation of
line. *Photograph by Lee Howick.*

7.5 Continuation

Definition: One of the gestalt laws of organization, which predicts that the visual elements requiring the fewest number of interruptions will most likely be grouped to form continuous straight or curved lines.

The eye, in a sense, is a lazy instrument and usually takes the path of least resistance in grouping visual information. Look at the illustration (opposite, upper center) and remember the configuration you first see. Now look at it longer and force yourself to see a different configuration or grouping.

Perhaps the first thing you saw was a pair of 'X's, since this would require the fewest interruptions or changes. Seeing a diamond shape is also relatively simple. Both the 'X's and the diamond are familiar and the lines involve few changes in direction. In addition, the diamond is a closed figure and this facilitates its perception. With extended and concentrated viewing, you can see other figures including 'W', 'M' and 'V'. These are harder to see since they require more interruptions and must be separated from an easier configuration.

The use of continuation as an organizing principle can be found in graphic designs, packaging designs, paintings and photographs. In fact, it can be found in any visual design, since it is basic to the way humans process information. The illustration of a package of cigarettes is an effective example of how continuation can be used as graphic design. The shape of the package is a vertical rectangle and continuation against an alternating black and white background produces a dynamic slanted line. Continuation of line can also be seen in the circles centered on the package, even though the design is such that the circle is divided by the slanted line and separated into two half circles by tonal differences. It is predictable that the split circle would be easier to see as a continuous circle and the split slanted line as a continuous line.

A much more sophisticated example of continuation of line can be found in cubistic paintings. Picasso's *Ma Jolie* serves as an example. In the painting the viewer can see considerable continuation of lines across other lines and areas having different tonalities. In some areas, the interplay causes lines to appear to change with continued viewing to form different movements and shapes.

Continuation can be used in the design of a photograph to facilitate certain groupings of visual elements or objects. Sometimes it occurs by chance and provides an interesting and humorous photograph as shown opposite where the glove on the table can be seen as a continuation of the man's arm.

Film editors and videotape editors are well aware of the importance of continuation in piecing together segments of film and tape so that the finished product flows smoothly. From frame to frame there needs to be a continuation of movement, position, color, line, music and so on if the sequence is to be believable. Animators using multiple overlays take extreme precautions to assure correct positioning. A slight error will cause a jerkiness or unnatural movement on the screen. Slides projected to show a related sequence of events must be carefully planned and mounted to assure continuity, since the visual system is sensitive to change of any kind.

Related terms: good continuation, gestalt, organization.
References: **105** (138), **119** (481—482), **215** (56—59).

Above, left: Visual elements group to form continuous lines.

Above, right: Tonal differences split the circle and slanted line, yet both are more easily seen as continuous.

Left: It is easy for the viewer to perceive a unified horse and rider in spite of the discontinuities produced by the narrow vertical lines and even the wide gap between the doors. *Photograph by David Korbonits.*

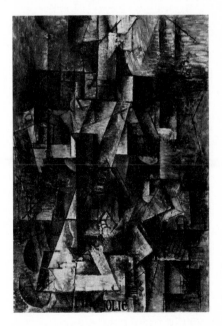

The placement of the glove on the table makes it appear continuous with the man's arm. *Photograph by Alonzo Foster.*

Shapes emerge as various lines are seen as continuous across tonal changes and across other lines. *Ma Jolie* by Picasso, from the collection of The Museum of Modern Art, New York (Lillie P. Bliss Bequest).

169

7.6 Similarity

Definition: The gestalt principle that visual elements which are alike (in shape, size, color, etc.) tend to be seen as related.

That similar visual elements tend to be grouped and seen as patterns is easily demonstrated and experienced by looking at the three arrangements of small circles and squares on the opposite page. In A, all of the visual elements are alike in shape, size and color and the entire arrangement is seen as one unit—a larger, overall square. This is the concept of the gestalt of the visual elements —the whole is greater than the sum of the parts. The situation is different in arrangement B, and it can be predicted that there will be a tendency to see not only an overall square, but rows of alternating circles and squares. Although the size and color of the elements are the same, the shapes are different. Shapes which are similar are seen as a pattern. The pattern seen in B provides a horizontal movement, while that seen in C suggests a vertical movement. Returning to A for a moment, there need only be a change in the color of the small circles to force patterns within the arrangement. This is easily done by darkening some of the circles with a pencil. Try patterning one of your initials in the arrangement. On a much larger scale, arrangement A is used for outdoor advertising signs. On a much smaller scale, it approximates half-tone screens used in photomechanical printing.

Symmetry is often seen in good design and can be considered a special case of similarity. Visual elements that are symmetrical provide a visual balance—for a 'good gestalt.' The arrangement on the right side of the opposite page shows that the more symmetrical an area is, the greater the tendency is to group it, and see it as figure.

The photograph of two animals provides an example of similar visual elements supporting or counteracting each other. The two animals are similar in shape, general orientation and, of course, species. However, they are dissimilar in tone and size. The animals are grouped together when the eye is attracted by their similarities. When differences in size and tone are attended to, the animals are seen as dissimilar. Another interesting characteristic of this composition is that similarity provides a visual linking, and comparison of the two animals in which size difference is accentuated therefore produces a strong perception of distance. This would be less true if the smaller animal were a horse or a pig, for example.

The weaving together of separate units by means of similarity of color, shape, size, texture, position, orientation or movement is an important factor in piecing together segments of motion picture film taken at different times and places. A smooth transition from evening to early morning can be made by fading from a circular red sunset and filling the screen with a reddish hue, to a circular clock indicating 8.00 AM and a whitish color. The similarity of circular shapes and sizes smoothly links the frames together while the colors separate the time dimension.

Related terms: grouping, pattern, rhythm, symmetry.
References: **10** (79–92), **119** (465–468), **215** (47–58).

A

B　　　　　　**C**

①　2　③　4　⑤

Above: The more symmetrical the boundaries of an area are, the greater the tendency is to group them into a figure.

Two animals similar in shape and general orientation but different in tone and size are readily grouped to provide a compelling depth cue. *Photograph by Liza Jones.*

7.7　Common Fate

Definition: The gestalt principle that visual elements which function, move or change in unison tend to be grouped and seen as a pattern or movement.

The principle of common fate is distinguished from the other gestalt principles because some type of movement is involved. It is related to the other principles in that the movement or change causes a regrouping of the visual elements. This can be simulated by looking at the two matrices of small squares shown.

In the matrix on the left, the squares are similar in size, shape, color and proximity, so that all the elements are seen as belonging together. Imagine for a moment that all the squares are cards being held high by a group of cheerleaders at a college football game, and that you are sitting on the opposite side of the field or watching the event on television. At a given command, certain cards in the matrix are flipped over by the persons holding them. As the cards are flipped, a *change* in color is seen. The flipped cards which are similar in color are grouped and separated from the remainder of the cards. These cards now emerge as figure X, with the remaining cards as ground. If, now, the situation is repeated but instead of the cards being flipped to change color, the people holding these cards actually *move* out as a group, the figure X will emerge. The motion and separation cause the cards to form a coherent and familiar pattern. The perceived pattern resulting from unified movement is called common fate. Such movement can be seen in events featuring dance groups and marching bands. Visual elements which move or change together are seen as a figural unit. Common fate, therefore, reflects the importance of movement or change as an organizing structure to visual perception.

Movement is also an organizing factor for the so-called *Phi Phenomenon* (*see* topic 14.3), but the Phi Phenomenon is distinguished from Common Fate in that it is based on apparent movement, not actual physical movement of the visual elements. Familiar examples are the 'moving' lights on theatre marquees and large advertising displays, like those in New York City's Times Square and London's Piccadilly Circus.

In nature, it is common fate that disrupts the effective camouflage that certain animals need for survival. So long as these animals remain still, it is difficult for a potential predator to detect them. Figure and ground remain as one. The slightest movement spells disaster, which may be the basis for the reflexive freezing that many species resort to when in danger.

In photography, common fate is routinely practiced when editing film or video tape. Careful editing of a visual sequence so that changes due to common fate are in synchronization with changes in sound can serve to enhance the experience of both sound and sight.

Related terms: apparent movement.
References: **10** (80–83), **86** (189, 330).

The 121 squares on the left are all the same and they form a static field. If some of the squares were to change simultaneously in color or to move in unison they would be grouped and seen as figure, a perceptual phenomenon identified as Common Fate.

The four small toy animals on the left can be seen individually or as a group. The instant two of them start in motion they are seen as separate from the others. *Photographs by Jeffrey H. Holtzman.*

7.8 Proximity

Definition: The gestalt principle that the closer two or more visual elements are, the greater the probability that they are seen as a group, pattern or unit.

The importance of the distance or space between visual elements can be seen opposite. In arrangement A, all 49 dots are equally spaced—horizontally and vertically. In addition, the elements are all the same shape, size, color and texture. For these reasons, all 49 dots make a single grouping or cluster, that could be described as a square shape. In arrangements B and C, only 35 elements are used to allow for increased spacing between certain dots. Although the number of dots is less, other characteristics such as shape, size, color and texture remain exactly the same. Simply changing the proximity or distance between elements has increased the probability that the dots in arrangement B will suggest a horizontal visual shape while those in C, a vertical shape. Part of the craftsmanship of a visual designer is to know and feel just how close or far apart visual elements need to be in order to be seen as grouped or as suggesting design.

One of the considerations in the field of design is anticipating or controlling the viewing distance of the observer. In a book, this problem is relatively easy since the viewing distance is predictable. In preparing photographs for books and magazines, the reproduction scale and cropping become important. For example, two photographs of the same size, close to each other and of similar line elements may easily be seen as grouped. If this is not desired, the size of one should be changed or the distance between them altered. The same is true, of course, in any display of photographs. In short, the visual design of the spacing between elements in a photograph does not end in the photograph. It only begins there, and is later influenced by the context or layout in which it is seen.

A common error in making photographs is forgetting that objects in space occupy a three-dimensional environment. When a person is photographed, for example, the proximity of other objects or elements side by side, up and down, front and back can attract the viewer's attention to, or distract it from, the center of interest. This depends on how peripheral visual elements are grouped with the center of interest. Figure can easily merge with ground, especially if the photographer does not have planning time and must shoot quickly. Even with pictures that have been posed, it is easy to find figure–ground mergers, as in the informal portrait of Minor White (*see* opposite). Sometimes these figure–ground mergers are done intentionally to add humor.

The gestalt concept of proximity is not restricted to visual elements, but also includes other sensory inputs such as sound.

Related terms: distance, gestalt, grouping, organization, space.
References: **105** (137), **151** (132–134), **215** (32–39).

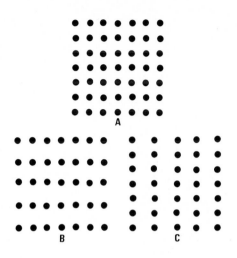

Visual elements that are close to each other tend to be seen as a pattern or movement. The B grouping is seen as horizontal and the C grouping as vertical.

Below: When figure and ground are in close proximity to each other, there is a tendency to group them. This is especially so when a long focal length lens is used and both figure and ground are in focus. *Portrait of Minor White by David Spindel.*

7.9 Isomorphism

Definition: The gestalt hypothesis that there is a point-for-point correspondence between a stimulus pattern and excitatory fields in the cerebral cortex.

This hypothesis was first put forward by Max Wertheimer, then carefully elaborated by Kohler in 1920. Kohler formulated the general principle in these words: 'Any actual consciousness is in every case not only blindly coupled to its corresponding psychophysical processes, but is akin to it in essential structural properties.' In this sense, isomorphism suggests equality of form and relatedness between brain functioning and feelings. Hering's 1872 theory of color vision, which was constructed in strict relationship to color experience and assumes that there are four basic hues with corresponding structural properties in the retina-brain, was given as an example.

Gestalt psychologists argued that if physical phenomena show configurations, so should the brain. They believed that visual patterns are represented in the brain, not symbolically, but directly as corresponding points of excitation: '. . . we began to suspect that certain properties of perceptual fields resemble properties of cortical processes to which they are related. The properties we had in mind were structural properties' (Kohler, 1969).

It is now believed that this psychophysical hypothesis, as a neurological model of perception, is incorrect, but the concept of isomorphism—a term which implies equality of form—is a useful one.

Isomorphism suggests that processes which are recorded with different media may nevertheless be similar in their structural organization. Run your fingers across a textured surface and it *feels* textured. The same surface properly illuminated and photographed *looks* textured. The textured look can be enhanced by actually adding texture to the print surface. What touch and vision have in common is more important: '. . . perceptual systems overlap one another—they are not mutually exclusive. They often focus on the same information—that is, the same information can be picked up by a combination of perceptual systems working together as well as by one perceptual system working alone.' (Gibson, 1966).

Isomorphism calls attention to the fact that what is to be represented or expressed is more important than the medium used. The choice of medium is personal—what is to be expressed must be a shared experience. This occurs if there is a structural similarity between the stimulus pattern and the retina-brain. For example, the percept that gives rise to a circle or roundness might be represented in various ways, depending upon the medium (photography, painting, sculpture, pottery, weaving, silk-screening, etc.), but there is a structural similarity of the representation and the perceptual concept, regardless of the choice of medium.

In the design of entertainment or instruction, in which more than one perceptual system is involved (sound motion picture and television, for example), it is important that sight and sound reinforce and enhance each other. That is why special musical scores are written and why books have to be scripted before being made into motion pictures.

Related terms: association, equivalent, visual synesthesia.
References: **8** (36, 61–63), **71** (4–5, 266–271), **97** (50–51, 136–138, 240, 242), **127** (62–63), **129** (65).

There is a universal structure in the retina-brain for the perception of 'roundness' that responds to appropriate stimuli irrespective of the medium used.

Photograph

Painting

Pottery

Below: Water and fire can be isomorphic . . . having equality of form. *Photograph by Robert Walch.*

7.10 Visual Camouflage

Definition: A means of concealing information so that it is not easily recognizable.

The word camouflage comes from the French word *camoufler*, which means disguise. It is not restricted to the visual sense as evidenced by the use of various products: perfumes, spices, and 'white noise' to disguise smells, tastes and sounds. Tactile camouflage was reported in the Bible when Jacob stole his brother's inheritance by deceiving his blind father who depended upon touch for identification of his first born son, Esau, who had hairy arms.

Periods in art such as anamorphosis and cubism, which dealt with the reorganization of objects in ways that contradicted everyday experiences, were involved with visual camouflage. Anamorphic techniques, which reached their golden age in the 17th and 18th centuries, severely distorted central perspective and the observer was easily deceived by a barely recognizable image. Picasso recognized the relationship between his work and camouflage techniques when, seeing the colors of paint and geometric design used to hide artillery in World War I, he exclaimed, 'We are the ones who made this—it's cubism'.

There are three basic methods of concealing information. The first is by *blending* the object with the surround—by merging figure with ground. This can be done by lowering the contrast between figure and ground, and making shapes, outlines, forms, surfaces, colors and the like common to both. A second method is by *hiding* the object so that it is no longer visible. In the early days of photography the 'detective camera' which consisted of a camera hidden in an object such as a flask, a cane or an umbrella, allowed the photographer to sneak pictures unobtrusively. Camera miniaturization now provides more subtle ways of concealment. The third way to conceal information is by *deceiving*—for example, by rearranging the figure so that it looks like something else, by dislodging old connections and introducing new configurations, by manipulating correspondences and by changing angles into crossings.

Although photographers do not think of it as such, much of what they do in preparing to take a photograph can easily be labeled as camouflage. In determining camera position a photographer sometimes places his camera so that an undesirable object is hidden from view. At other times the unintentional use of a busy background detracts from an important subject area. Before taking a portrait of a person, particularly a girl, cosmetics are often used to *hide* blemishes on the skin, to dull its shiny surfaces and to add color to the face. Lipstick and eye makeup are used to *deceive* —the shape and size of the lips and eyes are altered to enhance the beauty of the face. Makeup artists in photographic studios, television studios and stage studios are masters in the art of camouflage. Lighting can be used to change the shape, form, surface and color of objects. Soft lighting reduces contrast so that small irregularities on the face *blend* into the face. Other examples of camouflage are the use of color filters and soft-focus lenses when taking a photograph, and the use of texture screens and textured papers when printing. In copy work, particularly in the restoration of old photographs, filters perform wonders in optically eliminating unwanted spots, streaks and stains.

Related terms: ambiguous figure, anamorphic image, composition, figure–ground, gestalt, identification, illustration, perception, selection, symmetry, visual search.
References: **10** (50, 73, 105, 307), **53** (708–711), **97** (47, 149–152, 163), **136**.

Left: 'Blending' is the manipulation of visual elements so that figure and ground merge. Two of the rungs on the ladder merge with the railings against which they rest and are seen as part of, and a continuation of, the railings. *Detail from Belvedere by Escher.*

Below left: 'Hiding' is the covering up of an object with another. In his chapter on *Expressionism*, Rudolph Arnheim points out that a parabolic curve is more gentle than a circular one. He shows how Michelangelo in the design of St. Peter's transforms two circular contours into a parabola by using a lantern to hide the intersecting points of the circles at the apex. **9** (450, 451)

Below: 'Deceiving' is the rearranging of visual elements so that they form a different gestalt. Sketch of a *Bull's Head* by Picasso. The original is a bronze cast of parts of a bicycle in the *Galerie Louise Leiris, Paris.*

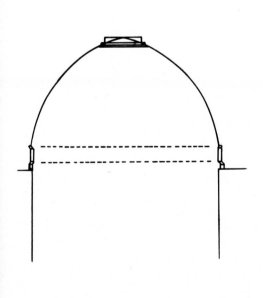

Post-Stimulus Perception

8.1 Persistent Image

Definition: A visual image of high fidelity and short duration that continues to be seen immediately after the stimulus has been removed.

When a briefly presented stimulus is terminated abruptly the viewer sees the image fade quickly rather than disappear simultaneously with the removal of the stimulus. This type of image which is seen when there is no stimulus present is commonly referred to as the *persistent image*, as distinct from the longer lasting *afterimage* (*see* article 8.2) and *eidetic image* (*see* article 8.4). The persistent image ensures that a continuous image is seen on motion-picture and television screens even though both screens are dark on an alternating basis for a considerable part of the viewing time.

Duration of the persistent image varies with a number of factors—one of the more important being the luminance of the stimulus. A convenient method of demonstrating persistent images is to put a half white and half black circle on a variable speed motor and note the minimum speed at which the persistent image will cause the black and white to fuse as an intermediate gray. If the speed is adjusted to produce fusion under normal room illumination and then a stronger light is added, the fusion will be replaced with a flickering appearance. This indicates that the duration of the persistent image is shorter at the higher light level.

Darkening the room to a point where it is just possible to see the difference between the white and black halves of the circle when it is stationary will produce fusion at a relatively slow speed due to the long persistent image. A functional explanation of this change in duration of the persistent image at different light levels is that at low light levels it is necessary for the visual system to integrate light over a longer period of time to produce an image, as specified by *Bloch's law*. This is comparable with the increase of exposure time required with a camera as the illuminance decreases to provide the film with sufficient light to produce a developable latent image. While it is normally desirable to perceive temporal attributes of visual stimuli accurately, as well as spatial attributes, this ability becomes a disadvantage when the eye needs to be deceived as in the discontinuous presentation of images with motion pictures and television. Thus, increasing the screen luminance with motion pictures may reduce the persistent image duration sufficiently to produce flicker even though the luminance appeared continuous at a lower level.

A stimulus which consists of a single pulse of short duration also produces a persistent image, but it is more difficult to detect changes in duration than with repetitive flashes where fusion and flicker are obvious clues. If an image is flashed on a screen in a dark room with a tachistoscope (a projector equipped with a shutter), it is impossible to shorten the presentation time sufficiently to prevent the viewer from seeing not only a flash of light but also much of the bolder detail of the image due to persistence of vision. At 1/500 second, for example, viewers are often able to identify the main subject and to describe some aspects of a picture. In numerous laboratory studies the average duration of the persistent image was found to be about 1/4 second.

The effect is somewhat different with motion picture flash cuts because the briefly presented image is followed by a different image, which produces visual masking, rather than by darkness. Thus, subliminal perceptions may be obtained by splicing in a single frame of a different image into a film which, at 24 frames per second projection speed, is on display for approximately 1/50 second. Haber and Hershenson note that in scanning a scene, picture, etc., if the eye pauses for a time shorter than 1/4 second between saccadic movements the persistence mechanism can keep the image available for processing for approximately 1/4 second.

Related terms: afterimage, flicker, fusion, iconic storage, masking, Parks' effect.
References: **29** (479), **30** (288–291), **86** (134–151, 161–163).

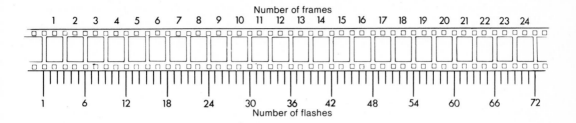

Number of frames

1 2 3 4 5 6 7 8 9 10 11 12 13 14 15 16 17 18 19 20 21 22 23 24

1 6 12 18 24 30 36 42 48 54 60 66 72

Number of flashes

Above: Sound motion pictures are projected at a rate of 24 fps. The screen is darkened not only while the film is being moved from one frame to the next but also twice while each frame is in the gate—as indicated by the dark lines beneath the film in the drawing. With 72 flashes per second, the persistent image prevents the viewer from detecting the dark intervals which would otherwise be perceived as flicker.

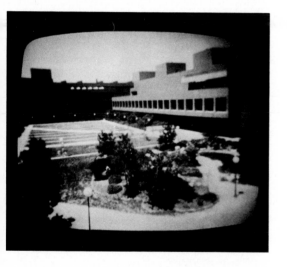

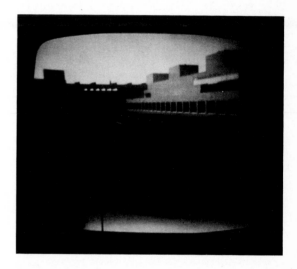

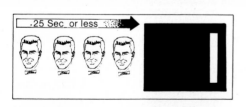

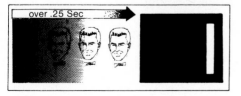

Above: Television images are built up by a scanning electron beam. Persistence of vision enables the viewer to see the complete picture, as illustrated by the photograph on the left which was exposed at 1/30 second. The photograph on the right exposed at 1/125 second shows the incomplete picture which existed at that particular moment.
Photographs courtesy of *RIT Instructional Media Services.*

Left: Persistence of vision can be demonstrated by moving a slit in a black card across a drawing. A complete image is seen if the slit scans the entire drawing in 1/4 second or less (top). At slower speeds, the persistent image of the first part of the drawing uncovered fades before the last part is uncovered (bottom).

183

8.2 Afterimage

Definition: A visual image that more or less resembles the stimulating field, is seen after the stimulus has been removed, and moves with the eyes.

When a briefly presented stimulus is terminated abruptly, a realistic persistent image may continue to be seen for up to $\frac{1}{4}$ second. Duration of the *persistent image* tends to decrease with an increase in the luminance of the stimulus or the length of presentation, whereas duration of the longer lasting *afterimage* tends to increase with the same conditions. Afterimages may be seen for only a couple of seconds with stimuli of moderate luminance and duration to a maximum of about 20 minutes. A stimulus that is capable of damaging the retina, such as the sun or a laser, can produce a permanent afterimage.

Afterimages are most apparent when, after looking steadily at a stimulus, the room is suddenly darkened or the eyes are closed and covered. The afterimage may be positive or negative with respect to lightness, and the colors may approximate the original colors or be roughly complementary to them. Negative images are typically complementary, although an intense white stimulus may be followed by an image that changes color—usually blue to green to red. Afterimages are commonly negative when looking at a light surface and positive with a dark surface or with the eyes closed and covered. Resolution of the early afterimage may be good enough to retain much of the detail of the original scene but the foveal afterimage blurs rapidly after about 2 minutes.

Also, the afterimage may disappear and then reappear again, usually with positive–negative alternations. Positive afterimages are attributed to continuing firing of the nerve cells in the retina and optic nerve after stimulation, and negative afterimages to bleaching of photopigments which reduces sensitivity and also inhibits spontaneous firing. The bleaching concept is supported by evidence that two nonidentical pulses, consisting of the same total amount of light but differing in luminance and duration by obvious amounts, produce identical late (at least 15 seconds old) afterimages. This is equivalent to absence of reciprocity law failure in photographic materials—which applies only to simple photochemical reactions but not to the developed image.

Even though afterimages are more dramatic and predictable when the stimulus is followed by darkness, darkness is not essential for the effect. Subsequent illumination of the eye after looking at a stimulus sometimes completely masks the afterimage, but if it is a uniform field it may serve only to alter the appearance of the afterimage, for example, to change it from positive to negative. If the secondary stimulus is colored, it tends to combine additively with the hue of the afterimage. Thus, a red afterimage in a dark field when it is superimposed on a blue surface appears magenta. Major factors that are known to have an effect on the afterimage include (1) the luminance, color and duration of the primary stimulus, (2) the luminance of areas adjacent to the primary stimulus, (3) the nature of the stimulation following the primary stimulus, (4) the part of the retina the image is formed on, (5) the state of adaptation of the eye, and (6) eye movements following the primary stimulus.

Although afterimages can retain certain types of information about the stimulus for some time after it has been removed, they do not seem to serve a useful purpose in visual perception (as compared to the elimination of flicker of intermittent stimuli by the persistent image).

In some situations afterimages can interfere with accurate perception. A photographer working in a studio, for example, who happens to look directly at an electronic flashtube when it is fired, finds it difficult to make discriminating visual judgments for a minute or longer. A less obvious but equally troublesome afterimage can result from looking at a strongly colored surface just before judging the color balance of a photograph.

Related terms: adaptation, aftereffect, eidetic image, Emmert's law, memory image, persistent image.

References: **28** (84–89), **29** (479–503), **80** (49–50), **176** (13–28).

Look steadily at the dot in the center of the figure on the left for 30 seconds under good illumination, then look at the dot on the right and note the afterimage. For a more dramatic afterimage, substitute a frosted light bulb for the figure on the left. (Never look at the sun, arc lights, lasers, or ultraviolet lamps.) The negative afterimage of the bulb may change to positive when the eyes are closed and covered. The afterimage may also appear colored, typically changing from blue to green to red, even though the stimulus is white.

Below: To demonstrate a color afterimage, look steadily at the dot in the center of the figure on the left for 30 seconds under good illumination, then look at the dot on the right and note the afterimage. The afterimage colors tend to be complementary to the original colors. For a more dramatic color afterimage, look at a frosted light bulb through a color contrast filter in place of the figure on the left.

8.3 Aftereffect

Definition: A change in perception of a picture or other visual stimulus that is attributable to the influence of the preceding visual experience.

It would seem that if you look at a drawing of a circle, for example, at different times under identical conditions, the resulting perceptions would be the same. That is, the drawing would appear to be the same drawing each time rather than a different or a modified drawing. In practice, however, each perception depends to some extent upon the preceding perception. Staring at a large circle tends to make a following smaller circle appear smaller than normal, and vice versa. In one experiment, the perceived size of a circle changed by 18% with variations in the preceding stimulus. Strangely, the circle seemed to shrink slightly when the preceding circle was the same size (Graham). These results provide additional evidence that the eye is not a dependable measuring instrument (although it can function well as a null comparator). Even prolonged viewing of a single stimulus can cause it to appear to change slightly in what can be considered to be an ongoing aftereffect. For example, in judging the density of a test print it is not uncommon to judge it alternately to be too light and too dark with prolonged viewing.

Aftereffects that involve the size, shape or orientation of the perceived image are commonly referred to as *figural aftereffects*. Looking at a curved line for some time can make a straight line viewed afterward appear to be curved in the opposite direction. A figural aftereffect can be observed by looking steadily at the dot in the triangle opposite for about one minute, and then looking at the centre dot to the right of the triangle. The horizontal distance between the two circles on the top tends to appear larger than between the two circles on the bottom even though the actual distances are the same.

Pictures shown in sequence, such as slides and scenes in a motion picture, are especially susceptible to aftereffects. For example, a tall object tends to appear taller on a vertical slide when preceded by horizontal slides or slides having strong horizontal lines. Most aftereffects encountered in everyday life are subtle and short-lived, but under controlled conditions they can be quite dramatic. A person who wore inverting eyeglasses for a number of days gradually came to see the world right side up, but when the glasses were removed everything appeared upside down as an aftereffect. Although the completely inverted aftereffect lasted only a few minutes, periodic traces of disorientation persisted for two months (Kohler).

The appearance of other attributes of images—such as motion, sharpness and color—can also be altered by a preceding visual experience. The speed of racing cars in a motion picture is dramatized by inserting an occasional shot of a stationary object, a soft-focus closeup is more effective if preceded by a sharp image, and a warm or cool color balance used to create a mood loses its effectiveness if left on the screen too long. Whereas a dramatic change in an attribute such as color between sequential visual stimuli can cause the viewer to misjudge that attribute in the latter stimulus, it is an effective method of dramatizing an attribute.

As suggested above, the direction of change in the latter stimulus generally can be predicted as being in contrast to the attribute characteristic in the preceding stimulus, but the magnitude of the aftereffect is difficult to predict.

Related terms: adaptation, afterimage, figural aftereffect.
References: **78** (555–562), **128** (474–497), **150** (211–212).

A figural aftereffect can be observed by looking
steadily at the dot in the figure on the left for 30
seconds and then looking at the dot in the center of the
figure on the right. The distance between the two
circles at the top appears larger than between the two
circles at the bottom even though the actual distances
are the same.

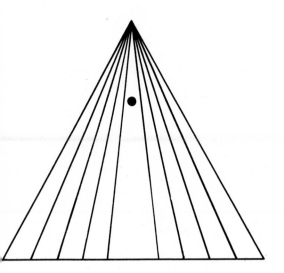

Below: A color aftereffect can be observed by looking
steadily at the dot in the figure on the left for 30
seconds under good illumination and then looking at
the dot in the figure on the right. The afterimage of the
first stimulus combines with the yellow to form a
greenish-yellow.

8.4 Eidetic Imagery

Definition: A visual effect in which a relatively vivid and accurate image that is capable of being scanned persists after removal of the stimulus.

Eidetic images should not be confused with afterimages and conventional memory images. A person who experiences eidetic imagery can continue to see an image of a photograph, for example, for 40 seconds or longer after the photograph has been removed. The image is positive, retains an approximation of the original colors, and remains stable when the eyes are moved, permitting examination of different areas. In some respects the visual experience is similar to that when the photograph is present since the subject can scan the eidetic image for details he was not conscious of before the photograph was removed—just as a person can remember details under hypnosis that he could not remember otherwise.

In contrast, afterimages move with the eyes, so they cannot be scanned, they may be either positive or negative, and they tend to fade rapidly. Also scanning, rather than prolonged fixation of the stimulus, is used to produce eidetic images. Conventional memory images, on the other hand, are less vivid and less accurate than eidetic images.

It was once thought that nearly all children experienced eidetic imagery but that the effect gradually disappeared with increasing age. A study by Haber and Haber made in 1968 revealed that only 8% of the approximately 200 elementary school students tested experienced eidetic imagery. Almost all of the eidetic subjects still experienced eidetic imagery when they were retested a year later, but it is generally agreed that this visual effect is rare in adults. Apparently other studies that have reported much larger percentages of eidetic imagery in children have included reports of afterimages and other visual effects in addition to eidetic imagery. A distinction should be made also between eidetic imagery and mental images that are imagined by creative people. For example, J. O'Neill describes how the inventor Nikola Tesla was able to visualize vividly in his mind the construction and operation of complex machines that did not yet exist.

Although a person can improve his long-term memory for visual as well as other types of experiences, eidetic imagery does not appear to be a learned ability. This visual experience does not seem strange to eidetic persons, and many are not aware of their special ability until it is brought to their attention. You should expect that if you show a picture to a large number of young people, some will be able to report seeing details for a longer time after the picture has been removed than others. Even though eidetic subjects have a longer time to examine the details of a briefly presented picture, once the eidetic image has disappeared they can report no more from memory than noneidetic subjects.

The picture opposite can be used to illustrate the concept of eidetic imagery. Scan the picture constantly for about 30 seconds and then look at a uniform gray surface. A person with eidetic imagery would be able to see and describe the picture in detail for 40 seconds or longer.

Related terms: afterimage, imaginary image, memory image.
References: **84** (350–356), **144** (89), **161, 176** (29–42).

After scanning the picture below for about 30 seconds, a person with eidetic imagery would be able to see and describe the picture in detail for 40 seconds or longer while looking at a uniform gray surface. *Photograph by David Spindel.*

8.5 Short-term Visual Memory

Definition: A temporary retention of visual information following exposure, during which time the information is available for processing in a variety of ways at the discretion of the viewer. Short-term memory is commonly equated with consciousness.

It is difficult to draw a sharp line of demarcation between perception and memory. Since you typically must scan a picture before you are satisfied that you have seen it, the final perception is actually a composite formed from a number of separate fixations. Memory must be involved in retaining information from the earlier fixations even while you are looking at the picture. After a person views a picture, the information is available in his short-term memory long enough to permit him to make a decision concerning its use. Options include putting the information in long-term memory, taking action based on the information, and making no use of the information (in which case the image is forgotten).

Much of the research concerning short-term visual memory has made use of numbers, letters, words and other specifiable stimuli in preference to pictures. Some of the findings apparently apply to pictorial as well as nonpictorial stimuli. Sperling found that when randomly selected numbers or letters were flashed on a screen, most subjects could report correctly what they had seen only when the display contained five or fewer items. When the display contained a larger number of items, subjects could report correctly only those four or five that they directed their attention to.

Presumably viewers will be able to retain in short-term visual memory only a limited amount of information about a picture that is presented briefly. It is the task of the photographer to 'direct' the viewer's attention to the most important information in the photograph. This may not be easy. An eye movement study revealed that in one situation students spent more time looking at the teacher's face than at the model plane she was discussing and pointing to with a pencil. Perhaps this behavior explains why simple line drawings that contain only the essential information are more effective for some learning purposes than realistic color photographs.

There are a number of recognized strategies that can be performed consciously while information is in short-term memory to improve long-term memory. At least some if not all of these strategies can be applied to pictures as well as to names and telephone numbers. Among the processes listed by Atkinson and Shiffrin that can be used at the discretion of the subject are rehearsal, coding, decision rules, organizational schemes, retrieval strategies and problem-solving techniques. Rehearsing a telephone number between looking it up and dialing it is a more obvious procedure than rehearsing a picture. There may be too much information in a picture to rehearse, but it is possible to select certain features such as the shape of the dominant object for rehearsal.

Just as it is impossible to remember a name you do not hear clearly, it is impossible to remember a picture you do not see clearly. The limitation on seeing is usually more a matter of attention than of physical factors. Thus, the above memory strategies can be effective only to the extent that you are able to see. Robert McKim suggests that picture memory can be improved by practice, and he provides exercises for this purpose such as drawing a doodle, covering it and immediately trying to duplicate it from short-term memory.

Related terms: learning, long-term memory, mnemonic device, picture memory, retrieval.
References: **12** (82–90), **14** (202–214), **144** (88–93).

The change in contrast of the girl and the change in shape of the tennis racquet which are obvious when the pictures are viewed simultaneously are less obvious when the pictures are presented sequentially with a 4-second delay between pictures. This is because the subject must compare the second photograph of each pair with the remains of a short-term memory image of the first photograph. Some attributes seem to be more difficult to remember than others. Only 58% of all subjects tested perceived a difference between the pictures of the girl, whereas 98% reported seeing a difference between the pictures of the tennis racquet.

8.6　Visual Memory

Definition: The mental process of reviving past visual experiences with a realization that the present experience is a revival.

Visual experiences revived from memory can vary over a large range from one so weak that a second presentation of the same stimulus creates only a vague feeling of recognition, to one so strong that essentially all of the information contained in the original stimulus can be made available from memory.

Recognition can be tested by showing a person a picture, and at a later time showing him a number of pictures all of which are new except for the one shown previously. When this procedure is repeated a number of times, the percentage of pictures correctly identified as having been seen before is a measure of recognition. Most people feel that they have good picture memories, based on experiences such as recognition of pictures in old magazines that they have not seen for years. A picture recognition experiment conducted by Standing, Conezio and Haber (1970) revealed that 96% of 1100 photographs were recognized by the subjects after a delay of one day, which indicates that the mind has an impressive capacity for visual memory.

A number of factors in addition to visual memory influence the score in a picture recognition test—including the distinctiveness of the original pictures, the display time, the delay between the two showings, the ratio of new to old pictures in the second showing, and especially, the similarity between the new and old pictures. The task of recognizing a portrait in a group of pictures of a variety of subjects is different from that of recognizing a portrait of an identical twin when presented with a picture of the other twin.

Recall, as distinct from recognition, must be tested without showing the original picture to the subject a second time. Procedures that have been used include asking the subject to describe the picture or identify objects in it, and to make a drawing of the picture. Neither method is entirely satisfactory since both involve memory of a limited number of attributes of the picture, and the latter method depends upon the drawing skill of the subject. A combination of recognition and nonrecognition methods is used successfully by police artists in making sketches based on eye witness descriptions from memory.

Photographers and artists hope that the pictures they make are remembered by the viewer. Whether this occurs or not depends largely upon the visual memory of the viewer and upon the picture itself. Visual memory can be improved (by the viewer) mostly by controlling what happens in short-term visual memory (*see* topic 8.5). The photographer and the artist can make a picture memorable in a variety of ways, but one of the most effective is to use a new approach with a familiar subject—exemplified by Picasso's cubistic *Mother and Child,* Dali's fluid watches, and Haas's photographs of bull fighting.

Photographers rely on visual memory for a variety of tasks including recall of the original scene while making a print—postvisualization. Those working with multiple related images, as in picture stories and motion pictures are especially dependent upon picture memory. Since visual memory is known to be fallible, still photographs are often made of motion picture sets. This ensures that shots taken on different days, but juxtaposed in the final film, do not contain incongruities such as a prop that suddenly appears in a new position. Visual memory is much better in recognizing objects and scenes than in remembering details.

Related terms: learning, long-term memory mnemonic device, picture memory, recall, recognition, retention, retrieval, short-term memory.

References: **86** (247–273), **144** (88–93), **176** (43–92).

Above: The recognition method of testing visual memory consists of the subject briefly viewing a number of pictures, represented here by the single picture on the left, and at a later time he is shown the same pictures plus new pictures in random order, represented here by each row of five pictures on the right. The task is more difficult and the memory scores are lower when the added pictures are similar in appearance to the original pictures (top row), than when they are dissimilar (bottom row).

Left and above: The recall method of testing visual memory involves the subject examining a picture for a specified length of time, and the subject is later asked to make a sketch of the picture from memory. The sketches were made by three different subjects one day after viewing the photograph for 30 seconds. *Photograph by Neil Montanus.*

8.7　Long-term Memory

Definition: The mental process involving the relatively permanent storage of information.

Memory has traditionally been divided into two categories, short-term and long-term. Recent research supports a three-level theory in which *short-term* memory lasts no more than a few seconds, *medium-term* memory lasts up to a few hours, and *long-term* memory represents more nearly permanent storage of information. Whereas short-term memory is commonly equated with consciousness, long-term memory can be equated with learning. There is no determinate limit to the capacity of long-term memory, and it has even been proposed that anything you have ever seen or otherwise experienced, even once, is permanently recorded in your brain.

Only in exceptional instances is visual recall from memory entirely true to fact. One explanation for this discrepancy has been offered by J. J. Gibson who states that only the information required to identify a thing economically tends to be selected from all of the information available—the remaining information being ignored. Things not seen or experienced cannot be remembered. Thus, if a painter wants to make a realistic painting of a certain scene at a later time from memory, it is important for him to examine all of the details that he will want to include in the painting. Beginning photographers, especially, are often surprised to see things in the background of photographs that they do not remember being in the original scenes because they were economically tending only to the subject in the foreground.

Even the things seen vividly are subject to alteration between perception and recall. Some such changes have been found to be systematic in nature and therefore can be predicted. For example, an oval that is almost circular in shape will tend to be remembered as a circle rather than an oval. That is, shapes are simplified, probably because the change makes it easier to remember. This psychological process is referred to as *leveling.* On the other hand, if you notice a small opening in a circular line drawing, you tend to remember the opening as being larger than it actually was, a psychological process known as *sharpening.* In addition to general changes in remembered images such as these, other changes can be based on previous individual experiences. In one study, children from low- and high-income families were asked to make accurate drawings of a nickel, and it was found that the drawings made by the children from low-income families tended to be larger—reflecting the greater value they placed on money.

Even if it is true that everything you see is permanently stored in your brains, you obviously cannot recall each percept upon command. John McGeoch maintains that memories do not fade as a function of time, but that a person forgets when new learning interferes with the earlier learning. Experiments have demonstrated that learning followed by sleep is remembered better than when it is followed by a different learning experience. Also, similar (but not identical) new learning experiences tend to interfere with earlier learning more than dissimilar ones. Thus, if it is important to remember the face of a stranger seen briefly, it is better not to study the faces of other strangers during the intervening time.

It has been demonstrated that supposedly forgotten experiences can be retrieved from the subconscious mind by means of hypnosis and electrical stimulation of areas of the brain. This suggests that anyone who wants to improve his long-term memory for visual imagery can develop appropriate retrieval strategies, such as association procedures. Also, procedures that strengthen the original visual experience, such as those discussed under the heading short-term visual memory (*see* 8.5), facilitate later recall.

Related terms: forgetting, learning, picture memory, retrieval, short-term visual memory, visual memory.
References: **35** (175–190), **72** (662–678), **116** (605–612), **176** (43–92), **199** (56–57).

Left: Remembered images are sometimes inaccurate because you tend to devote most of your attention to the main subject. As a result, it is not uncommon for photographers to discover background objects in photographs they do not recall having seen when the picture was made. *Photograph by Günther Cartwright.*

Above: An ellipse can be perceived as a tilted circle. The psychological process of leveling causes the viewer to remember the image as the simpler shape of a circle, or more circular than the actual shape.

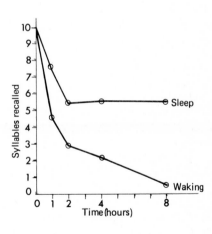

Above: The psychological process of sharpening, which emphasizes distinctive features, causes the viewer to remember the opening in the circle as being larger than it actually is.

Above: The top curve shows the superior recall of a learning experience followed by sleep. The bottom curve represents the same learning experience followed by other activities. Jenkins and Dallenbach. *American Journal of Psychology*, 1924, *35*, 605–612. Copyright, 1924 by The American Journal of Psychology. The University of Illinois Press, Publisher.

8.8 Imagination Imagery

Definition: A visual image that is constructed in the mind, being neither a response to a visual stimulus nor a memory of such a response.

Nocturnal dreams constitute the most common and obvious example of visual images that are not directly related to visual stimuli. Imaginary images can also, for example, be produced by hallucinogenic drugs, sleep deprivation, stimulus deprivation, psychoses and meditation. Although there are widely held negative connotations for some types of imaginary images—strong for hallucinations, mild for day-dreaming—imagination imagery is actually an important part of the normal thought process. Young children apparently make the most use of images in thinking, but as they mature they tend to substitute language and organized ideas for the visual images. In some circumstances, imaginary images can seem very realistic, especially when related to a dream, a hallucination or a psychosis. Sigmund Freud popularized the use of dream interpretation in the field of psychoanalysis. In recent years, considerable research has been undertaken to investigate the visual images perceived during sleep and the drowsy periods immediately preceding and following sleep. Truck drivers, pilots, radar operators and others have reported vivid mental images after long hours of physical or mental stress.

Even the imaginary image produced by thinking about an object can be difficult to distinguish from a real image. In an experiment, subjects were instructed to try to visualize an object, such as a banana, while looking at a blank screen. Unknown to them a photograph of the object was projected on the translucent screen from the other side at a visible but near subliminal level. Many of the subjects accepted the actual image as being a product of their imagination.

Of special interest to photographers and artists are the positive implications of imagination imagery. It is apparent that an artist who creates a picture that does not correspond to anything he has experienced is guided by an imaginary image. Photographers also rely on mental images, not only when they make sketches in preparation for making photographs, but when they anticipate the appearance of an arrangement of objects or of changes in the choice of backgrounds, lighting, cropping, etc. One study revealed a direct relationship between the vividness and frequency of visual images experienced during the twilight period between wakefulness and sleep, and creative achievement. Evidence of this are the numerous reports of people who have visualized the solutions to difficult problems during the twilight period. The results of this study should not be interpreted as indicating that imagination imagery and creativity are inherent in each person.

Robert McKim, in *Experiences in Visual Thinking*, suggests that everyone has imagination and the ability to experience conscious mental imagery, but like any skill these can deteriorate through disuse, and he offers exercises for their enhancement. Before beginning the exercises, it is important to find an environment that eliminates distracting stimuli, become moderately relaxed, and assume an attitude of interest without becoming overmotivated. Introductory exercises to encourage clarity of mental imagery include visually imagining a familiar face, a galloping horse, and the moon through clouds. More complex exercises include visualizing a person shrinking to half his original size, mentally changing the proportions of the parts of a room, and visualizing the changing relationships of the moving parts in an engine.

Related terms: dream images, hypnagogic images, mental images, surrealism, visualization, visual thinking.
References: **144** (81–113), **176** (93–126).

The photographer employed imagination imagery to anticipate the appearance of this photograph before he rotated the subject in front of a slit camera to record the circumference of his head. *Photograph by Andrew Davidhazy.*

A person's ability to construct visual images in his mind can be enhanced with practice, for example, by imagining someone suddenly changing size in relation to his surroundings. This photograph of children inspecting a miniature village in Holland illustrates the effect. *Courtesy of KLM Royal Dutch Airlines.*

8.9 Memory Color

Definition: A recalled perception of color appearance, usually different from the perception of the actual object.

If an observer is asked to state the color of foliage, the conventional answer is 'green.' Objectively considered, foliage displays many different colors, from the dark desaturated green of ivy leaves to the much lighter and more saturated green of tulip leaves, with variations in hue from the yellowish-green of many grasses to the bluish-green of spruce needles.

When an observer chooses from a set of colored chips one that to him typifies the color of foliage, he must abstract from a multitude of past perceptions of many kinds of foliage seen under many different lighting conditions. The same situation exists for the memory color of other familiar objects, such as human skin and the sky.

When a single chip is chosen to represent such a variety of colors, subtle color differences disappear, so that memory colors fall into a few categories having pronounced attributes. Light colors are usually remembered as lighter than they were in fact, dark colors as darker and hues as more saturated than the real ones. Memory colors also differ in hue from the actual colors. Yellowish-reds are recalled as more nearly red, bluish-greens as green, etc. The details of the color characteristics are forgotten, so that memory colors are simpler than the actual ones.

These characteristics of visual memory are typical of the memory process in general. What is called *levelling* is the tendency to reduce irregularities and to leave out details. *Sharpening* is the process of accentuating some details in memory, so that objects and events are more sharply defined in the recall than they were in the original experience.

Although what has been described above involves long-term memory, experiments involving short-term and medium-term color memory over only a few minutes or hours show similar results. Even more remarkable is the influence of memory shown in experiments in which observers match the colors of various shapes, cut from colored paper, by adjusting the sectors of a color wheel. If the shape is that of a heart which is strongly associated with red, the observer tends to make the matching color redder than if the shape (e.g. oval) has no such association. This occurs, even though the paper from which the shapes are cut is uniform in color.

Memory colors are important in color photography because usually the quality of the image is judged not against reality but against memory. When a tourist sees the photographs he has made on a trip, he has no opportunity to compare them with the real scenes. Art directors similarly must rely on their memories to judge the quality of photographs made by other persons.

Thus, in the manufacture of color photographic materials, the process is adjusted to generate images that conform to color memory and are therefore 'pleasing,' rather than to duplicate reality. Fortunately, most of us have a reasonably common background of color experience for frequently seen objects like skin, sky and sand, and therefore a consistent color memory.

A different kind of problem arises in color photomechanical reproduction where the observer has the original at hand. Here he can estimate the quality of the reproduction by direct comparison with the print or transparency to be reproduced, and color memory is hardly involved. The same situation is found with in-camera color print processing where the image is available in a few minutes for comparison with the scene.

Related terms: color constancy, long-term memory, short-term visual memory, visual memory.
References: **16** (73–77), **36** (87–88), **121** (317, 398, 413, 424–426), **159** (43–56).

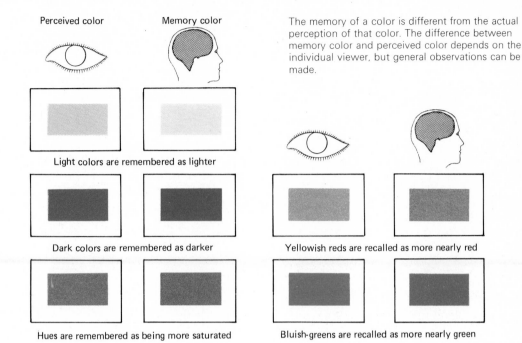

Perceived color Memory color

The memory of a color is different from the actual perception of that color. The difference between memory color and perceived color depends on the individual viewer, but general observations can be made.

Light colors are remembered as lighter

Dark colors are remembered as darker

Yellowish reds are recalled as more nearly red

Hues are remembered as being more saturated

Bluish-greens are recalled as more nearly green

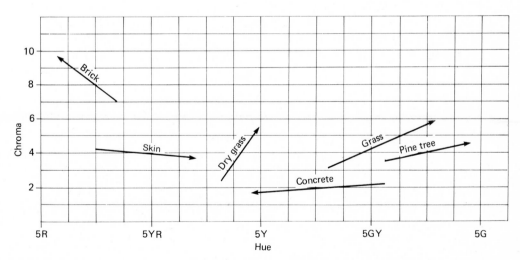

Each arrow shows the shift from the perceived color (at the tail of the arrow) to the memory color (at the head of the arrow). The data are in Munsell notation. Except for the colors of skin and concrete, the memory colors are more saturated than the actual perceptions. Data from Table VI, p. 52, Newhall, Burnham and Clark, *J. Op. Soc. Am*, vol. 47, no. 1, January 1957.

9

Perception of Depth

9.1 Depth

Definition: The subject dimension that corresponds to variations in distance from the viewer, or to the representation of that dimension in a photograph or other image.

Two-dimensional objects can be represented in photographs with great fidelity —under ideal conditions it may be difficult to distinguish between the original object and the reproduction. However, illusion must be employed to represent the third dimension, depth, of an object or scene because, obviously, photographs themselves are two-dimensional. The term depth is commonly associated with the actual or the perceived distance to an object, but it properly includes the third-dimensional attribute of an object (*form*) and the small scale third-dimensional attribute of a surface (*texture*). This topic is primarily concerned with the perception of distance.

The ability to judge distances with a rather high degree of accuracy is often credited to the use of two eyes which look at each scene from different viewpoints. But, of the approximately dozen visual cues that have been identified for the perception of distance, only two are attributed to the use of two eyes. These are known as *disparity* and *convergence*. Stereoscopic vision produces distance perception because the images formed on the two retinas are not quite identical due to the difference in positions of the eyes. The viewer is able to make sense out of this disparity, or incomplete fusion of the two images, only by interpreting it as representing depth. The same principle applies to the perception of depth in stereophotographs and holograms.

The two eyes also act as a rangefinder to provide distance information based on the angle of convergence between the two eyes. Thus, information about the angle formed by the eyes in looking at a black dot on a flat white surface assists in estimating the distance, even though the subject itself is two-dimensional and there is no disparity.

Most of the remaining distance cues, which apply to monocular vision, can be used in conventional photographs to create the illusion of distance. The *size* of the image of an object is a good distance cue if the viewer is familiar with the object's actual size—a horse that produces a small retinal image can be assumed to be at a large distance. In a picture, however, it is only the relative size rather than the actual size that is useful. Thus, *linear perspective* reveals distance by the apparent convergence of parallel subject lines, such as railroad tracks, toward a vanishing point or by the decrease of image size of objects, such as telephone poles, with increasing distance. *Interposition* refers to the fact that a near object covers up part of the background, which provides solid evidence as to which is nearer, although it is not helpful in determining more specific relative distances. *Aerial perspective* represents distance as a loss of contrast and an increase in lightness as the distance increases, due to scattering of light by particles in the air. *Motion parallax* reveals distance by the apparent movement of distant objects in the same direction as the observer moves and of nearby objects in the opposite direction. This cue can be used most effectively in motion picture photography, television and holography.

Light and *shade* enable the viewer to translate the modulation of light by objects into distance information. Shadows cast on the foreground are especially useful in revealing distance between objects. As a viewer moves closer to an object, the *accommodation* or focus of the eye and variations of *sharpness* of objects at different distances provide him with information about distances. *Color* as a distance cue is more subtle. But red, a so-called advancing color, may under some circumstances appear closer than an equidistant blue, a receding color.

Related terms: accommodation, aerial perspective, color, convergence, depth, disparity, interposition, light and shade, linear perspective, motion, parallax, sharpness, size, stereopsis.
References: **10** (233–234, 245–250), **56** (253–334), **79** (504–547).

Examples of the three basic types of depth—distance, form, and texture. *Photographs (top to bottom) by Arthur Underwood, Ansel Adams, Douglas Lyttle.*

9.2 Form

Definition: The surface configuration of an object or its representation in a picture.

Although the terms form and shape are used interchangeably in some disciplines, in photography form refers to the depth or three-dimensional attribute of an object and shape refers to the outline. Shape is considered to be the most important attribute for the identification of objects. But the depth attributes of form, distance, and texture add realism to the visual world, even when these attributes are two-dimensional representations in photographs or other pictures.

Form, unlike reflectance or hue, is an object attribute that can be perceived through more than one of our senses—namely sight and touch. Craftsmen who work with clay, wood and metal develop an important relationship between the two senses. Also, it might be noted, desk decorations designed to provide both visual and tactile esthetic pleasure, called 'feelies,' have gained some popularity. An experiment was conceived to answer the question of which sense would be believed if the information obtained through sight and touch did not agree. In the experiment, a box-shaped object was viewed through a window that distorted the height:width proportions. The subject was then allowed to feel the object in the dark. The results indicated that the subjects tended to have more confidence in what they saw than what they felt.

Photography students are sometimes presented with the problem of making two photographs of a white cube, one so that it appears realistic and the other so that it appears two-dimensional. The most common solution is to illuminate the cube so that the three visible planes have different luminances (such as 1:2:4) for the realistic interpretation, and all three planes have the same luminance for the flat interpretation. The dramatic difference in appearance between the two photographs suggests the important part that lighting plays in representing form in photographs. Nonlighting solutions to the cube assignment are possible, such as drawing lines on the three visible planes

for a three-dimensional effect and selecting a viewpoint that shows only one side of the cube for the two-dimensional effect. The form of curved surfaces, as on the human face, is revealed most realistically with lighting that produces gradation, or a gradual change in tone across the surface. Professional photographers are expected to be able to light any subject, whether it be a face or a commercial product, so that every important surface that makes up the form is evident.

A realistic representation of form is not always desirable in photographs. The silhouette represents a lighting effect that eliminates form and places the emphasis on the outline shape. Similarly, high-contrast film can reduce the tones in the original scene down to black and white in the picture. Tone separation techniques distort the appearance of form by converting gradations of tone on curved surfaces to a selected number of uniform tones with abrupt edges in the photograph. The part that memory plays in the perception of form is revealed when you view a high-contrast image of a human face that has no detail in the skin areas and still accept the face as being three-dimensional.

Evans and Klute have demonstrated how easy it is to fool the eye with respect to form in photographs. They placed two-dimensional cutouts in scenes with three-dimensional objects in such a way that the viewer cannot distinguish between them in the photograph (Evans, 1960). An application of this concept is to place small cutouts of photographs of fashion models in three-dimensional scenes and then to photograph the combination for special effects. This is a reversal of the projected background technique in which people are photographed in front of two-dimensional photographic images in a studio to make it appear that they are on location.

Related terms: depth, distance, shape, texture.
References: **56** (280–285, 304–307), **182** (594–596).

Left: Shadows and the association of form with the human face enable a three-dimensional face to be perceived in this painting on a barn. This perception occurs even though the boards emphasize the two-dimensional nature of the wall. *Photograph by David Korbonits.*

Above: Form is an object attribute which can be perceived through the senses of sight and touch. Potters develop an important relationship between the two senses. *Photograph by John Jean.*

Below: Light gradation effectively reveals the form of this woman's shoulders and back. *Photograph by Abigail Perlmutter.*

9.3 Texture

Definition: A relatively small-scale surface characteristic that is associated with tactile quality.

Texture can be thought of as a depth attribute similar to form except smaller in scale. Thus, an extreme closeup view of fine-textured beach sand might resemble the form of large boulders. The small-scale qualification refers to the image, not the object. For example, a distant view of large boulders can have a texture appearance, and the gradual change in the coarseness of the perceived texture in a picture produces a texture gradient which is considered an important distance cue. When the texture of an object is to be represented in a photograph, an appropriate scale of reproduction is important—too large a scale and the texture may be so coarse as to be unrealistic or unrecognizable, too small a scale and the texture may be so smooth that the detail cannot be resolved. If a photograph of texture is to be reproduced for mass viewing, the capabilities of the reproduction process must be taken into account. For example, texture must be exaggerated for reproduction on television because of the limited definition of the process. The same is true for halftone reproductions in newspapers, but the requirements are considerably different for one-column and full-page reproductions.

Lighting is considered to be the most effective means of controlling the appearance of texture either for direct viewing or for representation on a photograph. Texture tends to be revealed most vividly with specular light skimming the surface, which creates shadows in the recessed areas, and the use of a small amount of fill illumination to lighten the shadows. Although it is appropriate to exaggerate somewhat the appearance of texture when it is represented photographically, there are dangers in gross exaggeration. For example, objects that are physically soft, such as wool, appear to be less soft, and colored designs contained in fabrics and other materials may be obscured by the texture shadows. Whereas light can easily be skimmed over an entire flat surface, it can only be skimmed over parts of curved surfaces. Fortunately, viewers tend to accept the appearance of texture in a small area as evidence that the texture is uniform over the entire surface, even in larger shadow areas where detail may be lost. Textured surfaces having a high sheen, such as pebbled leather and rough glass, do not respond to the skim-light treatment and must be illuminated to produce highlights on the bumps rather than shadows in the indentations. Realistic or exaggerated representations of texture are not always appropriate on photographs of textured surfaces. When it is desirable to reduce the appearance of texture, as with wrinkles, opposite techniques to those described above are used—diffused front lighting, a smaller scale of reproduction, and in the case of portraits, even a soft-focus lens can be effective.

There has been disagreement about the perceptual effect of textured surfaces on photographic prints. Justifications for the practice include that the print texture can be associated with texture on the object photographed, and that the texture provides an artistic effect analogous to brush strokes on oil paintings. Opposite opinions are held as to whether print texture increases or decreases the perception of depth in the scene represented. One side claims that depth is destroyed by making the two-dimensional nature of the photograph so obvious, while the other side claims that the texture serves as a foreground reference, like a window frame, that adds depth. Equally controversial is the use of texture screens that produce a texture effect without a corresponding relief pattern on the surface. Aside from any artistic and depth effects that may be involved, print texture generally tends to minimize minor defects in the photographic image such as graininess and unsharpness.

Related terms: depth, roughness, texture gradient.
References: **56** (154–156, 299–300, 344–345), **217** (24–26).

The texture of the weathered wood is revealed by backlighting which produces highlights and shadows. Viewers tend to assume that the texture is uniform over the entire surface of objects having curved surfaces, such as this, even though the lighting emphasizes the texture only in one area. *Photograph by John H. Johnson.*

9.4 Linear Perspective

Definition: The representation of depth in a picture by means of convergence of parallel subject lines, or the decrease in image size with increasing object distance.

When an object is moved away from a viewer, the angle it subtends at the eye decreases—a relationship known as *Euclid's law*. Based on experience, an observer knows that a decrease in the angular size of an object can be caused either by an increase in the distance to the object, or by an actual decrease in size of the object at a fixed distance. If a person walks away from an observer, it is easier for the observer to interpret the decrease in angular size as resulting from an increase in distance, rather than a reduction in size of the person. In an ambiguous situation, such as an illuminated balloon in an otherwise dark room, a decrease in the size of the balloon (by allowing air to escape) may be correctly interpreted. Alternatively it may be misinterpreted as an object of constant size moving away from the viewer.

Accuracy in judging distance to an object requires some previous knowledge about the object or the surroundings, commonly in the form of a memory of a similar object or situation perceived previously. It is even more difficult to judge distances to an object accurately from looking at a photograph—especially due to the absence of stereoscopic cues and the effect that different focal length camera lenses have on image size. The latter effect is illustrated dramatically with zoom shots in motion pictures and television, where the apparent distance to a subject changes drastically even though the camera-to-subject distance remains the same.

As with the perception of brightness and most other subject attributes, the eye is best able to perceive distance on a comparative rather than an absolute basis. Thus, if two similar objects are at distances of 10 and 20 m (30 and 60 ft), it is easier to estimate the 1:2 ratio of distances than the actual distances. If a camera is now placed in the position of the eye, the images of the two objects will be recorded on the film in a 2:1 ratio of sizes regardless of the lens focal length. A short focal length lens will produce smaller images of both objects, causing them to appear farther from the viewer. The difference in image size between the two objects seems too great for objects that are apparently so far away, an effect identified as *strong perspective*. Conversely, the same decrease in size seems too small for the apparently near objects when a long focal length lens is used, an effect known as *weak perspective.*

Linear perspective is most obvious when the subject consists of a row of identical objects such as telephone poles, or the scene contains parallel lines that converge toward a vanishing point in the photographs. Almost any repetitive detail, such as wheat in a field or bricks in a wall, serves a similar perspective function. This is due to an apparent decrease in size and spacing with increasing distance, an effect J. J. Gibson referred to as *texture gradient*. Distance can be portrayed almost as effectively with different size objects such as a cat in the foreground and a mountain in the background, if the viewer is familiar with the actual sizes of the objects.

It is important for photographers to develop an awareness of normal, strong and weak perspective and to become familiar with the perspective conventions for various types of subjects. Strong perspective is seldom considered attractive on studio portraits and catalog photographs, for example, but is commonly used for dramatic effect or for architectural subjects where the photographer wants to increase the apparent size of a room or building.

Related terms: converging lines, depth, distance, strong perspective, texture gradient, vanishing point, viewing distance, weak perspective.

References: **86** (295–307), **193** (118–132).

Examples of three variations of linear perspective—
decreasing image size with increasing object distance,
convergence of parallel subject lines, and texture
gradient. *Photographs by left Peter Henry Emerson
('Women in the fields 1885'), right John H. Johnson,
and below John H. Johnson ('Endless sand pattern')*

ailure of the parallel parking lines to converge on this
hotograph, despite the wide angle of view, resulted
rom using a slit camera in a car that moved from
ght to left so that each segment of the row of cars was
hotographed from a full frontal position. The vehicle
on the left and the man on the right, both moving in the
opposite direction to the camera, are compressed
horizontally. *Photograph by Andrew Davidhazy.*

9.5 Center of Perspective

Definition: The position at which a photographic image subtends the same angle to the viewer as the object subtended to the camera lens when the photograph was made.

There is a tendency to think that the perspective of a photograph is determined solely by the position of the camera, and that the perspective becomes fixed at the moment the film is exposed. Actually, the perspective of the photograph can be influenced considerably by variations in the viewing distance. Since the center of perspective is the viewing position where the perspective appears most natural, the distance from that point to the picture is commonly referred to as the 'correct' viewing distance. When contact prints are made, the 'correct' viewing distance is equal to the lens-to-film distance when the film was exposed—which is about equal to the lens focal length (except for close up photography). For example, the 'correct' viewing distance for a contact print from a 6×6 cm negative exposed with a 80 mm focal length lens is 80 mm (3 inches). When an enlarged print is made, the lens to film distance is multiplied by the magnification. Thus, a 24×24 cm ($9\frac{1}{2} \times 9\frac{1}{2}$ inches) print made from a 6×6 cm negative exposed with a 80 mm focal length lens should be viewed at 80 mm \times 4 or 320 mm ($12\frac{1}{2}$ in).

Strong and weak perspective effects do not exist if photographs are always viewed from the center of perspective. Perspective tends to become weaker when the viewing distance is decreased, and stronger when it is increased. An explanation of this phenomenon is that as a person approaches a three-dimensional scene, the near parts appear to increase in size more rapidly than the far parts. When the person approaches a photograph of the same scene he expects the same thing to happen. But, when the near parts of the photographed scene do not increase in size more rapidly than that of the far part, the perspective appears weaker than expected for the close viewing distance. In practice, the perspective in a picture changes with the viewing distance only if the scene contains strong depth cues, such as distinctive objects in the foreground and background, or parallel lines.

It is fortunate for photographers who want to use weak and strong perspective, that people tend to view pictures from a distance about equal to the diagonal of the picture, rather than from a distance where the perspective appears normal. Thus, strong perspective can be obtained by using a short focal length lens on the camera, so that the center of perspective is closer to the photograph than the usual viewing position. In a motion picture theater, the difference in viewing distance between the front and back rows is usually considerable. This results in weaker perspective than normal for those sitting in the front and stronger than normal for those sitting in the back.

For the pictures opposite, the 'correct' viewing distance is shorter for the picture on the left than for the picture on the right. Therefore, when both are viewed from the same distance the perspective is stronger for the picture on the left. The reader may be able (if his eye accommodation is sufficient) to discover the center of perspective for the picture on the left by moving closer to it.

Related terms: anamorphic, normal perspective, strong perspective, weak perspective, viewing distance.
References: **64** (1071–1073), **193** (126–131).

The center of perspective for the picture on the right is at a distance that most people find comfortable for reading so the perspective appears normal. The picture on the left has its center of perspective considerably closer to the page, producing an impression of stronger perspective. *Photographs by M. A. Geissinger.*

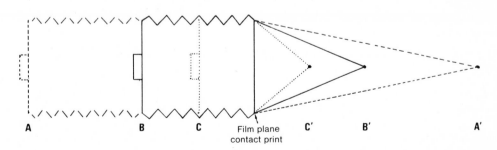

A, B and C are the positions of long, normal, and short focal length lenses on a camera. A', B' and C' are the corresponding centers of perspective for viewing contact prints of negatives made with the three lenses. Viewers will tend to look at all three prints from position B' which is at a distance equal to the diagonal of the prints. This makes the perspective appear too strong on the photograph made with the short focal length lens and too weak on the long focal length photograph.

211

10

Perception of Detail

10.1 Identification

Definition: The final stage in the process of obtaining information from a photograph or other visual field.

Identification concerns the ability of the observer to state what the perceived object is. There are several fairly distinct steps in the perceptual process that result in identification. When you are driving a car, you may see something 'out of the corner of your eye.' This is an example of *detection*, the near-threshold perception that something exists in your visual field. A moment later you may be able to say that it appears to be an object on the road about a mile away, an example of *localization*, which is the perception of an object as occupying a specific position. As the distance to the object decreases you are able to see some of the separate parts of the object, an example of *resolution*, which leads you to perceive the object as a car, an example of *recognition*. *Identification* would involve your ability to say that the car is a Volkswagen, and at a higher level that it is a 1979 Volkswagen driven by your friend Tom.

Each of these successive stages in the perceptual process resulting in error-free identification may occur so rapidly in a real-life situation that you are hardly aware of them. It is only in an artificial experimental situation that they can be studied separately. Research shows that each higher stage of perception requires more information. Mere detection is possible when the light energy at the retina from the object is only barely above the noise level of the eye—a few quanta suffice. For localization to occur, the stimulus must have a higher level of energy and it must be present for some minimum length of time. The time varies with the light level and may often be a small fraction of a second.

Resolution, recognition and identification demand still more information, there hardly being an upper definable limit for difficult perceptual problems. A taxonomist attempting to identify a bird may need to capture it, so that he can examine the details of its structure and coloration.

The amount of information needed by a given observer to solve a given perceptual task varies with the expertise of the observer. Skilled persons can make correct identifications on the basis of very slender clues. Experts in photoreconnaissance can identify vehicles and aircraft when the images hardly appear more than indistinct blurs to the inexperienced.

An observer's bias may strongly influence his efforts at identification. For example, if he is shown a projected slide so grossly out-of-focus that the object is totally unidentifiable, but he is required to identify the object nevertheless, the observer is likely to give an incorrect identification. When the same image is later focused sufficiently to reveal the observer's incorrect identification, he is unlikely to change his mind. Experiments in group dynamics have shown that a person denies the evidence of his senses if the contrary view of his associates is strongly expressed. Observer bias of the first kind is perhaps responsible for the firm belief of some that they have seen ghosts or UFOs, despite evidence to the contrary.

For the preceding reasons, it is not easy to relate objective measures of image excellence, such as resolution or acutance, to the identifiability of objects from photographic images. For example, it is not yet known which characteristics of photographs permit error-free identification in military, geodetic survey or other applications.

Related terms: Information theory, psychophysics, test targets, figure–ground.
References: **34** (424–425), **65** (15–24), **86** (158, 247–272).

Look at the first photograph in the upper left of this photographic sequence and attempt to identify what is in the doorway. The out-of-focus image in the doorway is easily detected and localized but not recognized. More information is needed but how much more? Follow the sequence carefully and attempt positive identification of the image in the doorway before looking at the last photograph. *Photographs by André LaRoche.*

10.2 Image Spread

Definition: A scattering of image-forming light resulting in an image of a point different in size from that predicted on the basis of geometrical optics.

If a photograph is made of the sky on a clear night, the images of the stars will be enlarged due to scattering of light by both lens and film. Scattering by the lens is described by the optical point-spread function and scattering within the emulsion is described by the photographic point-spread function. A plot of the change in density across the image of a point on a photograph is a curve resembling a normal-distribution curve rather than a line with an abrupt change at the edge of the image. A similar effect occurs in the eye due to scattering by the lens and in the retina so that a pinpoint white area against a black background produces a larger image than a black area of the same size against a white background. It is impossible to make a white stimulus area so small that it cannot be detected (providing it is emitting or reflecting sufficient light). The apparent difference in the size of various stars at night is due to differences in the amounts of light reaching the eye rather than differences in the angles the stars subtend to the eye. If the stars were black spots of the same size, without image spread, against a bright background, they would not be visible. The importance of contrast can also be observed with the stars by the order in which they appear and disappear at dusk and dawn.

Because a sufficiently bright stimulus cannot be made so small as to avoid detection, targets made for the purpose of measuring detection consist of dark figures against a uniformly light background. The extent to which there is a difference, with respect to visual acuity, of light images on a dark background versus dark images on a light background in slides and other visual aids has not been well documented, but it should not be assumed that fine detail will be perceived equally in the two situations. It is also possible that small white defects, such as dust spots, may be more apparent under certain conditions than dark spots of equal size with contrasting backgrounds. From a pictorial viewpoint, a diffused photograph that is produced by a soft-focus camera lens, where highlights are surrounded by light halos due to image spread typically appears more natural and attractive than one produced by diffusion during printing where shadows are surrounded by dark halos, as illustrated on the opposite page. Light halos can be obtained by diffusion during printing with reversal materials, as when making color prints directly from transparencies. A soft-focus effect with light halos can be obtained also by placing a diffuser on a slide projector or movie projector lens.

Diffraction of light by the iris of the eye also contributes to image spread. This effect can be demonstrated by making a pinhole in a file card and looking at a bright light source, such as a photoflood lamp, through the hole. The apparent size of the pinhole will decrease as the card is moved to one side to position the hole in front of a less bright background. Radiating streaks may be seen when one looks through the pinhole or when one looks at any small, bright light source such as a star or the filament of a bare bulb from a distance due to irregularities of the opening in the iris. A similar effect commonly occurs in photographs due to diffraction of light by the diaphragm blades in the lens. Each blade produces streaks on opposite sides so that ten streaks appear around bright lights in photographs made with lenses containing five-bladed diaphragms. Wire screening may be placed in front of a camera lens to produce an exaggerated star effect.

Related terms: diffraction, flare, irradiation, optical-spread function, point-spread function, spread function, star pattern.
Reference: 178 (322–323).

Two copy negatives were made of a high-contrast photograph, one normal (top) and one with a diffuser on the camera lens which produced light halos around the white areas (center). One more print was made from the normal negative with a diffuser on the enlarger lens which produced dark halos around the black areas (bottom). An enlarged section is shown to the right of each picture. Camera diffusion appears more natural than enlarger diffusion because it corresponds more closely to image spread in our own visual process. *Photographed by Lori Stroebel.*

10.3 Sharpness

Definition: The aspect of acuity in visual images, or of definition in photographic images that is associated with the distinctness of edges.

Edge reproduction, combined with good rendition of small image elements, is an important factor in the small-scale quality of visual and photographic images. A sharp edge is one in which there is a marked change in luminance or color where two different tones of a scene or photograph meet. The visual system judges the edge characteristic on the basis of the rate of change of luminance or color as the eye scans the edge. Thus sharpness is in part determined by this characteristic of the boundary between the two tones.

The impression of sharpness is also affected by the total contrast between the two juxtaposed areas, that is, by the luminance ratio or the color difference associated with the tones. If the contrast is small, even an abrupt change in the image characteristic is hardly observable, whereas if the contrast is high the edge appears relatively sharp even if the gradation at the edge is gradual.

For photographic images, the appearance of sharpness has been shown to be well-correlated with the measured value called *acutance*. This is based on an average slope found from a trace across an edge made with a microdensitometer, an instrument capable of measuring the density of very small image areas. For the comparison of photographic materials, the formula for acutance is $G^2 DS$, where G^2 is the average of the squares of the slopes found at a number of points in the edge trace and DS is the density scale, the difference between the largest and smallest densities in the trace. The division by DS has the effect of removing from the acutance value the total edge contrast, although as mentioned the total contrast does affect edge appearance.

Like most other aspects of the visual or photographic image, sharpness is affected by many factors. Low illumination levels, as in moonlight, reduce sharpness because only the rods of the retina are sensitive at low light levels, and they are neurologically linked into groups that constitute receptors of increased size. Graininess produces a similar photographic effect. Reduced sharpness in the photographic image is also caused by a number of other factors including optical defects, diffraction, and subject or camera motion.

Edge enhancement occurs in photography through the influence of adjacency effects, whereby edges have greater slopes than would otherwise be the case. Advantage is taken of these effects especially in photolithography, where infectious development generates sharper lines and 'harder' dots than would conventional films and development. Edge enhancement associated with neurological interactions in the visual process helps to compensate for the loss in sharpness caused by diffraction, lens defects and accommodation errors. However, if the edge in the retinal image is sufficiently unsharp, a reversal of enhancement occurs. This results in the viewer not detecting a tonal difference that is obvious with a sharper edge.

If it is known how the unsharpness of an image is caused, edges can be sharpened by the use of computer analysis and data processing. Such methods are used, for example, to improve the pictures taken by earth satellite cameras.

Related terms: acutance, detail, Mach band, recognition, resolution.
References: **119** (141−152), **195** (197−233), **202** (268−269).

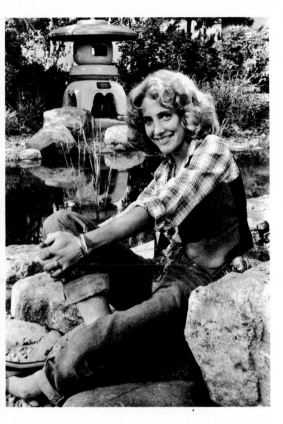 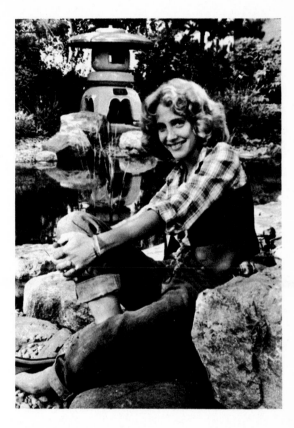

Sharpness is dependent upon good focus. The photograph on the right is slightly out of focus and has lost sharpness, particularly in the fine detail (high frequency) areas such as the hair and the patterned shirt. Loss of sharpness is less noticeable in the low frequency areas. Sharpness affects contrast as can be seen by the loss in contrast in the less sharp

photograph. A microdensitometer scan of an edge (black edge of the back of the vest) is shown in the lower right. The in-focus photograph is represented by the solid line, the out-of-focus by the dotted line. The steeper slope indicates a sharper image. *Photographs by John Jean, curves by M. Abouelata.*

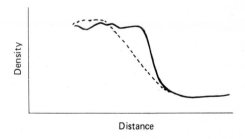

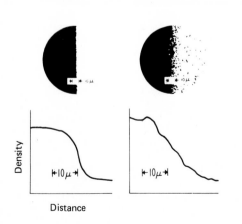

Left: Sharpness is dependent upon the graininess of the film. The edge on the left is made on fine grain film and is sharper than the edge on the right made on coarse grain film.

10.4 Acuity

Definition: A measure of the ability of an observer to distinguish detail in a test target.

Acuity is a numerical value found from an experiment in which an observer is presented with a test object consisting of small parts—spots or lines or characters—and is asked to specify the smallest one he can distinguish. The measured value is expressed in one of two ways: *Either* as a ratio of distances, such as 6/12, meaning that the observer can distinguish at 6 meters what a person of normal vision can distinguish at 12 meters, *or* as the reciprocal of the angle in minutes subtended at the observer's eye by the critical dimension of the barely distinguishable part of the target, such as 1/2 if the angle is 2 minutes. Optometrists, who work under standardized conditions, commonly use the first method. An advantage of the second method is that the value is independent of distance, but size–distance relationships can be determined by the use of trigonometry. For example, an object having a critical dimension of 1 mm subtends an angle of about 1 minute when the object is 3·5 meters from the observer.

Like photographic resolution, acuity depends greatly upon the experimental procedure, and is by no means determined solely by the observer's visual ability. The nature of the test object is in part dictated by the task that the observer is called upon to perform. *Detection* involves simply the ability of the observer to state whether or not the test object is present in the visual field. *Localization* requires identification of the position of a critical element of the test object such as the opening in the Landolt ring (*see* topic 3.10) or the break in a straight line when part of the line is displaced to test vernier acuity. *Resolution* measures the ability of the observer to state whether there is only one element or there are two or more closely adjacent elements in the field. *Recognition* requires the observer to state the identity of the test character, such as the letters on a Snellen chart. Other factors that affect acuity include the following:

1. The polarity of the target. Light or bright lines or spots on a dark background are more easily detected than dark lines on a light background because diffraction and scattering of light in the eye cause the image of a bright area to be widened.

2. The contrast of the target. Black spots on a white background are more visible than the same spots on a gray background.

3. Pupil size. Maximum acuity occurs when the pupil diameter is about 4·0 mm. When the eye is 'stopped down' diffraction worsens the image. When the pupil opens beyond the optimum the image deteriorates because of the effects of aberrations.

4. Illumination level. At very low illumination, only the retinal rods function. At very high illumination, glare interferes.

5. Adaptation level. It is common experience when a person enters a dark theater from daylight to observe a gradual improvement in the ability to see objects over a period of several minutes. The reverse adaptation process occurs much more rapidly.

6. Illumination color. At low and moderate light levels, acuity is higher for middle spectral wavelengths (green and yellow) than for the extremes (blue and red). The cause is the chromatic aberration of the eye.

Related terms: detail, identification, resolution, sharpness, signal–noise, test target. *References:* **86** (112–117), **151** (77–78, 82), **178** (321–349).

A barely visible black line was used as a target to
measure the effect of background luminance on acuity.
Varying the illumination on a resolution target results
in a graph with a similar shape but acuity values are
only about 1/60 of these.

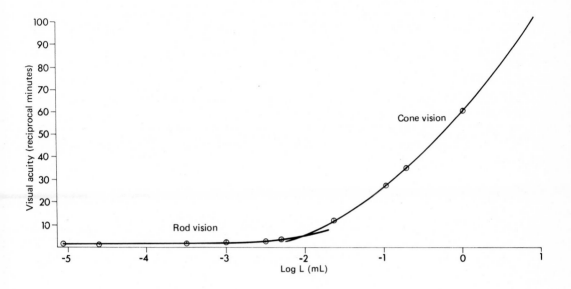

A resolution target was used to measure the effect of
pupil diameter on acuity. The vertical bars represent the
ranges of several measurements.

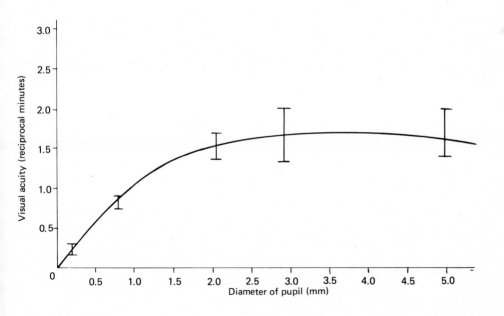

221

10.5 Resolution

Definition: A measure of the eye's ability to discriminate the elements in a set of small similar items, often bars.

Resolution as a measure of the quality of a visual or optical system had its origin in astronomy. With an excellent telescope an observer can see that there exist double stars —two points of light so close that in a poorer telescope the two blend into one.

To measure resolution, a target consisting of small (usually similar) objects is used, and the observer is asked to point out the smallest ones that he can distinguish as separate. For vision, resolution is usually expressed as an angle, a typical value being about one minute of arc. For example, a resolution of one minute enables an observer to recognize that there are two side-by-side pennies when they are about 60 m (200 ft) away. In a photographic print at 25 cm (10 inches) viewing distance, the same value implies that two spots less than 0·1 mm apart can be discriminated.

Resolution is a threshold measurement since it involves a barely detectable difference. For this reason, it may bear little relation to the quality of the image as a whole. It is not well correlated to the ability of the observer to identify objects. The familiar Snellen eye test chart (containing black letters of decreasing size) includes the task of recognition, and the Landolt chart (containing C-shaped figures of decreasing size rotated to place the openings in different positions) includes the task of localization.

Many factors affect the resolution value of the eye as found in an experiment. Among these are:

1. The nature of the test target. Lines are more easily resolved than are points. An offset in an otherwise straight line is detectable when the offset is only about 2 seconds of arc—about 1/30 of that needed to see two lines as two. Black lines on a white background are more easily resolved than are dark gray lines on a light gray background, hence the importance of the contrast of the target.

2. The light level. Resolution decreases in weak light or in light at such a high level as to cause discomfort.

3. The color of the light. Visual resolution, like acuity, is best for green light, and poorer for blue light and red light.

4. The area of the retina receiving the image. Resolution is best in the fovea, and falls rapidly to much lower values as the image moves to the outer region of the retina.

In photography, resolution is estimated from the image of a target (*see* opposite). The measure is usually 'lines per millimeter.' One 'line' consists of one bar plus one intervening space, and is more clearly named one line-pair, or one cycle. Although a resolution of 1 minute of arc corresponds to 14 line-pairs per mm at a viewing distance of 25 cm (10 inches), 10 line-pairs per mm is usually sufficient resolution in handheld prints. Care should be taken when comparing photographic resolution and visual resolution, since the latter is often computed on the basis of one line rather than one line-pair.

Like visual resolution, photographic resolution is affected by many variables. To those in the list for the eye should be added, for example: the camera optical system; the film, the exposure level, and the development process; and the printing method and material. Thus, resolution estimates the performance of a *system*, not merely that of a single part of a system such as a lens or film. There is no theory that relates system performance to that of the parts of the system. One empirical rule is: $1/R = 1/r_1 + 1/r_2 \ldots$ where R is system resolution and r_1, $r_2 \ldots$ are the resolution values for the system components (lens, film, observer, etc.).

Related terms: acuity, blending, detection, discrimination, recognition, sharpness.
References: **178** (325–326, 329–330, 337–338), **202** (273–275).

Below is a portion of a resolution test target commonly used in photography. The table gives data about the target in terms of the angle subtended by one line-pair of each target set when it is placed 1 m (39·4 in) from the observer. Also are given the lines/mm in the target, and at the retina, assuming a focal length for the eye of 17 mm. The target and the accompanying data can be used to find visual resolution under different conditions. (Select the smallest pair of vertical and horizontal lines that can be resolved at the specified distance.)

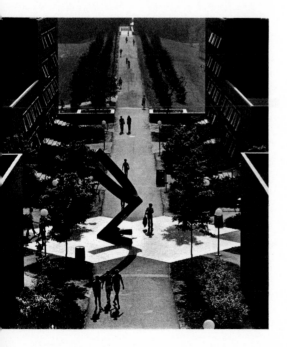

	Identification number		Angle (minutes) per line pair at 1 m	Target line-pairs per mm	Retinal line-pairs per mm
	0	1	3·44	1·00	56
		2	3·12	1·10	62
		3	2·75	1·25	70
		4	2·46	1·40	79
		5	2·15	1·60	90
		6	1·91	1·80	101
	1	1	1·72	2·00	112
		2	1·56	2·20	124
		3	1·37	2·50	140
		4	1·23	2·80	158
		5	1·07	3·20	180
		6	0·95	3·60	202

Above: Vernier focusing scale. When the numbers line up the camera is in focus at that distance.

Left: The students in the photograph are countable but not identifiable. *Photograph by A. Franklin.*

10.6 Gloss

Definition: The visual impression of surface smoothness associated with the reflection of light in a preferred direction (specularly) from the surface.

An unscratched polished glass surface has a high gloss. Other similar surfaces are those on varnished and waxed furniture, plastics, metallic surfaces like unworn coins and silverware, and 'glossy' photographic prints.

The impression of gloss results from the surface reflection of a small light source. The effect is like that produced by a good mirror which is itself nearly invisible, and forms images of the light source.

For nonmetallic surfaces, the gloss reflection has a color identical with that of the light source, independent of the underlying color of the object itself. The object color arises from the diffuse reflection of light that penetrates the surface and is reflected back from the pigment or other colorant below the surface. This effect can be seen with the variously colored balls on a pool or snooker table. The highlights resulting from the gloss reflection have the same color regardless of the color of the balls themselves. Metallic surfaces, on the other hand, give gloss reflections that are at least partially modified by the color of the material. Therefore, gloss reflections from silver and gold differ in color.

Most photographic papers are made with an overcoating of gelatin. During manufacture the surface characteristics are controlled to produce more or less gloss. If the surface is smooth, the gloss reflection will be in essentially a single direction when the print is illuminated with a single source. The observer angles the print in such a way as to avoid seeing the gloss, and instead sees the tones of the print by the diffuse matt reflection from the silver or dye particles of which the image is composed.

If the surface is textured, there will be random tiny gloss reflections in almost all directions. The observer cannot avoid seeing some of these, no matter how he angles the print. The consequence is that the dark tones of the print are 'grayed' by the admixture of the gloss reflections. For this reason, the deepest possible blacks and the greatest range of tones, can be obtained only by the use of a glossy surfaced paper—maximum density may be 2·0 or more, and the tonal range over 100 to 1. A matt paper may have a maximum density of hardly 1·4 and thus a tonal range of only 25 to 1. The change in the appearance of the black tones in a matt print as it dries and the smooth water film on the surface disappears is obvious. Such techniques as ferrotyping, waxing or lacquering prints make them appear richer by making the surface smoother.

Skillful photographers learn to light glossy subjects, like glassware and silverware, to produce large subdued reflections which tend to be more attractive than small glaring ones. They accomplish this by using indirect or bounce light, or by putting a diffuser between the light source and the subject. Since nonmetallic gloss reflections are highly polarized at an angle of about 35° to the surface, a polarizing filter on the camera can eliminate reflections that obscure detail at that angle. At other angles, as in the photography of oil paintings, and for metallic surfaces, polarizing filters are required over the light sources as well as over the camera lens. Dulling sprays can be used to reduce glare reflections from metal objects, but they also destroy the typical appearance of the surface. Some dull surfaces can be made glossier by wetting them with appropriate liquids e.g. street pavements can be sprinkled with water, and oil used on dry skin.

Related terms: luster, matt, sheen, specular.
References: **56** (141, 148, 299, 341, 343), **192** (66–72), **202** (37–39, 79–81, 282–283).

Light reflected from the upper surface of a glossy print (left) is directional while that from a mat print (right) is not.

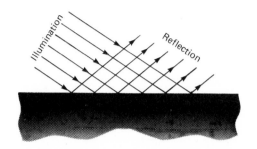

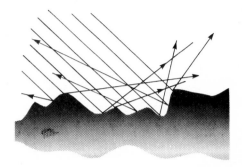

Specular surface reflections can be an important factor in imparting a sense of drama. *Photograph by Penny Rakoff.*

Perception of Shape and Size

11.1 Shape

Definition: The outline of an object, or the representation of such an outline in a picture.

Of the various visual attributes that are generally associated with objects, shape alone is sufficient for the recognition and identification of many. Thus, the simple outline drawings that teachers put on chalk-boards and that are used in some textbooks often serve the learning process adequately. In fact, some experimental studies have revealed that realistic color photographs may result in less learning. However, if you are teaching a child to associate colors with their names, it is obviously necessary to include the color attribute in the illustrations.

Although shape is commonly shown in drawings as a black line on a white back-ground, it can be represented in various other ways. For example, the image of the object can be solid black against a white back-ground, as in a silhouette. Or, the difference between the image and the surround can be in hue (a red image on a blue background), or in saturation (a red image on a maroon background), or in texture (a rough white image on a smooth white background), or in sheen (a glossy white image on a matt white background), or it is even possible to have an embossed outline depicting the shape of the object without any of the above attribute differences. The choice is more restricted with photographic images than with drawings and paintings. Nevertheless, photographers have considerable control including choice of background, lighting, and any of a number of types of films such as color, black-and-white, high contrast, con-tour, and false-color infrared. To reveal the shapes of objects depicted in photographs and paintings, it is generally desirable to have good separation between objects and back-ground. But, there are important exceptions, such as some Rembrandt portraits where subtle separation between the subject and the background is used to avoid attracting attention away from the more important facial areas.

Whereas there are widely used standard-ized vision tests to determine how accurately a person sees detail (acuity tests) and colors (color-blindness and anomalous-color-vision tests), there are no routine tests for measuring accuracy in the perception of shapes. This is primarily because this type of error is not as hazardous as not being able to read road signs or distinguish between red and green traffic lights. However, there can be signifi-cant errors in the perception of shapes. Such errors can be demonstrated most dramati-cally with the standard illusion images where straight lines appear curved, lines of equal length appear unequal, ambiguous figures can be seen alternately as two different shapes, etc. These illusions are rarely en-countered in the three-dimensional world and the effects are seldom as dramatic when found in pictures not designed specifically to demonstrate the illusions, but they can be troublesome. For example, when the edge of a print is trimmed parallel to a vertical line in the picture it sometimes does not appear parallel —due to the perceptual influence of other lines in the picture. It has also been demon-strated that the viewer tends to overestimate the length of vertical lines in comparison to horizontal lines in pictures.

The most serious errors in the perception of shape result from the necessity of repre-senting a three-dimensional subject by a two-dimensional photograph. These errors are mostly of two types. First, there is only a single correct viewing position for each photograph. Since photographs made with short focal length lenses are viewed from too great a distance, objects near the corners tend to appear stretched out of shape, an effect known as *wide-angle distortion*. Sec-ond, the viewer depends greatly on previous experience and memory, and is influenced by what he expects the perception of the object shape to be. This may cause problems with objects that are photographed at an angle rather than straight on and the viewer may tend to misjudge some irregular shapes as idealized simple shapes, such as right angles and circles, an effect known as *shape generalization*.

Related terms: ambiguous figure, figure–ground, illusion, perspective, shape con-stancy, shape generalization.
References: **48** (357–364), **81** (364–369), **218** (16–54).

The contribution of the shape attribute to perception can be illustrated by placing a dark object first in front of a dark background and then a light background. The line drawing shows how much information is retained when all of the attributes except shape are eliminated.

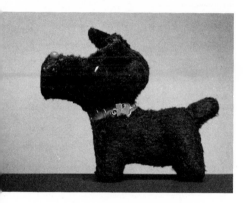

The shape of the container has been de-emphasized in the photograph on the left by reducing the contrast between the container and the background, thereby placing more emphasis on the main subject—the flowers. *Photographs by Langone.*

11.2 Apparent Size

Definition: The perceived size of a visual stimulus with respect to its actual or relative size, or other criterion.

As a measuring device, the eye at times can be amazingly precise and at other times it resembles an elastic ruler. It is important for photographers and others who are concerned with visual perception to be aware of some of the major factors that are responsible for this variability. When you are asked to provide an 'exact' dimension of an object, you place a ruler or other calibrated measuring device alongside the object and note the appropriate marking. Thus, your judgment of size is best when you can make a side-by-side simultaneous comparison with an object of known size. Your judgment is poorest when a stimulus which is not recognizable is presented in isolation from surroundings, in which case it may be perceived with equal ease as a small nearby object or a large distant object.

In most activities, including looking at pictures, a person is not frequently required to perceive the exact size of objects. But also, the inconsistencies in the perception of sizes seldom fool the observer—when he picks up a pencil, cup or book, each feels about the size he anticipated on the basis of the visual image. In one experiment, viewers were asked to adjust the size of a circular area of light on a screen at a distance of 3 m (10 ft) to match what they judged to be the actual size of larger white test circles at various greater distances. Under normal viewing conditions, the matches were quite good. When the distance cues were eliminated for the test circles they were perceived as being much smaller because they were then assumed to be at the same distance as the comparison circle, rather than at a greater distance. The relationship between perceived size and distance is also revealed by *Emmert's law* which states that the perceived size of an afterimage is proportional to its apparent distance. In other words, if a person looks steadily at a bright light and then projects the afterimage first on a near wall and then on a more distant wall, the after-image will seem to increase in size in proportion to the apparent distances of the two walls.

Other psychological factors can also affect the perception of size. Jean Piaget found that when a person gives his undivided attention to viewing an object, especially for an extended length of time, he tends to overestimate its size. Also, Ralph Evans noted that when a person looks at a particular part of a scene intently he tends to remember it as almost completely filling his field of view.

A viewer is most easily deceived by the apparent size of unfamiliar objects in photographs. When a huge new supersonic aircraft is photographed in flight against a sky background, it is difficult for the viewer of the photograph to accurately perceive the size. Because of the relationship between distance and size, the accurate perception of the size of unfamiliar objects is possible only if cues are provided concerning the size or the distance. Inclusion of a calibrated object is necessary for photographs used for some legal purposes. But the conventional depth cues such as converging lines, texture gradient and selective focus are effective in pictorial photographs where it is not appropriate to place a familiar object side-by-side with the unfamiliar object. Conversely, when it is desirable to misrepresent size, appropriate changes can be made in the cues. Since short and long focal length lenses respectively expand and compress distance as perceived in photographs, the apparent size of distant objects can be decreased with a short lens and increased with a long lens. The effect is reversed for close objects.

Related terms: distance, Emmert's law, perceived size.
References: **56** (43–46, 270–272), **119** (322–366).

It is difficult to accurately judge the size of unfamiliar objects from a photograph unless size or distance cues are provided. *Photograph by Steve Diehl, North-South Photography.*

Two white circles of the same size were placed on this photograph. Because the upper circle is superimposed on a more distant part of the scene, the viewer tends to think of it as being at a greater distance and therefore perceives it as being larger. This is similar to the moon illusion where the moon appears larger when it is near the horizon than when it is overhead.

11.3 Anamorphic Image

Definition: An image having different vertical and horizontal scales of reproduction.

Anamorphic images are most commonly associated with wide-screen motion pictures, whereby a wide angle of view of the original scene is squeezed onto normal width film and then unsqueezed in projection. This produces a high aspect ratio image that fills a wide screen. Occasionally the squeezed (anamorphic) image is found to be attractive as an end product with the unnatural width to height proportions of familiar objects. A few artists (eg. El Greco) and sculptors (eg. Giacometti) have produced effective works incorporating unusual horizontal and vertical proportions. Also, automobile advertising went through a period in which it was common practice to stretch the images to make the automobiles appear long and low.

A commonly overlooked aspect of photography is that a change in width to height proportions is produced when a normal photograph is viewed from an angle. Since the correct position for viewing is normally on a line perpendicular to the photograph at the center, a motion-picture theater may have only one seat that does not produce an anamorphic effect. Obviously, this effect is very subtle for most of the seats in the theater. This fact, combined with the shape constancy phenomenon, prevents the viewers generally from being conscious of the anamorphic effect, although it is inescapable in the extreme front and side seats of most theaters.

Even though the esthetic appearance of pictures is greatly influenced by changes in the width to height proportions, the viewer has little trouble recognizing familiar objects in anamorphic pictures, unless the change in proportions is quite drastic. The reader can demonstrate this by noting how far he can tilt this page before the type becomes illegible. It should be noted that viewing a normal photograph at an angle from the side causes the horizontal lines to converge in addition to reducing the width, in contrast to a squeezed image produced by an anamorphic lens. A procedure for producing such a squeezed image, without using an anamorphic lens, is to copy a photograph from a side angle, make a print without cropping, and copy this print from an angle on the other side. The width is reduced at each copying step, but the converging horizontal lines introduced on the first copy are automatically corrected on the second, *(see* opposite).

Some early artists were fascinated with both *slant perspective*—in which the image had to be viewed from an extreme angle to appear realistic—and distorted images which could be reformed only by viewing the reflected image produced in a polished cylinder placed perpendicular to and in contact with the painting. Oblique aerial photographs also display slant perspective which must be rectified if they are to be used for mapping purposes.

Related terms: distortion, slant perspective, squeezed image.
References: **64** (35–42), **68** (110–116), **121** (35–42).

Above: An anamorphic self-portrait made by Ducos du Hauron in 1888. (Louis Ducos du Hauron was an early French photographer and experimenter who announced in 1869 a technique for a subtractive color photographic process.)

Left: Squeezed and stretched anamorphic images produced with a two-generation copying procedure. The short image was obtained by copying a dollar bill with the right end swung away from the camera and then copying a print with the right end swung toward the camera. The long image was obtained by tilting the top of the bill toward the camera and then copying a print with the top tilted away from the camera. *Photograph by Leslie Stroebel.*

Above: Large anamorphic sculptured figures in Brasilia, Brazil. *Photograph by Peter Gales.*

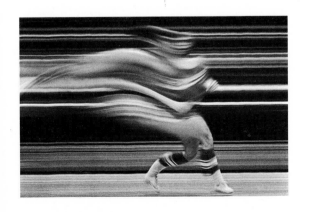

Left: Photograph made with a slit camera. A horizontal elongation of parts of the picture occurs where, due to the combination of movements of the camera and the subject, the image remained at the slit for a longer than normal time as the film moved behind the slit. *Photograph by Andrew Davidhazy.*

Perception of Brightness/Lightness

12.1 Brightness

Definition: The aspect of visual perception that relates to an object seen as a light source, and that varies with the level of light produced by the source.

One star is said to be brighter than another, and the sun is said to be too bright to look at directly. Thus, the term *brightness* is applied to objects which are perceived as sources of light, as distinct from the term *lightness* which is properly applied to objects that are perceived as reflecting light.

The scale of brightness extends from dazzling, at one extreme, to very dim (and finally invisible) at the other. A sequence of brightnesses can be seen when a household lamp is operated with a dimmer. The brightness control on a television set causes a similar change.

For a given wattage, a small-area source like a spotlight appears much brighter to the portrait sitter than does a large-area source like a diffused floodlight. Small-area sources emphasize texture and shadows. Large-area sources, such as banks of fluorescent lamps, give soft lighting and reduced texture.

The perception of brightness is partially related to the psychophysical measurement of luminance. Luminance is defined as the light in candelas emitted per unit area of a source. The luminance unit is candelas per square meter or per square foot. Luminance is measured with a light meter that has a restricted angle of view, and that can be aimed at a small area of a surface. Such meters are commonly called 'reflectance' or 'brightness' meters, and the result is known as 'photometric brightness'.

Since brightness is defined as perceptual, it is measurable only with the help of a human observer. In one type of experiment, an observer is asked to adjust the operating level of a lamp so that it appears to be intermediate in brightness between that of two other lamps having different brightnesses. By a series of such experiments an interval scale of luminances as related to brightnesses can be constructed. In a different experiment, the observer adjusts the source so that it appears to be twice as bright as a given lamp, leading to a ratio scale of the data. Or, an observer may adjust a source so that it appears to be just barely brighter than a given lamp. This last experiment involves the concept of the *just-noticeable difference* (*jnd*) as a unit of measurement.

Experiments of this kind show that the relationship between measured luminance and brightness obeys this law: $B \propto kL^{0.33}$ where B is brightness and L is luminance. The constant k varies with the adaptation level of the observer. The constant is small when the observer is adapted to a low light level, as in starlight. In such a situation brightness changes only very little with luminance. If the observer is adapted to high light levels, k is larger and the perceived brightness changes more rapidly with luminance. Two examples are shown in the first graph. Both of the curves have about the same general shape, indicating that as luminance increases so brightness increases more and more slowly.

The influence of changed adaptation level in part explains the effect of the surround on perceived lightness in photographic prints, as shown in the seond graph.

There is another general meaning of the term 'brightness.' When bright colors are mentioned, bright refers to colors that have strong or vivid hues. For example, a bright red is one that is greatly different from gray. To distinguish between this use and the one discussed above, the term *saturation* (*see* 13.2) is used.

Related terms: lightness, luminance.
References: **36** (14), **55** (16, 38–39, 118–119, 121–122, 158–168, **216** (I items 48, 63).

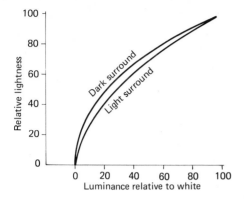

Left: The relationship between perceived lightness of tones in a photographic print and measured luminances of the print. The scales are relative, 100 representing white and 0 ideal black. Lightness changes more rapidly initially when the surround is dark than when it is light.

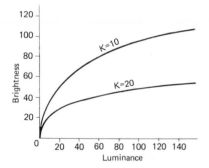

Left middle: The relationship between perceived brightness and measured luminance. The curve labeled $k=10$ applies to a low level of adapting light, the one labeled $k=20$ to a higher level.

Below: The reflection of the sun in the water was the brightest area in the original scene. If the illuminated clouds were perceived as sources of light, they have lower brightnesses. The term *lightness* is properly applied to the various tones in the print, which cannot reproduce the range of the scene. *Photograph by George Waters Jr.*

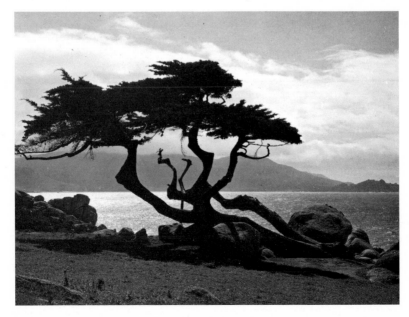

12.2 White

Definition: **1.** A perception of high lightness associated with a diffusing surface of high reflectance and no identifiable hue. **2.** A perception of high brightness associated with a light source of no identifiable hue.

In the sequence of neutral surface colors (grays), white lies at the end of the series opposite to black. White is associated with surfaces that reflect a large proportion of the incident light and that reflect different wavelengths of light about equally. The white paper on which this page is printed has a reflectance of about 90%. Clean snow has a reflectance of about 95%. White surfaces, in contrast to mirror surfaces, reflect light diffusely i.e. at all angles, no matter how they are illuminated.

In photographic prints the viewer accepts as white those tones that are near to the tone of the paper stock, despite variations in the reflectances of different paper bases. Also, the surround influences the perception of white. A very light gray may look white if it is surrounded by a black tone.

Sources of light, as distinct from surfaces, may be perceived as white despite great physical differences among them. Sunlight, tungsten lamps, and fluorescent lamps appear white when each is the sole source of illumination. A tungsten lamp gives light that is physically much redder and much less blue than sunlight—yet at night the lamp looks nearly white. This is explained by the adaptation of the eye, which changes in its color response to suit the color of the prevailing light. It is only by a direct comparison of a tungsten lamp with a fluorescent lamp that you can see the difference between them.

Because the photosensitive materials used in photography, unlike the eye, cannot adapt to the light source, different lamps that may appear visually similar may not be photographically equivalent. It is for this reason that color correction filters are needed, for example, when a color transparency film intended for use with tungsten lamps is exposed in daylight conditions.

With light sources, the perception of white can be elicited in many different circumstances.

Some of these are:
1. A mixture of many different wavelengths of light, as from the sun, tungsten lamps and fluorescent lamps.
2. An appropriate mixture of three differently colored lights, especially red, green, and blue. This fact is the basis of the additive method for producing different color perceptions as in color television, where the screen consists of dots that emit red, green or blue light.
3. An appropriate mixture of complementary pairs of colored lights. e.g. the right proportions of blue light and a yellow light are seen as white.
4. A light of any color that falls on the outer portion of the retina where only rods are present. Since rods do not detect hue differences, any light that stimulates only rods appears white.
5. A light below a given threshold level where only the rods can function. Light of any wavelength composition appears white. Such a situation occurs in starlight where no hues can be distinguished.
6. A light at such a high luminance level as to cause discomfort. At this level all of the sensitive cone elements in the image area of the retina are stimulated, and their combined response results in a perception of white.

Related terms: adaptation, additive, black, complementary, contrast, lightness constancy, midtone, neutral.
References: **56** (105, 131, 160–161, 240–243, 283–286, 321–322), **216** (I items 4, 15, 23, 26, 65. II items 49, 51).

The perception of white is associated with the lightest tone in a set of grays.

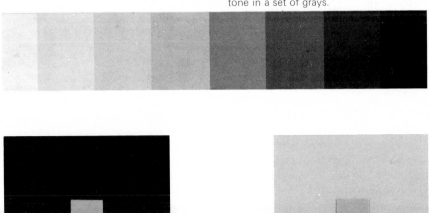

Above: The perception of white, for a given tone, is affected by the surround. The central areas above are identical; the one with the black surround looks more nearly white than does the one with the light surround.

A high key photograph contains many 'whites.'
Photograph by David Spindel.

12.3 Black

Definition: A perception of low lightness and no identifiable hue associated with a surface having low reflectance.

The perception of black appears whenever (1) the light level is below a threshold (this level changes with the adaptation level of the observer); (2) the observer identifies what he sees as a surface as distinct from a light source; (3) the observer cannot identify the hue as reddish, yellowish, bluish, etc.

In the scale of neutral colors (grays), black lies at the opposite end from white. It is normal to speak of black cats, black-dyed fabrics, and black hair. The physical characteristic of such objects is that they reflect light poorly, and that the weak light they do reflect is not predominantly a hue such as red, blue or green.

The perception black is never associated with a light source, such as a tungsten lamp operated with a dimmer. For such a source, lowering its intensity causes it to be perceived firstly as dim and then later as imperceptible, but never black. Similarly, a lightbox never looks black, even if very dim. When a transparency is placed over the lightbox, the observer then sees the transparency as a surface, and may perceive blacks in the shadows.

Opaque surfaces seen as black reflect about 3% or less of the incident light. Such a reflectance is typical of the darkest tone in newspaper reproduction. The blackest possible tone in a photographic print reflects about 1% of the incident light. Such a tone is labeled 0 in the zone system. Even the darkest surface commonly seen—black velvet —reflects about $\frac{1}{2}$% of the light it receives. Thus, black is never the complete absence of light.

In photographic prints, the darkest possible tone is seen when the paper surface is glossy; the maximum 'black' of a matt print is gray by comparison. Wetting or lacquering a matt print makes the dark tones darker. Thus, the glossier the surface, the darker the maximum black. In terms of density, a glossy print may have a maximum value over 2.0, whereas the maximum in a matt print may be 1.7 or lower. Because the value of the maximum density in part determines the possible tonal range, glossy prints have a greater potential range than matt prints.

Whether or not a surface is perceived as black depends upon several factors in addition to its reflectance. Among these factors are:

1. The surround. A patch may look dark gray against a dark background but black against a white one. Thus the mount for a print, or the presence of a white border, affects the appearance of the blacks and the other dark tones in a print.

2. The ambient light level. The appearance of the dark tones in a projected transparency, or one placed on a table viewer, changes noticeably if the room lights are turned on. The same effect is noticed when viewing television.

3. The observer's level of adaptation. Outdoors on a dark night, at first everything looks black. As adaptation occurs, some 'black' objects may now appear gray. The absolute black threshold, however, is determined by what is 'seen' in the absence of light. In complete darkness, random activity in the retina and in the neurons gives rise to faint swirling sensations—the 'noise' of the eye.

Related terms: adaptation, extinction point, lightness, neutral, white.

References: **55** (105, 124, 321), **216** (I, items 15, 50, 66. II, items 46–48, 51).

The perception black is associated with the darkest tone in a set of grays.

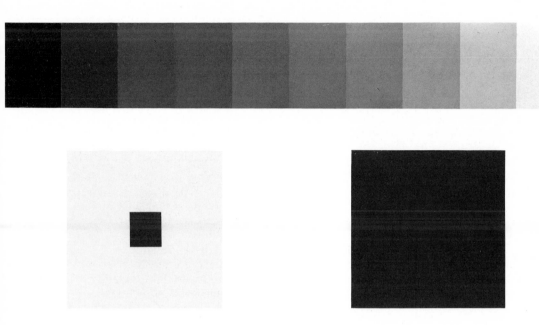

Above: The dark gray patches are identical in ink thickness. The one against a white background, however, looks more nearly black than does the one against a black background.

A low-key photograph involves mostly dark tones, many of which are black. *Photograph by John Jean.*

12.4 Midtone

Definition: A subject or image area that is intermediate in lightness between two other specified areas, commonly the lightest and darkest.

Beginning photography, students are often surprised to discover that an 18% reflectance gray card (a reflection density of 0·7) is widely used as representing a lightness midway between black and white. Since reflected-light exposure meters are generally calibrated to reproduce the metered area as a medium tone on the photograph, it is important that the reading be taken from an appropriate subject midtone area.

If a number of gray patches, each of a different reflectance, are given to various people and each is asked to select one patch that represents the medium lightness between black and white samples, there would be considerable variation among the choices. It can be predicted, however, that the mathematical average of all of the choices would be close to an 18% reflectance. Another approach would be to present each person with a large variety of gray patches and ask him to construct a gray scale of just-noticeable differences, and then select the middle patch as a perceptual midtone. The value scale in the Munsell system (*see* 3.8) is made up of eleven neutral patches varying in lightness from black to white with increments based on equal perceptual differences. The middle patch has a reflectance of approximately 18%. When equal areas of black and white paper are placed on a motor and rotated rapidly, the fused tone more closely matches a 50% reflectance gray sample (a reflection density of 0·3).

Since photographers frequently take close-up exposure meter readings from midtone areas, they should be aware of several factors that can affect their perceptions. The lightness of the background can influence the lightness perception of an object due to simultaneous contrast. When a white background, instead of a gray one, was used in selecting the gray patches with the original Munsell system, a somewhat lighter gray was perceived as being centered between black and white—one having a reflectance of 25%. The size of the area being judged affects the perceived lightness, an effect that can be attributed at least partially to simultaneous contrast. It is also important to standardize the illumination level, as the state of adaptation of the visual system can influence the choice of a midtone. Few scenes are composed entirely of neutral tones, however, so that confusion occurs due to the inability to isolate the lightness attribute from the hue and saturation attributes of color. An even more troublesome factor is the difficulty in judging lightness when there are both reflectance and lighting differences in a scene. A white surface in the shade may be an appropriate area for an exposure meter reading, but because of the lightness-constancy phenomenon, you tend to judge it as being lighter than a gray of equal luminance located in the sunlight.

By measuring the lightest and darkest areas in a scene with a light meter, a luminance midtone can be determined. Such a calculated midtone may or may not be perceived by an observer as being a lightness midtone. This is because the only time luminance values can be used to predict perception accurately is when the two stimuli have the same luminance and are viewed side by side—where it can be predicted that they will match in lightness. Calculated luminance midtones, however, are appropriate when determining the camera exposure settings. It should be noted that the luminance midtone is a logarithmic, not an arithmetic average. Thus, with low and high values of 1 and 64 luminance units, the middle value is 8, not 32.5. Most modern exposure meters have scales that position the logarithmic average midway between the high and low readings.

Related terms: adaptation, lightness contrast, Munsell system, sensory scaling, simultaneous contrast.
References: **32** (229–240), **55** (157–164), **214** (451–453).

The perceptual midtone between black and white is an 18% reflectance gray (a reflection density of 0.7). Physically averaging the light from equal areas of black and white paper produces a tone corresponding more closely to a 50% reflectance gray (a reflection density of 0.3).

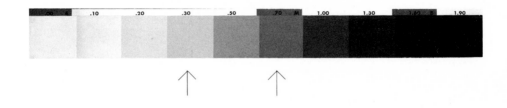

Above: With scenes that contain a high luminance ratio between the lightest and darkest areas, it is more dependable to calculate a luminance midtone than to visually select a midtone area for a single closeup exposure meter reading.

The contribution of a midtone to visual perception is illustrated by this tone separation photograph which contains only one gray tone between white and black, yet appears quite realistic. *Photograph by William W. DuBois.*

243

12.5　Extinction

Definition: A point on a luminance scale below which changes in luminance produce no change in appearance.

All of the steps of the gray scale opposite can be seen when it is examined with adequate illumination, such as that recommended for reading. When you reduce the illumination, as by walking into a darkened room and gradually closing the door, the separation disappears—first between the two densest steps and then between progressively less dense steps. In other words, the extinction point moves up the scale from the black end toward the white end as the illumination is decreased, as illustrated. However, if you remain in the dimly lit room for an extended period, the extinction point at least begins to move back down the scale as your eyes adapt to the darkness— but it may never reach the bottom of the scale if the light level is quite low.

An implication of the extinction phenomenon is that photographs should be assessed under the same conditions of illumination as when they are presented for viewing. The extinction point may be quite different under safelight illumination in a printing darkroom than under normal room illumination—even when your eyes are adapted to the darkroom illumination. As a result, shadow areas that appear black on a print viewed by safelight illumination may appear too light when the print is displayed. Before there were effective illumination standards for assessing photographs, photographers were often dismayed to find that their prints, which looked good under normal room illumination, appeared too light under the spotlights used for judging. Conversely, the prints that looked good under the spotlights seemed to lack shadow detail when displayed later under normal room illumination.

A similar effect occurs if you attempt to assess a color slide by holding it in front of a sheet of white paper or a blank wall with low-level room illumination. The extinction point may be much different when the slide is projected on a screen in a darkened auditorium. The effect can be observed also when a slide is judged by projecting it on a small screen close to the projector and is then shown to a large audience with the projector at a considerable distance from a large screen.

Although it might appear that the converse of this effect, whereby highlight detail is lost with high levels of illumination, could also cause perceptual errors, this seldom occurs in practice. This is because the upper threshold of vision is much higher than the highest luminance values normally encountered in viewing photographs. The effect can be experienced, however, by going directly into bright sunlight after being in a darkened room for an extended period. Due to dark adaptation of the eyes, it may be painful to attempt to look at the highlight areas of the sunlit scene.

Related terms: black point, threshold.
References: **44** (13–18), **57** (116).

On the original gray scale, separation could be seen between all 10 tones under normal room illumination. As the light level was reduced, the extinction point moved along the scale. The arrows indicate the darkest steps that were visible at different light levels.

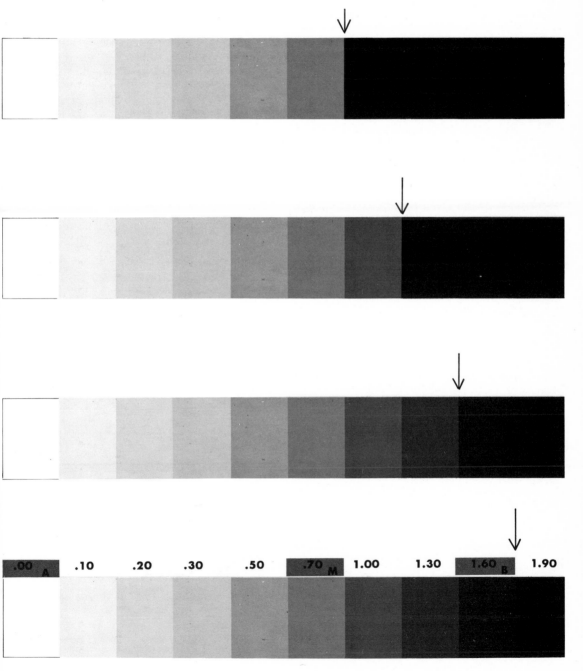

.00 A .10 .20 .30 .50 .70 M 1.00 1.30 1.60 B 1.90

12.6 Luminosity Function

Definition: The relationship between the sensitivity of the human visual system and the wavelength of light.

If you look at a spectrum of the sun as displayed in a rainbow, the central green and yellow portions look brightest, and the red and blue edges of the band of light fade into imperceptibility. This is the result of two factors—the energy emitted by the sun at various wavelengths, and even more important, the sensitivity of the eye to different wavelengths.

In the laboratory, an experimenter can present to a viewer equal energy levels at various wavelengths, and by a matching experiment find the amounts of energy needed for the entire light spectrum to appear equally bright. The resulting data are usually plotted to show the reciprocal of the energy, on a relative basis, needed to produce a constant visual effect at any wavelength of light.

An important factor in such an experiment is the light level. At moderately high levels of light, a curve like that labeled *photopic* in the illustration is obtained. It shows that the sensitivity of the visual system is greatest for a middle wavelength, green in hue, at nearly 555 nm. The sensitivity falls rapidly in both directions from the peak, to a value of nearly zero at 400 nm (extreme violet) and 700 nm (extreme red). This behavior is attributed to the response of the cones of the retina.

At a very low light level, a similar experiment gives the curve labeled *scotopic*. As compared with the first plot, the second has a similar shape, but the peak is shifted toward shorter wavelengths, a phenomenon called the *Purkinje effect*. The scotopic response is associated with the rods of the retina. The consequence of the shift is that in dim light blue objects appear lighter and red objects darker than they do in stronger light. The effect can be seen outdoors at twilight as the light diminishes.

The two curves in the figure are the extremes of a family of curves, each describing the eye sensitivity at a different light level. Those intermediate between the two shown are called *mesopic*.

The importance of the luminosity function is its relationship to similar measurements of sensitivity for receptors other than the eye. The sensitivity of a typical panchromatic black-and-white photographic film varies with wavelength in a manner quite different from that for the eye. The film is most sensitive to very short wavelengths—in the ultraviolet, in fact—and the shape of the curve is entirely different. This means that when it is necessary to make a photograph that simulates the brightnesses or lightnesses of a scene exactly as viewed (e.g. copying paintings), a filter must be used on the camera to generate a net response that duplicates the luminosity function. The filter must reduce especially the blue light level, and to some extent the red light level. The specific filter varies with the light source and the film, but is generally green in hue for incandescent illumination and yellow for daylight. For most photographic work this filter is unnecessary.

Another application of the luminosity function involves the measurement of light with photoelectric cells. The sensitivity curves for four different such cells show that no two are the same and that none of them duplicates the response of either eye or film. If photoelectric cells are to measure light exactly, they must be properly filtered to match the eye response function.

Related terms: adaptation, colorimetry, variability, visualization.
References: **190** (16–18, 364, 375–376), **202** (16–17, 184–191).

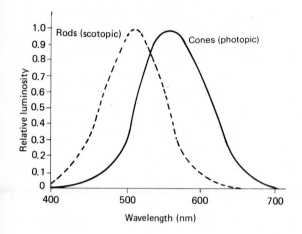

Phototopic and scotopic response curves for the human eye.

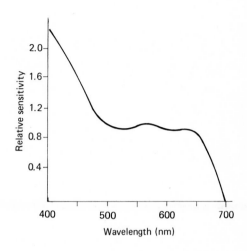

Relative spectral sensitivity of a panchromatic film.

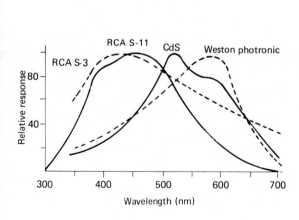

Spectral response of four types of photoelectric cells.

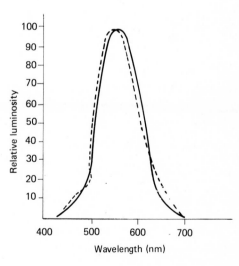

A properly filtered silicon photodiode (dashed line) has a relative spectral response comparable to that of the human eye (solid line).

12.7 Transparency

Definition: The property of a material that permits a person to see through it with clarity.

You are most aware of the transparency of a material when you can clearly see an object located behind it. Being able to see through material does not always result in the perception of transparency, however. For example, air is considered to be invisible rather than transparent, at least when viewing nearby objects. Clean glass walls that are devoid of reflections may also be invisible. Thus, it is necessary to be aware of the transparent material for a perception of transparency to exist. The transparency of a piece of glass can be decreased by adding homogeneous light-absorbing material to the glass, as with neutral-density and color filters. Alternatively, light-scattering materials may be added as with opal glass, or the surface may be roughened as with ground glass. If it appears that none of the incident light is transmitted, the material is perceived as being *opaque*.

Transparency can be represented in a picture by a contrast reduction of an object seen through another material. All three parts of the first illustration are composed of the same four pieces of paper—black, white and two grays. When the gray pieces are placed in the centers of the larger black and white pieces there is no appearance of transparency. But when they are placed adjacent to each other at the dividing line, they appear to be a single rectangle of transparent material that is modifying the appearance (ie. reducing contrast) of the black-and-white paper. Thus, perception of transparency depends upon the context assumed by the viewer in addition to appropriate tones.

Photographs that are framed under glass suffer little loss of contrast as a result of being viewed, under ideal conditions, through a transparent material, although this would not be true if tinted rather than clear glass were used. In practice, however, severe loss of image contrast can occur in local areas where there are glare reflections on the surface of the glass. In an effort to eliminate such reflections, roughened 'glareless' glass is commonly used in picture frames. The rough surface eliminates the glare by producing a less-bright uniform reflection over the entire surface, which also reduces contrast but by only a small amount.

It is necessary when photographing glass objects to reveal form and surface gloss or texture in addition to transparency. The transparency is most convincingly portrayed by showing some detail through the glass, although the darkening that occurs near the edges of a glass object (due to refraction) when it is placed in front of a light background also strongly suggests transparency (*see* opposite). The form and gloss of glass objects are best revealed by smooth reflections.

Predicting the appearance of a colored object seen through transparent colored material such as glass and liquids is more complex than the above situations using clear or neutral transparent materials. Basically, the colored glass acts, like a filter, absorbing light that is complementary in color to that of the glass, as explained in 13.6 Subtractive. Since photographers do not have the freedom of control artists have over image color, they must use other procedures to modify the color of transparent objects. A technique commonly used by advertising photographers to alter the appearance of beer, for example, is to conceal a piece of gold foil behind the glass so that the warmer transmitted light makes the beer more appealing.

Related terms: clear, invisible, opaque, translucent.
References: **145** (95–116), **146** (90–98).

The two pieces of gray paper shown on the left can be perceived as a single piece of transparent material when they are placed adjacent to each other at the dividing line (center); this is due to the apparent reduction in contrast of the black-and-white background. The illusion is even more convincing with an irregular boundary (right).

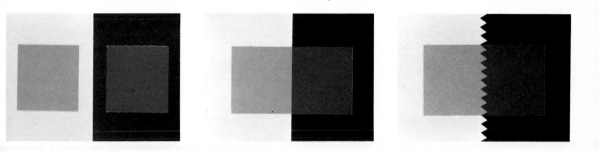

Left: The transparency of the glass is suggested both by detail seen through the glass and by the darkening due to refraction at the edges. The reflections provide cues concerning form and gloss.

Below: The transparency of the water is communicated to the viewer by the visibility of the immersed figure. The uneven surface is suggested by the distorted shape, the pattern projected on the body and the pool bottom, and reflections. *Photograph by Abigail Perlmutter.*

12.8 Mach Band

Definition: The visual effect which occurs along the border of two areas of different luminance, whereby a light band is seen near the edge in the lighter area and a dark band is seen near the edge in the darker area. This effect is a result of lateral inhibition.

Spin a color top or color wheel rapidly and the pattern on the top or wheel visually merges or fuses into a single color. Children delight in this phenomenon which has been known since ancient times. Ernst Mach, in 1865, used such a technique to study the visual effects which result by combining or juxtaposing fields that differ in color or lightness. When a small black pie-shaped sector is made to merge with a white field by spinning, a uniform gray value is seen. However, if the black sector is disrupted so that it jumps from a small sector to a larger sector, an unexpected effect occurs. Instead of seeing two uniform gray areas, the transition from one area to another is interrupted by a narrow ring—a light ring is seen near the edge in the lighter area and a dark ring near the edge in the darker area. These rings are known as Mach rings, or more generally, Mach bands.

Such effects depend on the inhibition of neural units in the retina and are an example of how the visual system selects edges and enhances them; edges appear sharper and more contrasty than they would otherwise. The network operates so that the light-sensitive cones and rods of the eye, which are excited by high and low levels of light, are also inhibited. An analogous effect, which is strictly physical, occurs in photography and is referred to as an edge effect or adjacency effect.

The Mach phenomenon is not restricted to rotating tops or wheels, nor is it dependent upon fusion of intermittent light. A familiar Mach band in photography occurs at the borders which separate the steps of a reflection gray scale or a transparent step wedge.

Contrast and borders are interrelated. You see borders between adjacent areas when there is a change or difference in the lightness or color, i.e. a contrast change. The type of border in turn affects the contrast of the areas it separates. Surprisingly, certain borders make large areas appear lighter or darker than they really are (*see* opposite). Artists have known about this visual effect for centuries, and have used it as a technique for increasing the contrast between both neutral and non-neutral areas. This is particularly true of the 19th century Neo-Impressionist school which used the Mach effect principally around the shadow and half-shadow areas of their paintings.

Photographers can learn the importance of the Mach effect by studying these paintings and incorporating the technique in their lighting arrangements. Photographic scientists can appreciate the role the Mach effect has on attempts to correlate physical and psychological measurements such as acutance and sharpness, objective tone reproduction and subjective tone reproduction.

Mach also observed that when neutral and non-neutral colors such as gray and red are placed next to each other a reddish band is seen at the very edge of the red area, while a complementary cyanish band is seen in the contiguous gray area. He found that the effect was not very pronounced when two non-neutral colors were used. More recent investigators have discovered that such color effects depend mainly upon lightness differences, rather than hue differences. Albers and other artists have exploited this phenomenon in their paintings.

Related terms: adjacency effects, edge effects, lateral inhibition, Mach rings.
References: **83** (22–29), **171** (90–101).

Left: A Mach band can be produced by printing the shadow of an opaque card on any photographic paper. Firmly position the card about 2·5 cm (1 in) or less above the paper. Experiment to get optimum results.

Above: When a density difference is added in a narrow vertical band to the center of a graycard by retouching, the card appears to have two different uniform tones. (Cover the edge with a pencil if you disbelieve.)

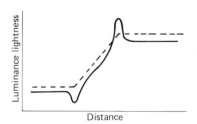

Above: Photographic print of the shadow edge showing the Mach bands—a narrow bright line and a broader dark line to the left and right of the shadow's edge.

Observed value or lightness (solid line) of the print above and measured luminances (dotted line). Notice the sharp increase and decrease in lightness at the shadow's edge. The Mach effect is a psychological phenomenon, not a physical one.

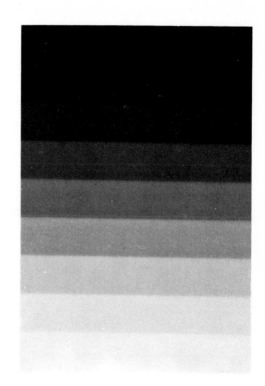

A photographic gray scale exhibits Mach bands. Although each area has a uniform density or luminance the perceived lightness is simultaneously increased and decreased at the edge of each step.

Perception of Chromaticity

13.1 Hue

Definition: The attribute of a perceived color that is associated with color names such as red, green, blue, cyan, magenta and yellow.

Hue is one of the three basic attributes of color perception, the other two being saturation and lightness (or brightness). Hue is the color characteristic most often noticed by an observer. If a person is asked 'What color is grass?', his response will usually be to indicate the hue, 'Green'.

Hue is the most obvious color difference seen in a rainbow or other spectrum of a light source. In the right viewing conditions an alert observer can see several dozen just-noticeable differences in a continuous spectrum of the sun or of a tungsten light source. Such a spectrum, however, does not contain all the hues—missing are many of the hues intermediate between red and blue, called magentas. When the magentas are added to the other hues, the set of hues can be arranged in a logical perceptual sequence in a closed curve, variously represented as a circle, a triangle, or a modified triangle. For example, the Munsell hue circle includes 10 major hues identified by name, with 10 subdivisions of each identified by number for a total of 100 hues (*see* 3.8 Munsell System).

All color perceptions have some hue with the exception of the neutral colors, those known as white, gray or black. Of the many different hues, four can be considered perceptually basic, in the sense that they do not appear to have any admixture of other hues. These four are red, green, yellow and blue, referred to as the psychological primary hues. Orange, on the other hand, is perceived as a combination of red and yellow, magenta as a combination of red and blue, and cyan as a combination of blue and green.

Hue perception varies within the retina. Only the central portion, in and near the fovea, responds to all hues. Outside this region the perception red and green vanishes, and only blues and yellows can be discriminated. Still farther out in the retina no hue discrimination remains. Also, hues cannot be distinguished in low light levels where the retinal rods function but not the cones.

What is popularly called 'color-blindness' is in fact a chronic deficiency in the ability to perceive different hues, such as to distinguish between red and green. However, some persons with normal color vision have difficulty in distinguishing between hues which are close together in the hue circle, a task others can accomplish with ease. This difficulty is known as low discrimination, a shortcoming that fortunately can be removed with training. Although there is a limited vocabulary for identifying hues by names, the hue of any sample can be identified with considerable precision by matching it with a set of calibrated colors.

'Color' balance, in connection with color transparencies and prints, refers to the rendition of hue. If the image of a gray scale appears too red, for example, the color balance is said to be red. Correct color balance implies that the image is not perceived as having any overall shift in hue in comparison with the original scene.

Fortunately, it is possible to obtain any hue from white light by using combinations of only three filters. In color printing, for example, any unwanted hue in an area of a print which should be neutral can be removed by using no more than two filters from the set of three subtractive primary colors. Similarly, in colorimetry, the hue of any sample color can be specified by the relative amounts of two from the set of red, green and blue additive primary lights required to produce a visual match.

Color-compensating (CC) filters are identified with letters representing their hues. A filter labeled CC–R ordinarily appears red, for example, one labeled CC–C appears cyan, etc.

Related terms: color, chromaticity, Munsell system, spectrum, wavelength.
References: **36** (13, 15, 54–67, 72–73, 82–84), **55** (118, 120, 129–130, 182–183, 215–218, 231–234), **216** (I items 3, 6, 8, 10, 62, 63).

variety of cold and warm hues having different
aturation (chroma) and lightness (value). *Photograph
y Ryszard Horowitz. Courtesy Fieldcrest Mills, Inc.*

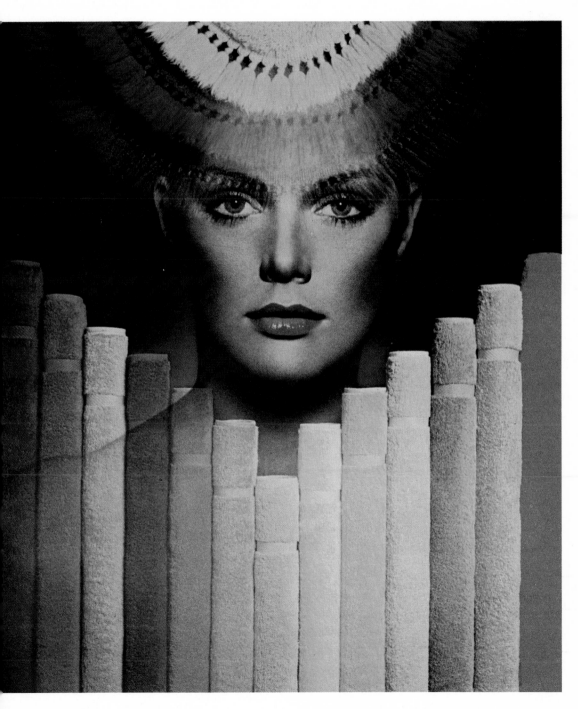

13.2 Saturation

Definition: The attribute of a perceived color that distinguishes it from a gray of the same lightness.

Saturation is one of the three basic attributes of perceived color, the other two being hue and lightness. Hue is the attribute associated with color names like blue, green, orange and purple. Lightness is the attribute that distinguishes among whites, grays and blacks.

Saturated colors are called vivid, strong or deep. Desaturated colors are called dull, weak or washed-out. All perceived colors have a degree of saturation with the exception of the neutrals (whites, grays and blacks). If a color has an identifiable hue, it has at least some saturation.

The colors of a given hue and lightness can be arranged in order of saturation on a scale of equal visual differences, from a gray to the most highly saturated color of the set. If colors of different hues and similar lightness are arranged in the form of a triangle (*see* opposite), the gray (having neither hue nor saturation) lies at the center of the triangle and saturation increases outward from the center.

In such a display, a navy blue lies close to the center of the triangle, since it is a color of low saturation. The blue typical of most national flags lies nearer the margin of the triangle, since it is a more highly saturated color. As compared with the red seen in most flags, a maroon would lie nearer the center.

The colors in a spectrum have maximum saturation when there is no veiling light. A rainbow is such a spectrum, but it appears slightly desaturated because it is diluted with stray white light. The most vivid colors ordinarily encountered are those produced by fluorescent paints in daylight. Colors of even higher saturation can be seen by taking advantage of eye adaptation. If you gaze for a minute or so at a fluorescent blue patch and then immediately shift your gaze to a yellow patch, you see a yellow of very high saturation. The reason is that the yellow afterimage generated in the eye by the blue patch is superimposed on the perception of the second patch.

Perceived saturation is therefore, like other attributes of color, dependent upon the immediate past history of the observer's visual system. Saturation also varies with the light level, being greater in situations where the level is moderately but not excessively high, and falling almost to zero as the light level decreases to the visual threshold. Outdoors in starlight, only grays are seen.

Saturation is a special problem for color reproduction systems used in photography and mechanical printing processes. If the images are optimized for the reproduction of neutrals, and if hues are most nearly reproduced, image colors are less saturated than those of the original. The cause is the unwanted absorption of light by even the best available dyes and inks. All such pigments are desaturated by comparison with ideal ones, and the problems are compounded when the pigments are superimposed in the reproduction process.

In color television, on the other hand, it is possible to reproduce saturation accurately provided the original color is within the saturation limits of the system. The 'color' control on the receiving set changes the saturation of the colors on the screen from nearly zero (as with a black-and-white set) to a high level limited only by the saturation of the colors produced by the phosphors that make up the screen.

Related terms: chroma, CIE, colorimetry, excitation purity, Munsell system.
References: **36** (14–15, 58, 61, 63–65, 73, 80–82, 85, 153, 155, 202, 217), **55** (118, 183, 215, 217, 239), **169** (100–103, 126–133), **216** (I items 7–10, II, items 53–56).

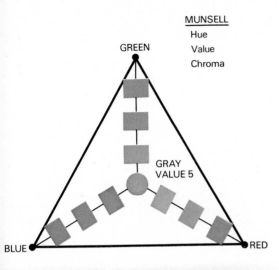

MUNSELL
Hue
Value
Chroma

GREEN

GRAY
VALUE 5

BLUE RED

The central patch (gray value 5) is nearly neutral, and thus has almost no saturation. The patches at the corners of the triangle display approximately the maximum saturation possible for these hues by the printing process used in making the illustration. The intermediate patches show increasing saturation as you look from the center to the corners.

One procedure for determining the correct enlarger filtration for color printing is to make a trial print and then modify the enlarger filtration as indicated by the hue and density of the viewing filter that produces the desired effect. If a trial print is too green in color balance, the saturation of the green can be reduced by viewing the print through a filter of the complementary hue—magenta. *Photograph by courtesy of Eastman Kodak Company.*

Color print viewing filters are produced in six hues that represent the three additive primary colors (red, green and blue) and the three subtractive primary colors (cyan, magenta and yellow). When the filters are viewed on a white-light illuminator, the saturation increases with the density from 0.10 to 0.40 for each hue. *Photograph by courtesy of Eastman Kodak Company.*

13.3 Primary

Definition: **1.** Any one of a set of colours that is perceived as 'pure', that is, not seen as a mixture of other color perceptions.

2. Any one of a set of three colored lights, or of three colored substances, that can be combined systematically in various amounts to produce a gamut of many different colors.

Among the million or more different color perceptions, a few are basic in the sense that they look unique, not like a combination of other colors. For example, the color of a dandelion is a nearly pure yellow, neither reddish nor greenish. On the other hand, the color of a California orange looks like a mixture of red and yellow. Thus, in the perceptual sense yellow is primary and orange is not.

There are four hues that are primary in this sense. They are red, green, yellow and blue. These hues are perceptually unique, unlike purple (seen as a blend of red and blue) or cyan (seen as a blend of green and blue.) To the four primary hues are also added black and white as primary perceptions. These two neutral colors are quite unlike the four primary hues, and they also are unlike each other. Gray, however, is perceived as a blend of black and white. Thus, altogether there are six primary colors as perceived—the hues red, green, yellow and blue, and the neutrals, black and white.

In a quite different sense of the term 'primary' there are in color reproduction systems sets of basic lights or colorants from which very many different colors can be made. It turns out that in each case only three primaries are required.

If colored *lights* are mixed, the primaries must be red, green and blue. An example is color television. All the different colors on the screen are composed of small dots of light; each dot being variable for intensity. The appearance of yellow is formed by a mixture of red and green, of white by a mixture of all three at a high level, and of black by a mixture of all three lights at a low level.

If *colored substances* are mixed (or overlapped as in color transparencies or prints) the necessary primaries are cyan, magenta and yellow. Magenta dye looks reddish-blue and absorbs green light. Cyan dye looks greenish-blue and absorbs red light. Yellow dye absorbs blue light. The amount of absorption depends on the quantity of the dye.

Thus in color reproduction, to simulate most of the colors of the real world it is necessary to control only the levels of the red, green and blue light entering the observer's eyes. The control may be exercised directly, as in color television, or by absorption, as in color photographic images. In each case, only three primaries are needed.

That various amounts of only three primaries can generate hundreds of thousands of different color perceptions is remarkable. This fact is related to, but not explained by, the presence in the human retina of three different types of color receptors, or cones. Each type responds differently to different wavelengths of light.

It is a common belief that the primary paints or inks are red, yellow and blue. This false belief arises from a problem with hue names. Paints called 'primary red' are in fact bluish-red, and thus magenta. Those called 'primary blue' are greenish-blue, and thus cyan. The correct names for the pigment primaries are the same as those for the primary dyes used in color photography, i.e., cyan, magenta and yellow.

Related terms: additive, complementary, subtractive.
References: **55** (119, 274–277), **192** (frames 1–24, 61–62), **216** (I, items 22, 30, 43, 65. II, items 49, 51).

Red, green, yellow, blue, black and white colors are the perceived primaries.

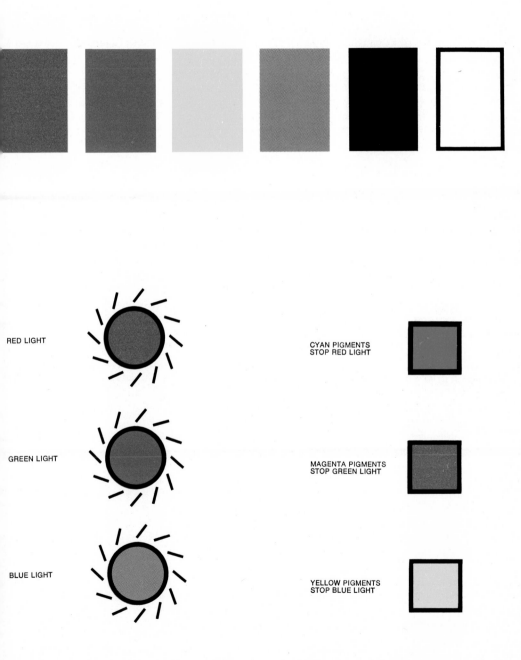

RED LIGHT

GREEN LIGHT

BLUE LIGHT

CYAN PIGMENTS
STOP RED LIGHT

MAGENTA PIGMENTS
STOP GREEN LIGHT

YELLOW PIGMENTS
STOP BLUE LIGHT

The additive primaries are red, green and blue light.

The subtractive primaries are cyan, magenta and yellow dyes, pigments, filters.

13.4 Complementary

Definition: Identifying pairs of colors that when appropriately combined produce a neutral color. The term also applies to an original color perception and its negative afterimage.

Suppose the beams of light from two slide projectors are superimposed on a screen. Over one projector lens is placed a blue filter, and over the other a yellow filter. If adjustment of the intensities of the beams can produce the appearance of white, the two colors are complementary. By such additive mixing of lights, a very large number of complements can be found. On a chromaticity diagram (color map) complements plot as points on opposite sides of a straight line drawn through the 'white' point. Since there are many 'whites' (daylight, tungsten, fluorescents), the choice of white determines whether or not two lights are complementary.

Among the spectral colors, single-wavelength violets and blues are additively complementary to yellows and oranges, and single-wavelength cyans are complementary to reds. There are no spectral complements for the greens—their complementary colors are magentas and these do not exist in the spectrum.

Additive complements can also be demonstrated by the use of a color wheel, a device that by rapid rotation causes color mixing in the eye. With pigments making up the sectors of the disk, complements produce a gray rather than a white, because the pigments absorb light.

Additive complements are of interest mainly because of their relationship to the theory of color vision. The fact that only two selected wavelengths from the spectrum can produce a match for any desired white clearly requires explanation; but no existing theory of vision explains this.

The term complementary is used in another sense, that of pigment mixtures. Two paints are complementary if when they are mixed in the correct proportion a visual neutral (gray) results. Because of the light-absorption characteristics of most pigments, it is rare to find the mixture truly neutral, and you must usually be satisfied with an approximate neutral. For the same reason, subtractive complements only roughly resemble the additive complements, but usually the pairing is, as before, red and cyan, blue and yellow, green and magenta.

Subtractive complements are of interest to the artist-painter, since he can make many near-neutrals and thus desaturated colors. In photography, it is usual to examine a test color print through a variety of CC filters, changing the filters until a 'neutral' appears neutral. Such a procedure aids in distinguishing a cyan color-balance error requiring a red complementary filter from a blue error requiring a yellow filter.

There is yet a third set of complements. If you look for a minute at a vivid blue patch and then shift your gaze to a white patch, you perceive yellow, the negative afterimage of the blue patch. The afterimage is a complement of the original perception, but is often different from the additive complement of the same patch. These perceptual complements are significant in color composition. If such complements are made part of the design, each has the effect of making the other appear lighter and more saturated, and thus makes the composition more dramatic than otherwise. On the other hand, an effect of delicacy and softness results from a design in which complements are avoided.

Related terms: additive, afterimages, primaries, subtractive.
References: **29** (479–603), **52** (108, 216, 239, 241–242), **192** (Frames 15–17, 63, 66, 82), **214** (230, 325, 333–334).

Complementary colors when mixed produce neutral colours. The examples shown are red and cyan, green and magenta, blue and yellow.

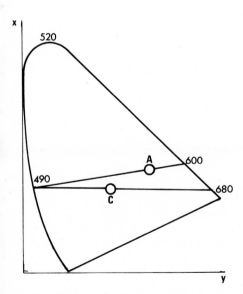

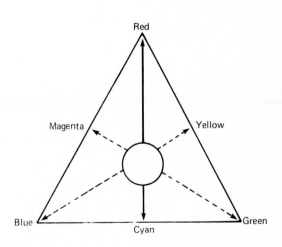

Spectral complementary colors as shown on the CIE Chromaticity diagram. If standard daylight 'C' is the white, the red of wavelength 680 nm is complementary to the cyan of wavelength 490 nm. If, however, the white is tungsten 'A', an orange of wavelength 600 nm is the complement of the same cyan.

In Maxwell's triangle, complementary hues lie at opposite ends of the lines through the middle. Neutrals are found in the center.

261

13.5 Additive

Definition: Identifying a photographic or other color reproduction process that involves the combination of three different lights, usually red, green and blue.

Color television is an additive process. In this case the lights are small dots of phosphors on the face of the receiving tube. When they are struck by an electron beam, they emit light—some red, some green and some blue. All the colors that are seen are formed merely by differing intensities of the light from the dots. The separate dots are indistinguishable at a normal viewing distance. The dots *add* together to form the various colors of the image.

It is remarkable that almost all the colors of the real world can be simulated simply by blending together different levels of just three lights. All the different *hues* can be formed by combining the lights in pairs. Various amounts of red and blue make magentas; various amounts of blue and green make cyans. The combination of red and green forms a series of hues from an orange (close to red) to a yellowish—green. A perceptually pure yellow is seen when the amounts of red and green light are about equal. That the red-green combination is perceived as yellow, and quite unlike the perceptions associated with the separate red and green lights, is an experimental fact not easily explained. You may perceive yellow if you place a red filter over one eye and a green filter over the other. At least in this case, the perception of yellow is related to the information-processing properties of the nervous system, since here the yellow cannot arise only by the activity of the retina.

For a given hue, any level of *lightness* can be made by adjusting the intensities of the lights. Dark colors arise from low light levels, and light colors from high light levels.

When the third light is added to any pair, the result is a loss in *saturation*, or vividness. Maximum saturation is obtained when the lights are used alone or in pairs. Thus, the most saturated yellow (apart from spectral yellow) results from the mixture of the red and green lights. If the third light (blue) is added

to the red-green pair in small quantity, the yellow looks paler and less vivid. If the quantity of the blue light is properly adjusted, the viewer observes a match for any desired white reference. At a lower balanced level of all three lights, the observer sees a gray, and at a very low level (not zero) a black. Thus a correctly adjusted additive system can form any *neutral* color.

No present-day color photographic process uses the additive method of color formation. However, the earliest technique for making a full-color photographic image was additive. It involved three projectors, each of which placed on a viewing screen an image of a black-and-white positive through a red, green or blue filter. Each positive was made from a negative which had been exposed in the camera with a matched filter. Although there were registration problems, a properly made set of positives gave an image displaying a full range of colors.

The screened processes used for the production of color images by photomechanical printing, as in magazines, are to some extent additive, inasmuch as some of the small ink dots on the paper lie side by side.

Colors also can be added in the eye if they are presented in a succession so rapid that the individual colors cannot be distinguished. A color wheel is a disk made up of several sectors of different colors. Rapid rotation of the disk results in color addition. With variable sectors of red, green and blue reflective pigments, all hues and many levels of saturation can be generated. However, very light colors, such as whites and yellows, cannot be formed because of the absorption of light by even the best inks or paints.

Colors are added sequentially in the Kodak Video Analyzer, which estimates the printing conditions needed to make a print of correct color balance and density. In this apparatus, rapidly rotating illuminated red, green and blue filters are used.

Related terms: CIE diagram, colorimetry, primary, secondary, subtractive.
References: **55** (64, 86, 235, 244, 287), **169** (106–109, 112), **216** (I, items 19–45).

Top picture: The lenses of three separate projectors are covered with red, blue and green filters (Wratten Numbers 29, 47B, and 61) Colored lights from the projectors are then projected separately and in combination on a white screen. A person in front of the screen casts a black shadow when the colored lights are on separately (*first row*) and coloured shadows when they are on in combinations (*second row and bottom picture*). Photographs by Michael M. Dobranski.

The following table summarizes the results:

Projected light	Screen	Shadow
Separate		
Red	Red	Black
Blue	Blue	Black
Green	Green	Black
Superimposed		
Red and blue	Magenta	Red and blue
Blue and green	Cyan	Blue and green
Red and green	Yellow	Red and green
Red, blue and green	White	Magenta, yellow, cyan, red, green, blue.

13.6 Subtractive

Definition: Identifying a photographic or other color reproduction process that involves the superposition of colorants, usually cyan, magenta and yellow dyes, each of which absorbs the complementary color from the viewing light.

A positive photographic color transparency or print contains three dye layers. The image is viewed by light that passes through all three layers, each of which partially absorbs light. What the viewer sees is the light remaining after the net absorption by the dye layers, hence the term 'subtractive.'

For successful simulation of most real-world colors there must be independent control of the three primaries of a white viewing light, i.e. red, green and blue. Nearly independent control of these primaries is possible by the use of three colorants.

Yellow dyes or other colorants absorb blue light. By designing the color photographic system so as to produce in the image more or less yellow dye, the image absorbs more or less blue light. Thus the yellow dye serves to control the level of blue light seen by the observer. Similarly, magenta dyes are used to control by absorption the green light level, and cyan dyes the red light level. Magenta colorants appear reddish-blue and cyan colorants have hues intermediate between green and blue.

You may think of each of the three dyes as a valve that determines the flow of each of the three basic components of white light. The success with which a subtractive process simulates real-world colors depends in part upon the extent to which the dyes are in fact independent in their absorptions.

Yellow dyes are generally very effective, in the sense that they absorb blue light almost exclusively, and leave nearly unchanged the green and red primaries. Even the best available magenta dyes, however, have a significant blue light absorption in addition to the desired absorption of green light. Cyan dyes absorb not only red light but also some green and blue light. Thus, with existing dyes completely independent control of the three primary lights is not possible.

The consequence of the unwanted dye absorptions is that entirely accurate reproduction of subject colors is unattainable. The effects of the dye defects typically are that image colors are darker and less saturated than the original subject colors. Furthermore, shifts in hue occur. Ordinarily, orange subject colors are reproduced as too red, cyans (blue-greens) as too blue, and greens also as too blue.

An additional result of the dye defects is that if the system is adjusted so as to produce the best possible reproduction of neutral (gray) colors, the non-neutral colors are reproduced as less than optimum. For this reason, a compromise is necessary—nearly exact reproduction of grays must be sacrificed in order to minimize errors in other colors. Masking, a technique used in most negative–positive color photographic processes, improves the reproduction of non-neutral colors and helps retain good reproduction of grays.

Like all present-day color photographic processes, photomechanical printing methods used for magazines and newspapers are basically subtractive. Three colored inks are used—yellow, magenta and cyan—and where they superimpose on the paper they act like the dyes in a photographic image. A fourth ink—black—is often used to improve the rendition of neutrals.

When paints are mixed by an artist on the palette or on the canvas, the results are based on the principles of subtractive color formation. The mixing of paints is similar to the overlapping of dyes.

Related terms: additive, complementary, primary, secondary.
References: 55, (64, 255, 256, 267, 277), **169** (106, 110–112), **216** (II items 1–56).

The three transparent pigments: cyan, magenta, yellow, when superimposed in various combinations and amounts will produce a large variety of colors. *Courtesy of Graphic Arts Research Center, Rochester Institute of Technology.*

13.7 Color Temperature

Definition: The actual temperature of a standard light source (blackbody) that matches in visual appearance the light from a given source.

When a piece of charcoal is first heated it emits light of a dull red color. As its temperature is further increased, the light goes through a fixed series of color changes from orange to yellow to white, and finally to bluish-white. For charcoal, which is close to the ideal blackbody, there is a close relationship between its temperature and the spectral quality of the light it emits. Its temperature is therefore an index not only to its appearance but also to the relative amount of energy it produces at any wavelength in the spectrum.

The indexing temperature scale is Kelvin (K), identical with the Celsius scale used in the metric system except that the zero on the Kelvin scale is at about −273°C. Thus, Kelvin temperatures are 273 higher than Celsius values.

A tungsten lamp operated with a dimmer acts much like a blackbody. At a temperature of about 1000 K it appears red. Household lamps operate normally at about 2850 K. Short-lived photographic tungsten lamps (photofloods) typically operate at 3200 K or 3400 K, and emit light that appears bluish-white by comparison with conventional lamps.

Color temperature extends the preceding concept to sources that are not necessarily identical in spectral output to the standard, and need not even emit light because they are heated. The color temperature of a lamp is in principle found by *visual* comparison with a standard source at various temperatures. The actual temperature of the standard when a match is obtained is the color temperature of the lamp. In cases where a visual match is unobtainable, the term 'correlated' color temperature implies the closest possible resemblance.

Because the eye is incapable of analyzing light into its components, a visual match of two sources by no means implies that the two are similar in spectral characteristics. To take an extreme example, a *visual* match for white daylight could be obtained with a source that emits only two complementary wavelengths, but that source would by no means be photographically equivalent to daylight. As another example, a sodium highway lamp emits light mostly at a single yellow wavelength. Although it would approximately match a tungsten lamp at a low temperature, the two would not be spectrally equivalent since the tungsten lamp emits at least some light at every wavelength of the spectrum.

Color temperature designations are useful indexes to the color-matching and the photographic equivalence of tungsten light sources. They have limited usefulness for daylight sources which differ considerably from standard blackbody sources. Color temperature is of little worth for vapor sources such as carbon arcs and for fluorescent lamps.

Color temperature meters operate on the basis of the response of a photocell to the light source when transmitted through two or three differently colored filters, usually red and blue; or red, green and blue. The calibration of such meters to give reliable data is possible only for sources that closely resemble blackbody sources in spectral energy output.

Because of significance of a given change in color temperature values varies with the magnitude of the values themselves, a conversion of the numbers into *mireds* is useful. The number of mireds is found by dividing the color temperature value into 1 000 000 (eg. 2500 K=400 mireds). A given change expressed in mireds has about the same significance at any level. Color conversion filters are often identified with the change in mireds they produce with any blackbody source operated at any temperature level.

Related terms: color rendering index, correlated color temperature, mired, spectral energy distribution.
References: **55** (213–215), **190** (78–134, 216–222), **191** (153–154), **202** (19–27, 31–36).

Left: Relative spectral energy curves for standard blackbody sources. As the temperature of the source is increased, the light is richer in short (blue) wavelengths, and relatively weaker in long (red) wavelengths.

Left, middle: Relative spectral energy curves for typical tungsten lamps and for standard daylight. A, 500-watt tungsten lamp, color temperature 2960 K; B, 3200 K photographic lamp; C, 3400 K photoflood; D, daylight. D cannot be precisely matched to any blackbody curve, making color temperature for daylight only a rough index.

Below: Nomograph used for the selection of a color conversion filter for various color films and various light sources. A straight line is drawn from the point representing the film on the left-hand vertical line to the source on the right-hand vertical line. The required filter is found at the intersection of the straight line and the central vertical line. The example shows that an 85B filter is needed to use Type B tungsten color film outdoors.

13.8 Colorimetry

Definition: The specification of the color characteristics of the light from a sample in terms of the hypothetical response of a standard observer.

It is an experimental fact that almost any color appearance can be matched by the additive mixture of just three colored lights— red, green and blue. The amounts of each of the three lights may be related to a scale from $0 \cdot 0$ to $1 \cdot 0$, with $1 \cdot 0$ representing the amount of each of the lights needed to match a reference standard light source.

If the primaries are *real*, some very highly saturated colors (e.g. spectrum colors) cannot in fact be matched directly. In the CIE system of colorimetry, the primaries are *ideal* and have only a mathematical significance. Mathematically, any color whatever can be specified by knowing the amounts of the three ideal primaries needed to match the light from a sample. An additional property of the CIE primaries is that both the blue and red components have zero luminance; all the luminance information is contained in the green primary. The amounts of the CIE primaries needed to match any spectral color are shown in the first illustration opposite.

CIE colorimetry involves the following steps: (1) assume a standard light source of known spectral energy distribution; (2) know the spectral reflectance or transmittance of the sample; (3) for each wavelength find the product of the values in (1) and (2) and the corresponding values for each of the three curves in the first illustration; and (4) integrate separately the three product sets. There result three numbers, designated X, Y and Z, called *tristimulus values*, which express the relative amounts of the three primaries needed to match the light from the sample.

A further data transformation yields the *chromaticity coordinates* x, y and z, which are found by dividing each of the values X, Y and Z by their sum (i.e. X+Y+Z). Since x, y and z sum to unity, it is sufficient to specify the levels of any two of them if Y (the luminance value) is also given.

The chromaticity coordinates x and y are commonly plotted as in the second illustration opposite. The nearly triangular figure contains the points for all possible hues and saturations. The curved boundary is the locus of the spectral colors as indicated by the wavelength values.

The second illustration also displays an alternative method of specifying position within the field. The *dominant wavelength* associated with a sample point, is found at the intersection of a straight line drawn from the point representing the light source and the boundary of the figure. The *excitation purity* is the ratio of the distance on the same straight line between the source and the sample to the entire length of the line. Dominant wavelength is related to, but not identical with, perceived hue. Excitation purity is related to, but not identical with, perceived saturation.

Although the CIE diagram is often called a map of colors, it is essential to understand that a match would only exist under carefully prescribed and highly idealized conditions. The CIE system cannot specify what a given observer perceives in a real situation with all its complex variables. Furthermore, the CIE diagram is highly nonlinear. Points that plot on the same dominant wavelength line do not represent perceived colors of constant hue. Equal intervals in different portions of the diagram do not represent equally different perceptions. The nonlinearity is indicated by the third illustration where Munsell samples—equally different visually —plot as unequally spaced.

Related terms: additive, Munsell system. *References:* **36** (123–141), **55** (205–213), **190** (278–295).

The amounts of the three CIE primaries needed to match unit amount of any spectral wavelength. For example, at 450 nm, the values are approximately: \bar{z} (blue)=1.77; \bar{y} (green)=0.03; \bar{x} (red)=0.35.

The 1931 CIE diagram. The sample may be specified as having (1) coordinates x=0.18, y=0.60, or (2) dominant wavelength 520 nm and excitation purity a/b=0.54. A value for luminance would be necessary for complete specification in this system.

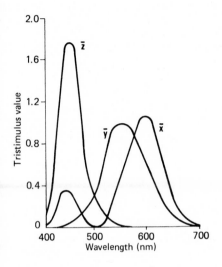

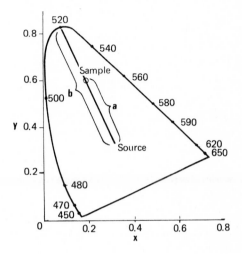

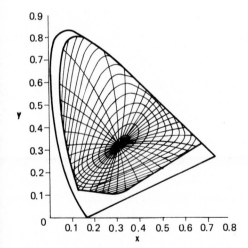

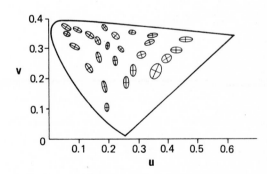

Munsell samples, for a single level of luminance, plotted on a CIE diagram. If the CIE system were linear with visual color perception, the radial lines would be straight and equally spaced from each other, and the ellipsoidal shapes would be circular and also equally spaced. Adapted from Judd. D. B. *Color in Business, Science and Industry*, New York: John Wiley, 1952, p. 227.

The 1960 revised version of the CIE chromaticity diagram, based on primaries different from those used for the 1931 diagram. The ellipses show, for various regions of the diagram, areas within which colors represented by plotted points are visually indistinguishable. On a diagram that was strictly linear with visual perception, the ellipses would be circular and of equal size. (For clarity, the ellipses are drawn ten times their actual size.)

13.9 Defective Color Vision

Definition: An abnormal physiological condition characterized by a chronic reduced ability to detect hue differences between certain colors.

Even persons with so-called normal color vision are unable to correctly identify object hues under a variety of conditions, including: low and very high levels of illumination, illumination with other than white light, short viewing times, states of color adaptation, small stimulus size, and use of peripheral vision. Reduced ability to make subtle discriminations between colors under normal viewing conditions can be due to a lack of color learning experience, in which case practice can result in an improvement in performance. To date there has been little hope for correcting defective color vision. However, recent research indicates that it may be possible to provide persons having certain kinds of defective color vision with viewing devices that will enable them to discriminate between colors that would otherwise appear identical.

Persons with normal color vision have three types of cone pigments in their retinas that selectively respond to red, green and blue light; they are known as normal *trichromats*. Defective color vision usually results from an absence or a reduced amount of one or more of these pigments. *Monochromats* are persons who are either missing all three pigments and see the world as gray, or are missing two pigments and see a single hue. *Dichromats* are missing one pigment and may be identified as red-blind, green-blind or blue-blind. All of the above defects are uncommon in men, with about 1% being red-blind and 2% being green-blind, and rare in women. *Anomalous trichomats* have a smaller than normal amount of one of the three pigments, with reduced sensitivity to the corresponding hue, and may be identified as red-anomalous, green-anomalous, and blue-anomalous. Among school children about 8% of the boys and $\frac{1}{2}$% of the girls have some form of defective color vision.

Various tests have been designed to detect and classify defective color vision.

Pseudoisochromatic test plates contain an assortment of color designs, each selected so as to be invisible to a person with the specified type of defective color vision. A green-blind viewer, for example, cannot distinguish between green dots that make up a figure and gray dots in the ground. The *Farnsworth-Munsell 100-Hue test* contains color samples that the subject arranges in order on the basis of gradual transitions from one hue to another. Each type of defective color vision is associated with arrangement errors for a certain range of hues. A person with normal color vision who has not learned to make fine discriminations tends to make about the same number of errors with all of the hues.

Defective color vision presents problems for photographers who make color prints and must adjust the filtration to obtain an appropriate color balance, and artists who must select or mix colors to match subject colors. Dichromats, green-blind persons for example, do not disagree with color matches made by someone with normal color vision, but they also accept certain other colors as matching. While anomalous trichromats to a lesser extent also accept a range of colors as matching, they may disagree with matches made by a person with normal color vision due to a shift in the spectral sensitivity curve for the deficient pigment.

Although there have been examples of color photographers who have been successful in spite of defective color vision, there have also been reports of others who have experienced considerable frustration in attempts to make prints to satisfy people with normal color vision.

Related terms: anomalous trichromat, color blindness, dichromat, monochromat, normal trichromat.
References: **36** (93–103), **70** (104–112), **111** (395–413), **210** (162–239).

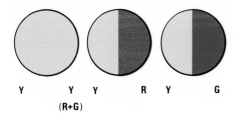

Y Y Y R Y G
(R+G)

Left: Anyone with normal color vision can match a monochromatic yellow as found in the spectrum with a mixture of red light and green light. However, red-blind and green-blind viewers find that all proportions of red and green, and even red and green alone, match the yellow.

Below: A color-blind painter made both paintings, but he selected the colors for the one at the top and his wife, who has normal color vision, selected the colors for the one on the bottom. The artist said that both paintings looked equally good to him. *Paintings by Henry B. Crawford (top), and Henry and Elizabeth Crawford (bottom).*

13.10 Metamerism

Definition: The visual equality of two color stimuli that have different spectral distributions. Such stimuli are identified as a metameric pair.

It is fortunate for color photography that the eye is unable to analyze subject and picture colors with regards to the spectral distribution of the light. For example, the eye is unable to distinguish between white light from an incandescent lamp that contains all wavelengths of radiation in the visible region of the spectrum, and white light formed by mixing the proper proportions of narrow bands of red, green and blue light. Thus, it is possible to simulate almost any subject color in a photograph with the proper proportions of three dyes even though the wavelength distributions are somewhat different.

A problem arises, however, in that two colors that match visually in one situation may not match in another situation. Most people have had the experience of noting a change in the color of clothing, food and other objects when examined by artificial light and by daylight. Without the perceptual phenomena known as Color Constancy (*see* 5.6) and Chromatic Adaptation (*see* 5.2), the color of all objects would appear to change dramatically for the two light sources. When two colors match visually with one type of illumination and appear significantly different with another type, it is usually due to irregular rather than smooth spectral distribution curves for at least one of the colors and one of the light sources. The spectral reflectance curves in the second illustration opposite are for two 'blue' materials that appear similar when examined by daylight illumination but considerably different under incandescent illumination. The spectral quality of the light reaching the eye is determined by the spectral energy distribution of the light source and the spectral reflectance of the object.

A color object and a color photograph of the object may constitute a metameric pair. If the color balance of a print is adjusted to provide a visual match with the original subject under one type of illumination, they may not match when compared under another type. Therefore, if it is important for a color print to match a certain subject closely, the same light source should be used for evaluation during the printing process as will be used by the customer. It should be noted that two colors which are judged to be a close match to one person may represent a mismatch to another person due to physiological differences in their visual systems or differences of training or experience in discriminating colors. An extreme example is that red and green traffic lights can be indistinguishable and therefore represent a metameric pair to a person with a certain type of defective color vision (color blindness).

Two color objects that appear to match to a person with normal color vision may not match in a color photograph of the two together. Thus, the spectral sensitivity of the film must be added to the factors considered above. Objects containing fluorescent dyes are especially susceptible to being altered in appearance on color photographs. For example, a brown suit may be recorded as blue on a color photograph in which all other subject colors appear normal. Infrared color film was designed to exaggerate, with false colors, differences in spectral reflectance of subjects that appear identical or similar to the eye. This film has numerous practical applications including early detection of plant diseases.

Related terms: color match, color mismatch, spectral distribution.
References: **52** (14–21), **198** (11–18).

Spectral energy distribution curves for three different light sources—3200 K incandescent lamp (A), 5500 K daylight (B), and cool-white fluorescent lamp (C). The spectral quality of the light reaching the eye when viewing an object is determined by the combination of the spectral energy distribution of the light source and the spectral reflectance distribution of the object.

Spectral reflectance distribution curves for two colored socks that appear similar in hue (blue) when viewed in daylight, but different when viewed with incandescent illumination where number 2 still appears blue but number 1 appears greenish.

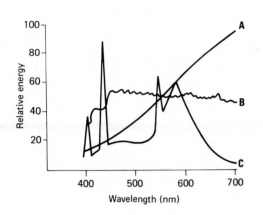

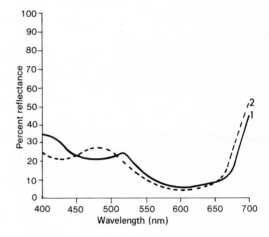

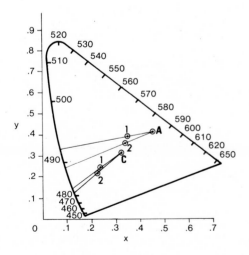

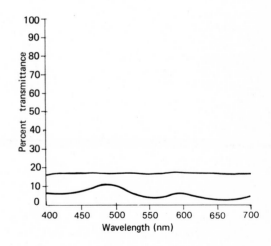

The dominant wavelengths for the two colored socks from the second illustration are located on the periphery of the chromaticity diagram by drawing straight lines from A (incandescent illumination) and C (daylight illumination) through the corresponding plotted points. The greater separation of the dominant wavelengths with illuminant A is in agreement with the greater difference in appearance of the hues of the two socks with incandescent illumination.

The top line is a spectral reflectance distribution curve for an 18% reflectance neutral test card and the bottom line is a spectral transmittance distribution curve for a photograph of the gray card on reversal color film. Since the curves differ in shape, the photograph and the gray card may match when viewed under one type of illumination and appear different when viewed under another type.

13.11 Theories of Color Perception

Definition. Attempts to account for the observed facts of color vision by means of consistent explanations.

The results of experimental work on color vision would if assembled fill many volumes. Some of the essential results are found in this book under the headings: Adaptation (5.1), Additive (13.5), Afterimage (8.2) and Defective Color Vision (13.9).

Efforts to explain these and other visual phenomena began early in the 19th century with Thomas Young, who first formulated the *trichromatic theory* of color vision. The explanations are based primarily on additive color perception, and they assume the presence in the retina of three different sensors, each sensitive to red, green or blue light. Recent work, involving microdissection of the retina to isolate individual cone elements, has provided support of this theory by the identification of three sets of cones of different properties. There are three different cone pigments, named erythrolabe, chlorolabe and cyanolabe, absorbers respectively of red, green and blue light.

The simple statement that red+green+blue =white is, however, not a necessary condition for the perception of white, since that perception can arise in the absence of any hue discrimination. Examples are found in monochromats (persons who are completely 'color-blind'), in the outer portion of the retina of all persons, and at very low light levels at which all wavelengths of light appear to have no hue.

A further problem with the simple trichromatic theory is the phenomenon of 'cortical yellow.' If one eye receives red light and the other green light, the appearance when the images are fused is often yellow, a perception that cannot arise through the activity of the retina alone. In addition, persons with the partial color defect described by the phrase 'green-blind' do not have diminished response to the luminosity of the spectrum in the middle wavelengths (i.e. green).

For these reasons, among others, Hering in the late 19th century proposed an *oppo-nents theory* of color vision which has been extensively developed by Hurvich and Jameson. It assumes the existence of three *pairs* of processes, one each for white-black, blue-yellow, and red-green. The processes are now thought of as excitation and inhibition of neural firings above and below the spontaneous rate.

The opponents theory accounts with considerable plausibility for the results of additive mixtures of light pairs, and also for the perception of neutral colors apart from the perception of chromatic colors. Data obtained with the null method, using opponent hues, are in reasonable agreement with the CIE 'standard observer' data. The theory is also consistent with phenomena related to receptive fields, lateral inhibition, and hue shifts of certain colors with variations of the illumination level. None of the early color theories accounted for perceptions with certain types of defective color vision.

To complicate matters further, Edwin Land has shown that a variety of hues can be perceived when only two colored images, sometimes of only very slightly different wavelength bands, are additively mixed on a projection screen. He therefore hypothesizes that the eye contains a difference-estimating mechanism that makes a judgment from a comparison of the long- and short-wavelength signals it receives, and is thus basically a two-channel information processing system.

No completely satisfactory theory of color vision has as yet been developed. It seems clear that the retina involves at least a threefold receptor system, but that this alone cannot account for the manifold visual phenomena. Neurological processes apparently involve complex linkages and feedback mechanisms that may well serve the functions required by the opponents theory.

Related terms: adaptation, additive, afterimages, defective color vision.
References. **36** (179–187), **70** (112–124), **86** (75–80), **134** (108–128), **142**, **196** (61–82, 113–137, 162–183).

Absorption spectra for three types of cones in the human retina. The data come from measurements on single cones, and are determined from the difference in absorption by the receptors before and after exposure to light of various wavelengths. The heights of the curves have been normalized to a value of 1.0 at the peak absorption. Note the considerable overlap of the right-hand pair of curves, and especially the failure of the curve on the right to show any absorption beyond about 650 nm.

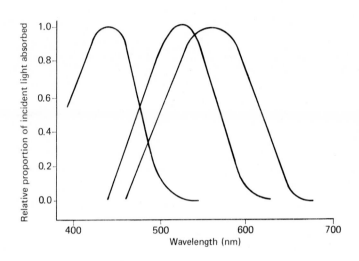

A proposed schematic arrangement by which three differently-sensitized receptors, designated α β and γ (as in the trichromatic theory) could be linked to the three pairs of neural connections as hypothesized in the opponents theory.

Perception of Time and Motion

14.1 Motion Perception

Definition: An awareness of an actual or an apparent change in position of a stimulus over a short period of time, based on the sense of vision.

Whether you perceive motion or not when an object moves within your field of view depends upon a number of factors. With respect to the rate of movement, there are both lower and upper thresholds. When looking at a watch, you perceive motion of the second hand but not of the minute and hour hands, even though you can detect a change in the positions of these hands over a relatively long period of time. At the other extreme, a bullet fired from a gun travels too rapidly to be detected. At a somewhat slower speed of about 180° per second a rapidly moving object may be perceived only as a blur. An advantage of motion-picture photography and television over direct vision is the ability to speed up the images of slow-moving objects and to slow down the images of fast-moving objects to a speed that can be viewed comfortably.

Since motion involves a change in position, a reference is necessary for motion perception. For this reason a small moving light in a dark room may not be perceived as moving and, conversely, a stationary light may appear to move. If only two objects are visible in the field of view and one of them moves, you tend to perceive the larger object as stationary and the smaller as moving even when this is the reverse of reality. The perceived motion of an object that is moving at a constant speed can vary over a considerable range. The variations depend upon such factors as the object size, illumination level, contrast with the background, and the amount of detail in the surround, plus psychological factors such as the threat of a moving car bearing down on a pedestrian viewer. There is a strong relationship between the assumed distance of a moving object and the perception of motion. A light that is moving at a constant speed appears to be moving slower when it is assumed to be near than at a greater distance. For this reason it is necessary to adjust the shooting speed when substituting scale models for falling objects in motion pictures. A scale model of a car going over a cliff would appear to fall too rapidly if perceived as a full-size car and cliff. Therefore the shooting speed has to be increased with a decrease in model size so that the slower projection motion appears normal.

There are three basic situations for the perception of motion in the real world. In the first, the eye is held steady while one or more objects move against a stationary background. The moving images on the retina stimulate different receptors. In the second, the eye tracks a moving object. The image of the moving object remains stationary on the retina, producing better detail, while the image of the background moves across different receptors. In the third type of situation, the viewer moves as when walking or riding. Even if the scene is stationary, the near parts appear to move in the opposite direction and the far parts appear to move in the same direction as the viewer. Theorists have had difficulty in explaining the visual processes of motion perception for these different situations, especially with respect to why the world does not appear to move when the eyes are rotated. But it can be noted that the visual cues are different for the three types of viewing conditions and the mind is normally able to interpret each set of cues in an appropriate manner.

Motion-picture photographers, in attempting to represent motion on the screen, use the same three techniques—a stationary camera, panning moving objects, and moving the camera itself. Beginning photographers often pan stationary scenes with unpleasant results, and it might be noted that the eye cannot pan smoothly except in tracking a moving object. In scanning a stationary scene the eye makes a series of quick jumps called saccades.

Related terms: autokinetic phenomenon, implied motion, induced motion, motion aftereffect, motion parallax, phi phenomenon. *References:* **75** (575–588), **80** (91–115), **86** (326–352).

Because motion is relative it is easier to detect when there is a nearby reference object. The small change in position of the sun in these two photographs is apparent, but an equal displacement with the sun higher in the sky would not be detectable. In one experiment it was found that the rate of movement had to be increased 10 times to be detectable when a reference grid background was removed. *Photographs by John Jean.*

30m (100 ft)

3m (10 ft)

Because small objects fall at the same speed as large objects, the model car falling from a 3 m (10 ft) cliff would reach the ground much sooner than a full-size car falling from a 30 m (100 ft) cliff. A motion picture made with the model would have to be exposed at a higher number of frames per second so that the projected screen time of the fall would be the same as for the larger car.

14.2　Flicker

Definition: The perception of rapid rhythmic fluctuations of luminance, hue or saturation of a stimulus.

Flicker is of special importance in the viewing of motion pictures where the screen must be darkened while the film is moved from one frame to the next. If a motion-picture film is projected in a variable-speed projector that can be adjusted from a low speed, say one frame per second, to a very high speed, three different types of perception result. At low speeds, the viewer sees individual pictures, as when viewing projected slides or filmstrip pictures. As the speed increases, the viewer is aware of a fluctuation of lightness which is first coarse and very obvious and later becomes so fine that it is barely detectable—flicker. The third state, fusion, occurs when the frequency is so high that flicker cannot be detected and the fluctuating stimulus appears to be continuous. The dividing line between flicker and fusion is referred to as the *critical fusion frequency* or the *critical flicker frequency (CFF)* and is the frequency at which flicker and fusion are each perceived 50% of the time with repeated presentations.

Early motion picture films were projected at speeds slower than the critical flicker frequency which led to their being called 'flicks.' Even increasing the speed to 24 frames per second, the present speed for sound motion pictures, would not eliminate flicker in the absence of chopper or flicker blades on the projector which cut off the light twice while each picture is in the gate. Thus, the flicker blades increase the number of flashes of light from 24 to 72 per second.

A number of factors affect the critical flicker frequency, one of the most important being luminance of the stimulus. Thus, if a motion-picture projector is speeded up from a slow speed until the flicker just disappears, increasing the image luminance by using a larger bulb, faster lens, or shorter projector to screen distance tends to make the flicker reappear. The critical flicker frequency varies in proportion to the log of the stimulus luminance over a large range of luminances as shown in the graph opposite. Flicker tends to increase with the size of the stimulus area. It also tends to be stronger when the image falls on the periphery of the retina rather than on the fovea, so that flicker that can be seen when looking to one side of a stimulus may disappear when it is looked at directly. CFF also varies with light and dark adaptation, age and fatigue. Rapid movement of the eyes may produce a strange stroboscopic effect with stimuli that are fluctuating just above the CFF, such as television, motion picture images and fluorescent light sources, since successive images fall on different areas of the retina. A stroboscopic effect can also be obtained in the study of the temporal addition of colors on a spinning disk such as a Munsell wheel if it is viewed by fluorescent illumination, even though each separately is fluctuating at a higher rate than the CFF.

The concept of flicker is used in flicker photometry to match the luminances of two stimuli. Although luminances of adjacent neutral areas can be matched with good precision, as in a visual densitometer, it is more difficult to match the luminances when the hues are different. By using a frequency that is above the CFF for hue differences but below the CFF for luminance differences, flicker reveals differences in luminance of the samples.

Related terms: critical flicker frequency, critical fusion frequency, flicker threshold, fusion.

References: **30** (251–320), **77** (69–70), **95** (979–991), **179** (311–314).

The flicker experienced in viewing a swinging golf ball illuminated by a stroboscopic light set at eight flashes per second is represented by the multiple images on the photograph on the left which was exposed for one second. Although flicker is annoying in motion pictures, rapidly flashing lights have been popular in discotheques and 'happenings' as visual experiences. The multiple-exposure photograph of the dancer simulates the flicker effect on a still photograph. *Photograph of dancer by Neil Montanus.*

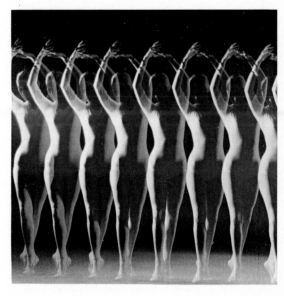

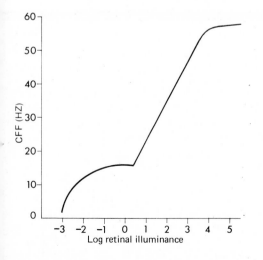

Critical flicker frequency versus illuminance of the retinal image. The rising curve indicates that more rapid fluctuation is required to eliminate flicker as the stimulus luminance increases. The lower part of the curve represents rod vision and the upper part cone vision. At a high illuminance level the curve flattens, indicating a relatively stable critical flicker frequency with further increases in the light level. *Hecht and Smith, 1936.*

281

14.3 Phi Phenomenon

Definition: The appearance of motion when two similar visual stimuli, somewhat displaced in position, are observed briefly with a short time interval between them.

The realistic perception of motion when viewing motion pictures is attributed to two basic visual phenomena—persistence of vision which prevents flicker, and the phi phenomenon which accounts for the apparent motion when the still photographs are viewed in rapid sequence. In its simplest form, the phi phenomenon can be demonstrated by sequentially flashing two lights that are separated in space in a darkened room. Not only is it possible for the viewer to perceive the two stationary flashes as a single moving, flashing light, but he may also report seeing light in the space between the two sources.

A number of factors can alter the realism of the apparent motion with two flashing lights including: the spatial separation between the two lights; the size, shape, luminance and wavelength distribution of the two sources; the temporal separation between the flashes; the duration of the flashes; and the instructions given the viewer. For example, if the delay between the two flashes is too short, they appear to occur simultaneously, originating from two separate sources, whereas if the delay is too long the two flashes seem to be unrelated and there is no perception of motion. Various researchers have reported optimum interval times ranging from approximately 1/20 to 1/2 second, depending upon variations in other factors. Apparent motion can be perceived with considerable variation in distance between the two light sources, but the effect is more realistic when the temporal delay increases with distance. Although flash duration can vary somewhat without destroying the perception of motion, too long a duration makes it obvious to the viewer that the light sources are stationary. In practical applications of the phi phenomenon the two stimuli are usually similar, but it has been reported that the direction of apparent motion can be reversed if a weak first light is followed by a strong second light, where the visual system responds as though the second flash occurred first.

Even with simple stimuli such as flashing lights, it is difficult to specify the interrelationships of the variables such as spatial and temporal separation with respect to apparent motion. But that was the intent of *Korte's laws*, published in 1915; not all of which have been confirmed by subsequent research. With the complex images used in motion picture photography, it is even more difficult to predict motion effects. The current standards have been arrived at largely through experimentation over the years. The standard professional motion-picture sound speed of 24 frames per second produces satisfactory apparent motion even though 24 flashes of light per second produce objectionable flicker. The flicker is eliminated by using a chopper blade on the projector to produce three flashes for each picture frame. A somewhat slower speed of 18 frames per second produces satisfactory apparent motion for nonprofessional purposes. Panning a stationary scene, even at 24 frames per second, can produce such a large displacement of consecutive images that the motion appears jumpy. On the other hand animators can sometimes cut the number of drawings required in half by photographing each drawing twice, a technique known as *double framing*, without producing a jumpy effect. The *skip-frame* technique of printing motion pictures whereby every other frame of the original film is omitted increases the rate of motion on the screen by doubling the displacement of images on consecutive frames, which may or may not appear jumpy depending upon other factors involved.

Related terms: animation, apparent motion, kinestasis.
References: **75** (580–583), **80** (109–111).

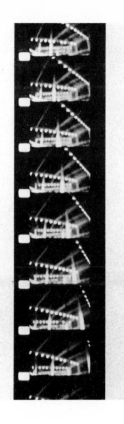

Left: The abrupt changes in position of the lights on a revolving merry-go-round in the adjacent frames of motion-picture film are perceived as smooth movement on the screen, due to the phi phenomenon, when the film is projected at 18 or 24 fps. *Courtesy of Martin Rennalls.*

Above: The phi phenomenon is responsible for the perception of movement of words in display signs with lights that flash on and off in sequence. The exposure time was sufficiently long to record more than one set of lights in the on position. *Photograph by Fred Schmidt.*

Motion can be perceived when a stack of cards containing simple drawings is flipped, providing the images of the moving parts appear in slightly different positions.

14.4 Implied Motion

Definition: The acceptance of certain stimulus characteristics as representing motion without perceiving the stimulus as actually moving.

If the rate of projection of a motion-picture film is gradually reduced, a speed is reached at which it becomes obvious to the viewer that he is looking at a series of still photographs with systematic changes in position of the images. In real life you are not accustomed to seeing objects suddenly disappear from one position and reappear in a different position without having traversed the space between, although the effect can be duplicated by illuminating a moving object in a darkened room with a stroboscopic flash. Realistic motion is not always desired in a motion picture. One stylized representation of motion, called *pixillation,* is produced by omitting some frames and making multiple images of other frames during the printing process, thereby producing an unrealistic jerky motion on the screen.

Two pseudomovement techniques used by motion-picture photographers commonly produce less than realistic perceptions of motion—the use of zoom lenses, where the relative sizes of near and far objects do not change as they would if the camera-to-subject distance were changed; and closeup panning of still photographs, where motion parallax is missing. Viewers accept as representing motion a series of still pictures placed side by side in which the position of one object systematically changes position with respect to the background, even though no sensation of motion is produced.

Photographers and artists have responded to the challenge of representing motion in a single picture in a variety of ways. The use of blurred images has been a natural byproduct of the photographic process due to the inability of the photographer always to use a sufficiently high shutter speed to 'freeze' the image, even when a sharp image is desired. Photographers learned that they could produce a sharp image of a moving object and still imply motion by panning the object and blurring the background. Artists also have used speed streaks, such as the drybrush effect, to suggest a blurred afterimage in the area trailing the moving object. Similarly, arrows are sometimes added to instructional pictures to clearly indicate the direction of movement of a part, such as a piston in an engine. Multiple exposures have been used by photographers to show an object in different positions in a single photograph. A realistic effect is easy to obtain by photographing the object against a dark background, whereas ghost-image effects can be obtained with lighter backgrounds. Some of the earliest and most dramatic multiple-exposure images of rapidly moving objects, such as a golf club hitting a ball, were made by Harold Edgerton, who developed the stroboscopic flash, and photographer Jon Mili.

Artists commonly modify the shape of objects, a car for example, to make them appear to be moving rapidly. Focal plane shutters on cameras can produce corresponding distortions in shape. Any picture in which it is obvious that different parts of the image could not have been photographed or seen at the same instant can suggest motion of the subject or the observer. Examples of this include a combined front and profile view of a face by Picasso and a streak photograph of a revolving subject that includes the entire circumference of the person's head. Ambiguous figures such as the Necker cube also imply motion when the perceived viewpoint changes. Some static images, such as certain op-art designs, go further and create a realistic illusion of motion.

Even straightforward record pictures can imply motion effectively if they contain clues that relate to the viewer's previous experience with motion. An apple suspended in air midway between a branch and the ground is easily assumed to be falling, and a sharp image of a bullet leaving a gun barrel is assumed to be traveling very fast indeed.

Related terms: movement, rhythm, suggested motion, tertiary motion.
References: **56** (320–321), **217** (244–289).

The arrow is a universal symbol used to indicate direction of movement. *Photograph by Lee Howick.*

A vivid perception of motion is created by the positions of the feet, legs and clothing, and the balanced bicycle. *Photograph by Dick Swift.*

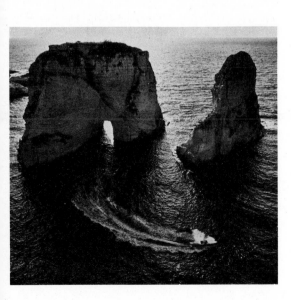

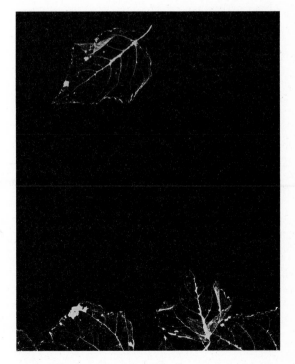

In addition to implying motion, the wake indicates the path taken by the boat. *Photograph by Norm Kerr.*

Photographs of objects suspended in air imply that the objects are falling. *Photograph by Leslie Stroebel.*

14.5　Motion Parallax

Definition: The apparent shift or change in position of objects at different distances when an observer moves laterally.

Photographers are familiar with the term parallax as it relates to viewfinder cameras, where the finder is in a different position from the camera lens. Because of parallax the composition seen through the viewfinder is different from that recorded by the camera lens.

A similar situation exists when you look at a scene from one position and then change to another position. This can be demonstrated by looking outdoors through a window across the room. Moving your head from side to side causes parts of the objects previously covered by the window frame to be revealed. You learn from experience that the partially covered object is behind the nearer object by a distance proportional to the extent of displacement. When you are moving relative to objects, you experience movement largely through the visual cue of motion parallax. Since motion is relative, it is possible for motion-picture photographers to create the illusion that the viewer and the actors in a car are moving when in fact the car is stationary in front of a projected moving background.

The magnitude and direction of motion parallax vary depending upon the position of the objects in space and their relationship to the object upon which the eye fixates (*see* opposite). As the observer moves to the left, the far object is perceived as moving to the left and the near object to the right when he fixates the middle object. If the near and far objects are separated from the middle object by equal distances, the near object will appear to move a greater distance because the ratio of distances for the middle and near objects is larger than for the far and middle objects. Motion parallax does not exist for two-dimensional fields such as photographs, paintings and decorated walls since all objects on a flat plane are the same distance from the eye—although a compression does occur resulting in a change in the height to width proportions as discussed in Anamorphic Image (11.3).

Motion parallax is a valuable compositional tool since a small change in the camera position can often produce a dramatic change in the relative positions of foreground and background objects. Although it may be more awkward to move a camera above or below eye level, this compositional control should not be ignored. A distracting horizon line or background object can be moved out of the picture at the top by raising the camera or at the bottom by lowering it—positions that have been used sufficiently to acquire the labels of bird's-eye and worm's-eye views.

When photographing from a moving position, as from a car, or when photographing rapidly moving objects, as in sports, the relative positions of objects at different distances change so rapidly that the photographer must anticipate the appropriate moment to make the exposure. The small delay required for the viewing mirror to swing out of the way in single-lens reflex cameras can cause the recorded image to differ considerably from that last seen through the viewfinder, an effect known as *time parallax.* Motorized cameras that produce a rapid sequence of exposures are useful in situations where the photographer cannot be certain of making a single exposure at the decisive moment. Focal plane shutters, at the higher shutter speeds where the shutter does not expose the entire film simultaneously, also produce a time parallax effect when the camera or subject is moving.

Related terms: binocular vision, motion perspective, parallax, stereoscopy.

References: **56** (31), **86** (317–319), **119** (234–239).

Two lights held by each of the men are recorded as vertical blurs when the hands are moved toward each other in the *top* photograph, made at a slow shutter speed with the camera stationary. The *bottom* photograph was made while the camera was moved from right to left and panned to keep the girl centered. The arrowhead shapes formed by the lights illustrate that the foreground figure moved to the right and the background figure moved to the left, the same direction the camera moved. *Photographs by Andrew Davidhazy.*

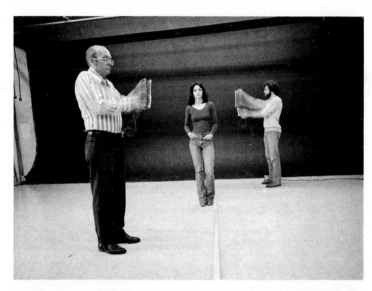

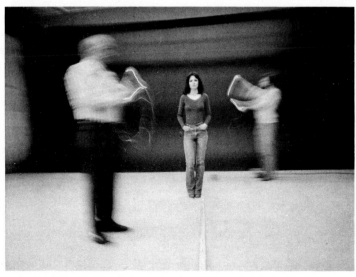

14.6 Motion Perspective

Definition: A changing image pattern with respect to the angular size and separation of objects in a three-dimensional scene, as the distance between the scene and the viewer (or camera) changes.

Linear perspective in a static situation refers to a fixed point of view. A change in distance between a scene and the viewer may be due to movement of the viewer, the scene, or both. But it is more convenient to think of the observer as a fixed reference point around which there is a continuous transformation or flow of objects, even when the viewer is moving. When a distant point is selected as representing the direction of movement of the viewer, the flow of movement of the parts of the scene radiates away from this point in all directions (*see* opposite). Also, the flow is most rapid closest to the viewer. Thus, the angles of the arrows show the directions of movement of the parts of the scene and the length of the arrows represent the relative rates of movement. The rate at which each object moves is inversely proportional to the distance to the observer. Perceptually, the inverse relationship does not hold exactly due to errors in judging relative distances, especially when they are large, but the small deviation from an inverse relationship will be ignored in this discussion.

Even though the viewer is traveling at the same speed toward near and far parts of the scene, eg. at 80 kph (50 mph) in a car, objects seem to accelerate as they approach the viewer. This is understandable when you consider that an object moving 30 m (100 ft) closer from a distance of 300 m (1000 ft) reduces the distance by only 1/10th, whereas the same movement from a distance of 60 m (200 ft) reduces the distance by 1/2. This effect was used dramatically in the motion picture *2001* where the viewer appears to be traveling at a tremendous speed between two horizontal planes that extend ahead as far as the eye can see.

When you approach a photograph of a three-dimensional scene, the effect is entirely different. Now, you are not only moving toward all parts of the representation of the scene at the same speed, but you are reducing the relative distances by the same fraction for all parts of the scene. A foreground object that appears twice as large as a more distant object on a photograph viewed from 3 m (10 ft) still appears twice as large when the photograph is viewed from a distance of 30 cm (1 ft). Thus, the illusion of depth in a two-dimensional photograph is less realistic when the viewer alters the viewing distance than when the viewing distance remains constant. This is one factor that contributes to the realism of depth in slides and motion pictures that are projected on a large screen where the viewing position remains constant.

The consequence of motion perspective can be seen in motion-picture and television pictures when the camera moves directly into a scene in comparison to using a zoom lens from a fixed position. The use of the zoom lens has an obvious advantage in convenience and in many situations the difference in effect is unimportant. But zooming-in on a scene tends to destroy the illusion of depth in a similar manner to moving toward a still photograph, because near and far parts of the scene increase in size at the same rate. Also, using a long fixed focal length lens decreases motion perspective because an object moving toward the camera increases in size more slowly. This technique was used effectively in the motion picture *Lawrence of Arabia* where the viewer is kept in suspense when the image of a distant horseman (friend or enemy?) very slowly increases in size, even though he is obviously riding rapidly toward the camera. Conversely, use of a short focal length lens for an auto race seems to exaggerate speed due to motion perspective.

Related terms: depth, distance, motion parallax, movement, perspective.
References: **86** (319–323), **117** (76–88).

When a person fixates at the horizon and moves in that direction the closest objects appear to move fastest and the farthest objects the slowest.

When a person fixates at a midpoint (x) and moves from right to left, objects beyond the fixation point move in the same direction while those forward of the fixation point move in the opposite direction. Movement appears least near the fixation point.

Motion perspective is relative. If a person is stationary and photographs objects in movement the closest objects will be blurred the most and the farthest objects the least. *Photograph by Elliott Rubenstein.*

14.7 Parks Effect

Definition: The perception of a complete image when a picture (word, etc.) is moved behind a narrow stationary slit.

Opposite is a picture of a camel and an opaque cover with a narrow aperture. Two different methods for viewing the picture through the slit can be considered: (1) the slit can be moved across the picture which remains stationary and (2) the picture can be moved across the slit which remains stationary. With similar rates of movement, the perceptions are quite different. As was noted in one of the illustrations for Persistent Image (8.1), a realistic image is seen when the slit is moved across the stationary picture providing the scanning time is not longer than 1/4 second. At slower speeds the persistent image of the first part of the picture that is uncovered fades before the scan is completed, and less than the complete picture is perceived.

When the picture is moved across a stationary slit, most viewers also report seeing a complete picture but one that appears anamorphic, being compressed in the direction of the movement. If it is assumed that the eyes remain stationary with respect to the slit as the picture is moved, it is difficult to explain how a complete image is perceived since all of the visual information is being superimposed sequentially on a narrow slit on the retina. Even though under normal viewing conditions it is possible to mentally scan a picture by directing attention to different areas of the picture without moving the eyes, this seems to be an unlikely explanation for the Parks effect. In fact, if you concentrate on looking at one edge of the slit rather than looking through the slit the effect largely disappears. Thus it seems that eye movement is involved which allows the sequential visual information to fall on different areas of the retina. Horizontal compression of the image would be accounted for if the movement of the eyes is less than that required for exact tracking of the moving picture.

The ability of the visual system to briefly store and combine visual information is taken for granted in a variety of common everyday experiences such as reading, and watching television and motion pictures. The pioneer photographic work of *E. J. Marey* and *E. Muybridge* involved this type of storage and synthesis, as did the *zoetrope*, a circular rotating viewer with slit apertures which was popular in the late 1800s. Marey's chronologically recorded movements of a running horse were converted, by Colonel Duhousset, into line drawings which appeared animated when viewed in the zoetrope.

On the basis of the Parks effect, if a photographer wanted to present segmented pictures sequentially in a motion picture for a special effect, he should spread the segments across the screen rather than superimpose them, and they should be presented within 1/4 second (about 6 frames) for a perception of the entire picture. The same is true if titles or captions are presented one letter at a time. If a sequence of letters or words is presented in the same position on a screen, a masking effect occurs which prevents the brief storage and synthesis of the information.

Related terms: brief visual storage, iconic storage, persistent image, short-term storage, visual masking.
References: **119** (528–529), **130** (45–50), **167** (78, 145–147).

Left: The Zoetrope ('Wheel of Life') consisted of a series of narrow apertures arranged as a wheel. When the wheel was spun slightly different pictures could be seen through consecutive slits, which gave the perception of movement. It was invented in the 1830s by William Horner, an English mathematician. By the 1860s, it had become a popular form of home entertainment. The Zoetrope and other similar 'projectors' (Thaumatrope, Phenakistoscope) were the forerunners of motion pictures. Motion pictures were first shown in Paris, in 1895, by Louis and Auguste Lumière. Les Frères Lumière called their camera-projector 'Cinématographe' ('motion-writing'). *Courtesy of International Museum of Photography, George Eastman House, Rochester, NY.*

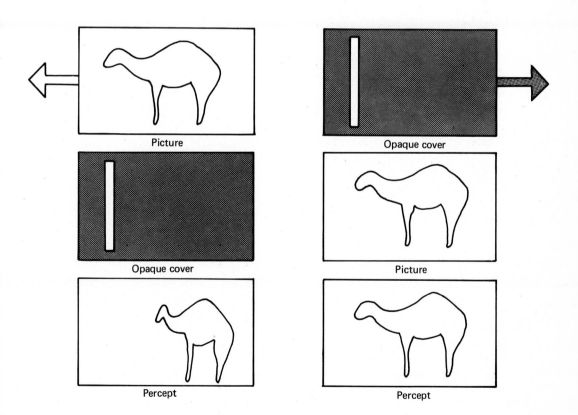

Picture

Opaque cover

Percept

Opaque cover

Picture

Percept

Moving a picture rapidly behind a stationary narrow slit (left) produces a perception of a complete but compressed image that is known as the Parks effect. The persistent image produced by moving the slit rapidly in front of a stationary picture (right) appears normal in shape.

15

Esthetics

15.1 Objective Approaches to Esthetics

Definition: The use of other than direct perception as a factor in achieving or determining esthetic acceptability in photographs or other images.

Most photographers, artists and other people who are involved with esthetic aspects of pictures have opinions concerning the appropriateness of using objective, as distinct from subjective, approaches to picture making and evaluation. At one extreme are those who object even to the use of a detached or objective attitude by an art critic, rather than projecting himself into each image he evaluates. At the other extreme are those who believe that almost every attribute of effective pictures can be specified in objective terms. Kay Tucker observed that since qualified critics often disagree about the quality of a photograph using subjective methods, they should not expect perfection of an objective method which could not possibly agree with all of the critics. The concern here is not with the prospects of programming a computer to produce a work of art, but rather of relieving the picture maker or evaluator of some of the perceptual decision-making responsibility.

Picture critics and judges often make a distinction between visual effectiveness (or some comparable term) and technical quality —as though a low-contrast image produced by underexposure, presumably a technical factor, does not influence the visual effectiveness of a picture. Early photographers would determine the correct exposure for a photograph by stopping the camera lens down until the image on the ground glass appeared to have the proper brightness for a constant exposure time, a technique they became quite expert at after years of experience. Beginning photographers now find that they can obtain more consistent exposures and therefore more esthetically pleasing photographs by allowing a photoelectric exposure meter to objectively determine the camera exposure settings. It should be noted that objective procedures are typically validated by correlating them with subjective procedures. The ASA film speed system, which provides numbers for use with exposure meters, is an outgrowth of experimental work that required the subjective evaluation of large numbers of photographs made over a range of exposures. The result was objective criteria that could be standardized.

Exposure meters are also used to objectively measure and adjust the lighting for studio portraits, for example, to obtain lighting ratios that have been found to give pleasing prints. Processing labs keep control charts on the color balance of a test strip for each batch of film processed. The supervisor knows that if the control limits are exceeded he will receive a large number of complaints from customers about the appearance of their color slides. Densitometers and printing photometers can be used to select the appropriate contrast grade of printing paper for black-and-white negatives and the color filtration for printing color negatives, and also to indicate the correct exposure settings. These measurements eliminate the need for a visual subjective evaluation of the printing characteristics of the negatives. Enlargers are available with electronic scanning devices that automatically dodge and burn local areas. They can be made to hold detail in the highlights and shadows with greater precision than could be done manually based on a subjective evaluation. Objective tone-reproduction curves representing different prints from the same negative can be used to predict which print most viewers will prefer. Objective systems operate on the principle of producing results that will be acceptable to a large proportion, but not *all* of the viewers.

Objective approaches to other aspects of esthetics are covered in Composition (15.3).

Related terms: automation, quality control, subjective evaluation.
References: **202, 203.**

The contrast grade three printing paper used for the top print was selected objectively by taking densitometer readings on the negative and referring to the table. Prints made on lower and higher contrast grades of paper are included for comparison. *Photographs by Langone.*

Paper grade number	Negative density scale
0	1.4 or higher
1	1.2 to 1.4
2	1.0 to 1.2
3	0.8 to 1.0
4	0.6 to 0.8
5	0.6 or lower

A table showing the relationship between negative density scale and contrast grade of printing paper which tends to produce the most acceptable print contrast.

15.2 Tone Reproduction

Definition: The study of the representation of subject luminances in a corresponding optical, photographic or visual image.

In viewing a photograph, if you want to know how closely your perception of the various tones correspond to the luminances of the original scene, it would be necessary to consider the tone-reproduction characteristics of the camera optical system, the photographic system, and the visual system of the viewer. The component of this tone-reproduction system that is most familiar to photographers is the film characteristic curve (graph of Density vs Log Exposure). Such curves are widely used for the comparison of different films and developers, and to observe the effects of altering camera exposure and film development. Similar curves for printing papers represent their tone-reproduction characteristics, including differences in contrast and maximum density of various papers. An important but less well-known factor is the camera flare curve, which reveals the loss of contrast, especially in the shadow areas, that occurs due to flare light. A comparison of flare curves indicates the different effects light and dark backgrounds have on tone reproduction (*see* 4.2 Flare).

By placing the camera flare curve, the negative curve, and the printing paper curve in three quadrants of a square, a composite curve can be drawn in the fourth quadrant to show the tonal relationship between the final print and the original subject. A straight 45° line in the fourth quadrant would represent an exact reproduction. Tone-reproduction plots can be expanded beyond four quadrants to include any number of generations of copies, or reproductions of photographs by photomechanical, electrostatic, television or other media.

Difficulty is encountered, however, when an attempt is made to add the visual system to the optical and photographic plot. This is due to the lack of satisfactory curves representing the relationship between stimulus luminance and perceived brightness or lightness. According to *Fechner's law,* derived in 1860, a straight-line relationship exists between brightness and log luminance. However, it has long been known that there is a departure from linearity at high and low light levels, representing a limitation of the law. Also, critics maintain that just-noticeable differences cannot be added to determine the sensation of brightness at any luminance level. The more recent *Stevens' Power law,* on the other hand, is based on the perceived *ratio* of brightnesses and the luminance raised to some power, which results in a curve of a dramatically different shape. Even if the experts can agree on the relationship between brightness and luminance under specified conditions, the shape of the curve will vary with a number of factors including adaptation of the eye, stimulus size, location of the image on the retina, and length of presentation of the stimulus.

From a practical viewpoint, much can be learned about tonal perception by comparing photographic tone reproduction curves and corresponding photographs—even without incorporating visual tone-reproduction curves. By photographing a gray scale and making prints with variations in density and contrast (in addition to the closest possible match), a comparison of each print with the original gray scale will reveal the significance of changes in the corresponding curves. When the same experiment is conducted with pictorial subjects, it is revealed that viewers generally prefer prints having tone-reproduction curves that deviate somewhat from a straight 45° line as illustrated by the 'preferred' curve opposite. The validity of conclusions concerning the appearance of pictures based on tone-reproduction curves depends upon standardized viewing conditions. Variations in factors such as illumination level and surround alter the perception of the pictures as discussed in Viewing Conditions (3.7).

Related terms: contrast, Fechner's law, image quality, lightness, Stevens' Power law, zone system.
References: **54** (79–86), **119** (67–76), **202** (90–94, 281–282, 300–302).

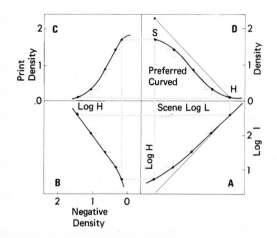

A four-quadrant tone reproduction graph which shows the relationship between a final print and the original scene (top right quadrant). Prints which are judged to be normal in density and contrast tend to have tone reproduction curves which conform closely to the preferred curves. Quadrants A, B and C show the camera flare curve, the film curve and the paper curve respectively.

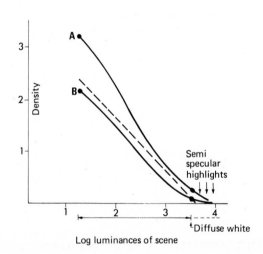

Objective tone reproduction curves for preferred photographs. Curve A, slide transparencies and motion pictures viewed with a dark surround. Curve B, slide transparencies and reflection-type prints viewed with a bright surround. The dashed reference line has a gradient of 1.00. From *Neblette's Handbook of Photography and Reprography* edited by John Sturge. © 1977 by Litton Educational Publishing, Inc. Reprinted by permission of Van Nostrand Reinhold Company.

An original gray scale (top) and a photographic copy which is represented by the 'preferred' curve in quadrant four of the tone reproduction graph. Since normal scenes have a greater luminance ratio than photographic papers can reproduce, tonal compression is usually necessary. Whites in the original scene are typically reproduced with greater density on the print so that light sources and bright reflections can be represented by a lighter tone.

15.3 Composition

Definition: The arrangement of visual elements in a photograph or other picture with respect to the effectiveness of the entire image.

Present knowledge of visual perception does not permit precise prediction of viewer responses to pictures. Better predictions can be made, however, for an average response of a large group of viewers than for any one individual. In some situations both cognitive and emotional average responses can be predicted with some confidence on the basis of known principles.

The intent of compositional rules is to enhance the effectiveness of pictures. A portrait photographer recently wrote that there are only five acceptable views of the human head for portraits—full front view, one-third left and right, and profile left and right. Photography students can react to this compositional rule in any of three ways— (1) they can accept it as being valid and apply it to their own photography; (2) they can reject it on the basis that it is inappropriate to use rules in esthetic matters or (3) they can accept the concept that certain views are more attractive than others but question the specifications. One method of resolving this matter is to conduct a controlled experiment in which portraits are made of a reasonably large random sample of subjects, including all possible views of each. The portraits are then shown to a large number of appropriately selected viewers, and their responses are tabulated and analyzed.

It is unlikely that a back view of the head would be considered the most attractive view by many of the evaluators, or perhaps even a frontal view where the tip of the nose appears to be just touching the outline of the cheek against the background. But it is difficult to anticipate how much effect a change of 5 or 10° either way from a one-third left view would have. Whereas the rule makes no distinction between one-third left and one-third right, an unexpected bonus of an experimental study could be the finding that viewers prefer one side over the other—as did Rembrandt who always painted the same side of the face on self-portraits and portraits of his relatives.

Comprehensive experiments of this type are rare with respect to purely esthetic aspects of pictures, although commonly used with technical factors that have important effects on the attractiveness of photographs—eg. the work by L. A. Jones used as a basis for ASA film speeds. A major problem in such experiments is the possibility of interaction effects whereby variations of even seemingly unrelated factors influence the response to the factor being studied. For example, it was found necessary to standardize the degree of development of film in the experiments on film speed. Would the preferred view of the head for a portrait change with variations in hair style, expression, image size, cropping, lighting, etc? Only by varying each factor systematically can this be determined. An especially important factor in the study of esthetics is the possibility of a change in criteria with time. One art-aptitude test that was reasonably valid when designed was found to have a negative correlation with other measures of art aptitude when re-evaluated some years later.

Compositional rules pertain to concepts such as placement of the horizon line and the center of interest, visual balance between picture elements, symmetry, patterns, groupings and arrangements in geometrical shapes including triangles, circles, and S-curves, and visual effects related to cropping through and near objects, direction of movement, overlapping objects, converging lines, image size and surrounding space, and format proportions. In general the rules are based on the analysis of effective pictures rather than on psychological theories or experimental studies.

Related terms: arrangement, balance, cropping, design, direction, esthetics, framing, harmony, isolation, movement, pattern, placement, rhythm, scale, sharpness, symmetry, tone, unity.
References: **50, 207, 218.**

Although photographers seldom compose pictures by rigidly following compositional rules, the application of various rules can often be discovered in successful pictures. It is left as an exercise for the reader to determine to what extent these photographs conform to or violate the better known compositional rules. *Photographs by John Jean (top left), Günther Cartwright (top right), Dick Swift (bottom left), and John H. Johnson (courtesy of RIT permanent collection).*

15.4 Color Preference

Definition: A subjective response by a viewer whereby certain colors are perceived as being more attractive than others.

When people are given the opportunity to select one color from many available, as when buying a car, clothing or house paint, most express a preference. When two people collaborate in making a choice they may agree or disagree, or one person may simply defer to the other. Many studies have been made to determine the factors that influence color preference, which could lead to a procedure for predicting such preferences in specific situations. Associating a color with an object may well produce a response based on the association rather than the color itself, so that a given color may be liked in one context and disliked in another. This influence is not completely eliminated by presenting the viewer with non representational color patches. There are other problems involved in designing appropriate experiments. For example, presenting the viewer with two or more colors simultaneously may produce interaction effects, whereas presenting single colors in isolation may make it impossible for the viewer to detect differences between colors that would otherwise be obvious. Colors are seldom truly presented in isolation, since the color sample is typically surrounded by black, gray or white achromatic colors that can influence the viewer's response to the test color.

Perhaps the subjective response to colors that is most generally agreed upon is the labeling of certain colors as warm and others as cool. No doubt many people associate the warm colors with fire and the cool with foliage and water, and on this basis a color preference may be expected to experience seasonal changes. It has been reported that some color printing laboratories have noted more customer complaints about the color balance of prints being too cool during winter than summer.

Given a choice of six common hues, an average of 26 different studies revealed a clear order of preference from most liked to least liked of blue, red, green, violet, orange and yellow. Each name, however, can cover a large number of colors that vary in lightness, saturation, and even hue, all of which will not be equally pleasing to a person. There is some evidence that for a given hue, there is a preference for a lightness that corresponds with the relative lightness of that hue in the spectrum, for example, light for yellow and dark for blue and red.

The influence of various factors on color preference has also been studied. Not all experiments have provided conclusive results, but there is evidence that: (1) men and women generally prefer the same hues; (2) the area of a color sample can influence the preference; (3) childhood preferences often change with age; (4) a person may change his color preference even during an experiment due to adaptation or other effect; (5) some people have much stronger color likes and dislikes than other people; (6) likes and dislikes tend to be stronger for colors of objects than for color samples; (7) preferences in general are determined by a combination of inborn and learned factors; (8) a person's preference can often be influenced by psychological means including operant conditioning; (9) changes in viewing conditions can alter color preference; (10) a person's color preference can be altered by presenting an attractive or unattractive color before the test color; (11) the memory of a preferred color may differ considerably from the actual color.

Because color preference is highly subjective, photographers should give careful consideration to color choices—not only in the photograph itself, but also for mountboards, submounts, frames, and the walls for display, reception and office areas. Until the results of research become more conclusive, the best basis for making such choices continues to be an educated eye.

Related terms: color adaptation, color harmony, esthetics, memory color.
References: **36** (206–213), **55** (308–317), **183** (86–90).

Although lipsticks are manufactured in many different colors, cool colors such as the green in the photograph are considered less appropriate. *Photographs by Tom Mason.*

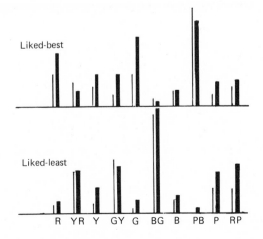

Left: Results of a study in which subjects were asked to identify the best-liked and the least-liked colors from the 10 hues in the Munsell color circle. The narrow bars represent the choices of one group of 200 first-year college students and the wide bars represent the choices of another group of 200 students one year later. Note the close agreement of the two groups in the number of choices of purple-blue as the best-liked color and blue-green as the least-liked color.

15.5 Balance

Definition: A compositional quality that produces a perception of equilibrium of an attribute such as size or color of picture elements, analogous to the equilibrium of physical weights on a beam.

A geometric balance can be obtained in a picture by placing each of two identical images on opposite sides of, and at equal distances from, the center. This is not generally considered a good compositional procedure since it creates two centers of interest. Reducing the size of one of the images shifts the interest to the larger image, but it will also destroy the visual balance—unless the smaller image is also moved farther from the center. Thus perceptual balance can be maintained by adjusting distances to the center to compensate for changes in visual weight. This procedure is not quite as simple as it seems. The visual weight of picture elements depends not only on physical factors such as size and shape, but also on the psychological factor of the relative amount of interest the viewer has in each area. For example, a small high-interest area can balance a somewhat larger low-interest area at equal distances from the center of the picture. Although attention should be given to geometrical balance at the time the photograph is made, minor adjustments can often be made at the printing stage by altering the cropping.

Munsell devoted considerable attention to the overall balance of pictures with respect to the hue, lightness (value), and saturation (chroma) of the picture elements, and he felt that a good balance of these color attributes was essential to achieve color harmony. A procedure he used to test this type of balance was to place a picture or the area of interest on a motorized disk and spin it at high speed to produce a uniform average tone. The midpoint on the lightness scale corresponded to an 18% gray, so that a black-and-white print, a color print or a monochromatic picture such as a toned print when spun should match the lightness of an 18% gray card. The center on the hue circle is a neutral, so that complementary colors or any combination of colors that would blend to form a gray would be considered balanced. The midpoint on the saturation (chroma) scale is 5, where 0 represents no saturation or neutral. Munsell also devised a simple formula for balancing small areas of highly saturated colors with larger areas of colors of lower saturation.

One exception to requiring a balance of hues to obtain an average gray is the use of a single hue or two or more hues that are located close to each other on the hue circle, providing a balance is maintained for the lightness and saturation attributes. Also, for certain mood effects it is considered appropriate to shift all of the image colors from a neutral balance toward a dominant hue, as in shifting the balance of a color print toward a warm hue to suggest illumination from candles or a fireplace.

In making color prints, one of the problems is to determine by inspection when the color balance (controlled by filters in the enlarger) is correct. When the prints are seen isolated from the surroundings, as when illuminated by a spotlight in an otherwise darkened room, the eye tends to adapt to a non-neutral color balance so that it appears more neutral than it would otherwise. Evans observed that when two prints having different color balances are presented to a person under such viewing conditions, the best color balance is always judged to be half way between the two. Even under optimum viewing conditions, Evans believed most people prefer color prints that are slightly warmer than a neutral color balance.

Related terms: color balance, composition, geometric balance, harmony.
References: **21** (11–15, 30–70), **56** (121–122, 172–175, 180–181), **92** (107–110).

Top: Because the buildings are uniformly dark, located at the same distance from the camera, and surrounded by an almost uniform light area, it is easy to calculate the relative perceptual weight of each building by multiplying its area by the distance between the center of the building and the center of the photograph. When this is done, it is found that the calculated center of balance is almost exactly the same as the center selected subjectively by the photographer. *Photograph by R. Walters.*

Bottom: The balance of this photograph must of necessity be determined subjectively because of the difficulty of comparing the perceptual weight of the inherently interesting figure on the left with that of the architectural configuration on the right. The figure contains curved lines and tones of subdued contrast, whereas the architecture has little inherent interest but is emphasized by the converging lines in the wall, the sharp angles, and the high contrast with the background. *Photographed by J. Brian King.*

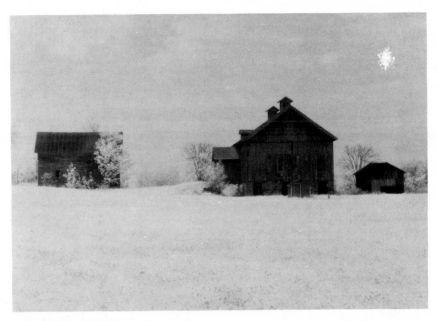

15.6 Color Harmony

Definition: A pleasing visual perception with respect to the choice and arrangements of colors, as in the composition of a photograph or painting.

When two colors are seen adjacent to each other, the subjective impression of attractiveness of the combination may fall anywhere on a continuum from very pleasant to very unpleasant. There is a temptation to compare color harmony with musical harmony where even a naive listener can detect when a pianist strikes a wrong key to produce a discord. The analogy is not entirely appropriate due to basic differences in the two sensory mechanisms—the ear is able to retain the identity of two tones presented simultaneously, whereas a corresponding mixture of two colors of light is seen as a single new color.

Certain aspects of color harmony appear to be predominantly psychological in nature so that the same combinations of colors produce varied responses in different viewers, or even in the same viewer at different times. However, color harmony seems to depend sufficiently on measurable relationships of hue, saturation and lightness so that useful principles can be established for the selection of colors.

According to the principle of similarity, colors tend to harmonize to the extent that they have a common attribute. Thus, two colors with the same red hue would be likely to harmonize, especially if they differed in only one of the other two attributes—lightness and saturation. This principle includes the neutral tones of black-and-white photographs where lightness is the only variable attribute. Also, two different hues tend to harmonize best when they are equal in lightness and in saturation. That is, two light colors harmonize better than a light color and a dark color, and two colors of medium saturation harmonize better than a saturated color and a desaturated color.

Principles concerning hues that harmonize are largely based on the color circle, an arrangement of hues in the order in which they appear in the spectrum and with an equal space for each hue. In 1839 Chevreul observed that two colors look best together when they are either adjacent on the color circle, such as red and orange, or are on opposite sides of the circle, such as yellow and blue. With three colors, an equilateral triangular arrangement on the color circle produces harmonious colors. Munsell observed that variations could be introduced in hue-lightness and saturation that violated the principle of similarity, providing the variations were distributed appropriately about a mid-point for each attribute (*see* 15.5 Balance). The principles of harmony were not considered to be rigid rules by their originators, but more like musical chords that should be learned before attempting more sophisticated combinations.

Universal color harmony principles will fail to the extent that certain psychological factors, such as the following, are more powerful in influencing perception. The size, shape and arrangement of colored areas can affect the perception of color harmony. Color combinations may have different effects on the viewer when seen as abstract shapes or as representations of recognizable objects. The response of a person to combinations of colors may change with age, especially during the developmental years, and with training, such as art education. An adaptation effect occurs with prolonged viewing in which the perceptions of both attractive and unattractive combinations of colors move toward a neutral position. Advertising and other factors can influence whether certain combinations of colors are considered in vogue.

Although photographers do not have the unlimited control over picture colors that artists have, they have many opportunities to control color combinations including the choice of subject, props, backgrounds, mount boards, submounts and frames.

Related terms: affective response, balance, composition, discord, esthetics, mood, Munsell, Ostwald, vibrating colors.
References: **19** (34–65), **20** (40–70), **21** (65–71), **36** (213–219), **55** (318–324), **64** (268–269).

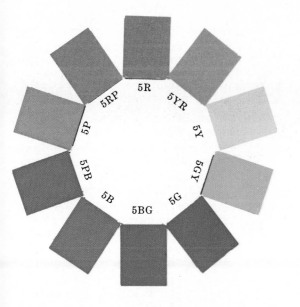

Left: A rule of thumb is that hues adjacent to each other and hues opposite each other on the color circle will harmonize. This rule ignores the effects of lightness, saturation, and various psychological factors. Four hundred subjects were asked to select colors from the circle that harmonize and that clash with the RP (red-purple) sample. PB (purple-blue) was selected most frequently as harmonizing best. GY (green-yellow) was selected as clashing worst with RP by more than a 2:1 ratio over any other color. *Courtesy of Munsell Color Co., Inc.*

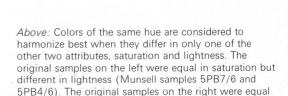

Above: Colors of the same hue are considered to harmonize best when they differ in only one of the other two attributes, saturation and lightness. The original samples on the left were equal in saturation but different in lightness (Munsell samples 5PB7/6 and 5PB4/6). The original samples on the right were equal in lightness but different in saturation (Munsell samples 5R4/6 and 5R4/12).

Left: Paint manufacturers assist their customers in selecting suitable combinations of colors for house decorating by providing color chips arranged in groups. Eight colors on the left have been selected to harmonize with or accent each of the three wall colors on the right. *Courtesy of Dutch Boy Paints.*

15.7 Symmetry

Definition: The sameness or characteristic correspondence of perceptual elements on opposite sides of a dividing line within a field.

Split an apple down the center and you have two very similar halves. This is an example of bilateral symmetry. It occurs frequently in nature, man being a prime example with familiar symmetrical features such as the face, arms, hands, legs and the not so familiar bilateral brain.

There are various types of symmetry, which can be described in terms of design elements, such as letters and symbols. Place a mirror perpendicular to a letter A and to one side and the reflection is unchanged, while the letter B remains unchanged only if it is reflected in a mirror directly above or below it. In both cases, *reflection* is used to describe the type of symmetry. Letters such as S, H and X can be rotated 180° (upside down) and appear the same. This is called two-fold symmetry, while a symbol such as a plus sign (+) possesses a four-fold symmetry, appearing identical in four different rotations. The letter O, or a circle, remains the same regardless of rotation or reflection and therefore represents complete symmetry.

A statistician describes symmetry in terms of a bell-shaped normal distribution of events. A non-normal distribution is said to be skewed. *Skewness* therefore is a measure of the degree of non-symmetry.

In graphic design, the more symmetrical the visual elements are the more they will stand out as figure (*see* opposite). Logos and graphic marks often incorporate symmetry. Such symmetrical designs provide for a strong figure and good balance.

Fred Attneave has demonstrated the importance of symmetry on the stability of an image such as an equilateral triangle by showing that it can be seen in any of three different orientations depending upon the assumed axis of symmetry. Though an equilateral triangle is physically symmetrical about all three axes, perceptually it appears to respond to the symmetry of one axis at a time.

Symmetry also has an effect on our perception of depth. Generally speaking, the more symmetrical a design the more it is seen as two-dimensional (*see* opposite).

In printing a photograph or showing slides, a problem can occur if the wrong side of the negative or slide is used. Surprisingly enough, this is only a problem with pictures having man-made objects, for in nature it is difficult to tell right from left. In making montages of nature scenes, however, or doing rear screen projections, care must be taken that the sun angles and shadows are alike if the combination picture is to look balanced.

Complete or perfect symmetry in photography is often undesirable, since it tends to portray a static or monotonous situation. Some asymmetry is necessary to establish interest and tension. In portrait photography, lighting is adjusted to break up the symmetrical form of the face and the subject is rarely photographed straight on.

Related terms: asymmetry, balance, redundancy, similarity.
References: **10** (33–37, 231), **11** (36–39, 55), **13** (62–71), **215** (56, 83, 93, 131), **218** (129, 210, 226).

A: Symmetrical design elements 1, 3 and 5 are seen as figure, while asymmetrical elements, 2 and 4, are seen as ground.
B: Symmetrical arrangements are more stable as two-dimensional figures.
C: Equilateral triangles are multistable and can be seen in any of three different orientations depending upon the axis of symmetry chosen.

The human body exhibits a bilateral symmetry, as shown in this photograph of legs. *Photograph by Charlotte Marine.*

The symmetrical architecture of the Taj Mahal is enhanced by the balanced landscape. *Photograph by Norm Kerr.*

15.8 Visual Vibration

Definition: The illusion of a shimmering movement at the boundary of areas of complementary colors which are nearly the same in lightness, or at the edges of lines in high-contrast designs having any of a variety of repetitive geometric arrangements.

The phenomenon of optical vibration is not new as it can be traced back at least to the recorded research of Ernst Mach in the late 1800s. In studying the intensified light and dark bands at the edge between two neutral areas of high contrast, he observed that there was no change in hue. The light and dark Mach bands (topic 12.8) were neutral, which meant that all the color components of white light were affected by the same amount.

Visual vibrations can be strong or weak depending upon the color combinations chosen. Maximum vibrations occur when highly saturated complementary colors, such as red and cyan, that are similar in lightness are juxtaposed. The strength of the vibrations can be further increased by including many borders in the pictures since it is at the edges of colors that the optical mixing and competition are greatest. Certain paintings by Victor Vasarely and Max Bill, for example, exhibit strong vibrations. Josef Albers (1972, p 62), in describing the effect in his paintings, wrote 'vibrations occur between colors which are contrasting in their hues but also close or similar in light intensity.' Another author noted that weaker vibrations can be produced by simply 'putting tone upon tone in a pure state, blue upon blue, yellow upon yellow, red upon red' (Homer, 1964, p 33). Some early artists, including Van Gogh, were aware of color vibrations and used this effect in their paintings. In a letter to his brother, Theo, in 1888, Van Gogh wrote '. . . to express the feeling of two lovers by a marriage of two complementary colors, their mixtures and their oppositions, the mysterious vibrations of tones in each other's proximity.'

Vibrations can also be observed with certain patterns which contain a repetitive arrangement of black-and-white lines. More complex designs are generally required to achieve the effect with black-and-white images than with color images. Paintings which vibrate have been classified as Optical Art or simply *Op Art,* and the effect has been used by commercial artists to attract attention in areas such as advertising and packaging, and for psychedelic posters.

The reason that edges seem to vibrate under favorable conditions is complex but appears to be related to physiological factors such as the inhibitory process in the retina and the tremors of the eye called nystagmus, and to perceptual phenomena such as simultaneous contrast and successive contrast.

Visual vibration is seldom seen in photographs as the required combination of attributes is seldom encountered in the things that are photographed, even assuming faithful color and tone reproduction. But the effect is not beyond the capabilities of the photographic process. Making high-contrast photographs of moiré patterns offers the possibility of producing black-and-white images that vibrate. One method for making color images that vibrate is to make high-contrast black-and-white positive and negative images of a geometric pattern on film and then print the images sequentially in register through complementary color filters onto color printing paper or color transparency film. This produces a final image having complementary hues with little difference in lightness.

Vibration effects can also be obtained by the careful choice of colors of mount board, submount paper and water colors for drawing lines around prints when such effects are appropriate. A convenient method for selecting combinations of colors that vibrate is to juxtapose different colors using the samples of color papers that are available in most art-supply stores.

Related terms: inhibition, Mach effect, moiré pattern, optical vibration, simultaneous contrast, successive contrast.
References: **24** (114–115, 118, 140), **41** (107–108, 152–154), **83** (23, 277–280), **109** (31–33, 69, 129), **170** (62–63, 76).

Left: Strong color vibrations occur when colors are complementary, highly saturated and nearly the same in lightness. *Illustration by Joyce Culver.*

Conserve

Above: Weak color vibrations occur when colors of similar hue but differing lightness are used.

Vibrations occur at the edges of high contrast line patterns.

15.9 Zeigarnik Effect

Definition: The tendency for some people to remember more effectively a task which is interrupted and not completed, than one which is completed.

In 1927 a Russian psychologist, Bluma Zeigarnik, conducted a series of experiments in which she showed that tasks which are interrupted before completion are more likely to be remembered than similar completed tasks. Subjects were asked to perform simple tasks such as recalling favorite quotations from memory, solving a riddle or doing mental arithmetic problems. Some of the subjects were given sufficient time to solve the problems and others were not. Upon questioning a few hours later it was discovered that the subjects who were not allowed sufficient time for completion had better recall. This superiority of memory recall for uncompleted tasks, however, is short and seems to disappear within twenty-four hours.

The experience is not an uncommon one, as evidenced by the fact that after a test or similar event you tend to give more attention to the questions you were not able to solve. A similar situation exists when you are puzzled about something you have read or seen and cannot make sense of it so you decide to 'sleep on it.' During the night the unsolved puzzle keeps the mind active and sometimes makes sleep difficult. Until the puzzle is solved, or frustration takes over and it is dismissed, it remains active in the mind. Unresolved, complex, personal problems and worry are even more persistent in refusing to be dismissed from the mind.

The Zeigarnik effect is a variant of the gestalt principle of closure. Recent research suggests that personality plays an important role. People who are highly anxious recall completed tasks better, while those who are achievement-oriented recall uncompleted tasks better. A task that is not completed can cause tension. People have different tolerances and strategies for coping with tension —for some, tension can provide motivation, for others it can encourage withdrawal.

A certain amount of visual tension in a picture, an ambiguity, an illusion, a confusion, a novelty, an unexpected situation, can result in a pictorial Zeigarnik effect. The picture becomes a visual riddle which may remain unsolved during viewing. This unanswered riddle remains in memory and is recalled and thought about until it is solved and a closure is formed. Many pictures have such riddle characteristics. The most common, perhaps, are those used in advertising. Often, picture and copy go together to produce a puzzle that is not solvable in the short time typically devoted to viewing the advertisement. Rebuses (riddles composed of word syllables depicted by pictures or symbols) can be found in some advertisements. You are seldom aware of the information hidden in pictures and advertisements. In discussing perception and memory, N. Dixon points out that emotionally charged elements in a picture are sometimes unperceived or unreported but can occur in subsequent dreams (*Poetzl effect*). He wrote (1971, p109) '. . . the subject perceives all that was presented, but when asked immediately afterwards to reproduce the stimulus material, forgets certain items. Registered but unretrieved items lie dormant until emerging in a subsequent dream—a phenomenon akin to the Zeigarnik effect.'

The relationship between the Zeigarnik effect and closure can be seen in Michelangelo's famous painting, '*The Creation of Adam*'. The distance between the fingers of the two outstretched hands is not completed. Since there is no closure, a visual tension is set up and when the painting is recalled the almost-touching fingers quickly come to mind.

Related terms: closure, Poetzl effect, retention, memory.
References: **39** (78), **49** (109, 133), **137** (55–56).

The critical space between the fingers of God and Adam provides a 'decisive distance' which causes a non-closure, a pictorial Zeigarnik effect. From *The Creation of Adam'* by Michelangelo.

A recreation of a Rebus which appeared in national advertisements for a perfume. Puzzlement by the viewer over the significance of the Rebus playing card displayed near the right edge tends to make the picture more memorable. *Photograph by André LaRoche.*

15.10 Perceptual Dissonance

Definition: Incongruous perceptual information which creates tension.

Dissonance is created whenever a person is confronted with information that is inconsistent with his expectations. Perceptual dissonance can be distinguished from cognitive dissonance in that the incongruous elements are related more to external stimuli rather than to incongruous thoughts. James Gibson reported some 40 years ago that when a person runs his hand along a straight rod while looking through a prism that made the rod look curved, the rod actually felt curved. It seems that when vision and touch provide contradictory information, visual perception dominates by biasing the tactile perception.

A familiar example would be simulated leather surfaces. By printing leather-like detail on smooth paper or plastic, the material is made to look like leather and is usually accepted as such even after a person attempts to confirm his visual perception by feeling the surface. Experiments by Irvin Rock, Jack Victor and Charles Harris also demonstrated that when a person is presented with conflicting visual and tactile information regarding the size and shape of an object, judgment tends to be made on what is seen rather than what is felt.

The adages, 'Action speak louder than words' and 'Do not listen to what he says but watch what he does' are advice to assist you in resolving a verbal-visual dissonance. Body language, particularly that of the eyes, is generally to be trusted over conflicting verbal information.

It is common to have dissonance within single sensory modalities as well as between modalities. Artists and photographers by design introduce dissonance into their work to create visual tension. The viewer is attracted by this, becomes involved, and finds pleasure in reducing the tension. Tension reduction is a strong drive and man will strive for tension-reducing fulfillment. When a picture deviates from what is expected, added energy is required to correct the discord and greater tension release accompanies the closure. Avant-garde artists and photographers thrive on presenting the public with the unexpected, forcing a disparity and variance from the conventional view of the world. The unexpected comes as a surprise and such surprises are usually playful and attractive. If the dissonance which work of this type generates can be resolved, pleasure is derived, if not frustration results. Those who become frustrated by the new look at the world often ridicule the artists, such as in the case of the drip paintings of Jackson Pollock who became known as 'Jack the Dripper.'

The key to creating perceptual dissonance is to present the viewer with conflicting visual information. Everyone has set notions of what the visual world is like. The perceptual system is tuned for certain expectancies regarding such things as shadows, reflections, gravity, symmetry, space and perspective. Dissonance can occur when shadows are out of context, such as in the paintings of Giorgio De Chirico or photographs of Arthur Tress. Dissonance can also occur when mirror reflections do not produce the expected reversed images, objects in pictures defy gravity, nonsymmetry appears where symmetry is expected (particularly in people's faces), and central perspective is violated as in the works of Maurits Escher. Paul Citroen's photocollage, *Metropolis, 1923,* with its complete disregard for perspective but concern for representing multiple viewpoints of a city simultaneously in one picture must have, when first seen, caused considerable perceptual dissonance.

Related terms: ambiguous figure, anamorphic image, cognitive dissonance, field dependent/independent, figure—ground, form illusion, perceptual readiness, subliminal perception, surrealism, visual synthesis, visual thinking.

References: **10** (123–127, 130–133), **83** (69, 83–89, 238–242), **181** (96–104), **182** (594–596).

Perceptual dissonance attracts attention and causes tension until the dissonance is resolved. *Photograph by Eva Rubinstein.*

15.11 Cognitive Dissonance

Definition: Inconsistent thoughts which can cause a person, in an effort to resolve the differences, to distort or otherwise alter one of the thoughts.

According to the psychologist Henry Murray, man derives so much satisfaction from tension reduction that he may purposely build up tension when none exists, so that he can then have the pleasure of reducing it. Thus, tension reduction is a strong motivational force. One type of tension is created when a person has two incompatible thoughts simultaneously. For example, if a person you admire did something unlawful, tension would develop due to the inconsistent thoughts. You could reduce the tension by lowering your opinion of the person or by minimizing the seriousness of the transgression. When you do something wrong yourself, the tension is even greater and you may reduce it by distorting reality through the use of any of various psychological defense mechanisms. Leon Festinger observed that the change introduced by a person to reduce dissonance is sometimes in the opposite direction to that predicted on the basis of commonsense. For example, he paid one group of people a generous amount of money to perform a boring task and he paid another group a trivial amount for the same task. Contrary to expectations, the people who were paid the smaller amount rated the task as being less boring. Since it seemed inconsistent to them that they would do such dull work for so little money, they reduced dissonance by perceiving the work as being less boring or even interesting.

Visual perceptions are also subject to being altered when doing so reduces cognitive dissonance. If a person praises a picture which he really does not like, simply because he lacks the courage to tell the picture maker the truth, he creates cognitive dissonance. This can be reduced either by lowering his self-esteem with respect to being a truthful person or by upgrading his perception of the picture. You should not expect a change from one extreme to the other, but there can be a significant lessening of the dislike. Picture critics, exhibition judges and photography teachers usually employ the technique of balancing negative comments about a picture with at least one positive comment. Insofar as redeeming qualities can be found, this is appropriate, but when it is necessary to fabricate things to praise, the evaluators may become less able to judge the pictures objectively.

Most professional photographers and artists realize that there are a number of ways in which they can enhance their pictures in the eyes of the viewers, other than by altering the pictures themselves. Some of these procedures create cognitive dissonance in viewers who then reduce it by perceiving the pictures as being of a higher quality than they would otherwise be judged. The addition of an expensive frame to a picture may actually detract from the picture, but spending a large amount of money to frame a worthless picture seems inconsistent in the mind of the viewer. So, to reduce tension, he tends to increase his regard for the picture. Other procedures that have a similar effect are to make pictures larger than usual, have a champagne reception for the opening of an exhibit, display a high sale price adjacent to a picture, and post a uniformed guard next to an exhibit.

A person may very well have a different perception of a picture if he is told that it was made by an unknown amateur photographer, than if he is told it was made by a famous professional. If the viewer holds the photographer in high esteem, any shortcomings the viewer may observe in one of his pictures creates cognitive dissonance which can be reduced by minimizing the seriousness of the offense. A charismatic sales person can praise a photograph or the photographer so convincingly that any negative thoughts a customer might have create cognitive dissonance, and therefore are likely to be tempered.

Related terms: tension, defense mechanism, subjectivity.
References: **45** (628–631, 681), **61** (93–102), **62.**

Left: A photographer's feelings about a photograph he has made can be influenced by a number of factors, including cognitive dissonance. An opinion expressed by a respected authority or a group of associates that differs from the opinion held by the maker of a photograph tends to create cognitive dissonance, which the photographer can reduce by modifying his own opinion. Another way of reducing cognitive dissonance is to discount the conflicting opinions expressed by others.

The amount of work involved in making a large portrait photograph, freezing it in a block of ice, and displaying it in an unusual setting on a cold day could produce cognitive dissonance in the viewer, resulting in an enhanced perception of the photograph itself.
Photograph by Anne Bergmanis, RIT Communications.

15.12 Golden Section

Definition: A ratio or proportion between two dimensions of a plane or line which is approximately 3 to 5.

The golden section can be used as a geometric or mathematical technique of composing visual or acoustic units. The diagram opposite concerns distances that are divided into two unequal parts in such a way that the proportion of the larger part to the full distance, corresponds geometrically to the proportion of the smaller part to the larger part. This can be mathematically stated as a geometric progression whose formula is $\frac{a}{a+b} = \frac{b}{a}$. When the full distance constitutes a unit, the larger distance or section is 0·618 and the smaller is 0·382. In whole numbers, this is approximately $\frac{5}{5+3}$ or $\frac{3}{5}$.

The origins of the golden section go back to the Greeks and Egyptians of antiquity. Pythagoras believed that order in the universe could be demonstrated by expressing all relationships among the parts of things in terms of simple whole numbers. Such relationships can be found in much of the Western visual and musical arts. Some of the experiments of Fechner in the 19th century bear this out. In one study he asked observers to indicate their choice of rectangles of varying dimensions, and found their preference was for rectangles with proportions near the golden section—about 3:5. However, when he measured the proportions of hundreds of paintings in museums, he found that, on the average, a rectangle shorter than the golden section was preferred by painters. The proportions were 3:4 for horizontal and 4:5 for vertical displays. Arnheim explains this by suggesting that the viewer is influenced by the pictorial composition within the rectangle.

An approximation of the golden section can be found in the dimensions of the great pyramids of Giza. The average ratio of altitude of the pyramids to their base is about 5 to 8. The Greeks based much of their architecture and art upon the same ratio which they called the golden mean, the front of the Parthenon being one example. Though they did not understand the mathematical basis for the golden mean (which was discovered in the 13th century by Fibonacci), they knew that this sense of proportion was pleasing to the eye—it provided a dynamic symmetry. Beautiful Greek vases were designed to golden proportions as were the designs of Greek figure sculptors who placed the navel so as to produce the desired proportions.

The Fibonacci number series 1, 2, 3, 5, 8, 13, 21, 34, 55, etc. represents a mathematical equivalent of many of the shapes inherent in nature, such as the curves of seashells and the galaxies. The number sequence is easily generated since each number is the sum of the two previous numbers. Its relationship to the golden mean is direct and precise, and is easily found by dividing any number in the series by the next higher number such as 3–5 or 5–8.

Similar proportions seem to be evident in photography. Negatives of 4×5 inches size, 8×10 inches prints and 16×20 inches mount boards have the same 4:5 ratio. A television screen conforms most closely to the horizontal 3:4 ratio while photographic slides (24×35 mm) conform closely to the 3:5 golden mean ratio.

It seems that, at some point the golden section has strongly influenced photographic formats. Some layout designs in magazines and books also have their origins in the golden section. Even a page can be folded in half and still maintain golden section proportions.

Related terms: golden mean, golden number.
References: **107** (110–124), **122** (175, 191, 206, 218–230).

In the 17th century Jakob Bernoulli investigated the relationship between the golden mean and logarithmic spirals so common in nature, a relationship that provides a measure of understanding to the esthetic appeal of the golden mean. If you draw a golden rectangle (1) in the ratio of 5 to 8 and then cut a square off one end of it you are left with another smaller, 3 to 5 golden section rectangle (2). Repeated formations of such decreasing forms (3) provide a whirling movement of squares that take the shape of a spiral (4) when the center points of the squares are smoothly connected. Such placement and organization of squares provides for a dynamic symmetry.

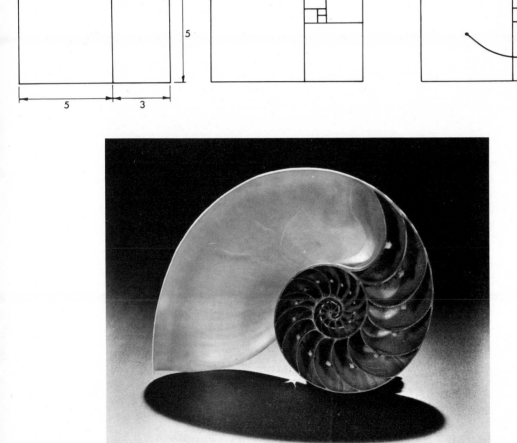

A Chambered Nautilus has a logarithmic spiral which enables growth to occur without any change in shape. *Photograph by J. Hood.*

15.13 Personal Space

Definition: The private territory around each individual, within which he feels at ease, or ill at ease if it is violated.

It is well established that animals stake out territories for themselves for food, shelter and reproduction. If these territories are threatened by others, an animal will become aggressive and defend its territory. Although humans do not actually stake out territories, each person does walk around with an imaginary bubble of space surrounding him, as if it were an extension of himself. If anyone threatens to enter this personal space bubble, the person will perhaps back off, close his eyes or even fight. A common experience is the uncomfortable feeling you may have when you are forced into crowded situations in an elevator or a bus.

Personal space is an elastic balloon that changes depending upon such factors as the persons, the culture and the senses involved. For example, two people in love feel comfortable at very close range, Mediterranean people accept closer personal space than the English and Americans, and some people may require a larger visual space than an acoustic space. For example, see how close you can walk up to another person face to face before one of you begins to feel uncomfortable because visual space is being violated. Now try the same procedure with your eyes closed and talking. Most people experience a considerable difference.

Edward T. Hall, an anthropologist, has studied man's reaction to the space around him and how he relates to it. He calls his study of the interrelated observations and theories of man's use of personal space— *proxemics.* In an attempt to structure some of the observations, he has suggested four distinct zones in which most people function. These are shown opposite and should be attended to by photographers to avoid unintentional intrusion into the personal spaces of their subjects.

Photographers can get around some of these intrusions by using long focal length lenses, which allow them to keep a reasonable distance from their subjects and still produce images of satisfactory size. Photographers should be alert and sensitive to nonverbal cues when they are posing persons for group shots and when they are trying to take intimate pictures. If the subject signals nervousness, it is best to back off. The cliché 'never touch the model' is a statement about personal space. It is, however, too general a statement. Whether or not you touch the model is an understanding to be reached by you and the model. Some areas of the body are less personal than others. The important thing to remember is that in order to touch the model you must come close—you must enter the model's personal space. This includes not only tactile space but also, visual space, auditory space and olfactory space. 'Do not touch the model' really means, 'Do not violate the model's personal space.' You must establish an excellent rapport before entering a model's personal space.

In motion pictures and television, actors and cameramen are well aware of the need to use exaggerated gestures for long shots, whereas in closeups emotion is conveyed by small changes in facial expression, such as a raised eyebrow or a quiver of the lips. The extent of gesture used is dictated by the viewer's perception of the distance or the personal space between him and the person on the screen.

Similar consideration should be given to making still photographs. For example, with pictures of people the viewer may have vicarious feelings of personal space that vary with image size and cropping, eyes directed at or away from the lens, etc. A picture to be used in a magazine might require a different treatment than one to be shown in a gallery. Similarly, two different slides might be required to elicit similar feelings of the same subject, when the slides are seen on a large screen and on a relatively small TV screen.

Related terms: ego environment, proxemics, territorial imperative, visual space. *References:* **88** (41–73, 113–125), **188.**

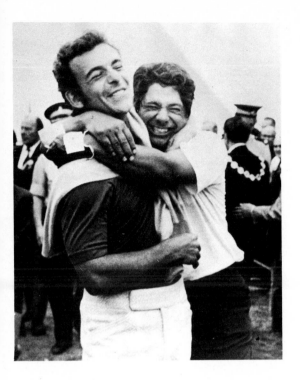

The personal space of Englishman Tony Jacklin is invaded by jubilant Mexican-American Lee Trevino in the excitement of sinking the winning putt to win the 1971 British Open Golf Championship. *UPI Cablephoto.*

Personal space

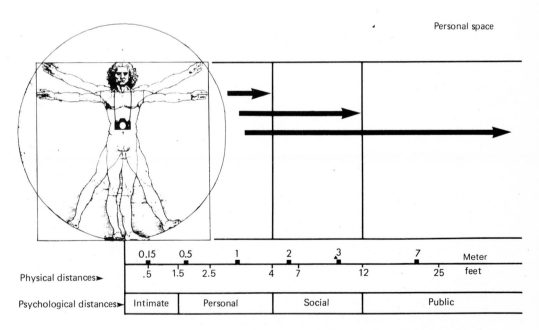

	0.15	0.5	1	2	3	7	Meter	
Physical distances ►	.5	1.5	2.5	4	7	12	25	feet
Psychological distances ►	Intimate	Personal		Social		Public		

Personal space is an elastic bubble that we all carry around us to protect our privacy. It is psychological space as distinguished from physical space. The perceptual zones in which humans function are intimate, personal, social and public.

15.14 Mood

Definition: A mild and transitory emotional state of mind that can be induced or altered by various means including visual, auditory and other external stimuli.

The strongest emotional responses are generally reserved for real-life situations, but moods or feelings that can be induced by viewing a motion picture, television program or still picture are suggested by words such as suspense, amusement, alarm, excitement, disgust, interest, pleasure, uneasiness, affection, relaxation, boredom, awe, sadness and romance. Visual experiences that you remember the longest and that have the strongest motivating influence usually involve emotions.

Establishing a sustained mood for the viewers of a motion picture is a complex matter that may involve the efforts of a large number of people, each of whom is an expert in his own area of specialization; these efforts must be unified by the director. Such specialized areas in a major production may include scripting, casting, sound, lighting, sets, props, camera operation, make up, special effects, costumes and editing. The contribution that the audio component makes to the mood of a motion picture cannot be over emphasized. Film producers commonly maintain music libraries in which the music is categorized on the basis of mood effects. Also, the expression of the actors' voices may be more important to the mood than the explicit meaning of the words being spoken. Even watching on television a spectator sport such as tennis or boxing, the enthusiasm or lack of enthusiasm expressed in the commentator's voice may strongly influence the mood of the viewers. The psychological effect of watching a motion picture with a group of people also tends to strengthen moods in comparison with those produced by watching alone. Excessive and inappropriate use of dubbed-in laughter in some television programs, however, has nullified this psychological effect on mood for many viewers.

Of the visual factors that determine the mood of a picture, the choice of subject is obviously important. In casting a motion picture, it is necessary to select actors who on the basis of appearance will be believable in their various roles, and the scenery or setting must be appropriate for the intended mood. Orson Welles demonstrated the importance of camera angle and perspective to the dramatic mood in the classic film *Citizen Kane*. The contribution of cropping of pictures to mood was established by the success of the Hollywood closeup, widely used for romantic and sad scenes, often coupled with a soft-focus lens. Breakthroughs in optical technology have provided additional means of creating mood effects, including zoom lenses, extreme wide-angle and telephoto lenses, wide-screen photography, and ultra high speed lenses that permit filming by existing light—even by candle light as in the color film *Barry Lyndon* in which an $f/0.7$ lens was used.

Lighting has long been the basic tool of both motion-picture and still photographers in creating moods. The feeling of mystery has commonly been heightened with low-key lighting, or with the main light positioned below the level of the camera, and with the diffused light provided by filming at night in a London fog. Shooting can be delayed for long periods waiting for appropriate lighting outdoors, and outdoor lighting is sometimes supplemented with artificial lighting or even faked indoors with studio lighting. With color film, photographers have unlimited control over the color balance of the light through the use of filters to produce a wide range of mood effects. The importance of lighting in creating mood effects is emphasized by the trend in recent years toward using natural light, or creating the illusion of natural light, even when it involves a decrease in tone-reproduction quality in order to achieve a mood of realism.

Related terms: affective, emotion, feeling, subjective.
References: **40, 63, 200** (26–50, 79–166, 207–230), **217** (88–93).

Viewers tend to have a pleasurable reaction to pictures of people who are enjoying themselves, such as these children in a playground tire. *Photograph by Lori Stroebel.*

More complex and varied moods are created in viewers by this photograph of a black child wearing a white mask and clutching his mother's hand. *Photograph by John Jean.*

Photographs of inanimate objects can also induce emotional reactions, especially when accompanied by suggestive titles, such as *Malevolent House,* the title of this picture. *Photograph by Dennis C. Kitchen.*

The warm color balance contributes to the mood of loving affection in this photograph of a mother and child. *Photograph by Douglas Lyttle.*

15.15 Abstraction

Definition: An image that emphasizes certain attributes of the subject and de-emphasizes others. A silhouette, for example, emphasizes shape and de-emphasizes form, texture and color.

In one sense nearly all pictures are abstractions since they are rarely facsimiles of the object photographed or painted. A photograph or painting of a tree, for example, represents a graphical two-dimensional transformation. If the tree is rendered as a black-and-white picture it would be more abstract than a color rendering. Only lightness differences of the tree are recorded in a black-and-white picture whereas the color picture would be a reproduction of all three attributes of color; hue, saturation and lightness. Photographers and artists have considerable freedom in selecting or abstracting the elements of a scene to be reproduced. Color, shape, form, size and texture are important characteristics but not all are needed for the recognition and appreciation of what the pictures are intended to represent. The photographer commonly determines the attributes to be abstracted from the subject as a personal matter of artistic expression, but he must also give consideration to the intended use of the image and the nature of the viewer.

Less information is needed to recognize familiar objects than strange objects, thus memory plays an important role. Shape is perhaps the most important characteristic of a picture when objects are to be recognized, whereas such attributes as color and texture add interest and feeling. It is difficult to imagine a picture without shape.

All images are abstractions but not to the same degree. This suggests a scale of abstraction. At one end of the scale is a realistic representation of the physical object, exemplified by a color catalog photograph, and at the other end an image that bears little representational relationship to real objects. This can be seen in the series of trees by Piet Mondrian. The first illustration of a tree appears similar to our common experiences of what a tree looks like and there is no problem in recognition. It is a realistic representation of a tree, not unlike a photograph. The second illustration is less realistic and presents more of the essence of the design of the tree, which provides impression of curvature, rhythm, space and movement. In the third illustration the image is hardly recognizable as a tree, and without previous knowledge few people would be able to identify it. Identification, however, is not a requirement for the feelings you might derive from the painting. Graham Collier calls our attention to Mondrian's concern with 'ground' rather than 'figure' in his abstract painting of a tree—'. . . once the artist ceases to regard the details of the tree's natural appearance as sacroscant he is free to concentrate perceptually and analytically on the space which the tree inhabits. In fact, if he is to eliminate unessential physical detail in favor of overall tree rhythms and proportions, it is absolutely necessary that he be aware of the *shape of space* which the tree's presence creates' (p. 189).

Although photography is usually considered to be highly realistic, it can be as abstract as any other graphic medium. There are many photographic techniques and materials available to the skilled photographer who wants to produce abstract photographs. Robert Routh used a 'tone line' technique for his Mondrian-like abstract photograph.

Related terms: derivations, expressionism, posterization, transformation.
References: **10** (139, 144, 165, 461), **41** (177–192), **185.**

A selection of *Piet Mondrian's* rendition of trees showing increasing abstraction. *Top, left:* Tree 1 1909–10 (drawing); *centre left:* The Gray Tree 1911 (oil), *below;* Flowering Apple Tree 1912 (oil). *Courtesy of the Haags Gemeentemuseum collection, The Hague.*

Tone line photographic abstraction. *Robert D. Routh.*

15.16 Equivalent

Definition: A photograph which serves as a visual metaphor to elicit particular feelings or meanings.

Alfred Stieglitz, in the early 1920's, first used the word 'equivalent' to describe how his cloud photographs provided visual stimuli that evoked feelings similar to those he derived from listening to certain music. Although the word and the concept were not new, the application to photography was. The general definition of the word 'equivalent' is something similar or equal in one or more characteristics such as substance, degree, value, movement or meaning.

Mathematicians use the word to refer to events capable of being put into a one-to-one relationship, while chemists refer to identical corresponding parts as equivalent. In psychology an equivalence exists when different stimuli produce similar percepts or responses. The Symbolist artists and writers of the late 19th century expressed their ideas and feelings indirectly through symbols, which can be thought of as equivalents.

Stieglitz acknowledged being strongly influenced by an 18th century scholar and scientist, Emanuel Swedenborg, who believed that there were connections between energy, matter and motion which he called *correspondence*. Music proved to be a strong influence on Stieglitz's photography, as it was on that of Edward Weston and some other remarkably skilled photographers. Stieglitz was a pianist and was strongly influenced by the music of Wagner. Some of his photographs were intended to provide an equivalent of the feelings Wagner's music evoked in him. Eye and ear properly stimulated arouse similar feelings. Weston drew much of his inspiration from Bach and Brancusi and you can find similes in Weston's writings that suggest equivalents: 'Brancusi's bird, and princess—these two I remember with most amazement. The princess was curious like one of my peppers'. Another simile: 'As she sat with legs bent under, I saw the repeated curves of thigh and calf—the shin bone, knee and thigh lines forming shapes not unlike great sea shells—

the calf curved across the upper leg, the shell opening.' Weston's photographs of peppers and shells become visual metaphors, or equivalents.

Minor White has written a considerable amount on equivalents and he suggests that it is a vehicle with which a photographer can deal with human suggestibility in a conscious and responsible way. There are many different levels of equivalence and the photographer can choose whichever level fits the occasion. You can work at a graphic level and establish equivalents of shape, form, color, texture, direction, movement and the like or at a higher level dealing with abstractions, symbols and highly personal imagery. Objects used are secondary. Stieglitz felt that all of his photographs serve as equivalents. Weston argued that subject matter is immaterial and that the approach to the subject, the way it is seen, is most important—'to photograph a rock, have it look like a rock, but be more than a rock.' White points out that equivalence is a function or an experience rather than some object. Bullock said it a bit differently when he observed that the symbol used is not what is symbolized. It is the feeling that is being expressed or symbolized. Whatever you choose to express becomes an equivalent when you succeed. Perceptual information from any of our senses and experiences drawn from memory provides an equivalence when the same emotion is aroused.

Related terms: analogy, correspondence, isomorphism, metaphor, simile.
References: **140** (168–175), **158** (10, 18, 121, 140, 234), **204, 211** (17–21).

Equivalent, as used in photography, refers to a
photograph which stimulates particular feelings and
meanings that lie within us. *Photograph entitled
"Ritual Branch, 1958" by Minor White, courtesy of The
Art Museum, Princeton University.*

15.17 Anthropomorphism

Definition: The perception of human qualities in nonhuman or inanimate objects, or in pictures of such objects.

The practice of attributing human characteristics to inanimate objects goes far back into history. Ancient drawings have been found in which facial features have been added to pictures of the sun, and no doubt early man as well as modern was able to visualize a face on the full moon. Greek mythology and various religions have given human qualities to their deities. For example, a Mayan sun-god carved in stone in the 8th century is in the form of a man's face with large crossed eyes and enormous earplugs. Personification, however, went beyond the perception of human qualities in the deities, as exemplified by a 6th century church-floor mosaic in which the months of the year are represented by twelve rustic human figures.

It is relatively easy for artists to anthropomorphize objects by adding facial features, arms and legs to their drawings and paintings. Even though this technique has been used to excess in animated television commercials where a wide variety of products including boxes of breakfast cereal and car tires talk, sing and dance, it has also been used effectively for various noncommercial purposes. It is unlikely that anyone who saw the lines of walking, man-like brooms carrying buckets of water in *The Sorcerer's Apprentice* in the Disney film '*Fantasia*' will be able to dispel the visual image from his memory. Similarly, one of James Thurber's most memorable cartoons in *The New Yorker Magazine* depicts a timid man coming home to a house drawn to resemble his nagging wife.

Although photographers do not have the unlimited freedom of artists, they have used a variety of techniques to achieve anthropomorphic effects. Multiple exposures in the camera and combination printing in the darkroom can realistically merge an image of a person with an image of an object. Jerry Uelsmann used the combination printing procedure effectively in his 1959 photograph *Enigmatic Figure* in which a half walnut shell is perceived as the head on a ghost-like human torso. Motion-picture photographers can use single-frame exposures, moving the object a small distance between exposures, to obtain life-like animated effects with inanimate objects. The time-consuming single-frame procedure can be avoided, however, by making a hollow model of the object that is large enough for a person to wear as a costume. Two such dancing packages of cigarettes became famous as a commercial in the early days of television.

The most satisfying form of anthropomorphism for expressive photographers is to locate objects in the environment that exhibit human qualities. This not only provides the photographer with an exciting feeling of discovery, but when the photograph is executed with finesse, it provides the viewer with a similar feeling. Perceptive photographers have created a wide variety of such anthropomorphic effects with both manufactured and natural objects, ranging in size from microscopic to mountainous. Edward Weston and Minor White, for example, have been notably successful in achieving a feeling of sensuousness in photographs of rock formations that resemble parts of the human body.

The converse of anthropomorphism is *mechanicomorphism*, in which a human subject, or a picture of a person, is perceived as having attributes of an inanimate object. Thus, an elbow can be seen as a hinge, and as many young children have observed, when the hands are clasped together, 'Here's a church, here's the steeple, open the doors and see all the people.'

Related terms: equivalence, mechanicomorphism, personification, visual memory.
References: **125** (10–12), **132** (729–811), **166** (2–22).

Left: Various early civilizations personified images of the sun. This anthropomorphic sun was photographed recently in Mexico. *Photograph by Norm Kerr.*

Above: An example of a discovered anthropomorphic image whereby the design in a piece of wood resembles a face. *Photograph by Elliott Rubenstein.*

Left: An accidental anthropomorphic image appears in the top right corner of this photograph of a Russian fencer who was disqualified from the 1976 Montreal Olympics for using an electronic device that would score false hits. The light area can be perceived as a disapproving gargoyle-like profile. *Courtesy of Wide World Photos.*

15.18 Projective Technique

Definition: The presentation of a standardized set of ambiguous or psychologically neutral stimuli to a person, for the purpose of eliciting responses that will reveal characteristic modes of perceiving the world and unconscious motivations.

As originally defined by Freud, projection is one of several defense mechanisms used for protection against certain anxieties. Thus, if a person feels anxious because he dislikes someone without cause, projection enables him to convert 'I hate him' into 'he hates me' and allows him to express his impulses under the guise of defending himself against an enemy. Henry Murray conducted an experiment that revealed how projection can alter a person's perception of pictures. He arranged to have a group of 11-year-old girls play a game called 'murder' in a country home one night for the purpose of inducing a feeling of moderate fright in the girls. Immediately after the game the girls were asked to rate a series of pictures on a nine-point scale with 'good, kind, loving and tender' at one end and 'bad, cruel, malicious and wicked' at the other. The girls rated the pictures significantly farther in the bad direction than an equivalent series of pictures rated by the girls before the fear-arousing game. Their perceptions of the pictures were altered by transferring their own feelings to the people and events in the pictures. A broad view of projection suggests that a person can find expression for many of his feelings and thoughts by projecting to aspects of the environment including people, animals, pictures, motion pictures, television, music and a variety of objects.

One of the oldest projective techniques is the word-association or free-association test. A word is presented and the subject responds quickly with the first word that comes to mind. The type of word used and the length of time required for a response are clues for identifying certain personality characteristics. The more ambiguous a projective test, the more the subject depends upon his own memories, feelings and thoughts to make the stimulus meaningful. The *Rorschach test* consists of a series of ambiguous ink blots which were designed to arouse emotional responses. The test was devised by the Swiss psychiatrist Hermann Rorschach after discovering, during some experimental studies in form perception, that certain forms produced quite different responses among his patients. Rorschach's diagnostic method was reported in 1921.

The *Thematic Apperception Test* (TAT), worked out by Henry Murray and his colleagues in 1938, requires the subject to interpret a somewhat ambiguous picture by telling a story. The person attempts to reconstruct the events that led up to the situation presented in the pictures, and to predict the outcome. The responses can reveal significant information about the subject's experiences memories, anxieties, feelings, needs and aspirations. Essentially, the subject projects himself into the picture and identifies with one of the characters represented. A somewhat similar projection process takes place in everyday life with viewers of less ambiguous motion pictures, television and still pictures.

An understanding of the concept of projection is important to a photographer when the purpose of a photograph requires personal involvement by the viewer. Designing such a photograph also requires knowledge of the intended audience. In targeting an audience, marketing people gather both *demographic* and *psychographic* data. Demographic information relates to age, sex, marital status, income and geographic location whereas psychographic information includes beliefs and needs. The effects of such research can be observed by comparing magazines designed for specific groups of people—men, women, teenagers, minority groups, etc. The photographer should give consideration to his choice of the model, clothing, body language and potential symbolism of props, and also to providing an appropriate amount of ambiguity.

Related terms: affective response, perceptual defense, perceptual readiness, stimulus-response, subliminal perception, surrealism. *References:* **46** (623–637, 651–665), **47** (177–187), **87** (44–49, 198–200).

Left: Thematic Apperception Tests require a subject to relate a story about an ambiguous picture. *Photograph by John Jean.*

Above: Rorschach-type inkblot presents an ambiguous picture and requires the subject to describe what he sees as figure.

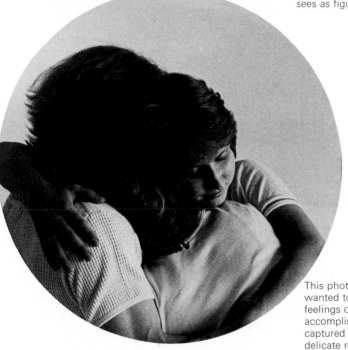

This photograph was made by a freshman student who wanted to create a photograph that would express her feelings of caring, sharing, love and warmth. To accomplish this she took 300 pictures of which this one captured her feelings—feelings she accentuated by the delicate repetitive circular design which symbolizes femininity. She also put a little mystery and ambiguity into the picture by including a third person. In a sense a photograph is a projection of the photographer's feelings at the time the photograph was made, and if successful it gives others an opportunity to project their feeling into the photograph. *Photograph by Sylvia Rygiel.*

329

15.19 Surrealism

Definition: A school of art, and hence, photography, based on Freud-inspired experimentation and chance, that especially emphasizes dream-related imagery and the unconscious.

Artists and photographers for years have used Surrealism as a way of visually relating man's conscious awareness and unconscious feelings. The surrealist painter Chirico wrote that 'Every object has two aspects: the common aspect, which is the one we generally see and which is seen by everyone, and the ghostly and metaphysical aspect, which only rare individuals see at a moment of clairvoyance and metaphysical meditation. A work of art must relate something that does not appear in its visible form.'

The Frenchman *Andre Breton,* who studied psychiatry in his youth and had become deeply influenced by Freud, is regarded as the founder of Surrealism, dating back to 1924. He placed great stress on the unconscious mind and dreams, and believed that the differences between our dream world and reality could 'be resolved in a kind of absolute reality—in surreality.' Contemporary with Breton were artists Braque, Chagall, Chirico, Dali, Ernst, Magritte and Picasso.

The techniques used range from the psychoanalytical idea generation to the technical skills of the visual artist. Breton used Freud's free-association method and automatic writing, in which words and phrases are dredged from the unconscious without any inhibitions. Another method used is based on chance or randomness, placement and juxtaposition of objects, events and colors in proximity to each other, regardless of any rational relationship. The rules of perspective and logic are set aside. Small objects appear large, far objects near, near objects distant, figure changes to ground and ground to figure, shadows are distorted, surfaces change unexpectedly, symbolism permeates, and so on. The visual effect is unreal—it is surreal, a dream—like the world as shown by the Magritte painting opposite. The first motion picture to make use of surrealism was the German film, *The Cabinet of Dr. Calagari.*

Dada artists in the early 1900's discovered that the technique of photomontage provided an excellent medium for their provocative surrealistic pictures. The composite image of a photomontage made possible the incongruous juxtaposition and chance arrangement of pictorial elements which served as a pictorial equivalent to automatic writing. Some of the earliest photomontages were strong political statements made by Berlin Dada artists such as George Grosz and John Heartfield. Surrealistic art has had great influence on such contemporary photographers as Robert Heinecken, Jerry Uelsmann and Duane Michals. Robert Heinecken made photomontages by mixing television images with photographic images. The photographic image was a large transparency which covered the entire screen. By photographing the television screen with the overlay, he obtained a composite of the stationary photographic image and a television image selected in a haphazard manner.

In describing Uelsmann's multiple-print photographs, Peter Bunnell uses the terms synthetic, mystery, alchemy, irrational, magic, theatrical, intuitive, iconographic, incongruous, fantasy and so on—words which describe man, the dreamer. Michals' basic technique of surrealistic photography has been to relate dreams through a sequence of photographs—his multiple prints are not superimposed but displaced side by side. To suggest his dream world, he uses blurred images, transparent images, floating images, mirrors and multiple reflections, and what he refers to as the spiritual power of light. He was strongly influenced by Magritte and even did a surrealistic photograph of him a few years before his death. 'Magritte was the first person who graphically challenged my preconceived notions about reality. Graphically, not intellectually, he shook me up and made me question things', he recalls.
Related terms: dreams, symbolism, unconscious.
References: **10** (298–302), **15, 83** (256–258, 273), **118** (254–260), **205**.

Euclid's Walks, 1955. *Painting by René Magritte, courtesy of the Minneapolis Institute of Arts.*

Below: Surrealistic portrait of René Magritte. *Photograph by Duane Michals.*

15.20 Visual Synesthesia

Definition: The interaction between the visual system and other sensory systems such as sound, touch, taste and smell.

The word synesthesia refers to the production of sensations in one sensory system that are the result of stimulation in another sensory system. Cartoonists commonly represent a person who has received a blow to the head as seeing stars, because such a physical stimulus can produce a visual sensation. For some people the stimulation of the auditory system with musical tones can give rise to vivid perception of colors. However, such 'color hearing' does not necessarily mean the music is more enjoyable or for that matter more understandable, nor does it exclude that possibility. When a proper musical background is used with moving colored shapes, such as in a Norman McLaren animated film, the musical experience is heightened. The common experience characteristics of motion, rhythm, color and shape strengthen each other across sound and sight sensory modalities. In a motion picture, television, or audiovisual production, the careful blending of the appropriate sight and sound can provide an audiovisual gestalt in which the cross modality experience is greater than the visual or audio components experienced separately. Sight influences sound and sound influences sight—terms such as *loud* colors and *bright* sounds are used, without much thought of the choice of words, yet everyone knows what they mean. Some artists have actually tried to render music visually. An excellent example is Piet Mondrian's painting of '*Broadway Boogie-Woogie*'.

A photograph that is designed to stimulate the other senses has to do so through the proper stimulation of *only* the visual sense. The eye is the opening for all the other senses when looking at a picture. Pictures used in advertising must be able to make you thirsty or quench your thirst, feel texture or a smooth surface, experience the moist and succulent taste of biting into a juicy orange, smell the fragrance of a special perfume or after shave lotion, feel the warmth of a sunlit beach, the cold of a frosted drink, hear the sounds of rustling leaves and so on. A successful photograph or painting gives rise to multisensory experiences. To provide for such visual synesthesia requires careful choice of subject matter, colors, arrangement, lighting and perspective.

As odd as it may seem, it is very difficult to make a picture that is strictly visual in its experience—one that does not stimulate the other senses. Wassily Kandinsky among others has labored hard to arrange form and color so that they would provide a purely spiritual meaning devoid of all representation of the sensory would. One such painting is his '*Sketch I for Composition VII*' which interestingly enough has a musical title.

Researchers have recently related synesthesia to thinking and language in general. The much used *semantic differential* test to measure the meaning and association of words by using bipolar adjectives grew out of research on synesthesia which implies a sort of 'neural cross-circuiting.' Words, like their pictorial counterparts, can stimulate any or all of the senses. High-imagery words are effective in this respect, and have been studied and classified by Allan Paivio and others in terms of imagery, concreteness and meaning. Words can also be classified according to the senses they stimulate:

Senses	*Words*
touch	texture, warm, moistness
taste	sweet, spicy, bitter
smell	fragrant, flowery, pungent
sound	shrill, soft, noisy
sight	green, bright, circular
kinesthetic	motion, weight, tension

Many words, of course, stimulate more than one sense—words such as texture, soft, hard, rhythmic.

Related terms: cross modality, correspondence, equivalent, onomatopoeia, semantic differential, sensory orchestration, verbal imagery.

References: **9** (109–111), **73** (366–376), **163** (20–23)m **164**.

Visual synesthesia occurs when a picture is designed in such a way that the visual information entering the eye serves to stimulate the other sensory modalities; tasting, smelling, hearing, touching. Combination photograph made from eleven different photographs. *Beach scene by David Hamilton, ice cream scoops by Frank Foster, art direction by Jim Fitts.*

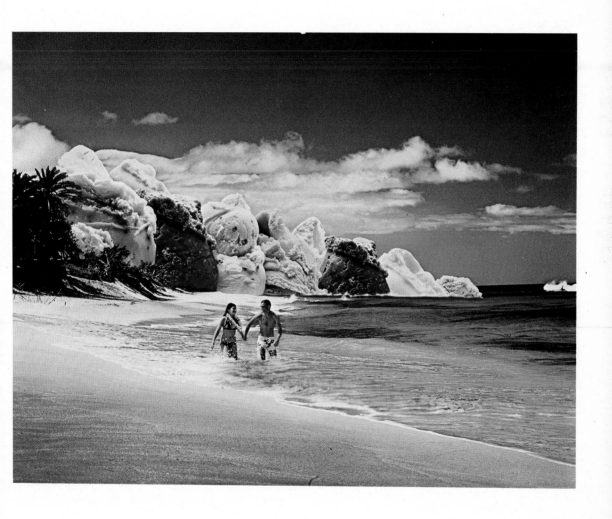

15.21 Verbal Imagery

Definition: The ability of words and phrases to arouse visual or other sensory images.

Perceptions that you construct from direct sensory stimulation of the eyes, or other sensory organs, often can be recalled or reconstructed by means of linguistic stimuli. In fact, it is essential to use words to describe the sensations and perceptions you have. Words and sensory experiences become associated through use and the extent to which a word can be used as a substitute for a direct sensory experience, or the extent to which it complements a sensory experience, is an indication of its imagery.

Considerable research over the years reveals that concrete words are generally more effective in arousing imagery than are abstract words. Words such as 'girl' and 'camera' are more easily associated with specific objects and events than are the more abstract terms such as 'theory' and 'proxy'. In a study of 925 nouns, Allan Paivio had a number of persons rate the nouns on a scale of 1 to 7 in terms of three factors: *imagery*, *concreteness* and *meaning*. The meaning of a word suggests intent, aim and significance, and may include other word associations. The sampling of words and their average ratings (*see* opposite) show that the relation of the three factors varies with different words. Correlation is best between imagery and concreteness ($r=0.83$; when correlation is perfect $r=1.00$) and least between concreteness and meaning ($r=0.56$). The process of correlating data averages out and obscures individual differences. These differences can often be of practical importance as shown by the listing of words that have high imagery and meaning but low concreteness.

The importance of words in mental imagery has a long history. About 500 BC the Greek poet Simonides wrote that 'Words are the images of things' and more recently, about 1890, the psychologist William James described concrete words as consisting of 'sensory images awakened.'

Two theories on how words arouse images have been put forth. The first is Plato's *wax tablet* model in which perceptions are impressed on the mind as on a wax tablet, to be remembered as long as the impression lasts. The second is that of *associative imagery* which holds that memory images are evoked by words with which objects or events have been linked in the past.

Although it should not be assumed that all visual perceptions are coded in word form in memory, our everyday reading, talking and listening experiences attest to the importance of concrete words for sensory arousal. You only have to scan the daily barrage of advertising and product names to realize the importance of high imagery words. The potential harm of cigarettes is masked by the 'goodness' in the associative imagery that words such as MERIT, TRUE, and FACT evoke. Words used to name and advertise cosmetics are a rich resource of highly sensory words. New word combinations are continually being invented to attract attention and emphasize imagery—wonderfeel (for a new fabric), fabuflex (for a stretch belt).

Choice of words in captioning a photograph can affect the pictorial communication. Many photographers do not caption their pictures and some, like Edward Weston and Jerry Uelsmann, simply identify them with neutral or factual captions such as 'Pepper No. 30', or 'Peter Bunnell 1972' or just '1974' which encourages more individualized perceptions among viewers.

On the other hand, words can reduce the variability of perception of pictures when it is important that the intended message is not misinterpreted. Words and pictures are not separable nor should they be. Paivio has found 'that naming enhances memory for pictorial items and image coding increases memory for words'. Words and pictures can work in concert and when they do, memory is enhanced.

Related terms: coding, cognitive responses, imagination imagery, memory, synesthesia.
References: **164, 165** (1—25).

Imagery, concreteness and meaning (I, C, M) vary for each of the sample words.

	I	C	M	High	Low
ankle	6.8	7.0	6.8	Imagery, Concreteness and Meaning	
flag	6.6	6.9	6.5		
anger	4.9	1.7	5.8	Imagery and Meaning	Concreteness
fun	5.3	2.5	5.5		
gadfly	3.8	5.9	3.3	Concreteness	Imagery and Meaning
wholesaler	3.9	6.2	4.9		
abdomen	6.0	6.8	4.8	Imagery and Concreteness	Meaning
professor	6.2	6.7	5.4		
belief	2.7	1.6	5.2		Imagery and Concreteness
chance	2.5	1.5	5.6	Meaning	

Above: Pictures can arouse word images.

Above, left: Words can arouse sensory images.

Left: Captions can change the meaning of a picture. Consider these captions: 'Early Frost', 'Folia Fantasy' 'Diseased Leaves'. *Photograph by C. B. Neblette.*

335

Bibliography

1. ADAMS, A. *Camera and Lens*. Dobbs Ferry, NY: Morgan & Morgan, 1971.
2. ADAMS, A. *The Negative*. Dobbs Ferry, NY: Morgan & Morgan, 1974.
3. ALBERS, J. *Interaction of Color*. New Haven: Yale University Press, 1972.
4. ALPERN, N. Effector Mechanisms in Vision, in Kling, J. & Riggs, L. (Eds.) *Experimental Pyschology*. New York: Holt, Rinehart & Winston, 1961.
5. AMERICAN NATIONAL STANDARDS INSTITUTE. *Direct Viewing of Photographic Color Transparencies*. (PH2.31–1969) New York: Author, 1969.
6. AMERICAN NATIONAL STANDARDS INSTITUTE. *Viewing Conditions for Photographic Color Prints*. (PH2.41–1976) New York: Author, 1976.
7. AMERICAN NATIONAL STANDARDS INSTITUTE. *Viewing Conditions for the Appraisal of Color Quality and Color Uniformity in the Graphic Arts*. (PH2.32–1972) New York: Author, 1972.
8. ARNHEIM, R. *Toward a Psychology of Art*. Berkeley, CA: University of California Press, 1972a.
9. ARNHEIM, R. *Visual Thinking*. Berkeley, CA: University of California Press, 1972b.
10. ARNHEIM, R. *Art and Visual Perception*. Berkeley, CA: University of California Press, 1974.
11. ARNHEIM, R. *The Dynamics of Architectural Form*. Berkeley, CA: University of California, 1977.
12. ATKINSON, R. & SHIFFRIN, R. The Control of Short-Term Memory. *Scientific American*, August, 1971, *225*.
13. ATTNEAVE, F. Multistability in Perception. *Scientific American*, December, 1971, *225*.
14. AVERBACH, E. & SPERLING, G. Short-Term Storage of Information in Vision, in Haber, R. (Ed.) *Contemporary Theory and Research in Visual Perception*. New York: Holt, Rinehart & Winston, 1968.
15. BAILEY, R. & MICHALS, D. *Duane Michals*. Los Angeles: Alskog, 1975.
16. BARTLESON, C. Memory Colors of Familiar Objects. *Journal of the Optical Society of America*, January, 1960, *50*.
17. BARTLETT, N. Thresholds as Dependent on Some Energy Relations and Characteristics of the Subject, in Graham, C. (Ed.) *Vision and Visual Perception*. New York: Wiley, 1965.
18. BECK, J. *Surface Color Perception*. Ithaca, NY: Cornell University Press, 1972.
19. BIRREN, F. (Ed.) *Ostwald: The Color Primer*. New York: Van Nostrand Reinhold, 1969a.
20. BIRREN, F. *Principles of Color*. New York: Van Nostrand Reinhold, 1969b.
21. BIRREN, F. (Ed.) *Munsell: A Grammar of Color*. New York: Van Nostrand Reinhold, 1975.
22. BLAKER, J. *Optics I*. New York: Barnes & Noble, 1969.
23. BLOOM, B. (Ed.) *Taxonomy of Educational Objectives*. New York: McKay, 1956.
24. BLOOMER, C. *Principles of Visual Perception*. New York: Van Nostrand Reinhold, 1976.
25. BOYNTON, R. Progress in Physiological Optics. *Applied Optics*, August, 1967, *6*.
26. BOYNTON, R. The Psychophysics of Vision, in Haber, R. (Ed.) *Contemporary Theory and Research in Visual Perception*. New York: Holt, Rinehart & Winston, 1968.
27. BOWER, T. *The Perceptual World of a Child*. Cambridge, MA: Harvard University Press, 1977.
28. BRINDLEY, G. Afterimages. *Scientific American*, October, 1963, *209*.
29. BROWN, J. Afterimages, in Graham, C. (Ed.) *Vision and Visual Perception*. New York: Wiley, 1965a.
30. BROWN, J. Flicker and Intermittent Stimulation, in Graham, C. (Ed.) *Vision and Visual Perception*. New York: Wiley, 1965b.
31. BROWN, J. The Structure of the Visual System, in Graham, C. (Ed.) *Vision and Visual Perception*. New York: Wiley,

1965c.

32. BROWN, J. & MUELLER, C. Brightness Discrimination and Brightness Contrast, in Graham, C. (Ed.) *Vision and Visual Perception.* New York: Wiley, 1965.

33. BRUNER, J. On Perceptual Readiness, in Haber, R. (Ed.) *Contemporary Theory and Research in Visual Perception.* New York: Holt, Rinehart & Winston, 1968.

34. BRUNER, J. & POTTER, M. Interference in Visual Recognition. *Science,* April 24, 1964, *144.*

35. BUGELSKI, R. *The Psychology of Learning Applied to Teaching.* New York: Bobbs-Merrill, 1964.

36. BURNHAM, R., HANES, R. & BARTLESON, C. *Color: A Guide to Basic Facts and Concepts.* New York: Wiley, 1963.

37. CAMPBELL, F. & MAFFEI, L. Contrast and Spatial Frequency. *Scientific American,* November, 1974, *231.*

38. CANTER, D. & LEE, T. (Eds.) *Psychology and the Built Environment.* New York: Wiley, 1974.

39. CHANCE, P. Ads Without Answers Make the Brain Itch. *Psychology Today,* November, 1975, *9.*

40. CLARK, F. *Special Effects in Motion Pictures.* New York: Society of Motion Picture & Television Engineers, 1966.

41. COLLIER, G. *Art and the Creative Consciousness.* Englewood Cliffs, NJ: Prentice-Hall, 1972.

42. CONSULTING PSYCHOLOGIST PRESS. *Embedded Figure Test Manual.* Palo Alto, CA: Author, 1971.

43. CONWAY, J. Multiple-Sensory Modality Communication and the Problem of Sign Types. *AV Communication Review.* Winter, 1967, *15.*

44. CORNSWEET, T. *Visual Perception.* New York: Academic Press, 1970.

45. CRM BOOKS. *Psychology Today.* Del Mar, CA: Author, 1970.

46. CRONBACH, L. *Essentials of Psychological Testing.* New York: Harper & Row, 1970.

47. DAVIDOFF, J. *Differences in Visual Perception.* New York: Academic Press,

48. DINNERSTEIN, D. Previous and Concurrent Visual Experience As Determinants of Phenomenal Shape, in Haber, R. (Ed.) *Contemporary Theory and Research in Visual Perception.* New York: Holt, Rinehart & Winston, 1968.

49. DIXON, N. *Subliminal Perception: The Nature of a Controversy.* New York: McGraw-Hill, 1971.

50. DONDIS, D. *A Primer of Visual Literacy.* Boston: MIT Press, 1973.

51. DOWDELL, J. & ZAKIA, R. *Zone Systemizer.* Dobbs Ferry, NY: Morgan & Morgan, 1974.

52. EASTMAN KODAK. *Color As Seen and Photographed.* Rochester, NY: Author, 1972.

53. ENCYCLOPEDIA BRITANNICA. *Encyclopedia Britannica.* London: Author, 1965, *4.*

54. ENGEN, T. Psychophysics, in Kling, J. & Riggs, L. (Eds.) *Experimental Psychology.* New York: Holt, Rinehart & Winston, 1971.

55. EVANS, R. *An Introduction to Color.* New York: Wiley, 1948.

56. EVANS, R. *Eye, Film and Camera in Color Photography.* New York: Wiley, 1960.

57. EVANS, R., HANSON, W. & BREWER, W. *Principles of Color Photography.* New York: Wiley, 1953.

58. FANTZ, R. Pattern Vision in Newborn Infants. *Science,* April 19, 1963, *140.*

59. FEININGER, A. *Photographic Seeing.* Englewood Cliffs, NJ: Prentice-Hall, 1973.

60. FERGUSON, E. The Mind's Eye: Nonverbal Thought in Technology. *Science,* August 26, 1977, *197.*

61. FESTINGER, L. Cognitive Dissonance. *Scientific American,* October, 1962, *207.*

62. FESTINGER, L. *Conflict, Decision and Dissonance.* Stanford, CA: Stanford University Press, 1964.

63. FIELDING, R. *The Technique of Special-Effects Cinematography.* New York: Hastings House, 1968.

64. FOCAL PRESS. *The Focal Encyclopedia of Photography.* New York: Mc-Graw-Hill, 1969.
65. FORGUS, R. *Perception.* New York: McGraw-Hill, 1966.
66. FROSTIG, M., MASLOW, P., LE-FEVER, D. & WHITTLESLEY, J. *The Marianne Frostig Developmental Test of Visual Perception.* Palo Alto, CA: Consulting Psychologists Press, 1964.
67. FRY, G. The Image-Forming Mechanism in the Eye, in Field, J. & Hall, V. (Eds.) *Handbook of Psychology*, Section I, v. 1. Washington, DC: American Physical Society, 1959.
68. GARDNER, M. The Curious Magic of Anamorphic Art. *Scientific American,* January, 1975, *232.*
69. GAZZANIGA, M. *Fundamentals of Psychology.* New York: Academic Press, 1973.
70. GELDARD, F. *The Human Senses.* New York: Wiley, 1972.
71. GIBSON, J. *The Senses Considered As Perceptual Systems.* Boston: Houghton Mifflin, 1966.
72. GIBSON, J. The Theory of Information Pickup, in Haber, R. (Ed.) *Contemporary Theory and Research in Visual Perception.* New York: Holt, Rinehart & Winston, 1968.
73. GOMBRICH, E. *Art and Illusion.* Princeton, NJ: Princeton University Press, 1969.
74. GORE, R. In Search of the Mind's Eye. *Life*, October 22, 1971, *71.*
75. GRAHAM, C. Perception of Movement, in Graham, C. (Ed.) *Vision and Visual Perception.* New York: Wiley, 1965a.
76. GRAHAM, C. Some Basic Terms and Methods, in Graham, C. (Ed.) *Vision and Visual Perception.* New York: Wiley, 1965b.
77. GRAHAM, C. Some Fundamental Data, in Graham, C. (Ed.) *Vision and Visual Perception.* New York: Wiley, 1965c.
78. GRAHAM, C. Visual Form Perception, in Graham, C. (Ed.) *Vision and Visual Perception.* New York: Wiley, 1965d.
79. GRAHAM, C. Visual Space Perception, in Graham, C. (Ed.) *Vision and Visual Perception.* New York: Wiley, 1965e.
80. GREGORY, R. *Eye and Brain.* New York: McGraw-Hill, 1966.
81. GREGORY, R. Distortion of Visual Space As Inappropriate Constancy Scaling, in Haber, R. (Ed.) *Contemporary Theory and Research in Visual Perception.* New York: Holt, Rinehart & Winston, 1968a.
82. GREGORY, R. Visual Illusions. *Scientific American,* November, 1968b, *219.*
83. GREGORY, R. & GOMBRICH, E. (Eds.) *Illusion in Nature and Art.* New York: Scribners, 1973.
84. HABER, R. (Ed.) *Contemporary Theory and Research in Visual Perception.* New York: Holt, Rinehart & Winston, 1968.
85. HABER, R. (Ed.) *Information-Processing Approaches to Visual Perception.* New York: Holt, Rinehart & Winston, 1969.
86. HABER, R. & HERSHENSON, M. *The Psychology of Visual Perception.* New York: Holt, Rinehart & Winston, 1973.
87. HALL, C. & LINDZEY, G. *Theories of Personality.* New York: Wiley, 1970.
88. HALL, E. *The Hidden Dimension.* New York: Doubleday, 1966.
89. HARBY, S. *Comparison of Mental Practice and Physical Practice in the Learning of Physical Skills.* Port Washington, NY: Office of Naval Research, 1952.
90. HARMON, L. The Recognition of Faces. *Scientific American,* November, 1973. *229.*
91. HARROW, A. *A Taxonomy of the Psychomotor Domain.* New York: McKay, 1972.
92. HAZ, N. *Image Management.* Cincinnati: Author: 1946.
93. HEBB, D. *Textbook of Psychology.* Philadelphia: Saunders, 1972.
94. HECHT, S. The Development of Thomas Young's Theory of Color Vision, in Teevan, R. & Birney, R. (Eds.) *Color Vision.* Princeton, NJ: Van Nostrand, 1961.

95. HECHT, S. & SMITH, E. Intermittent Stimulation by Light. VI. Area and the Relation Between Critical Frequency and Intensity. *The Journal of General Physiology,* 1936, *19.*

96. HELD, R. (Ed.) *Image, Object and Illusion.* San Francisco: Freeman, 1974.

97. HENLE, M. *The Selected Papers of Wolfgang Köhler.* New York: Liveright, 1971.

98. HENLE, M. (Ed.) *Vision and Artfact.* New York: Springer, 1976.

99. HERNANDEZ-PEON, R., SCHERRER, H. & JOUVET, M. Modification of Electric Activity in Cochlear Nucleus During "Attention" in Unanesthetized Cats. *Science,* 24 February, 1956, *123.*

100. HERON, W. The Pathology of Boredom. *Scientific American,* January, 1957, *196.*

101. HERSHENSON, M. Development of the Perception of Form, in Haber, R. (Ed.) *Contemporary Theory and Research in Visual Perception.* New York: Holt, Rinehart & Winston, 1968.

102. HESS, E. Attitude and Pupil Size. *Scientific American,* April, 1965, *212.*

103. HESS, E. The Role of Pupil Size in Communication. *Scientific American,* November, 1975, *233.*

104. HILGARD, E. & BOWER, G. *Theories of Learning.* New York: Appleton-Century-Crofts, 1966.

105. HOCHBERG, J. *Perception.* Englewood Cliffs, NJ: Prentice-Hall, 1978.

106. HOCHBERG, J. Perception, in Kling, J. & Riggs, L. (Eds.) *Experimental Psychology.* New York: Holt, Rinehart & Winston, 1971.

107. HOFFER, W. A Magic Ratio Recurs Throughout Art and Nature. *Smithsonian,* December, 1975, *6.*

108. HOLWAY, A. & BORING, E. Determinants of Apparent Visual Size with Distance Variant. *American Journal of Psychology,* 1941, *54.*

109. HOMER, W. *Seurat and the Science of Painting.* Boston: MIT Press, 1964.

110. HOWLAND, B. & HOWLAND, H. Subjective Measurement of High-order Aberrations of the Eye. *Science,* 13 August, 1976, *193.*

111. HSIA, Y. & GRAHAM, C. Color Blindness, in Graham, C. (Ed.) *Vision and Visual Perception.* New York: Wiley, 1965.

112. HUBBARD, J. *The Biological Basis of Mental Activity.* Menlo Park, CA: Addison-Wesley, 1975.

113. HUBEL, D. The Visual Cortex of the Brain. *Scientific American.* November, 1963. *209.*

114. HUNT, R. & WINTER, L. Colour Adaptation in Picture-Viewing Situations. *The Journal of Photographic Science,* May/June, 1975, *3.*

115. HURVICH, L. & JAMESON, D. An Opponent-Process Theory of Color Vision, in Teevan, R. & Birney, R. (Eds.) *Color Vision.* Princeton, NJ: Van Nostrand, 1961.

116. JENKINS, J. & DALLENBACH, K. Oblivescence During Sleep and Waking. *American Journal of Psychology,* 1924, *35.*

117. JOHANSSON, G. Visual Motion Perception. *Scientific American,* June, 1975, *232.*

118. JUNG, C. *Man and His Symbols.* New York: Doubleday, 1964.

119. KAUFMAN, L. *Sight and Mind.* New York: Oxford, 1974.

120. KAUFMAN, L. & ROCK, I. The Moon Illusion. *Scientific American,* July, 1962, *207.*

121. KENNEDY, J. *A Psychology of Picture Perception.* San Francisco: Jossey-Bass, 1974.

122. KEPES, G. *Module, Proportion, Symmetry, Rhythm.* New York: George Braziller, 1966.

123. KERN, E. The Neuron. *Life,* October 22, 1971, *71.*

124. KEY, W. *Media Sexploitation.* Englewood Cliffs, NJ: Prentice-Hall, 1976.

125. KITZINGER, E. *Israeli Mosaics.* New York: New American Library, 1965.

126. KLING, J. & RIGGS, L. (Eds.) *Woodworth and Schlossberg's Experimental Psychology.* New York: Holt, Rinehart

& Winston, 1971.

127. KOFFKA, K. *Principles of Gestalt Psychology.* New York: Harcourt, Brace & World, 1963.

128. KOHLER, I. The Formation and Transformation of the Visual World, in Haber, R. (Ed.) *Contemporary Theory and Research in Visual Perception.* New York: Holt, Rinehart & Winston, 1968.

129. KOHLER, W. *The Task of Gestalt Psychology.* Princeton, NJ: Princeton University Press, 1969.

130. KOLERS, P. & EDEN, M. (Eds.) *Recognizing Patterns.* Cambridge, MA: MIT Press, 1968.

131. KRATHWOHL, D., BLOOM, B. & MASIA, B. *Taxonomy of Educational Objectives, Handbook II: Affective Domain.* New York: McKay, 1956.

132. LAFAY, H. & HARVEY, D. The Maya, Children of Time. *National Geographic,* 1975, *148.*

133. LAND, E. Experiments in Color Vision, in Teevan, R. & Birney, R. (Eds.) *Color Vision.* Princeton, NJ: Van Nostrand, 1961.

134. LAND, E. The Retinex Theory of Color Vision. *Scientific American,* December, 1977, *237.*

135. LANNERS, E. (Ed.) *Illusions.* New York: Holt, Rinehart, & Winston, 1977.

136. LEEMAN, F. *Hidden Images.* New York: Abrams, 1976.

137. LEVANWAY, R. *Advanced General Psychology.* Philadelphia: Davis, 1972.

138. LINFOOT, E. Information Theory and Photographic Images. *Journal of Photographic Science,* November/December, 1959, 7.

139. LUCKIESH, M. *Visual Illusions.* New York: Dover, 1965.

140. LYONS, N. (Ed.) *Photographers on Photography.* Englewood Cliffs, NJ: Prentice-Hall, 1966.

141. MANNING, S. & ROSENSTOCK, E. *Classical Psychophysics and Scaling.* New York: McGraw-Hill, 1968.

142. MATTHAEI, R. *Goethe's Color Theory.* New York: Van Nostrand Reinhold, 1971.

143. MCCAMY, C., MARCUS, H. & DAVIDSON, J. A Color-Rendition Chart. *Journal of Applied Photographic Engineering,* Summer, 1976, *2.*

144. MCKIM, R. *Experiences in Visual Thinking.* Monterey, CA: Brooks/Cole, 1972.

145. METELLI, F. Achromatic Color Conditions in the Perception of Transparency, in MacLeod, R. & Pick, H. (Eds.) *Perception.* Ithaca, NY: Cornell University Press, 1974a.

146. METELLI, F. The Perception of Transparency. *Scientific American,* April, 1974b, *230.*

147. MILLER, G. Information and Memory. *Scientific American,* August, 1956, *195.*

148. MILLER, G. The Magical Number Seven Plus or Minus Two, in Haber, R. (Ed.) *Contemporary Theory and Research in Visual Perception.* New York: Holt, Rinehart & Winston, 1958.

149. MORRIS, D. *Manwatching.* New York: Harry N. Abrams, 1977.

150. MOTOKAWA, K. *Physiology of Color and Pattern Vision.* New York: Springer-Verlac, 1970.

151. MURCH, G. *Visual and Auditory Perception.* Indianapolis: Bobbs-Merrill, 1973.

152. NEISSER, U. Decision-Time Without Reaction-Time: Experiments in Visual Scanning. *American Journal of Psychology,* September, 1963, *76.*

153. NEISSER, U. Visual Search. *Scientific American,* June, 1964, *210.*

154. NEISSER, U. *Cognitive Psychology.* New York: Appleton-Century-Crofts, 1967.

155. NELSON, C. The Theory of Tone Reproduction, in Mees, C. & James, T. (Eds.) *The Theory of the Photographic Process.* New York: Macmillan, 1966.

156. NELSON, C. Photographic System As a Communication Channel. *Applied Optics,* January, 1972, *11.*

157. NELSON, C. *Tone Reproduction and Visual Adaptation.* (Visual Encyclopedia) Rochester, NY: Rochester Chapter, Society of Photographic Scientists

& Engineers. n.d.

158. NEWHALL, N. (Ed.) *The Daybooks of Edward Weston, II. California* Millerton, NY: Aperture, 1973.

159. NEWHALL, S., BURNHAM, R. & CLARK, J. Comparison of Successive with Simultaneous Color Matching. *Journal of the Optical Society of America,* January, 1957, *47.*

160. NOTON, D. & STARK, L. Eye Movements and Visual Perception. *Scientific American,* June, 1971, *224.*

161. O'NEILL, J. *Prodigal Genius: The Life of Nikola Tesla.* New York: McKay, 1964.

162. ORNSTEIN, R. *The Psychology of Consciousness.* San Francisco: Freeman, 1972.

163. OSGOOD, C., SUCI, G. & TANNENBAUM, P. *The Measurement of Meaning.* Urbana, IL: University of Illinois Press, 1971.

164. PAIVIO, A. *Imagery and Verbal Processes.* New York: Holt, Rinehart & Winston, 1971.

165. PAIVIO, A., YUILLE, J. & MADIGAN, S. Concreteness, Imagery and Meaningfulness Values for 925 Nouns. *Journal of Experimental Psychology,* (Monograph Supplement), 1968, *76,* No. 1, Part 2.

166. PARKER, W. Uelsmann's Unitary Reality. *Aperture,* 1967, *13,* (3).

167. PARKS, T. Post-Retinal Visual Storage. *American Journal of Psychology,* March, 1965, *78.*

168. PINES, M. We are Left-Brained or Right-Brained. *New York Times Magazine,* September 9, 1973.

169. RAINWATER, C. *Light and Color.* New York: Golden Press, 1971.

170. RATLIFF, F. *Mach Bands.* San Francisco: Holden Day, 1965.

171. RATLIFF, F. Contour and Contrast. *Scientific American,* June, 1972, *226.*

172. READ, R. *Tangrams.* New York: Dover, 1965.

173. REED, G. *The Psychology of Anomalous Experience.* Boston: Houghton Mifflin, 1974.

174. REESE, W. New View on Color Viewing. *Printing. Production,* November, 1967, *98.*

175. RICE, B. Rattlesnakes, French Fries and Pupillometric Oversell. *Psychology Today,* February, 1974, *7.*

176. RICHARDSON, A. *Mental Imagery.* New York: Springer, 1969.

177. RICKMERS, A. & TODD, H. *Statistics: An Introduction.* New York: McGraw-Hill, 1973.

178. RIGGS, L. Visual Acuity, in Graham, C. (Ed.) *Vision and Visual Perception.* New York: Wiley, 1965.

179. RIGGS, L. Vision, in Kling, J. & Riggs, L. (Eds.) *Experimental Psychology.* New York: Holt, Rinehart & Winston, 1971.

180. ROBINSON, D. Eye Movement Control in Primates. *Science,* September 20, 1968, *161.*

181. ROCK, I. & HARRIS, C. Vision and Touch. *Scientific American,* May, 1967, *216.*

182. ROCK, I. & VICTOR, J. Vision and Touch: An Experimentally Created Conflict between the Two Senses. *Science,* 7 February, 1964, *143.*

183. ROOD, O. *Modern Chromatics.* New York: Van Nostrand Reinhold, 1973.

184. ROOSEN, R., STAES, K. & VERBRUGGHE, R. Color Reversal Silver Halide Systems, in Eynard, R. (Ed.) *Color: Theory and Imaging Systems.* Washington, DC: Society of Photographic Scientists & Engineers, 1973.

185. ROUTH, R. *Photographics.* Los Angeles: Peterson, 1976.

186. SAUNDERS, A. On the Application of Information Theory to Photography. *Journal of Photographic Science,* November/December, 1973, *21.*

187. SCHIFFMAN, H. *Sensation and Perception: An Integrated Approach.* New York: Wiley, 1976.

188. SOMMER, R. *Personal Space.* Englewood Cliffs, NJ: Prentice-Hall, 1969.

189. SPERRY, R. The Great Cerebral Commissure. *Scientific American,* January, 1964, *210.*

190. STIMSON, A. *Photometry and Radiometry for Engineers.* New York: Wiley, 1974.

191. STROEBEL, L. *Discrimination of Pictorial Stimulus Attributes.* (Doctoral Dissertation, University of Rochester.) Ann Arbor, MI: University Microfilms, 1974a, No. 74–15, 103.

192. STROEBEL, L. *Photographic Filters.* Dobbs Ferry, NY: Morgan & Morgan, 1974b.

193. STROEBEL, L. *View Camera Technique.* New York: Hastings House, 1976.

194. STROOP, J. Studies of Interference in Serial Verbal Reactions. *Journal of Experimental Psychology,* December, 1935, *18.*

195. STURGE, J. (Ed.) *Neblette's Handbook of Photography and Reprography: Materials, Processes and Systems* (7th ed.) New York: Van Nostrand & Reinhold, 1977.

196. TEEVAN, R. & BIRNEY, R. (Eds.) *Color Vision.* Princeton, NJ: Van Nostrand, 1961.

197. TEUBER, M. Sources of Ambiguity in the Prints of Maurits C. Escher. *Scientific American,* July, 1974, *231.*

198. THORNTON, W. Lamps for Assessing Metamerism. *Journal of the Illuminating Engineering Society of America,* October, 1974, *4.*

199. TIME. Exploring the Frontiers of the Mind. *Time,* January 14, 1974, *103.*

200. TIME-LIFE BOOKS. *Color.* (Life Library of Photography.) New York: Author, 1970.

201. TODD, H. *Photographic Sensitometry: A Self-Teaching Text.* New York: Wiley, 1976.

202. TODD, H. & ZAKIA, R. *Photographic Sensitometry: The Study of Tone Reproduction.* Dobbs Ferry, NY: Morgan & Morgan, 1974.

203. TUCKER, K. *The Educated Innocent Eye.* Berkeley, CA: The Image Circle, 1972.

204. TURBAYNE, C. *The Myth of Metaphor.* Columbia, SC: University of South Carolina Press, 1970.

205. UELSMANN, J. *Jerry N. Uelsmann Silver Meditations.* Dobbs Ferry, NY: Morgan & Morgan, 1975.

206. UNITED PRESS INTERNATIONAL. Ryan Credits Photos for 4-Hit Victory, *The Times-Union.* Rochester, NY: Gannett, May 11, 1974.

207. VALENTINE, C. *The Experimental Psychology of Beauty.* London: Methuen, 1962.

208. VANCE, A. West Coast, *Popular Photography,* Holiday, 1976, *79.*

209. VERNON, M. *Perception Through Experience.* London: Methuen, 1970.

210. WALD, G. Molecular Basis of Visual Excitation. *Science,* 11 October, 1968, *162.*

211. WHITE, M. Equivalence: The Perennial Trend. *Photographic Society of America Journal,* July, 1963, *29.*

212. WHITE, M., ZAKIA, R. & LORENZ, P. *Zone System Manual.* Dobbs Ferry, NY: Morgan & Morgan, 1975.

213. WITKIN, H. The Perception of the Upright. *Scientific American,* February, 1959, *200.*

214. WYSZECKI. G. & STILES, W. *Color Science.* New York: Wiley, 1967.

215. ZAKIA, R. *Perception and Photography.* Rochester, NY: Light Impressions, 1979.

216. ZAKIA, R. & TODD, H. *Color Primer I and II.* Dobbs Ferry, NY: Morgan & Morgan, 1974.

217. ZETTLE, H. *Sight—Sound—Motion.* Belmont, CA: Wadsworth, 1973.

218. ZUSNE, L. *Visual Perception of Form.* New York: Academic Press, 1970.

Index